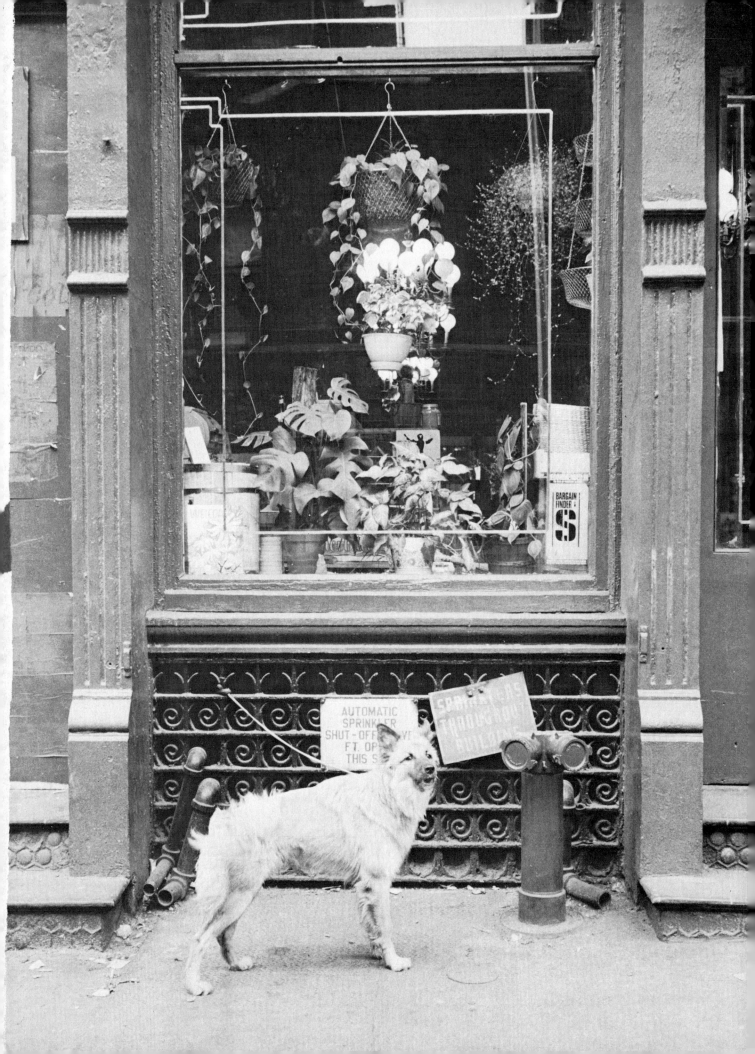

PHOTOGRAPHY TODAY FOR PERSONAL EXPRESSION

Principles/Equipment/Techniques

Lou Jacobs Jr.

Goodyear Publishing Company, Inc., Santa Monica, California

Acknowledgements

To the many people and companies that contributed information and photographs, the author is grateful. To Tom Carroll who encouraged the project and offered many fine pictures, a very special thanks. To Robert Routh, my appreciation for advice beyond the call of duty. To my editors, Clay Stratton, Sue MacLaurin, and Gail Ellison, a low bow for your patience and understanding. To John Isley, praise for the jacket/cover design. And another special thanks to designer Einar Vinje, who worked and worried to create a handsome book in which words and pictures are neatly synchronized.

Library of Congress Cataloging in Publication Data

Jacobs, Lou.
 Photography today.

 Bibliography: p.
 Includes index.
 1. Photography. I. Title.
TR145.J3 770 76-42205
ISBN 0-87620-669-0
ISBN 0-87620-668-2 pbk.

ISBN: 0-87620-668-2 (paper) 0-87620-669-0 (case)
Y-6682-2 (paper) Y-6690-5 (case)

Interior Design: Einar Vinje
Cover Design: John Isely
Supervising Production Editor: Sue MacLaurin

Cover photo credits: Top: Ken Rogers
Bottom, L. to R.: Lou Jacobs Jr., Joel Marcus, Jerry McCune.

Photographs in the book not credited to other sources are by the author.

Current Printing (last number): 10 9 8 7 6 5 4 3 2 1
Printed in the United States of America

"Your nose is cold" by Bud Grey ▶

CONTENTS

From chapter 2—by Tom Carroll

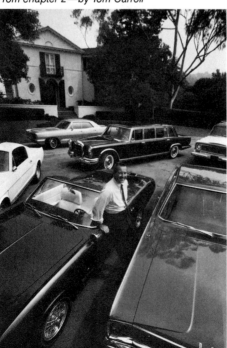

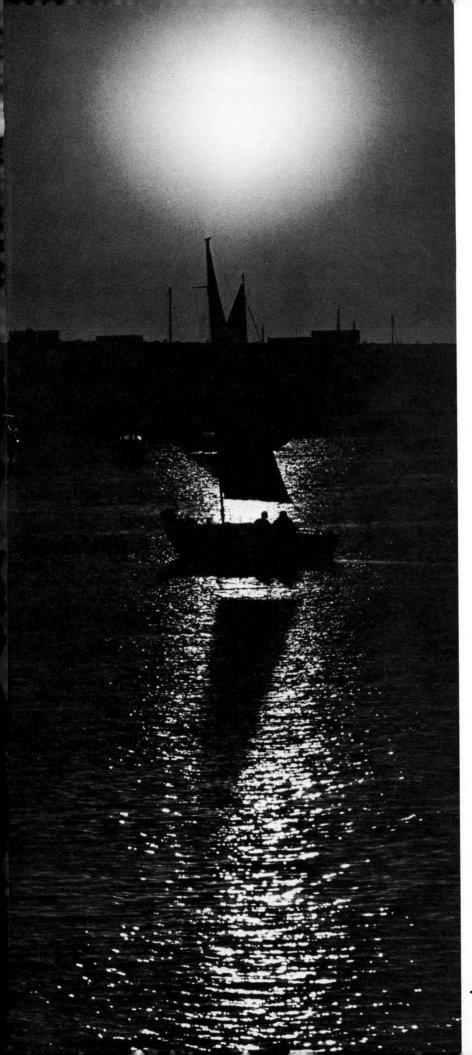

◄ *From chapter 4 — by the Author*

From chapter 9—by Grant Heilman

From chapter 10—by De Ann Jennings

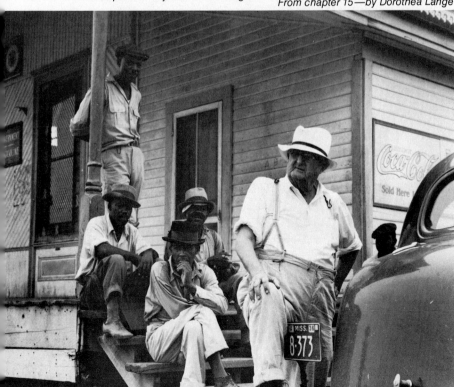

From chapter 15—by Dorothea Lange

INTRODUCTION

All artistic, commercial, personal graphic representation evolve from the effects of light on form, texture, color, and so on. Photography offers the one superb and literal means of permanently recording images originated by light. Fortunately, photographs do not always have to be literal, and thereby hangs the tale of personal expression with a camera. Like any intriguing story, it unfolds slowly as a solid foundation is established. Unlike fiction, you create the denouement of the personal expression tale for yourself. No two endings are alike.

The word *photography* is a combination of two Greek words: *phos*, meaning "light," and *graphein*, meaning "to write." While photography involves optical and mechanical instruments, chemicals, and principles of physics, the most important ingredient of "light-writing" is human vision. It may guide a photographer to be artistic, mundane, or somewhere between. Not only are we able to register on film anything the eye sees, but the resulting prints and slides are often a dynamic means of communication—and occasionally they may be art.

Taking a photograph seems so easy. You simply point a camera at a subject, focus a lens, adjust exposure settings, and push a shutter button. When the film is developed, you have images to project or view by reflected light. Children take millions of pictures. An untrained person (or even a trained chimpanzee) can hold a camera, make an exposure, and go through the motions of photography.

If this is true, why take the time and effort to *study* this subject? The answers are apparent, but I'll review them anyway. In the first place, operating an optical/mechanical instrument *effectively* requires technical skill, awareness of aesthetic principles, and practical experience to produce (or create) photographs of temporary or lasting value. Anyone can load a camera with film and go through the motions of picture-taking, but without training only a few individuals (or chimpanzees) do it well enough to make prints and slides worth a fast glance. A minority of people use the tools and materials well enough to be called professional, but many more learn to communicate ideas or express visual feelings well enough to exhibit or sell occasionally. Professionals and amateurs alike also enjoy the ego satisfaction that comes with creativity.

Therefore, you study photography to become comfortably proficient with its complexities, and achieve the controls to make camera work a career or a source of expression. Knowledge guides experience to commercial and personal success. Such knowledge involves a lot of theory that may seem tedious, but is necessary to the solid foundation I mentioned.

During this process, you also develop your ability to *see*. The camera makes it possible to translate your visions of the world into meaningful images to show and sell. All the data, formulas, and

theories are merely a means to that end. When you absorb the technicalities, they are yours to use in your own style.

Professionals, or those who are accomplished in any medium, know that creative fulfillment is worth the struggle to learn principles and practice techniques required for mastery of the medium. In photography, the goal is far beyond mere pictorial recording of people, places, and things. Through development of aesthetic taste we aim for images of lasting value, and the bonus is visual excitement. Increased perception and visual sensitivity with a camera enable you to solve the problems of time, space, and light. (Ernst Haas once wrote that photography is "the language of light and time.") Resulting are images that no child or chimp could possibly make, even by the luckiest of accidents. Fine photography is never accidental, though serendipity is often involved.

I hope photography is a turn-on now, and becomes more stimulating in the future. What you eventually will do with cameras and the array of available equipment, I don't know—and you may not either at this time. However, the options to produce the beautiful or the bizarre on film are encouragingly numerous.

Photography "talks" to people without words. Through prints and slides we tell stories, communicate ideas, sell products and services, sway emotions, keep records, and above all, make images for personal expression. Training and study develop awareness to see effectively through a camera viewfinder, and later to evaluate your images. No other graphic medium offers wider applications or more satisfying involvement.

I have tried to write as though you were sitting in my classroom, and I expect your attention, but you can "listen" again by rereading. Chapters are planned to follow each other in logical sequence. Illustrations are most often from my files, though I have included many from photographer-friends who contributed as a favor to us both. Words and pictures are synergistic, and hopefully many of them will inspire or motivate you to develop skills and talent you may not know you have.

As an art, craft, science, or profession, photography is *not* easy. Nothing worth learning is easy, but anything you strive to master can repay you handsomely in a variety of ways.

Some readers may want to know how this book ends, though it is not a mystery. I invite you to read the last chapter's history of photography first if you wish. I placed it intentionally at the end, however, because I feel it will have more meaning after you are more familiar with photographic tools and techniques.

Listen, see, analyze. Expose plenty of film. Stretch your imagination. Be daring. Grow through mistakes. Watch your skill increase. Be prepared for success. You won't be the first, nor the last, to fall in love with photography.

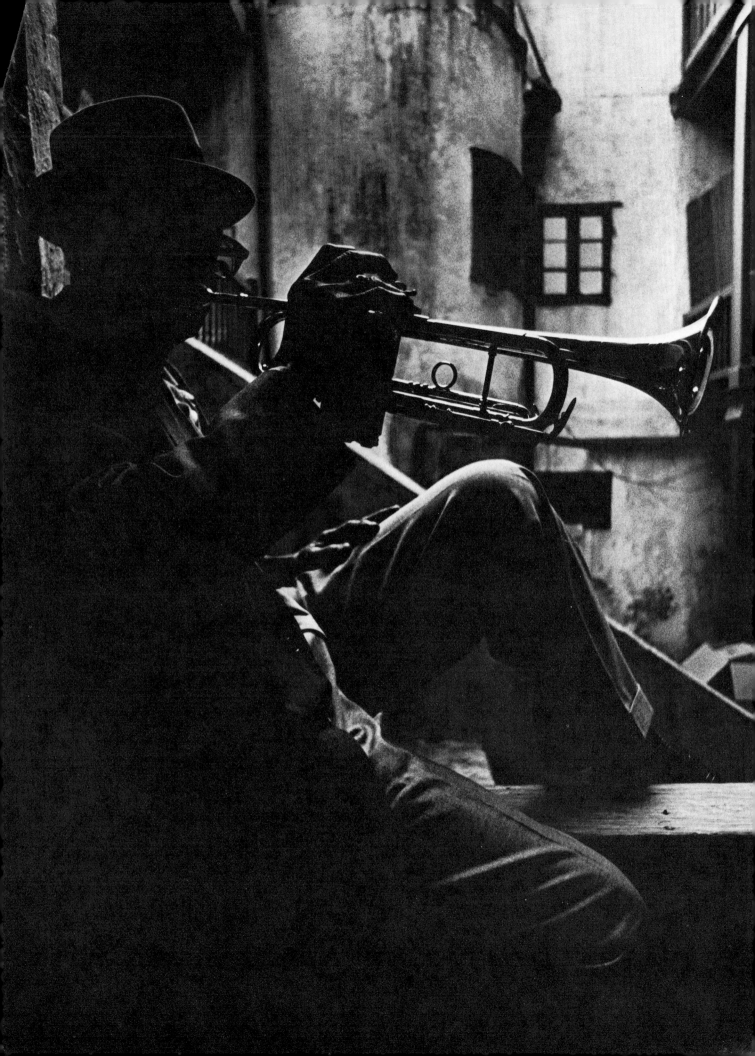

PHOTOGRAPHIC EXPOSURE

1 Oldtime Dixieland trumpeter Kid Thomas in his New Orleans setting by Jim Cornfield, photographic director of East/West Network (which publishes many airline magazines). Illustrating a story about the roots of American music, Cornfield used a Nikon F2 with 20mm lens.

It might be said that all photography is divided into three parts:

Seeing pictures

Exposing film in a camera to record those pictures

Processing film to make slides or prints for many purposes

The list is misleadingly simple. It does not indicate how much artistic and technical awareness and skill are required in photography. There is no mention of craftsmanship, nor of evaluating pictures once they have been seen, exposed, and processed. However, this entire book is designed to reinforce the theory and practice of using the camera, which you know to be somewhat complex and at the same time fascinating.

It would be my pleasure to open with a selection of photographs from many categories to inspire interest and to illustrate how others have used their art and craft. Instead, those pictures are spaced throughout the book and related to topics being discussed. As you come to these pictorial examples, past and present, it is my intention that they will have more meaning for you. Continued growth in photography will help refine your taste, judgment, and insight about worthwhile images.

Meanwhile, before turning to the tools for professional or personal expression, we delve into what those delightful combinations of metal, glass, plastic, and fabric actually do.

HOW A CAMERA WORKS

Ever since Niepce made the first photograph in 1826, a camera has been a box with a lens on one side and light-sensitive material inside the darkened enclosure opposite the lens. Today a camera can be an intricate arrangement of dials, levers, buttons, and meters, but it must have these essentials:

A *diaphragm* inside the lens that can be opened and closed to specific settings or *f-stops* to alter the amount of light reaching the film.

The diaphragm opening or f-stop is also known as the lens *aperture*.

A *shutter* mechanism that also opens and closes, usually in fractions of a second, to govern the time in which film is exposed.

2 ESSENTIAL PARTS OF A CAMERA.

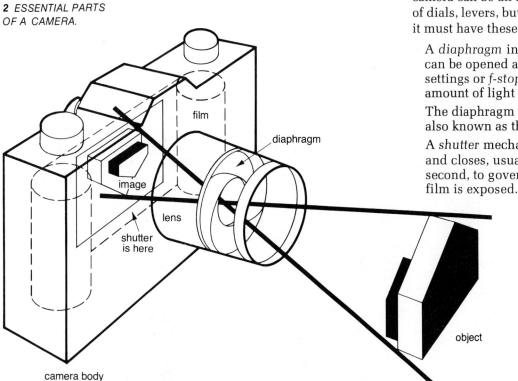

film

diaphragm

image

lens

shutter is here

object

camera body

3 *Underexposure results in little or no shadow detail.*

4 *Correct exposure is a compromise for shadow and highlight detail.*

5 *Overexposure has detail in the shadows but none in the highlights.*

We know cameras to be sophisticated instruments, but the simplest type can illustrate exposure. Make a pinhole in one end of a shoebox. In the dark, place a sheet of film or enlarging paper at the other end; then tape the box at the edges and aim this *pinhole camera* at a scene. If you are careful, and expose the film or paper long enough in bright light, you will have an image when it is developed. If you reduce the size of the box and add controls over exposure, focus, and image size and sharpness, you will, in principle, have a modern camera.

THE THEORY OF EXPOSURE

Photographic film is made up of a flexible plastic backing coated with an *emulsion* of chemicals sensitive to light. (Types of film are covered later in chapter 5, and film development is explained in chapter 8.) At this point, think of a sheet of film as though it were a piece of bread about to be toasted. In a toaster the bread is darkened by the heat from electrical elements, and in a camera the film is "darkened" or exposed to an image carried on rays of light. If the toast is too light, it has not been heated long enough, and if black-and-white film is too light, it has not been exposed to light long enough. This is called underexposure. A color slide appears too *dark* under the same conditions because it is a positive, not a negative image.

If toast is too dark, it has been heated too long. Black-and-white film that's too dark, or a color slide that's too light ("washed out"), have been affected by too much light and are overexposed. In a toaster you adjust the heat by a timing device, and in a camera you regulate exposure by adjusting the diaphragm opening or *aperture* within the lens, and/or the shutter speed.

Through the proper choice of f-stop and shutter speed to match the light-sensitivity of a specific film, plus correct development of the film, an ideal photographic exposure is possible. However, as we shall see, "ideal" is as difficult to achieve in photographic

6–9 As a modern 35mm SLR lens is stopped down, the diaphragm opening becomes smaller (precisely measured in f-stops), admitting less light to expose the film. (Reflections are seen on the outer surface of the lens.)

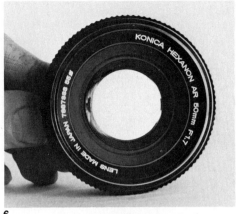

6

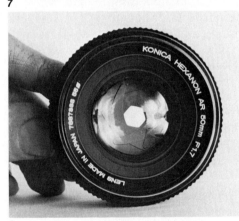

7

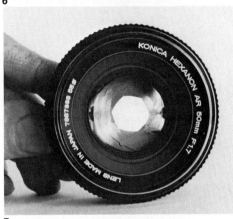

8

9

exposure as it is in marriage, because there are many mitigating circumstances. Primary among these is the contrast between highlights and shadows, the intensity or level of the light and the color of its source, and the ability of a given film to record detail in the brightest areas and the deepest shadows at the same time. These may seem like barriers to you now, but they are also stimulating (and frustrating) technical challenges you meet as you move more deeply into photography.

How Aperture Affects Exposure

In a given interval, more water pours through a piece of hose 1 inch in diameter than through a ½-inch piece of hose. On the same principle, more light passes through a 1-inch hole in a fraction of a second than it does through a ½-inch hole. This is the basis of the lens aperture and photographic exposure.

In the nineteenth century many cameras did not have adjustable openings built into the lens. Instead the photographer inserted into the lens barrel small sheets of metal called *waterhouse stops*. Each piece of metal had a different-sized hole in it to control the amount of light reaching the film. In modern lenses, the aperture is provided by a built-in adjustable iris diaphragm made of thin overlapping metal leaves. As you turn a ring on the lens barrel, the diaphragm opening or aperture becomes larger or smaller.

F-Stops

Each lens opening is called an f-stop and has an *f-number*. The term comes from a formula you won't need, but you must know the relationship of f-numbers to each other. What happens as you take pictures is this: To *increase* exposure, subjecting the film to more light during a given shutter speed interval, you *open up* the aperture to a larger or "wider" f-stop. To *decrease* exposure, or reduce the amount of light, you close or *stop down* the aperture to a smaller f-stop. These are common terms in the language of photographers, and they will become part of your vocabulary if they aren't already.

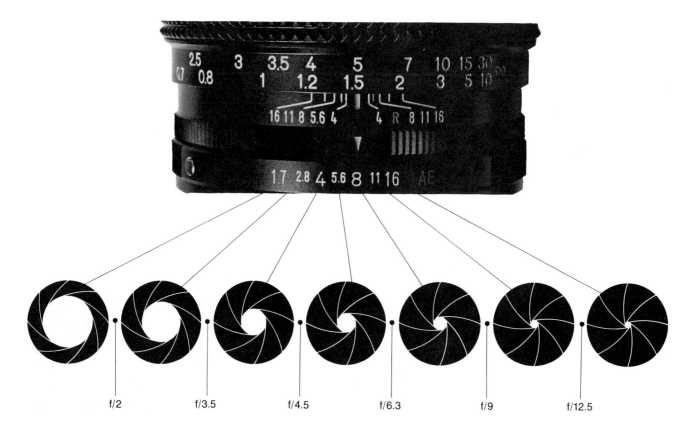

f/2 f/3.5 f/4.5 f/6.3 f/9 f/12.5

10 *Full stops (in circles) and half-stops on a camera lens.*

In the dim past optical experts came up with a set of numbers to designate specific lens openings or f-stops, and we're stuck with them. Modern lenses are calibrated in f-numbers that seem somewhat arbitrary and odd to the novice. However, an opening such as f/8 means the same in Germany as it does in Japan or Indiana, so all photographers set their lenses, meters, and minds according to an established standard.

These are the *full* f-stops of a lens: f/1.0, f/1.4 or f/1.5, f/2, f/4, f/5.6, f/8, f/11, f/16, f/22, f/32, f/45, f/64. Starting at f/1.0 (found on only a few rare lenses for 35mm cameras), each f-number represents *half* the lens opening size or half the amount of exposure of the f-number before it. For example, adjusting a lens from f/8 to f/11 reduces exposure by one-half, and in reverse, opening up from f/11 to f/8, increases exposure by one-half or doubles it. If you hear the phrase, "It should have

had twice the exposure you gave it," it means you should have *opened* the aperture a full stop. "Give it half the exposure" means *close* the aperture a full stop.

These are the *half-stops:* f/1.7 or f/1.8, f/2.5, f/3.5, f/4.5, f/6.3, f/9, f/12.5, and f/18. They are not usually marked on a lens barrel. However, on many lenses there are click-stops to indicate settings midway between marked full stops. Don't let these numbers stop you from adjusting a lens anywhere you wish, at any point on or between clicks or numbers, to set the precise lens opening for any exposure.

In summary, ignore the arithmetic relationship of the numbers because f/4 isn't twice as much exposure as f/8, nor is f/22 half the exposure of f/11. The fact that the largest lens openings are represented by the smaller f-numbers is another anomaly. Watch the diaphragm of a lens as you open it (to larger f-stops) and close it (to smaller f-stops), and you'll have a clear understanding of a basic fact of photographic life. F-numbers will have additional mean-

11 In late afternoon sun an f-stop of 11 was chosen for this setting, taken with a compact 35mm camera and 38mm lens.

ing and gain their full importance as you take pictures and are confronted with further theories of exposure and optics.

Shutter Speeds and Exposure

On a shutter-speed dial or ring, the numbers representing one second divided into fractions are easier to grasp because these numbers are literal, not symbolic. Think of the interval between two fractions as one stop, and the relationship with f-numbers is clearer. This means that a setting of 1/60 second allows half the amount of light to reach the film as 1/30 second. In reverse, 1/30 second exposes the film to twice the amount of light as 1/60 second. On most modern shutters there are no in-between speeds, except on certain automatic exposure cameras. These include a number of 35mm and larger-format cameras, such as 2¼x2¼, which have electronic shutters. Dials are marked in conventional shutter speeds, but according to the intensity of light measured by a built-in meter, the shutter may operate at a broad range of speeds such as 1/347 or 1/94 second.

In addition, most camera shutters have a B setting for time exposures. If operation is manual, the shutter stays open as long as the release button is held down. You guess or meter the exposure time and use a watch. Automatic cameras provide up to 10 or 15 sec-

12 Typical 35mm camera shutter-speed dial, including film-speed settings to guide built-in exposure meter.

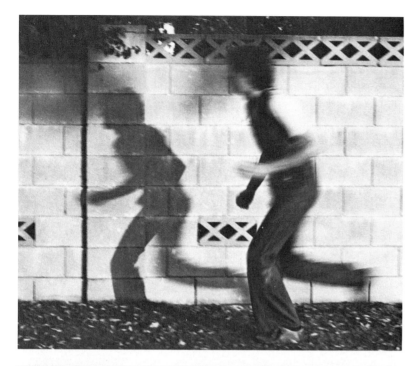

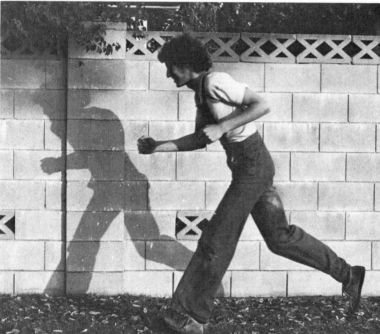

13–14 *Relationship of aperture and shutter speed. Figure 13 made at 1/30 second and f/16 blurred the running figure; figure 14 made at 1/250 second and f/5.6 resulted in the same amount of light for exposure, but the figure is sharp.*

F-stop	f/2	f/2.8	f/4	f/5.6	f/8	f/11	f/16
Shutter speed	1/500	1/250	1/125	1/60	1/30	1/15	1/8

onds for exposures, timed by electronic components connected to a built-in metering system. This feature can be very handy, and we'll discuss it further later.

Aperture and Shutter Speed Combined

Since both f-stops and shutter speeds are adjustable to control the amount of light affecting film during an exposure, the photographer has a choice of regulating one or both when taking pictures. This choice is influenced by light intensity, subject movement, depth of field (the area in sharp focus from near to far in a scene), and the type of scene or activity being photographed. How and why these choices are made are explained in many sections of this book. Here these points should be understood:

1. Opening the aperture one stop to *increase* exposure is equivalent to decreasing the shutter speed by one step. For example, changing the aperture from f/11 to f/8 is exactly the same in terms of exposure as changing the shutter speed from 1/125 to 1/60 second. *Decreasing* exposure is accomplished by *reversing* the procedure.

2. Exposure remains constant if shutter speed is increased one step (or more) while aperture is opened one stop (or more) in exact relationship. By switching from 1/125 second to 1/250 second and, at the same time, opening the lens from f/8 to f/5.6, the first adjustment compensates for the second, and the film receives the same amount of light in each case.

Below left is a set of f-stop and shutter-speed combinations, *all* of which are interchangeable in terms of equal exposure, though movement and focus are likely to be vitally affected, depending on the subject.

As an exercise, start with a different combination of f-stop and shutter speed, such as f/2 and 1/125 second, and calculate your own progression of exposure constants. In time you will figure f-stops and shutter speeds instinctively because experience makes

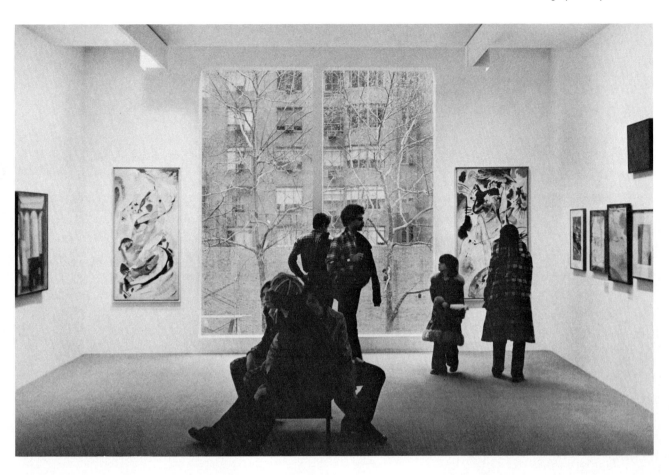

15 *Light in a gallery at the Museum of Modern Art balanced outdoor light, making the window scene appear as two framed pictures.*

knowledge an intrinsic part of your technique. If you want less exposure, you'll stop down or use a higher shutter speed, or both, depending on the circumstances. If you want more exposure, you'll open the lens or use a lower shutter speed, or both, depending on the scene.

As an example, if you're shooting indoors at 1/30 second at f/4 in room light, and you dash outdoors for pictures, you will at the same time adjust your camera to fit a new meter reading of 1/250 second at f/11. That's for bright sunlight. When you move into the shade, you may open up to f/8 because you want a fast shutter speed to be sure a running child is sharp. And when the sun goes down, you will reduce the shutter speed to 1/60 second and open up to f/2.8 because that's what the light intensity requires, according to your meter. In every case, you are aware of the relationship of lens opening and shutter speed, because you're in search of those ideal exposures.

SUMMARY

An instinct for correct exposure comes with experience in photography. Other factors such as film development, subject movement, camera shake, and pictorial effects are all tied to the choice of f-stop and shutter speed. Each of these factors will be discussed in due time.

1 *Everett McCourt chose a 21mm wide-angle lens to keep both hand and head in focus for this Kodak/Scholastic Award winner.*

In a simple camera there is usually a single curved piece of molded plastic serving as a lens. It may make pictures that are acceptable to the average amateur, but serious photographers require lenses that are far more sophisticated. These lenses produce very sharp images, can be precisely focused, transmit colors accurately without distortion, and are made in a fantastic variety of sizes, shapes, and image-producing formulas.

HOW A LENS WORKS

The basic function of a camera lens is to "gather" light rays from a subject, form and focus those rays into an image, and project this image onto film inside the camera. Optical glass can bend or change the direction of light rays that pass through it. When a piece of glass is shaped with concave or convex surfaces, light rays may be directed up, down, or straight, depending on the configuration of the lens.

Lens designers cleverly combine variously curved glass segments, called *elements*, within a metal container called the lens *barrel*. The object of almost every lens design, or formula, is image sharpness and color accuracy. Lenses vary according to the area they cover from a given distance, their maximum aperture size, and other specifics discussed below. While addi-

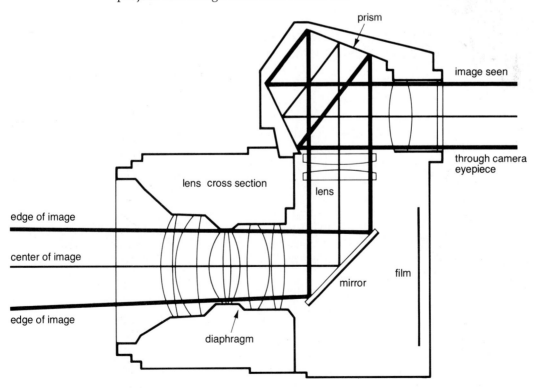

2 *Rays of light, focused by an SLR lens, are reflected from a mirror into a prism, and through the viewfinder window. The image you see is recorded on film when the mirror flips up during exposure.*

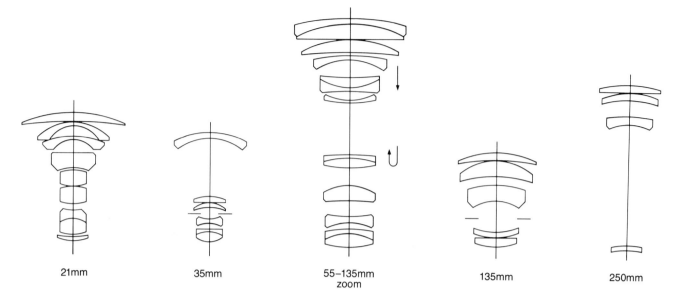

21mm 35mm 55–135mm zoom 135mm 250mm

3 Typical lens formulas showing cross sections of optical glass lens elements in configurations that make various focal lengths possible.

tional knowledge about optics or the physics of light may be helpful to some photographic specialists, the average professional and the student do not need many technical details. The important thing is choosing the correct lens for a variety of photographic situations, and learning how to use such lenses efficiently.

BASIC LENS TERMS

Focal Length

Just as automobile engines are made to develop a certain amount of horsepower, a lens is designed with a certain reducing or enlarging power which is expressed as focal length. This length is usually measured in millimeters, but for some long-focal-length lenses, it may be expressed in inches. Technically, the focal length of a lens is the distance from the optical center of the lens to the film when the lens is focused at infinity. In pictorial terms, lens focal length determines how much of a scene will appear on the film from a given distance.

For example, a 50mm lens (which is the normal focal length for a 35mm camera) has an angle of view of 46 degrees. By comparison, a 28mm lens views a much wider 74 degrees of a scene from a given camera position, but a 135mm lens spans only 18 degrees of the area at which it is pointed. Thus, *as*

focal length decreases, the total area covered by a lens increases. In reverse, as focal length increases, the total image produced by a lens decreases. A short-focal-length lens is called a *wide-angle*, and will produce an image that includes more of a scene than a normal lens does. A long-focal-length lens is called a *telephoto* and has magnifying characteristics similar to binoculars.

Lens focal length influences not only the camera's angle of view, but also the feelings of perspective (through convergence of lines) and space (through relationship of forms). In addition, it influences a very important item called *depth of field*, which is explained below. Later in this chapter, when lens focal lengths for a 35mm camera are compared, these characteristics and their photographic effects are discussed and illustrated.

4–13 This series was taken with the camera stationary on a tripod as a visual comparison of lenses from 400mm through 21mm. ▶

400mm

300mm

200mm

135mm

100mm

85mm

50mm

35mm

28mm

21mm

Depth of Field

A picture may seem sharp from the foreground to infinity, even though the lens is focused at a specific distance, such as 12 feet. The reason for this optical phenomenon is a photographic term you will hear often: depth of field, sometimes written d.o.f. By definition, depth of field is the area, zone, or distance range between the nearest and farthest objects that appears in acceptably sharp focus in a print or slide.

For example, if you focus a 52mm lens at 7 feet and set the aperture at f/16, the depth of field or area of sharpness begins at about 5 feet and ends at about 11 feet. This means you can expect objects nearer than 5 feet and farther than 11 feet to appear out of focus to the extent that they are closer or more distant than the optically dictated d.o.f. range. Of course, the camera must be steady when an exposure is made, or the whole picture will be fuzzy, making depth of field purely academic.

Depth of field depends on three factors:

1. *F-stop.* The smaller the f-stop or aperture, the more d.o.f. created with a lens of *any* focal length. It is an optical law that sharpness *increases* in front of and behind the point or distance at which a lens is focused, as a lens is stopped down, and camera-to-subject distance is unchanged. In reverse, d.o.f. *decreases* in front of and behind the point of focus as a lens aperture is opened to a larger diameter. On 35mm and some larger cameras, there is a depth-of-field scale on which you can check this in relation to aperture, which also influences d.o.f. Printed tables are also available for most lenses (from manufactuers or in technical books) showing precise d.o.f. measurements at specific f-stops and focusing distances. You need not carry such tables with you, but it is a good idea to examine a few of them for lenses you own. You will then be in a better position to interpret d.o.f. from the scale on a camera lens, as discussed later.

2. *Lens focal length.* Here's another optical law that is constant: The shorter the focal length of a lens, the greater the d.o.f. it produces at any given aperture, compared with a lens of longer focal length. Reverse this law, and it also holds true: The longer the focal length of a lens, the less d.o.f. it produces at a given aperture, compared with a lens of shorter focal length.

15–21 In this series, depth of field can be seen increasing as aperture size decreases. ▶

14 DEPTH OF FIELD FOR 50MM LENS FOCUSED AT 10 FEET.

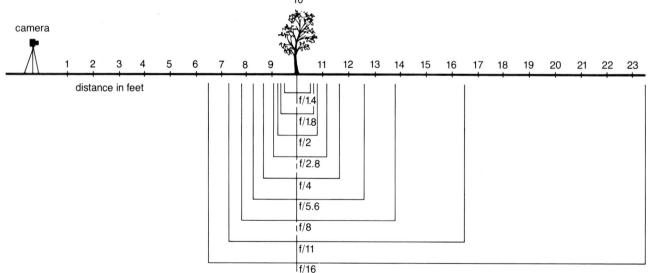

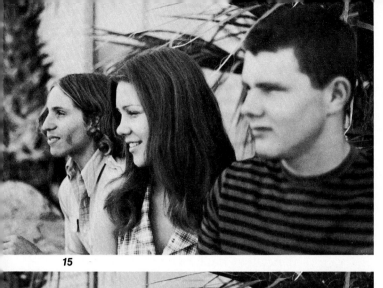

15

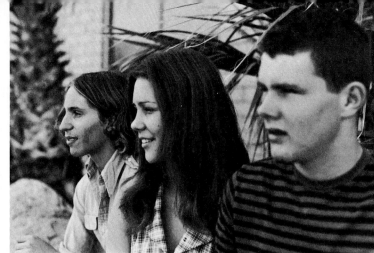

16

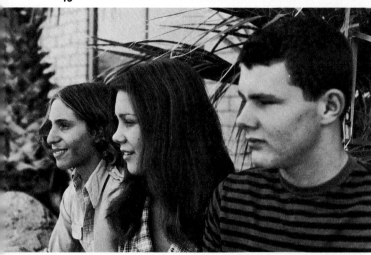

17

18

19

20

22–23 *Approximately the same area was photographed with a 50mm lens (figure 22) and a 200mm lens (figure 23), each set at f/11. The shorter-focal-length lens produces more depth of field inherently.*

24 *When a close-up lens set at f/22 was focused within inches of a flower, depth of field was not extensive enough to make the background leaves sharp.*

This merely means that a wide-angle lens (short focal length) offers greater depth of field at f/8, for instance, than a normal or telephoto lens. In a theoretical example, a focal length of 35mm may give you depth of field from 5 feet to 20 feet when focused at 10 feet; a normal 50mm lens at the same aperture and distance setting will give you d.o.f. from 7½ feet to 15 feet; and a 135mm telephoto lens under the same conditions offers d.o.f. from 9 feet to 12 feet. These are not accurate figures, but they illustrate the influence of lens focal length on depth of field.

3. *Focusing distance.* Finally, a third optical law: The closer to a subject you focus, the less depth of field a lens of any focal length produces at a given aperture. This law works in reverse, too: As focusing distance increases, d.o.f. is enlarged. In another hypothetic example, if you focus at 6 feet with a 50mm lens set at f/8, d.o.f. extends from about 4 feet to maybe 6½ feet. Back up and focus on the same target at 10 feet with the lens still set at f/8. Now d.o.f. has increased from about 4 feet to about 13 feet.

One other optical characteristic is worth remembering: A lens of *any* focal length creates more depth of field *behind* the point of focus than it does in front of that distance setting. As a hypothetic example, a lens focused at 8 feet and stopped down to f/11 may produce an area of sharpness from 6 feet to 18 feet. A glance at any depth-of-field table will demonstrate this factor. In practice, therefore, by adjusting the focus according to a depth-of-field scale on the lens, or by viewing through a ground glass, you set the focusing distance for a scene slightly *farther than* the closest subject you wish to be sharp. Using the example above, if closest sharpness is desired at 5 feet, you might set focus at 6½ feet, knowing that sharpness will begin at five feet and taper off at perhaps 16 feet.

In photographic terminology this is known as "splitting the focus." You

25

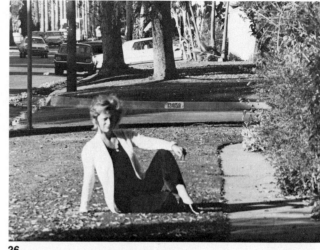

26

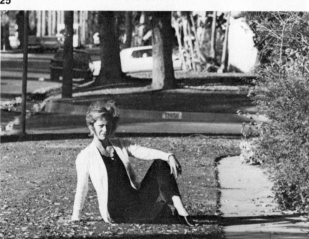

27

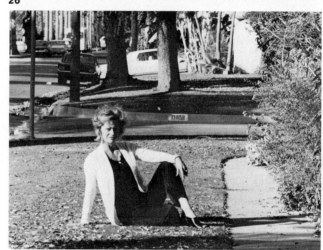

28

25–28 *Depth of field is re- lated to the point or plane at which the lens is focused. A 200mm lens set at f/11 was used for figures 25–27. In fig- ure 25 focus was on the white car in the background. For figure 26 focus was shifted to the curb number. In figure 27 focus was on the model. The same 200mm lens was set at f/16 for figure 28, and focus was set just behind the model for maximum depth of field; the background is not com- pletely sharp.*

choose the most efficient focusing dis- tance based on the amount of depth of field desired, in relation to practical choices of aperture and shutter speed. In many situations, those choices are numerous, offering a creative challenge to photographers.

Lens Speed

There are "fast" lenses and "slow" lenses, though the allusion to speed refers not to motion, but to f-number rat- ings that indicate the light-gathering ability of one lens compared with another. For instance, at its widest aper- ture, an f/1.4 lens passes four times as much light as an f/2.8 lens at f/2.8. This means you can shoot a picture at f/1.4 and 1/30 second in poor lighting condi-

tions with a hand-held camera (if your nerves are steady). In comparison, if the maximum aperture of your lens is only f/2.8, it's a slower lens, and you must shoot the same scene at f/2.8 and 1/8 second, usually requiring a tripod.

Thus the term "fast" is applied to lenses with maximum apertures of f/1.4, f/1.7 or f/1.8, and f/2. These lenses are handiest for available-light photog- raphy, when you can't or don't wish to add flash or floodlighing. However, lenses with these large apertures are not always the first choice of photog- raphers because of certain disadvan- tages: along with speed come weight and cost. The larger the aperture of a

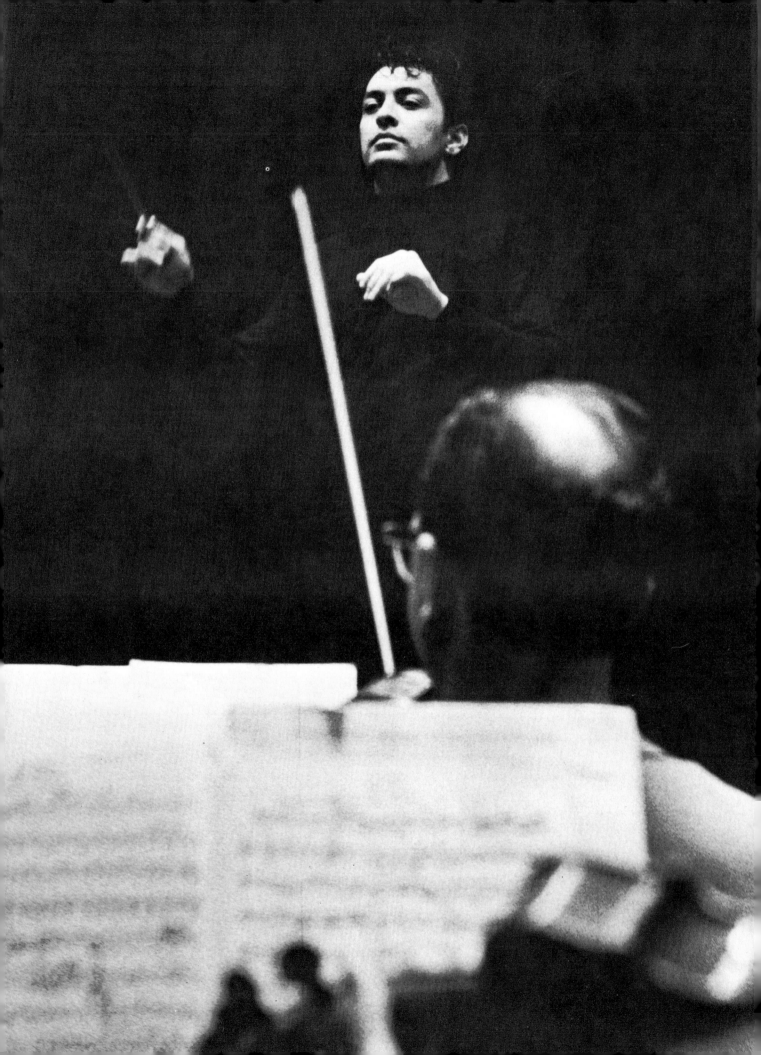

29 *When Zubin Mehta rehearsed the Los Angeles Philharmonic at a low light level, the lens was focused on Mehta. At f/4 with a 135mm lens you know the foreground and/or background will not be sharp, but subject movement dictated that aperture combined with 1/125 second on Tri-X film.*

lens, the more elements it requires in its design; therefore, an f/1.4 lens is heavier and costs more than an f/2 lens.

In addition, large-aperture lenses are easier to manufacture for small-film formats than they are for larger ones. This means that an f/1.4 lens may be common for a 35mm camera, but the maximum aperture of a normal lens on a 2¼x2¼ camera is f/2.8, and for a 4x5 camera, it's f/3.5 or f/4. If you compare the size and weight of a 50mm f/1.4 lens for a 35mm camera and a 75mm f/2.8 lens for a 2¼x2¼ camera, you'll find that the latter must be physically bigger because the film size is larger. Mount a 50mm lens made for a 35mm camera on a 2¼x2¼ camera, and you will get an image that covers only the center area of the film with black edges around it. Optical laws dictate that each camera format or film size requires lenses of a specific focal length and design to fill the complete film area without darkening the corners, which is called *vignetting*.

I may say it again, but I am not a member of a fast-lens cult, and do not associate status with photographers who own and use huge circles of glass because they are known to be expensive and look impressive. There are those who *need* an f/1.4 or f/1.2 lens to work in dimly lighted places where they prefer not to be noticed. These journalistic types are in the minority. I have done assignments under such circumstances, but in my opinion, an f/1.7 or f/1.8 lens on a 35mm camera is

quite adequate for 95 percent of the population. That's all I have ever owned. When lighting conditions are dismal, 95 percent of us turn to flash or floodlights to insure proper exposures without subject or camera movement. The next lens term reinforces my case.

Lens Sharpness

A hundred years ago camera lenses were good, and 50 years ago they were better, but today they are remarkable. In the past a lens designer sat for weeks or months figuring out formulas for shaping and arranging lens elements for various purposes. Now this work is done by computers in hours or days, providing new types of lenses and more consistency of excellence. Not every lens made for cameras used by serious photographers is superbly sharp and without optical flaws, but the chances of getting an acceptably sharp lens on a modestly priced camera are now better than ever. In addition, there are many brands, focal lengths, and types of lenses available, and the competition among suppliers benefits us all.

Sample cross-sectional diagrams of various lenses show the diversity of designs. Some have elements that are thin, some are thicker, some are sharply curved, and others are bowed only slightly. Some elements touch each other while others are separated. Lenses vary in the number of elements as well as in the groups in which those elements are placed. Each formula has a purpose, according to the type of lens, its focal length, and its cost of manufacture. However, almost every lens on the market or in use by modern photographers has one quality in common: an ability to produce a sharp image within certain tolerances and according to certain visual (naked-eye) standards.

Lens sharpness is dependent on a number of characteristics, among them:

1. *Number of elements.* As mentioned before, a fine lens usually has

30 *FILM SIZES RELATED TO LENS FOCAL LENGTHS.*

FILM SIZE	STANDARD OR NORMAL LENS	AVERAGE MAXIMUM APERTURE
35mm	50–57mm	f/1.4–f/2
2¼x2¼ (120)	75–80mm	f/2.8
4x5	127–135mm	f/3.5
8x10	12–14 inches	f/5.6

more elements in more groups than an average lens. More elements are required to correct and project rays of light sharply onto film for a larger-aperture, shorter-focal-length lens than for a smaller-aperture, longer-focal-length lens. Therefore, an f/1.8 50mm lens may have six or seven elements while an f/3.5 135mm lens may have only three or four, but each may produce excellent sharpness, because its particular formula requires only the configuration of glass it contains.

2. *Resolving power.* This quality refers to the ability of a lens to produce fine detail on film. Resolving power is measured by the number of closely spaced lines per inch that a lens will reproduce. However, if a lens takes sharp pictures under ideal conditions, with the camera mounted firmly on a tripod, and exposure and development at the optimum, you need not be concerned with specific figures for resolving power. Those statistics have far more importance to engravers.

3. *Aberrations.* Essentially, this term refers to minor flaws in a lens that affect its ability to acceptably reproduce color, lines, and bright spots of light. *Chromatic aberration* means that certain colors of the spectrum are rendered less exactly than others. The use of various kinds of optical glass in today's lenses has generally eliminated this problem. *Spherical aberration* and *astigmatism* occur when a lens is not ground properly, and straight lines appear slightly curved. Again, modern lenses are rarely afflicted. *Flare* refers to light rays bouncing between lens elements, producing a fogged effect that reduces shadow detail and contrast on a negative or slide. Lens coating (see below) eliminates almost all of this phenomenon, and flare is noticeable only when you shoot directly into a light source or forget to use a lens shade.

Lens aberrations are mentioned merely to inform you of their existence. They were common in the early twentieth century and before special types of optical glass—and more recently,

32 *Lens resolving power is challenged by fine detail in a weathered log.*

31 *In this college medical class a Leitz 21mm lens on a Leica was used by Tom Carroll for its excellent depth of field at f/5.6.*

33 *Flare from the window light partly fogged the image, even with a coated lens on the camera.*

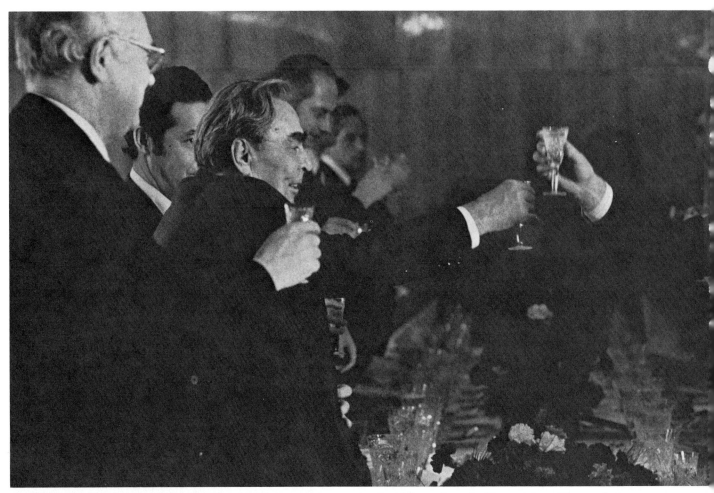

34 The first of several photographs by President Ford's personal photographer David Hume Kennerly, this was taken at the conclusion of SALT talks between Brezhnev and Ford.

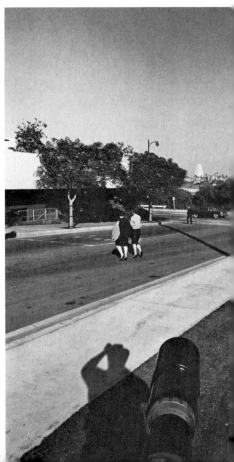

35 Modern lens coating helps prevent flare when shooting into a light source as Paul Moore did in his Kodak/Scholastic Award scene.

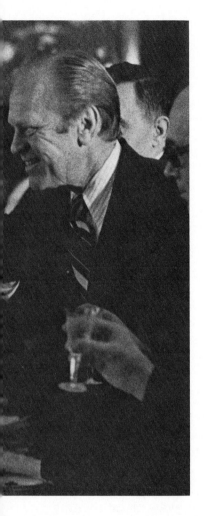

computerized lens formulas—were devised. If you use or buy a lens that isn't sharp, or seems to have flaws that distort negatives and slides, trade it or exchange it for another. There's no good reason to be optically handicapped in this era of reasonably priced equipment.

Wide-open sharpness. Here's another law of optics: A lens is less sharp wide open (at maximum aperture) than it is when stopped down. Almost all lenses used at full aperture are incapable of producing as much sharpness, or image definition, as when they are stopped down one stop or more. The exceptions are engravers' Apo lenses which are sharpest wide open, and a few special large-aperture lenses for Nikon and Leica 35mm cameras.

In general, a fast lens, such as f/1.4 or f/2, reaches its maximum sharpness two or three stops less than wide open, and a slower lens, such as f/2.8 or f/3.5, may be sharpest between two and four stops less than its widest aperture. However, it is obvious that many lighting situations require shooting at close to maximum aperture, or at f/11 and f/16, and you need not be inhibited. The

difference in sharpness at small apertures is often not noticeable. Test your own lenses at a series of f-stops with the camera on a tripod, and determine for yourself if and how sharpness is affected.

Lens Coating

All modern lenses are coated with a microscopically thin chemical film to help reduce flare due to the reflective qualities of glass, as well as to increase the amount of light passing through the lens to the film. The difference in sharpness, and especially in image contrast, between an uncoated lens and a coated one is quite apparent. Even so, on a print or slide you may occasionally see one or more ghostly images, referred to as lens flare. These usually take the six-sided form of the iris diaphragm and are due to internal reflections from bright light sources that even coating cannot eliminate entirely.

The latest lenses are given several chemical layers called *multiple coating*, to make them more resistant to flare. You will see ads for multi-coated lenses, and tests have shown that they are superior to lenses with only a single antireflection coating. If you have the latter type, don't be concerned; the occasions when you must shoot into a bright light are rare, and flare once in a while is inevitable. For all other situations, either single coating or multi-coating produces similar photographs.

DEPTH-OF-FIELD PRACTICE

In the course of photographing people, places, or things, you will choose certain lenses because of their focal length. As noted, the wide-angle or telephoto characteristics of a lens are associated with its inherent depth of field. Awareness of the d.o.f. of any lens is one of a photographer's primary controls. It helps govern the choice of a lens, camera position or angle, f-stop, and type of film. It will also influence the camera format for some purposes.

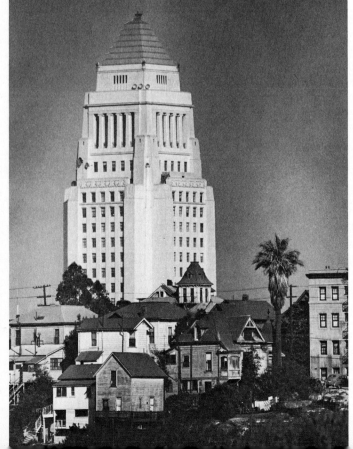

◀ **36–37** Photographer Tom Carroll's shadow is seen next to his 400mm lens in the foreground of figure 36, as he takes a picture of the camera position with a 21mm lens. The image of Los Angeles City Hall tower which Carroll shot with the telephoto lens from that spot is seen in figure 37.

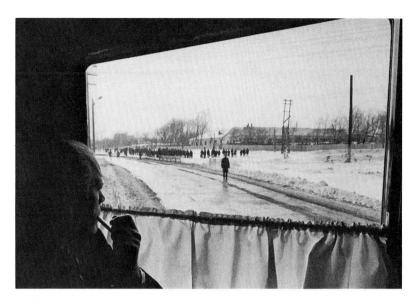

38 *When President Ford arrived in the USSR for talks with Soviet leaders, David Hume Kennerly carefully stopped down his wide-angle lens to achieve appropriate foreground-to-background sharpness.*

Figures 15–21, illustrating depth-of-field improvement as a lens is stopped down, demonstrate how the type of film and time of day can affect photography. I first shot this exercise in bright sunlight, using a 4X neutral-density (ND) filter to reduce Tri-X film speed from ASA 400 to ASA 100. (These neutral gray filters, available in different densities such as 2X, 4X, and 8X, cut film speed by decreasing light intensity without affecting color or contrast. They are covered in chapter 4.) The series of pictures was not successful, however, because I could not use a fast enough shutter speed to shoot at f/2 with my 50mm lens.

For the next try I posed my models in open shade, still using the 4X neutral-density filter with Tri-X. In this situation, the light intensity was such that I could shoot at f/2 and 1/1000 second to begin the series taken at seven lens openings.

Shoot your own depth-of-field demonstration, and experience the problems directly. If the lens focal length is short, or the subject matter is too small and not widely enough spaced, or if aperture/shutter speed combinations are difficult to obtain, you will be getting a preview of d.o.f. practice.

Control over depth of field, directly or subtly, influences photographic technique. As you analyze a scene and its specific light intensity, you anticipate depth of field for a given lens, and perhaps check it on the camera. Some-

times you may choose a lens to work in a certain intensity of light, because of its d.o.f. capability. For instance, suppose you are shooting in open shade, and people are moving. With a slow color film (ASA 64) you know that depth of field will extend perhaps 4 or 5 feet with a 105mm lens, but a much more workable 8-to-10 feet with a 35mm lens. Presuming you include the same number of subjects from farther away (with the 105mm) as you would from a closer camera position (with the 35mm), you have more margin for focusing error with the shorter-focal-length lens.

The same knowledge and experience offers you better control over a portrait background, since a wider aperture with less d.o.f. throws unwelcome background areas out of focus. In a crowd you may wish to emphasize only one row of people, and select a telephoto lens because of its relatively shallow d.o.f. This is termed *selective focus*, which may also be thought of as selective-out-of-focus, useful when limited depth of field is most suitable to a subject.

Distant scenes. A lens focused at 40 or 50 feet allows you to relax about d.o.f., because at this point most lenses provide sharpness from many feet in

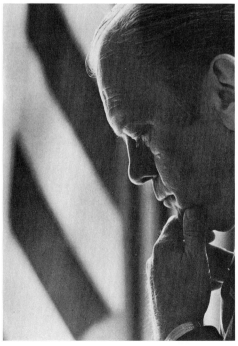

39 *With a normal lens on his 35mm camera, David Hume Kennerly focused on President Ford by the light of the Oval Office windows, and chose a lens aperture that would throw the background flag out of focus.*

40 *With no subject movement, Steve Crouch was able to stop down his 4x5 view camera lens to f/32, and expose at dusk for a full second.*

front of the point of focus to infinity. It is assumed that nothing of importance is closer than about 35 or 45 feet where sharpness may begin. However, if a subject requires d.o.f. from close by to infinity, you might choose a wide-angle lens and take advantage of its greater d.o.f. capability, especially in medium-bright light or with a slow film.

Depth-of-Field Preview

Many cameras allow you to preview depth of field while looking through the lens before shooting. On most single-lens reflex cameras, 35mm and larger, there is a button or lever for this purpose. After you choose the lens opening, pressing the preview button or lever allows you to see *approximately* where sharp focus begins and ends. Depth of field can only be approximate through the lens of a reflex camera, because the viewfinder image is

rather small. Therefore the borderline between sharpness and out-of-focus is not precise. The best camera with which to preview depth of field is the view camera. Its ground glass (4x5 and larger) is more adequate to determine d.o.f. accurately as you stop down the lens.

Depth-of-Field Scale

On most hand-held cameras there is a ring adjacent to the footage scale marked with f-numbers that are identical on each side of a center point. This is the depth-of-field scale, and is handy for quick reference instead of, or in addition to, previewing through the lens. When you focus the lens, a glance at the d.o.f. scale shows you the span or sharp focus at various f-stops.

As an example, the lens in the illustration is focused at 7 feet. (Top numbers are in feet; bottom ones are in meters.) Between the f-stop numbers at left and right is the d.o.f. or area of sharp focus for each specific lens opening. Therefore, at f/16 the complete d.o.f. for this 35mm lens ranges from 4 feet to almost infinity. At f/11, d.o.f. runs between just under 5 feet and 20 feet. At f/8 sharpness ranges from about 5½ feet to nearly 12 feet. As you see, it is necessary to guesstimate the number of feet on such a scale, because there isn't room for all of the lines and numbers on a lens barrel.

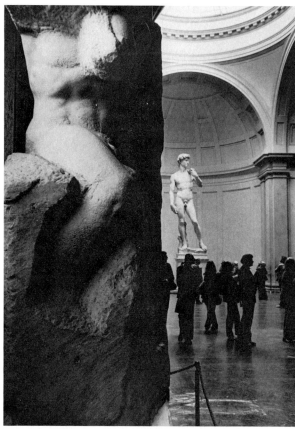

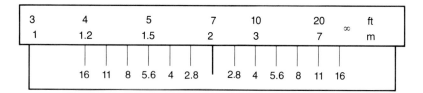

41 *DEPTH-OF-FIELD SCALE FOR 35MM LENS.*

In practice, the d.o.f. scale is used often, and is especially needed when focusing very wide-angle lenses. These lenses on 35mm cameras offer such great d.o.f. that it is difficult to determine for certain where you have focused. Thus you refer to the footage scale, often making a guess as you would with a simple camera, and double check with the d.o.f. scale to control the area you want in sharp focus. When you first use a 21mm, 24mm, 28mm, or 35mm lens, you will be impressed with the enormous depth of field that is inherent in them, even at wide apertures and close distances.

Zone focusing. Choosing a point of focus via the depth-of-field scale, as described above, is termed *zone focusing.* It is particularly useful with wide-angle lenses with their good d.o.f. even at large apertures, but is applicable to any lens. In situations where there is activity at several distances from the camera, you may not have time to focus carefully for each exposure. In this case, focus the lens with the depth-of-field scale as a guide, and shoot at subjects that fall between the close and far distance settings.

Zone focusing is handy for any mobile situation in which you want to

42 *A 28mm lens on an SLR was focused (and aperture chosen) so that Michelangelo's* David *in the background and an unfinished sculpture in the foreground would both be sharp. Setting is the Accademia in Florence, Italy.*

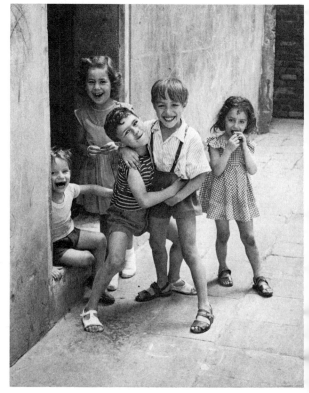

43 *Children playing in Venice, Italy, were snapped quickly with a 50mm lens on 35mm rangefinder camera. Lens was zone focused at f/11 and 8 feet.*

view, compose quickly, and make exposures with minor attention to focusing. When there is adequate light, zone focusing gives you excellent opportunities to move, turn, and shoot at will, as if you were using an inexpensive fixed-focus camera.

Depth-of-Field Summary

For good depth of field and wide-span sharpness:

1. Use a small aperture with any lens.

2. Choose a wide-angle lens when feasible.

3. Focus carefully, and check the d.o.f. with the preview lever and/or with the depth-of-field scale around the lens barrel.

4. Use a tripod in medium and low light levels when a small aperture requires a slow shutter speed.

For reduced d.o.f. in conjunction with selective focus to assure out-of-focus areas in a photograph:

1. Choose a fairly wide aperture such as f/2.8 or f/3.5 if lighting conditions permit.

2. Use a longer-than-normal-focal-length lens, such as 85mm, 105mm, or 135mm, especially for portraits or subjects that you want to appear sharp in contrast with a soft-focus background; shoot at a medium aperture such as f/5.6 or f/8 depending on the film and light intensity.

3. Select a medium-or-slow-speed film that allows you to use an adequate shutter speed (1/60 second or faster, hand-held) along with a large or medium lens opening.

4. If you have a fast film in the camera and do not wish to change it, use a neutral-density (ND) filter over the lens.

Make a series of black-and-white (b/w) pictures with the camera on a tripod, varying the f-stop from wide open to fully stopped down, without changing the focus once it's set. Half a dozen 8x10 prints from these negatives will demonstrate quickly the varying control you have over d.o.f. which is so vital to photographic technique.

44 *For an annual report the foreground in each photograph was intentionally out of focus as a visual device. Camera was a 2¼x2¼ SLR.*

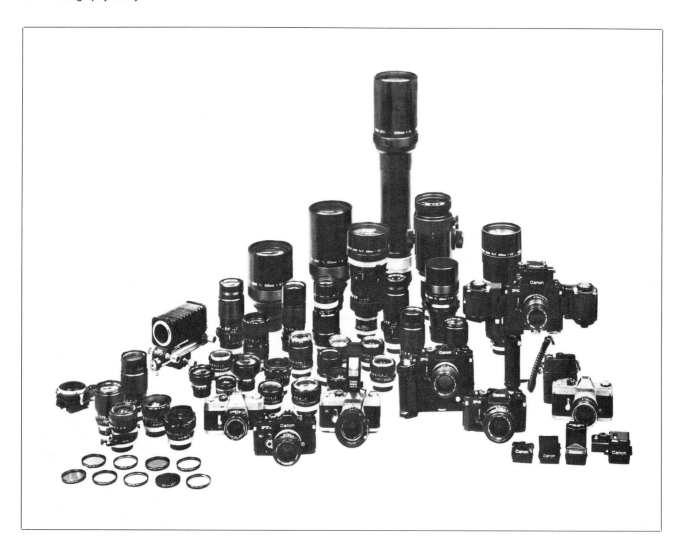

45 *The Canon family of cameras, lenses, and some accessories.*

A SURVEY OF LENS TYPES

In the *Popular Photography Directory & Buying Guide* or the *PhotoGraphic Magazine Equipment Buyer's Guide*, there are long lists of lenses for 35mm and larger cameras. The number and variety of lenses are staggering, but only certain ones will fit your cameras, a limitation that offers some comfort. This survey is not concerned with brand names, but will divide lenses into types to assist you in buying and using them for all kinds of photography. Most of this information refers to lenses for 35mm cameras (followed by headings for larger formats); however, the function of each category of lenses is similar for all sizes of cameras.

Lens-Mount Systems

Bayonet mounts. More than half of the available 35mm and larger hand-held cameras (a view camera must be used on a tripod) use a bayonet lens mount. When the lens is seated into the camera body by lining up two red dots or index marks, it clicks into place if you give it about a quarter turn. The lens-mount latch is released by pressing a button or lever, and with a reverse turn, the lens is lifted away from the camera body. This is a fast and positive system, and is popular because changing lenses during a shooting session is often necessary, and the less time required, the sooner you return to the action.

Each camera manufacturer uses a different bayonet-mount system. Though the camera body or lens of one brand may look like that of another, chances are they will not be compatible. If you

46 Eleanor Bralver captured spontaneous expressions working with an automatic-exposure Konica Autoreflex T and a 65–135mm zoom lens.

buy a lens that is not made by the manufacturer of your camera, be sure to specify the brand to be assured of the correct mount or adapter. Most lenses are available with adapter mounts in a "T" system which is widely convertible for various brands and models.

Threaded mounts. The alternative lens-mounting system offers a standard thread that screws into the camera body. Known as the Exakta or Pentax screw-mount, the advantage of this system is the compatibility of lenses with many brands of cameras. The disadvantage of this method is the time it takes to change lenses, compared with the bayonet system. However, many fine cameras include threaded mounts, and in some situations the time differential is negligible.

Mounting adapters. As mentioned, adapters are made for most cameras to make possible the use of lenses that would otherwise not fit. However, the automatic-diaphragm capability and/or the automatic-exposure operation of a lens may be canceled when an adapter is used. Both of these functions are important to using a camera most efficiently, so check before you buy. Consider trading a lens for a replacement rather than buying an adapter if the price is right and your need seems great enough.

Aperture Operation Methods

Automatic diaphragm. Most lenses sold with 35mm single-lens reflex cameras today include an automatic diaphragm. This means that as you view through the finder and lens, the dia-

47 With a normal lens on a 35mm camera and a slow shutter speed, Edward Pace photographed a young mother "thinking about her early childhood" to win a Kodak Newspaper Snapshot Award.

phragm or aperture is wide open for the brightest image. The instant before exposure, as you press the shutter release, the diaphragm is automatically stopped down to a prechosen f-stop. Immediately after the shutter closes, the diaphragm reopens completely.

Preset Diaphragm. A number of lenses made 15 or 20 years ago, plus some current models for close-ups and perspective control on 35mm cameras, are designed to use a preset diaphragm. To view through the finder, you open the lens manually. When exposure has been determined, you set an index mark on a ring opposite the f-stop required. Before shooting the picture, you turn the aperture ring by hand, and it stops at the preset position. After exposure, to view the scene at maximum brightness again, you open the diaphragm manually. These operations, done *for* you by automatic-diaphragm lenses, are time consuming with preset lenses, and it's also easy to forget to stop the lens down before making an exposure. The result can be frustrating overexposure.

Some brands and types of macro lenses, variable-perspective lenses, and very long telephoto lenses are still made with preset diaphragms, which cost less to make. Because you work slowly and deliberately with such lenses, the fact that they are not automatic is acceptable. Otherwise, avoid preset lenses (which are usually vintage) if you have the choice.

Normal Lenses

On a 35mm camera, the normal-focal-length lens ranges between 50mm and 58mm, depending on the brand. Years ago, 50mm was chosen as "normal" because it approximates the diagonal measurement of a 24x36mm frame or image on the film. Although some professionals claim to prefer the 35mm focal length as normal, the 50mm range has many uses in everyday photography. The 50mm lens is midway between wide-angle and semitelephoto, and is usually made with the largest apertures for working in very low light levels.

48 *Shooting from a ladder with a 21mm lens, Tom Carroll made a strong composition of publisher Robert Peterson and his car collection.*

Wide-Angle Lenses

For my purposes, lenses with focal lengths shorter than 21mm are listed later under a superwide heading. The range from 21mm to 35mm offers images that are more consistently comparable.

Wide-angle lenses have a broader angle of view than the human eye, which means that they span a wider scene, including several times as much area as we can see without turning our heads. These lenses are most useful for the following:

Shooting from a restricted viewpoint. A wide-angle lens functions beautifully in rooms where you cannot back up because of walls or furniture, or outdoors when you cannot or don't wish to stand

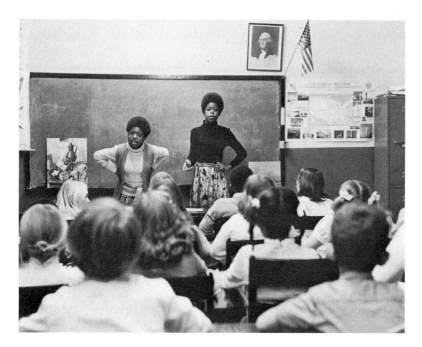

49 The author chose a 35mm lens on an SLR to include several rows of students and two visiting speakers in sharp focus at 1/60 second and f/5.6.

farther from a scene. In a crowd, a wide-angle lens includes people near and far, which is an asset when your mobility is restricted. From the top of a building, a wide-angle view may tell the story more graphically than a normal or longer-focal-length lens.

Maximum depth of field. As mentioned before, the shorter the focal length of a lens, the greater its depth of field at a given aperture. In medium and low light levels, when you must shoot with a hand-held camera, a wide-angle lens might give you enough d.o.f. at f/8 or f/5.6 to use a reasonably fast shutter speed. For instance, if you are photographing a picnic at dusk and want to be sure that several rows of tables will be in focus in one shot, a wide-angle lens coupled with a fast film or medium-speed film can be a practical solution. Indoors in dim light without flash, a wide-angle again assures better depth of field, even if a certain amount of distortion does occur (explained below). With most films in bright light, wide-angle d.o.f. is remarkable.

Pictorial emphasis and distortion. When a wide-angle lens is used, there is often a fine line between pictorial emphasis and unintentional distortion. Imagine a situation in which people or objects in the foreground loom large in

a print or slide, compared with subjects farther back. Since a short-focal-length lens exaggerates the relationship between near and far objects, you must be aware of the distinction between the functional and the bizarre. Foreground people may be dramatically large or strangely distorted. Use a wide-angle lens for a portrait at a fairly close distance, and the person may easily appear to be a freak. A wide-angle lens also tends to make the lines of a building converge at steep angles towards the top. The effect might be desirable to accentuate height, or awkward because of unnatural perspective.

Subject matter close to a wide-angle lens tends to be enlarged, while things farther back seem diminutive in size. This is the optical heritage of a short focal length. Use it carefully and it's impressive; use it at random, and pictures may be grotesque. Experience will show you the division between pictorial emphasis and unattractive distortion, after which you will have a marvelous photographic tool at your disposal.

The following are the standard wide-angle focal lengths for 35mm cameras:

21mm. The 21mm and the 20mm lens are the shortest focal lengths (with a few superwide exceptions) that provide a full 35mm negative or slide without darkened corners. For journalistic or reportorial situations, the 21mm lens is very effective. At f/4 its d.o.f. is remarkable, and at f/11, focused at 5 feet, everything from 2.5 feet to infinity is in focus. However, the 20mm or 21mm is a specialized lens for intentional distortion, exaggerated relationship of forms, or panoramic views. In ways, it's like a small, sleek racing car: you can't use it for conventional purposes, but at the right time and place, it performs better than a normal model.

50–53 To demonstrate how size and spatial relationships are altered by lens focal length, four lenses were used for this series taken with an SLR on a tripod. From figure 50 through 53 respectively, lenses were 28mm, 50mm, 90mm, and 135mm. The camera was moved farther from the subject for each longer focal length in order to include a similar area each time.

50

51

52

53

54 *Canon 24mm f/1.4, an extremely wide aperture for this focal length.*

55 *Vivitar 24mm f/2.8, more typical and less costly.*

56 *Hexanon 28mm f/2.8.*

24mm. A few manufacturers make this focal length. It is quite similar to the 21mm in pictorial effect, with slightly less distortion of image.

28mm. Usually available with a wider maximum aperture than the 21mm lens, and at less cost, the 28mm is a great compromise between the 21mm and the 35mm wide-angle. Its depth-of-field qualities offer excellent pictorial opportunities, and distortion is not as noticeable. For some purposes, the 28mm lens may be the first choice, before the 35mm, as a wide-angle selection, depending on personal taste and need.

35mm. The 35mm is the all-around favorite wide-angle focal length, because it has d.o.f. characteristics superior to the normal 50mm lens, with almost no pictorial distortion. Also, the average 35mm is less expensive than the 28mm. There are 35mm lenses with maximum apertures as large as f/1.4 and f/1.8, though the usual is f/2.8. If you are in the process of buying equipment, check the 35mm against the 28mm, unless you're able to buy both.

Semitelephoto Lenses

The classification is my own, and covers the range from normal up to, but not including, 135mm. I feel these lenses should be distinguished from really long focal lengths that are more specialized.

85mm. Though the average maximum aperture is about f/2.8, the 85mm lens is also available at f/1.8 and f/2. It is a pleasantly mild departure from the normal 50mm and good for portraits. However, the 85mm and other focal lengths under this heading are included in many short-range zoom lenses covered below.

100mm and 105mm. The 100mm and 105mm lenses are very useful for portraits and scenes. They produce an image twice the magnification of the normal 50mm lens.

57 *A 100mm lens on a 35mm camera places the photographer a comfortable distance from the model. One electronic flash unit in front was reflected from an umbrella, and another illuminated the wall.*

58 *New Nikkor 135mm lens is 3.6 inches long.*

59

60

59 *Canon 200mm f/2.8 lens is 5.4 inches long.*

60 *Vivitar 300mm f/5.6 telephoto is 7 inches long and weighs 26.5 ounces.*

Telephoto Lenses

These are the "reach out" lenses so practical for many purposes. Sports, nature, and news photography may all require use of a telephoto that enables you to make large images of distant subjects.

A telephoto compacts space and perspective, giving objects a look of being closer together, and background subjects diminish less in size than you see them normally. Lines of poles or cars have a "telephoto look" as they recede into the background of a print or slide. The series of lens photographs shows how perspective relationships change as focal length increases.

Keep in mind that the longer the telephoto, the less inherent depth of field it produces. In addition, because a telephoto gives you an enlarged image, the slightest camera movement is also magnified. As a result, for predictable sharpness many of these lenses beyond 135mm should be used with the camera on a tripod.

135mm. An excellent compromise between the normal 50mm and much longer focal lengths is the 135mm lens, which is available at f/1.5 and f/1.8, but is most often an f/2.8 lens. Because of its convenient weight, it may be hand-held in medium low light. This focal length is the longest one usable on a rangefinder 35mm camera without the addition of a reflex housing.

200mm. At 200mm, lenses become heavier and bulkier, making them difficult to hand-hold at shutter speeds under 1/500 or 1/250 second. Some photographers pride themselves on being able to shoot with a variety of lenses at shutter speeds of 1/30 second and slower, but tests show that sharpness of pictures taken from a tripod is always superior. In other words, you may hand-hold a 200mm or longer lens, but sharpness, even at 1/1000 second, can be improved by anchoring the camera. The 200mm lens (or the 180mm which is analogous) is delightful for sports, news, and some scenic situations. However, it is wise to investigate a zoom lens that includes 200mm before buying the 200mm as a single focal length.

300mm to 1000mm. In the over-300mm category are the lenses that begin to look like cannons. They are necessary for special photographic applications, but should not be tempting to novices. The average photographer has little need for longer focal lengths that are heavy, expensive, and limited to tripod use. However, pictorial effects can be spectacular if you wish to invest time and money for special purposes.

62 *Super-wide-angle 8mm Zuiko fisheye lens for Olympus OM cameras creates a circular image which attracts attention.*

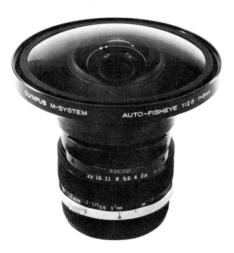

63 *Mamiya/Sekor 14mm fisheye projects a full-frame 35mm image.*

Mirror optics. Manufactured in the 500mm, 1000mm, and up to 2000mm range are specially designed lenses in which mirrors within a wide barrel reflect and magnify the image before it passes through several glass elements onto the film. The principle of using mirrors makes possible a much lighter telephoto lens, and some 500mm models can be hand-held in bright light. The disadvantages of a mirror lens are very shallow depth of field and a fixed aperture of f/4, f/5.6, f/8, or f/11, which means that exposure adjustments must be made by changing shutter speeds or filter inserts. A mirror lens is a specialist's tool—sometimes at a premium price.

Superwide-Angle Lenses

In this category are *fisheye* lenses with a 180-degree angle of view. Focal lengths run from an amazing 6mm to about 18mm; f-stop ranges begin at f/1.8, but average f/3.5 and f/4. It's easy to accidentally photograph your own feet with a superwide lens. Effects are dramatic but perspective and space are highly exaggerated. Most superwides project a black-bordered circular image onto the film. A few new superwides in the 15mm class do not vignette the image, but offer a full-frame 35mm negative or slide. This is an advantage if you are not aiming for a typical fisheye look and appreciate less distortion.

Macro Lenses

The word *macro* is derived from the Greek and means "to enlarge." In photographic terms, a macro lens is designed with extended focusing capability to shoot a few inches from a subject. Close-up photography with a macro lens is a pleasure, though add-on lenses or extension rings are also available for this purpose. Some macro lenses include an extender that is mounted between the camera body and the lens to provide life-size, or 1:1, images.

There are two main types of macro lens. One is meant to be used on a

61 *MIRROR OPTICS PRINCIPLE*

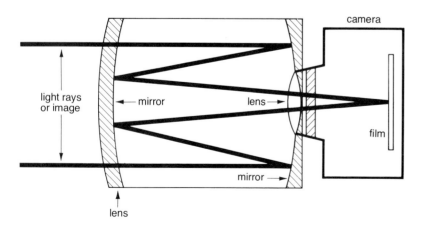

64 Visual effects with a full-frame fisheye lens, such as the 16mm Zuiko on an Olympus OM-1 camera, can be dramatic—or bizarre.

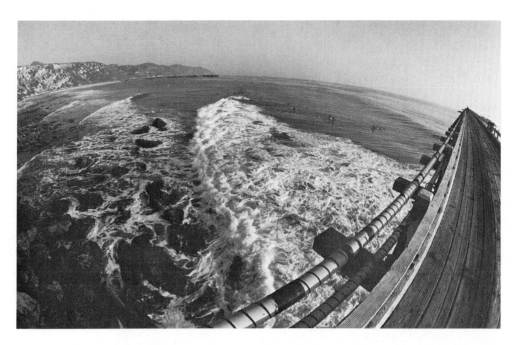

65 Vivitar 55mm f/2.8 macro lens, at infinity (left) and focused for 1:1 magnification (right).

hand-held or tripod-mounted camera, and ranges from 40mm to about 90mm, with the average about 55mm. The other type is either a wide-angle or a lens with a focal length of 100mm or more and is designed for use with a close-up bellows attachment on the camera. The longer lenses give a larger image and are most suitable for static subjects and painstaking photography.

There is a certain amount of debate about using the average 55mm macro lens as the normal lens on a 35mm camera. Some say it is designed to work most efficiently when focused on a nearly flat surface, and others swear by a macro for general photography. The macro for my camera seems to be sharp for close-ups as well as distant scenes, and if you are so inclined, you could outfit your 35mm camera with a 50mm or 55mm macro instead of the normal lens. Extreme close-ups could be shot at any time, but you would sacrifice lens speed since f/2.8 and f/3.5 are the macro's usual maximum aperture settings. If you are not involved in available-light photography (when f/2 at 1/30 may be a necessity, for instance), a macro-normal lens may suit your needs well.

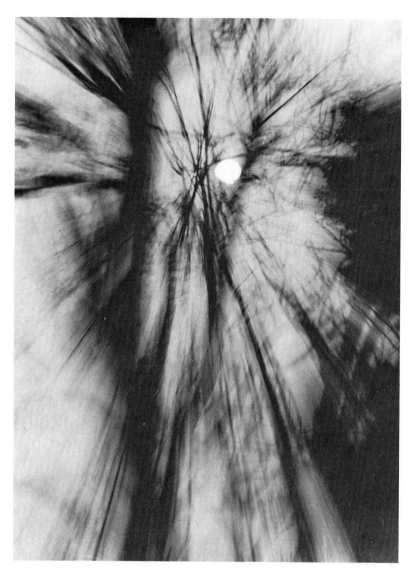

66 *When the focal length of a zoom lens is changed during an exposure, images are unpredictable and often exciting. For the moon at dawn through bare branches, a 65–135mm zoom lens on a Konica Autoreflex T gave this impression with a 1-second exposure at f/5.6 with Tri-X.*

67 *Hexanon 45–100mm short-range zoom lens with macro mode.*

Zoom Lenses

Several decades ago the first zoom lenses were incapable of producing really sharp images, and gave the whole category a bad name that hangs on. However, new designs have proved to be marvelous optical devices that can be highly recommended. Both of my zoom lenses give just as sharp images as many single-focal-length lenses.

Within a zoom lens is a series of elements that shift as one turns or push-pulls a collar on the lens barrel to change focal length at will. While a zoom lens is longer and heavier than a single-focal-length lens such as the 135mm, its extreme versatility more than compensates for the extra weight. When standing in one position, you have an almost infinite choice of compositions while zooming back and forth from one focal length to another. For sports, travel, and even portraits, a zoom lens has no equal. I used my 65–135mm zoom (which weighs about 17 ounces) more often on a month's tour of Europe than any other lens in my kit. The same lens on a tripod-mounted camera gave me instant changes of image size while shooting the lighting-exercise portraits in chapter 7.

There are short-range zooms, medium-to-long-range zooms and macro zooms. The short-range focal lengths begin at 35mm and run to 100mm and 135mm. Medium-to-long zooms start about 70mm and extend to about 230mm. A few zooms are made in the 180–410mm range.

The macro zoom is relatively new in both long- and short-range classes. By turning a ring on the lens barrel, you are able to focus as close as three or four inches and still use the zoom capability. Such a lens gives you close-ups as well as variable focal lengths, and the macro zoom is taking over this field.

A final zoom category is the variable-focal-length lens which operates in the same manner as a zoom,

69 *Pentax Takumar 45–125mm f/4 zoom lens.*

70 *Nikkor PC (perspective control) 35mm f/2.8 lens, excellent for architectural subjects.*

71 *Nikkor Auto-GN (guide number) 45mm f/2.8; aperture opens and closes as focus changes for use with flash.*

68 *Vivitar 85–205mm zoom lens with macro mode; focuses 12 inches from the subject.*

but requires refocusing each time you change image size. An advantage is large aperture, averaging f/2.8 compared with f/3.5 and f/4 for other zoom lenses. A disadvantage is added weight.

Think of the average zoom lens as an outdoor lens, or for use in good lighting conditions, because some of them are difficult to hold steady at shutter speeds slower than 1/125 second. A zoom that ranges up to 200mm requires exposures of 1/250 and 1/500 second to assure sharpness, though use of a tripod is always an option. By all means, investigate short-range zoom lenses while you are shopping for single-focal-length lenses to augment your equipment. Look at medium-to-long-range zooms before buying a telephoto lens. Compare weight, price, and versatility, because zooms are often a blessing.

Special-Purpose Lenses

Two special-purpose lenses in particular should be familiar to you. The first is adjustable through movement of the front portion up and down for perspective control (PC). Architectural photographers benefit by using a PC lens that offers some control of perspective, similar to using the tilting front and back of a view camera.

The other lens, a guide-number (GN) lens, includes a diaphragm mechanism that changes aperture as the lens is focused to synchronize exposure and distance with a specific flash attachment on the camera. A GN lens can be handy, but the use of an automatic electronic flash unit would make the GN lens unnecessary.

Incidentally, a number of compact 35mm rangefinder cameras with fixed (noninterchangeable) lenses are guide-number equipped. As a flash unit slips into the accessory shoe on top of the camera, a small pin is activated that synchronizes change of aperture with focusing. In this way distant subjects are photographed through wider f-stops than close ones, giving the effect of exposure automation.

Add-on and Teleconverter Lenses

Add-on lenses. Principal among add-on lenses is the fisheye lens that is screwed into the front of a normal 35mm camera lens, offering a super-wide effect for less cost than a separate fisheye lens. Sharpness may not be as good as a fisheye alone, but for occasional superwide photographs, the add-on may be quite adequate.

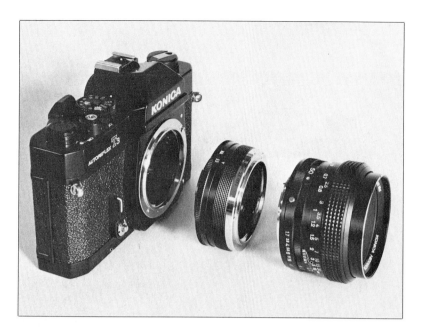

72 *When a 2X teleconverter is used it doubles the focal length of a lens. Optical quality can be good, but effective lens aperture is reduced.*

Teleconverters. Also called lens extenders, teleconverters are fairly simple optics attached to a 35mm camera body, into which a regular lens is threaded. Available as 2X, 3X, or 4X, the teleconverter in effect doubles, triples, or quadruples the focal length of any lens used with it. Thus, with a 2X converter, a 50mm lens becomes 100mm, or a 100mm lens becomes 200mm.

Advantages of an extender are minimum cost, reduced carrying weight, and increased versatility of lenses on hand. Disadvantages include reduced maximum aperture (because the extender may decrease a lens from f/2 to f/4 based on an optical law), and a reduction in lens sharpness (because the addition of an extender tends to some degree to soften the resolving power of a lens).

BUYING AND TESTING LENSES

It is unnecessary to buy lenses made only by the manufacturer of your camera, because many others offer satisfaction. Brands, types, and prices vary greatly. Choose the lenses you feel will best suit the photography you will do. Ask about the return of unacceptable lenses for refund or exchange. Lenses are guaranteed, and reputable dealers will see that you are satisfied.

Test a lens by mounting the camera on a tripod and shooting pictures. You may experiment with a lens test kit, but that is unnecessary. Focus at infinity, at a middle distance, and on something close, and shoot carefully. Either color-transparency or black-and-white film is suitable. To examine sharpness, project the color or make 8x10 or 11x14 prints from the black-and-white negatives. Unless you work from a tripod, however, you cannot be sure of maximum sharpness and performance.

If you wish, photograph a newspaper, a sign, or anything with good-to-medium contrast. Try the lens at its widest aperture so you know its characteristics, even if you rarely shoot that way later. Look for sharpness of lines, complete sharpness to all four corners, and accuracy of color. It will be rare to get a lens that must be returned, but it happens occasionally. Testing gives you a good rundown on how a lens operates, and confidence later when you shoot in all sorts of circumstances. If test results are satisfactory to you, that's what counts. Should you be unfamiliar with the slide or print standards by which to judge, ask an instructor or someone experienced in photography.

Stay out of verbal competition with others about lens quality. It's like comparing friends, and only leads to confusion and anxiety. If a lens works for you, opinions of others are superfluous.

73 *TYPICAL LENS TEST CHARTS*

74 Murray Smith used a 28mm lens for this intriguing San Francisco scene, both for overall sharpness and a wide-angle view.

LENS CARE

Caps and shades. When a lens is not in use, a lens cap should cover it as a protection against fingers, dust, and scratches. A lens shade or hood is advisable for all lenses that are not designed with a deeply inset front element. The shade not only blocks extraneous light rays that may degrade a slide or negative, but also prevents the lens from being easily touched by fingers or foreign objects. Optical glass is vulnerable to scratches that will reduce image sharpness if they are major. A small scratch or two on a lens may have a negligible effect, but any mark on the glass is unfortunate.

Some lenses are made with retractable shades. For others, metal or rubber shades may be purchased, depending on your preference. In any case, use the correct size of lens shade that will not cut into the corners of the image. A rear lens cap should always be used when storing a lens in its own case or in a camera bag.

Cleaning. Use only special lens-cleaning tissue to wipe a lens, and with it use lens-cleaning fluid sparingly. The latter comes in small squeeze containers easily carried in a camera bag. Don't use a handkerchief; avoid facial tissue; and never touch lens glass with your fingers. A soft lens brush may be used to dust over and around a lens. Don't use tissues made for eyeglasses because the silicones in them can harm a coated lens.

Photographic lenses are fine tools. There's no mystique about them to mislead photographers. Each focal length has a purpose, and experienced photographers carry a limited number of lenses, including just the ones that give them mastery of many picture situations.

Photographic exposures are made through lenses mounted on a vast assortment of camera types, sizes, and models. In the 1930s, when I first scanned photo magazine ads and bought a 35mm rangefinder camera by mail, I thought I was faced with plenty of choices. Today the proliferation of camera brands makes my former options seem paltry. Dealers' shelves offer a rich assortment of equipment which may seem bewildering until we sort and classify cameras for various purposes. It is still possible to own good equipment on a limited budget, though prices have become inflated in the 1970s. It helps to be rich, but quality is not exclusive to well-known brand names. Knowing exactly which camera(s) you need is essential to keeping costs down.

VIEWING AND FOCUSING SYSTEMS

There are three basic camera types in terms of viewing and focusing. The first type allows you to see and compose a picture while looking *through the lens*. Included in this category are single-lens reflex (SLR) cameras and view cameras. The second type is the twin-lens reflex (TLR) which has one lens for viewing and another to project the image onto film. The third type uses a window finder separate from, but next to, the lens, plus a rangefinder (RF) for focusing.

A fourth kind of camera also uses a window finder for viewing, but has a fixed-focus lens; it offers limited focus-

ing capability for close and distant pictures. In this class are most of the simpler cameras of the instant-load pocket variety, which often take excellent pictures, but are not suitable for serious photography because they usually lack control over focus, change of lenses, shutter speeds, and f-stops.

There is no "best" type or brand of camera for *every* kind of photography. However, cameras that offer through-the-lens viewing and focusing are most suitable for photography students because of their great versatility and their accuracy for image selection, composition, and focus. These cameras will be covered first.

THE 35MM SINGLE-LENS REFLEX

While the view camera may be recommended by many photography schools for specific classes, it is likely that the single-lens reflex is far more popular among students and most instructors. The crux of the matter is negative and color-slide size, which dictate the size of a camera finder. There is obviously more accuracy and precision in viewing a subject on the ground glass of a 4x5 view camera than there is in composing through a 35mm SLR finder. However, the 4x5 camera (or an even smaller format such as the 2¼x2¼ or 6x7cm camera) is so much larger, bulkier, and slower to use than the 35mm SLR, that its viewing advantages are offset by the mobility one has with the smaller format.

To this advantage may be added the excellent enlargement potential of 35mm films as prints or slides, their

1 In 33 frames of a contact print, Thomas Hopkinson designed an ingenious self-portrait for an assignment in the author's class at Brooks Institute. The 35mm camera on a tripod was panned in five steps across, and precisely lowered six times after the top row of frames was exposed. Hopkinson directed his remarkable tour de force, and the actual photography was done by a friend.

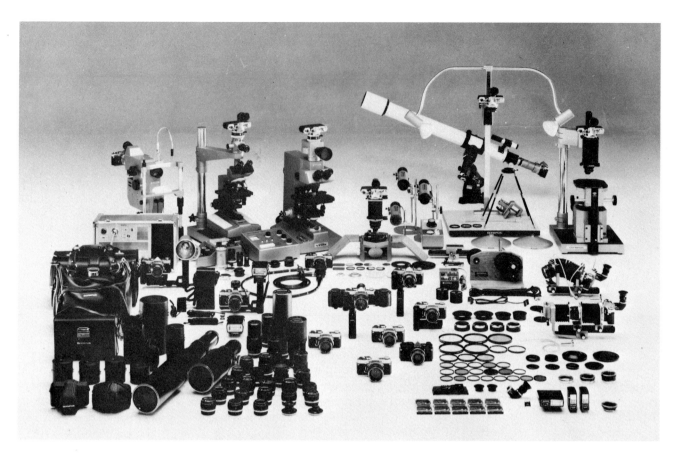

2 In a typical 35mm SLR system, such as that for the Olympus OM-1 and OM-2, there is a large variety of equipment and accessories for specific purposes.

lower cost compared to larger films, the advantages of more exposures per roll, and the enormous choice of lenses and accessories for SLR cameras. Years ago I wrote a magazine article about the 35mm SLR which I called "a view camera on a neckstrap," and the description is still valid.

The SLR Design Concept

As illustrated, an image carried by rays of light passes through the SLR lens and is reflected by a mirror upward into a prism where the image is rectified right-side-up and left-to-right. One sees

3 CUTAWAY VIEW OF A 35MM SINGLE-LENS REFLEX (SLR) CAMERA

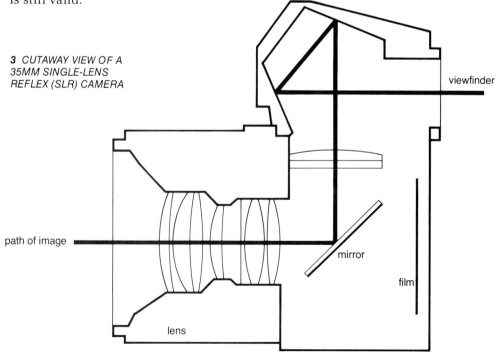

this prism image through the viewfinder almost exactly as the lens sees it. There are several reasons why you do not see a subject *exactly* as the lens views it:

1. Most SLR viewfinders crop (or cut off) several millimeters along all four edges of the image to compensate for a margin covered by the average slide mount or negative carrier in an enlarger.

2. As noted in the last chapter, there is a depth-of-field-preview lever or button on most SLR cameras with which you stop down the lens to check the area of sharp focus. However, until you activate the d.o.f. preview, you view a scene with the focus characteristics of a specific lens at widest aperture. This is not necessarily a handicap, and is paralleled by the view you get on the ground glass of a view camera, which does not indicate precise d.o.f. until you stop down the lens.

3. Brightness of image through an SLR finder is influenced by the maximum aperture of the lens in use. The film and the naked eye may see more detail in shadows than you observe in the viewfinder when the light level is low.

Composing and focusing. Despite its relatively small size, the image you see through an SLR finder is more than adequate for precise composition. No matter what lens you use on the camera, you see in the viewfinder very nearly what will appear on film. This is directly related to the view-camera concept, and is a big advantage over the

5 Close-up photography is a normal part of the SLR repertoire. Tropical fish were eight inches from the lens; one electronic flash was placed above the tank.

rangefinder 35mm camera that requires a separate finder image, usually through concentric framing in the viewfinder, for each lens.

Focusing an SLR lens is usually fast and easy. Revolve the lens barrel, watch a fine-focus grid in the middle of the viewfinder, and sharp focus is assured. Certain SLR cameras have a small split-field rangefinder image in the middle of the viewfinder for even more precise focus, though this is objectionable to some photographers who feel it interferes with composition. The finder system of an SLR depends on the personal taste and eyesight of the user. A choice of finders and eyepiece correction lenses is available for many cameras to facilitate precise operation. Check the literature for each camera brand to learn the details.

4 A selection of focusing screens is available for some SLR cameras, such as this series for Olympus OM equipment.

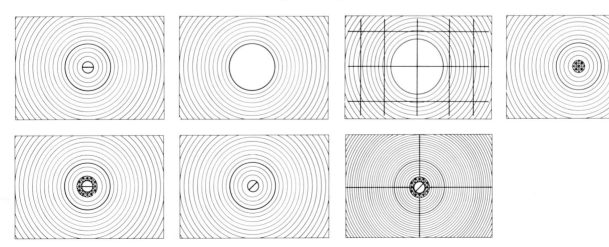

HORIZONTAL ACTION

VERTICAL ACTION

6 *TYPICAL FOCAL-PLANE SHUTTER MOVEMENTS FOR 35mm CAMERAS*

Courtesy of Yashica

Mechanical features. An instant-return mirror, depth-of-field preview capability, many shutter-speed options, motor-drive accessories (discussed further in chapter 4), sound-dampening materials, and other internal features of modern single-lens reflex cameras all make photography pleasant and versatile. If one had to choose from among the six or eight best SLR brands and models while blindfolded, the margin for error would be small because each of them includes most of the controls needed for a wide range of picture-taking. Camera bodies are part of a larger system of accessories for specialized applications, such as extreme close-ups, microscopic photography, copy-stand work, and so on.

Exposure-Meter Systems

In addition to price, weight, lens options, and other considerations regarding choice of an SLR, the exposure-meter system is of prime importance. Almost all modern SLRs include through-the-lens (TTL) exposure meters using cadmium sulfide (CdS) light-measuring cells. Internal designs vary; cells may be located on the back of the mirror, within the prism, or beside it. However, they all *work,* and improvements are often announced. The big difference is manual versus automatic exposure operation.

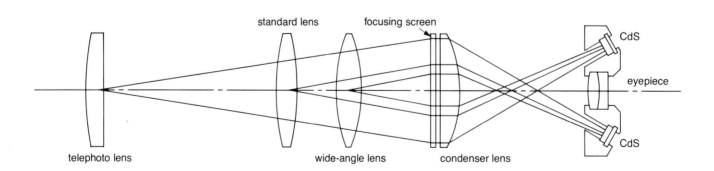

7 *A TYPICAL SLR BUILT-IN EXPOSURE METERING SYSTEM*

MATCH-NEEDLE FINDER

AUTOMATIC-EXPOSURE FINDER

8 *TYPICAL SLR FINDERS*

Manual exposure operation. As you view a scene through the viewfinder, a meter needle or small colored lights (called light-emitting diodes or LED) at one edge of the viewfinder indicate the meter reading for that situation. By adjusting either the aperture ring, the shutter speed dial, or both, you center the meter needle or see the proper array of LED lights. In most instances, the meter indicates correct exposure for the light intensity and subject reflectivity seen in the viewfinder, no matter what focal-length lens is used. By the "match needle" process, a built-in SLR metering system simplifies exposure and assures accuracy if technique is precise. If the light on a scene or individual doesn't change as you shoot, there is no need to adjust exposure settings. When the light or the scene changes, either shutter speed or f-stop can be altered as you compose through the viewfinder.

Automatic exposure operation. Since the late 1960s more and more top-rated SLR cameras have been introduced with automatic exposure systems. The first of these is called *shutter priority*, because the photographer chooses a shutter speed, and the au-

tomatic system, linked to the exposure meter, selects an f-stop setting for correct exposure. As you change shutter speeds (indicated in one margin of the finder as well as on the shutter speed dial), a needle in the finder shifts from one f-stop marking to another. Therefore if light intensity changes from one scene to another, the camera maintains proper exposure automatically.

The second method is called *aperture priority*, and operates in reverse of the first. You select the aperture that suits your needs, and the camera automatically adjusts the shutter speed to match. Infinitely variable speeds are possible within SLRs using electronic shutters. In addition, with aperture-priority SLRs, many lenses made for nonautomatic cameras can be used in the automatic mode.

Both priority methods have advantages and disadvantages, and both have their champions. Either means of automation is preferable, in my opinion, to manual "match-needle" exposure setting, because automation is faster, leaves less room for error when working quickly, and frees your mind to think of composition, action, and expression.

9 *Exposure for this circus shadow pattern was determined through a shutter-priority automatic SLR, though aperture priority has advantages, too.*

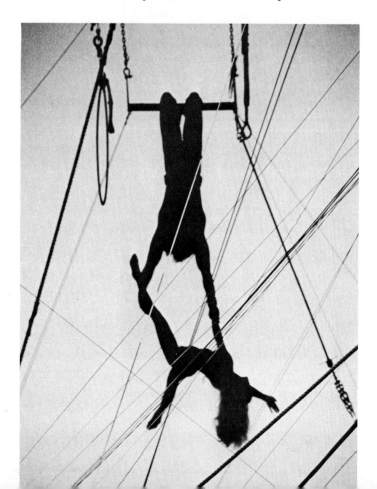

When automatic SLRs were first offered, most professionals scorned them as "high-priced Instamatics." Professionals are often loathe to use new systems that substitute built-in or automatic methods for manual ones. However, automatic single-lens reflex cameras have proved themselves to be as reliable as the "match-needle" variety, and most manufacturers of fine equipment now sell automatic cameras which consistently find new acceptance. Most lenses are available with adapters for automatic (also termed EE for electric eye) SLRs, so the selection runs quite a gamut of prices. It is my feeling that

before 1980, a vast majority of professionals and amateurs will be using automatic-exposure SLR cameras for their convenience. Why fiddle around with setting exposures by hand, if the camera will do most of the work for you?

Exposure override. Whether an SLR includes a manual or an automatic exposure system, the photographer is able at any time to override or alter the exposure measurement of the meter, and shoot at a substitute setting. For additional exposure when a meter is unduly influenced by backlighting (shooting into a light source), for instance, one merely adjusts shutter speed or aperture accordingly on either match-needle or automatic cameras. On the latter you simply revolve a ring away from the EE setting, taking the system off automatic, and choose any f-stop you find suitable. Some automatic cameras make this even easier by providing a dial to continue automation one or two stops over or under the setting indicated by the meter. (Some automatic cameras *discontinue* meter operation on manual mode, which can be a handicap. Check this feature while shopping.)

Meter sensitivity. While most SLRs have built-in exposure meters that operate in very low levels of light, there are separate hand-held exposure meters which excel in this capability. If you use a modern SLR, it is unlikely that you will need a separate meter for this purpose or any other, because camera meter sensitivity is more than adequate. More important is learning how the meter works in many lighting conditions, so you can make mental and manual adjustments when necessary. Equipment is only as good as the mind that operates it.

As mentioned later in chapter 4, you should be aware that a CdS cell in any exposure meter, built-in or hand-held, may be affected by a few seconds of exposure to bright sun or other intense light, and momentarily "go blind." If you include the sun in a picture, be sure the meter is turned on for the minimum interval possible to avoid this inconvenience.

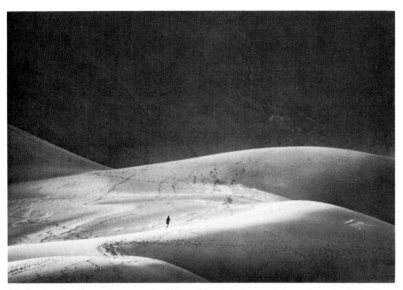

10 *Dr. Joe Atchison photographed Nags Head, N.C. sand dunes in color, including the girl in a red shirt for an accent. Kodak Newspaper Snapshot Award winner.*

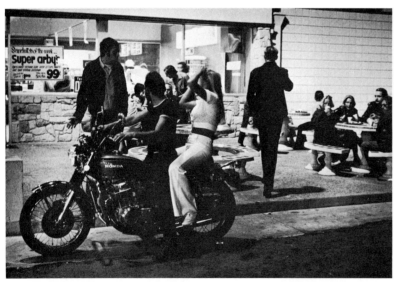

11 *Built-in camera meters are usually sensitive enough for accurate exposure at night in situations such as this one. Hand-held Konica T and Tri-X.*

12–21 TYPICAL 35MM SLR CAMERAS

12 *Olympus OM-2, automatic, aperture priority.*

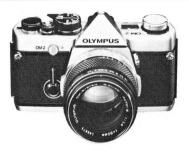

13 *Contax RTS*

14 *Canon F-1.*

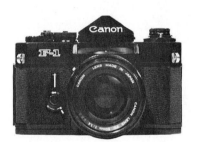

15 *Pentax K-2 with bayonet mount is automatic.*

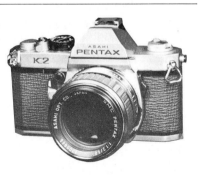

16 *Yashica TL-Electro.*

17 *Konica Autoreflex TC automatic, shutter priority.*

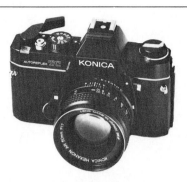

18 *Mamiya Auto X1000, shutter priority.*

19 *Nikon F2.*

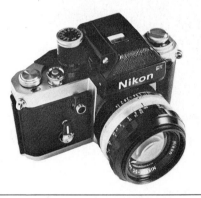

20 *Nikkormat EL, automatic, aperture priority.*

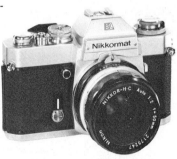

21 *Vivitar 420/SL.*

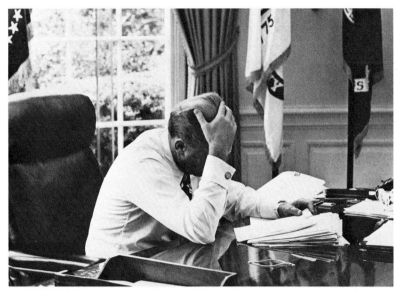

22 *To be unobtrusive, David Hume Kennerly sometimes chooses a 35mm RF camera for its quiet operation. Here President Ford ponders decisions and goes over mail, unaware of the photographer.*

THE 35MM RANGEFINDER CAMERA

A rangefinder is a device that enables you to focus a camera by joining together two halves of a split image or by joining two separate images into one, all within the viewfinder or beside it. Rangefinder focusing is fast, more precise in low light levels than focusing through the lens of an SLR, and necessary for cameras that do not use a mirror-and-prism finder system.

At present the only interchangeable-lens 35mm rangefinder cameras are manufactured by Leica. A number of lens options and other accessories are included in their system. Though these are fine cameras, it seems likely they would serve best as auxiliary equipment, since a reflex-type or view camera is more suited to student needs.

There are also a number of compact 35mm rangefinder cameras from many manufacturers of SLR equipment. These include automatic exposure systems and lenses with focal lengths in the 38-to-40mm range that cannot be removed from the camera; all the cameras are very lightweight. They are most popular with serious amateurs, or as second cameras for professionals who wish to travel with a compact 35mm rather than no camera at all. Lens quality is good, and the fact that these cameras offer a full 35mm negative or slide, compared with the smaller format of the best amateur equipment, makes this category of camera worthwhile.

23 *Konica C35EF, a compact 35mm RF camera with built-in electronic flash.*

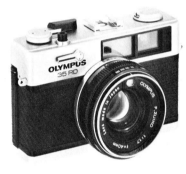

24 *Olympus 35RD, a compact 35mm RF camera with automatic exposure.*

25 *RANGEFINDER (RF) TAKING AND VIEWING SYSTEM*

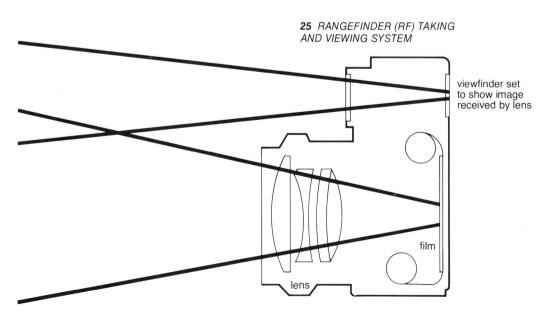

viewfinder set to show image received by lens

film

lens

LARGER-FORMAT HAND-HELD CAMERAS

There are three types of hand-held cameras in this classification. All of them use 120-size film on which the image size is either 2¼x2¼ inches (6x6 centimeters) or 6x4.5 centimeters.

Twin-Lens Reflex

Daddy of them all is the 2¼x2¼ twin-lens reflex, pioneered by Rolleiflex in the 1930s. Rollei and several other brands use a top-viewing lens that projects an image, the same size as the negative, via a mirror to a ground-glass viewfinder. A matching bottom lens is used to take pictures. The system is convenient and precise, though a reversed image is seen in the finder unless one adds an accessory eye-level prism. On some brands, lenses are not removable, while at least one brand, the Mamiyaflex, offers interchangeable, matched lenses mounted together. Add-on lenses are available for the Rolleiflex with a normal lens; the Rollei also comes in wide-angle and telephoto models.

26 *David Hume Kennerly photographed President Gerald Ford in the Oval Office soon after he became president, using a wide-angle lens.*

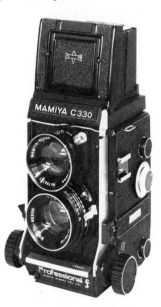

27 *Rolleiflex with f/3.5 lens.*

28 *Mamiya C330, TLR with interchangeable lenses.*

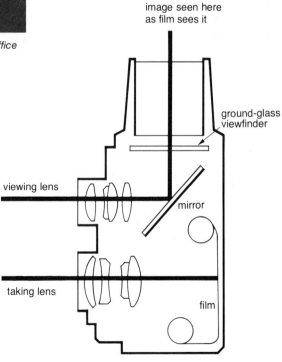

29 *TWIN-LENS REFLEX (TLR) VIEWING AND TAKING SYSTEM*

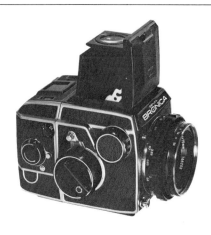

30 Bronica EC with electronically timed shutter.

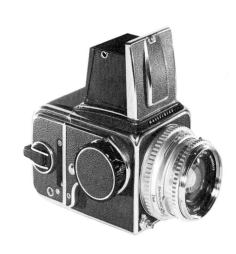

31 Hasselblad 500C, for which each lens includes its own shutter.

Single-Lens Reflex

Somewhat heavier than the average twin-lens camera is the single-lens larger format reflex, such as the Hasselblad, Bronica, Kowa, Rollei 66 and Mamiya RB 6x7. Except for their metering systems, these cameras are designed with the same concept as the SLR, and have long been popular with professional studio photographers for subjects such as fashion and advertising. While the larger reflex is often used on a tripod, it can be hand-held in reasonably good light, and offers a negative or color transparency midway between 35mm and 4x5. This is often appealing to commercial and industrial clients for added sharpness in prints and for media reproduction.

The newest larger-format SLRs provide electronic shutters, through-the-lens exposure meters, automatic exposure, and a wide variety of lens options. Most models have removable backs, an important feature. In the middle of a roll, one can switch from color to black and white or vice versa, without moving the camera or needing two cameras side by side.

Lenses from fisheye models to telephotos are made for these SLRs, all of which (including the camera bodies) are more expensive than the average 35mm SLR. For this reason, and because of their added weight and bulk, a larger format reflex offers more drawbacks than advantages to the average student. As a second camera, however, a larger SLR is a delight, mainly because the larger viewfinder image makes composition more accurate, and the negative lends itself to more extreme enlargement.

33 The square image of a larger-format SLR ▶ lends itself to either horizontal or vertical cropping. A Bronica with 135mm lens was used for this Death Valley scene.

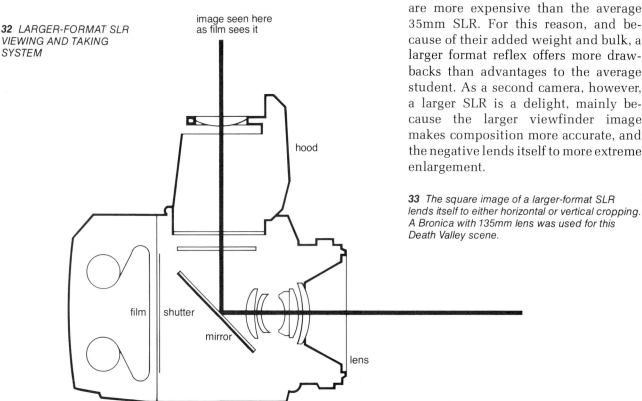

32 LARGER-FORMAT SLR VIEWING AND TAKING SYSTEM

image seen here as film sees it

hood

film shutter

mirror

lens

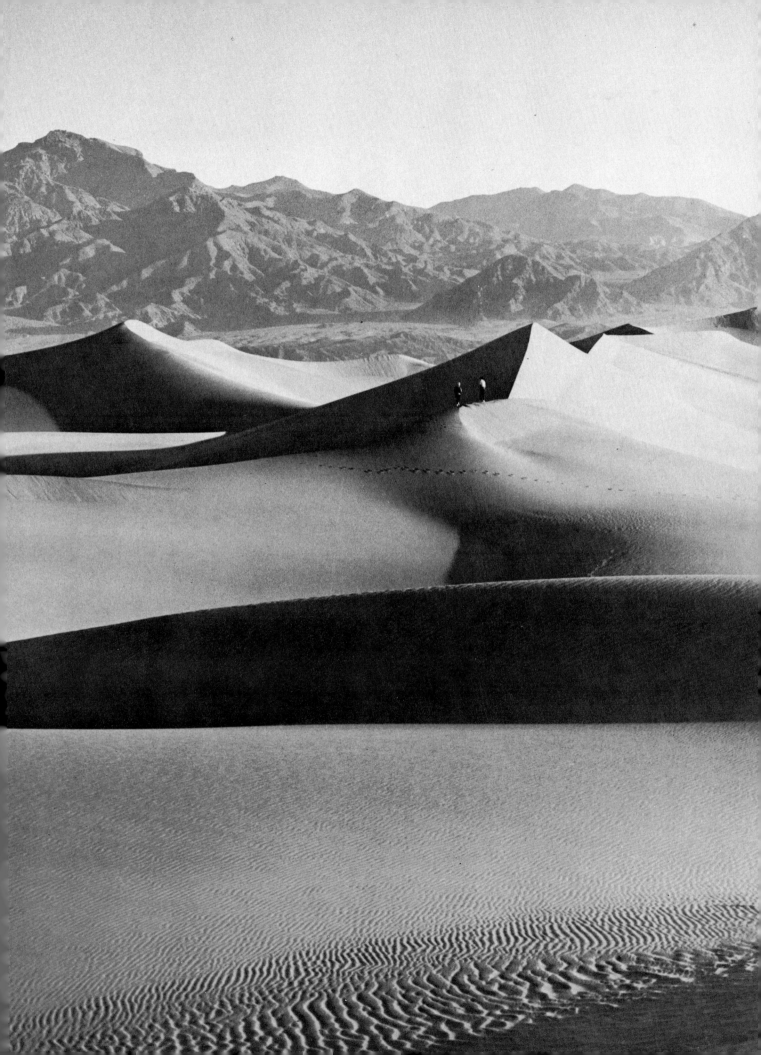

The 6x7cm format is similar to the 8x10 in shape, and provides more negative or transparency area than the 6x6cm. However, the latter can be cropped horizontally or vertically with ease. Both formats are adaptable for almost any subject, and use of a heavier, larger-format SLR is a matter of choice.

The Eye-Level Reflex Camera

Shaped much like a 35mm SLR, the larger reflexes operate in a similar way, but are twice the weight and bulk. Most make 6x7cm negatives or slides, ten exposures to a roll of 120 film. This type of large SLR with eye-level finder may be handier for mobile subjects than the waist-level camera, such as the Bronica or Kowa, but it does not have a removable back, nor is it as versatile in terms of accessories.

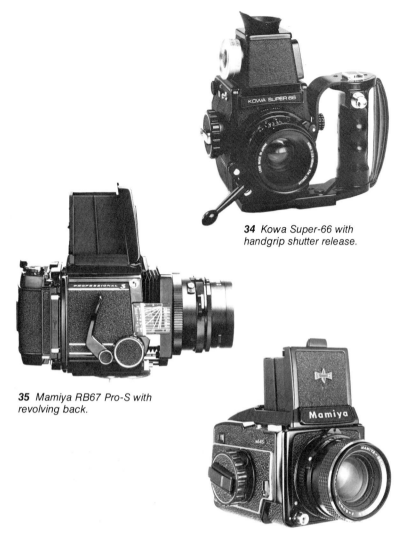

34 Kowa Super-66 with handgrip shutter release.

35 Mamiya RB67 Pro-S with revolving back.

36 Mamiya M645 medium format camera.

38 Comparison of medium format (42x56mm) and 35mm (24x36mm) image sizes.

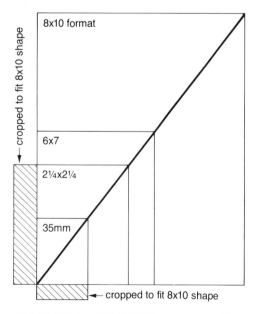

37 LARGER-FORMAT CAMERA IMAGE SIZES COMPARED WITH EACH OTHER AND WITH 35MM

THE VIEW CAMERA

Here is the pioneer camera with a lens mounted in front, a bellows in the middle, and a back that accepts sheet film in holders, roll film, or Polaroid film in adapters. The view camera, so named because it was used to shoot "views" in the early days of photography, is used on a tripod, and offers exceptional flexibility in terms of perspective correction and manipulation of focus. By tilting the back or front, or swinging these parts laterally, the photographer has controls that are not possible in more portable, faster-operating cameras. In

39 The superb detail of Edward Weston's "Artichoke Half, 1930" is derived from his use of the 8x10 view camera, and making contact prints which retain sharpness and subtle tones.

chapter 11 is a short survey of view camera movements for photographing architectural subjects and improving focus at wide lens apertures.

While the view camera is most appropriate for static subjects, or for those where movement can be anticipated, it also offers an extremely precise and disciplined way to learn composition. You get used to twisting your head to

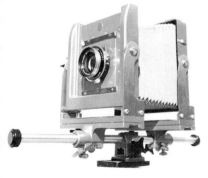

40 *A typical 4x5 view camera, the Calumet.*

see the image upside down on the ground glass beneath a dark focusing cloth. As compensation you may use a variety of lenses, shoot close-up subjects (especially with cameras that include long extension bellows), and view depth of field more clearly than with any other camera.

Most view cameras are fairly heavy in their carrying cases with film holders and accessories, but use of a size larger than 4x5 inches is rarely necessary. Camera artists such as Edward Weston or Paul Strand used an 8x10-inch view camera, requiring strong shoulders, enormous patience, and careful selection of subject matter. The normal lens on an 8x10 camera does not present much depth of field until stopped down to f/22 or f/32, which means using slow shutter speeds. Weston was known to wait an hour for the wind to calm down so he could shoot tall grass standing still at perhaps a 1-second exposure. For Weston and other camera artists, the 8x10 was part of a direct approach to photography, the end product of which was a contact print. This was made by laying the 8x10 negative on a sheet of 8x10 printing paper and exposing it. The ultimate in sharpness and beautiful tonality is thereby achieved. However, it is possible to make an 8x10 enlargement from a 4x5 negative that has the best qualities of a contact print, though it is seldom equal.

Another feature of the view camera is being able to expose—and later develop—sheets of film, *one at a time.* Individual exposures can vary along with development, giving the photographer remarkable latitude for manipulation, though this is more important to the student than to the professional who tries to standardize technique, even with sheet film.

The fortunate student receives some experience with a view camera in the educational process. Training in composition, processing, and deliberate technique is thereby enhanced. However, if use of the view camera is restricted, a valid approach to photog-

raphy need not be inhibited, for the same careful approach can be applied to smaller-format cameras. In addition, only certain career specialties will require using a view camera in the studio or on location. Commercial and industrial jobs can usually be accomplished with other cameras, and if a view camera is needed, it can be borrowed or rented.

View-Camera Backs

The back of the standard view camera springs open to allow a film holder to be inserted, and springs back for viewing after the holder is removed. However, for 4x5 cameras (and older 3¼x4¼ view cameras no longer manufactured), there are useful alternatives to single-sheet cut-film holders alone:

Roll-film back. By using an adapter, a roll-film back can be slipped onto a view camera with the ground glass removed. Such a back uses 120-size film, makes pictures about 2¼x3, and cuts the cost of film. At the same time, it makes shooting a bit faster. In addition, a greater variety of films is available in 120 size than in 4x5.

Polaroid 4x5 adapter. The Polaroid Land 4x5 film holder #545 accepts 4x5 Polaroid films in black and white or color, and slips into the view camera back like a film holder. Though Polaroid film is more expensive than conventional film, being able to see and evaluate pictures moments after they are taken is a big advantage. Many photographers make test pictures with the #545 holder before shooting on regular sheet film. Polaroid also supplies Type 55 P/N film in black and white, which develops as a print and negative in 30 seconds.

Polaroid pack-film holder—Model 405. This adapter slips into place like a sheet-film holder, but allows you to use regular 3¼x4¼ Polaroid films in color or black and white. A mask for the 4x5 view camera finder is included with the

41 *Enlarging a full 4x5 negative to an 8x10 print* ▶
offers an excellent approximation of an 8x10 contact print, as the detail in this portrait of an English coal miner demonstrates.

42 Family protrait made with a Polaroid Model 180 camera and Polaroid 105 positive/ negative film. Excellent enlargements are possible from 3¼x4¼ negatives.

holder. In my estimation, using the Model 405 combined with Type 105 Polaroid film, which develops an excellent black-and-white negative as well as a print, is an expedient to view-camera work that offers quality and economy. One can work carefully, see results in potentially excellent prints immediately, and have a full-scale negative for later printing, cropping, or manipulation. The Pack-Film Holder fits most recent 4x5 cameras, but older ones may have to be adapted because the back will not spring open wide enough.

View-Camera Variety

Most students will find a 4x5 view camera entirely adequate, and will have no need for the larger 5x7 or 8x10. Among 4x5 brands, some are all metal, and some are wood. The latest are finely designed to fold into compact shapes for more convenient work on location. These may not offer the extremes of swing and tilt operation, but are useful for almost all general photog-raphy. A Calumet view camera is excellent for a minimum price, while the imported Sinar is more elaborate and expensive.

OTHER TYPES OF CAMERAS

The previously mentioned cameras are those most likely to be used by students and professionals. The following are more specialized cameras that you should know about:

Press Cameras

The Koni-Omega Rapid is the best example of this type. It takes 120-size roll film and has a rapid film-advance system, interchangeable lenses, a handle grip, and other handy features.

Also available is the Linhof, a rather heavy, finely made 4x5 camera that can be used hand-held or on a tripod. It offers some, but not all, of the swing and tilt versatility of the view camera, and is popular with photographers who want a combination of features.

If the occasion should arise for you to use a 4x5 press-type camera, there are used older-model Speed Graphics.

For decades press photographers used the Speed Graphic, which became a trademark, along with the typical press card sticking from a hatband. Though this camera is no longer manufactured, used models are quite adequate if they are in good working condition. Look over used equipment when you shop, because it can save you money and suit your needs very well. Buy from a reputable dealer and get a guarantee for 30 to 60 days. Buying from a private party is more risky, but if the price is right, you might benefit.

Subminiature Cameras

In this category is the well-known Minox and others like it, as well as the best Pocket Instamatics. The Minox makes a negative 9x11mm, while 110-size pictures from Instamatics are 13x17mm.

When their lenses are well made, all of these cameras are capable of surprising sharpness and picture quality, but they are best suited for play rather than work, unless your technique is superb and your need for enlargement beyond 8x10 is minimal.

Specialized Cameras

Wide-angle cameras. Several cameras are available that make extremely wide-angle pictures on 120-size film; one is the Panon Widelux.

Underwater cameras. There is a camera called the Nikonos that can be used underwater or on dry land without a housing or special equipment. The Nikonos is designed for easy handling in aquatic conditions.

Underwater housings are also available for many 35mm cameras, for the Rolleiflex, and for inexpensive Instamatics. These are usually watertight plastic boxes with exterior controls for changing the focus and exposure and for advancing the film.

Superspeed camera. If the need arises to shoot up to 40 or 50 frames of 35mm film *per second*, there's the Hulcher camera with a unique motion-picture-type exposure gate operated by an internal motor. The Hulcher is most valued by sports photographers with large expense accounts or wealthy employers, but it can be rented in some large cities.

Polaroid Land cameras. Models keep changing, but for the student and professional, the Model 195 Polaroid with conventional shutter and very good lens can be a useful tool. Most professionals use a Polaroid back on a 2¼x2¼ or 6x7 reflex camera, rather than the 195, but the latter is convenient for exposure and general photographic testing. Loaded with Type 105 film, this camera can turn out more than acceptable negatives and prints for use in publications or exhibits. Compare the price of the Model 195 or a Polaroid back for your larger-format reflex. Each has different advantages.

44 *Nonautomatic Polaroid Model 195 with excellent lens and shutter speeds from one second to 1/500 second.*

43 *Nikonos III, self-contained underwater camera.*

CAMERA ACCESSORIES

Dozens of items are manufactured to fit all kinds of cameras, from motor drives on 35mm models to through-the-lens exposure meters for 4x5 view cameras. You should check equipment guides, camera literature, and supply shops for the latest and most complete information on this equipment. At this point there are only a few necessary accessories:

Lens shade. As mentioned previously, a lens shade is an essential for *all* photography. It prevents extraneous light rays from reaching the film where they might degrade sharpness of the image. It also protects the lens.

Cable release. This inexpensive accessory is most useful for slow or time exposures when touching the shutter release button could shake the camera, even imperceptibly. One type has a locking mechanism; the other has to be held manually during the full exposure.

Motor drive. A motor drive is not a necessary accessory, but for certain purposes, a motor drive on a 35mm camera has distinct advantages. Principal among these is in action photography where things are happening in a hurry and taking the camera from your eye to advance the film could mean missing essential activity. Some photojournal-

46 *Nikon F2 with motor drive and power pack.*

ists work with a motor drive almost all the time, because they like the convenience of automatic film advance and shutter cocking. They pay for this asset in added weight and expense.

Do not be seduced by a motor drive until you find a real need for it. At that time, no matter what the investment, this special piece of equipment will be worth it.

CHOOSING A CAMERA

The basic information to help you choose a camera has all been included previously in this chapter. Here are a few personal notes.

Though it may sound like I am copping out, an old industrial designer's axiom seems to apply in this case: "Form follows function." The type of camera you use will be determined by the type of pictures you take most often. If your ambition and aptitude are aimed at more static photography, such as architecture, small products, etc., a view camera or a larger-format reflex would be most appropriate. If you need a negative or transparency larger than 35mm, a camera using 120-size film is a sound answer.

However, if you want the most versatility in terms of lenses, films, on-or-off-tripod capability, and portability, the 35mm SLR is in most abundant supply and does an enormous number of tasks very well. It is not a substitute

45 *Olympus OM-1 with motor drive and accessory 250-exposure back.*

47 *A camera should offer flexible control over exposure, precise focus, and interchangeable lenses. This one-second exposure in existing light was shot with an SLR hand-held by the author who braced himself against a wall.*

for a view camera, and the sharpness of a 35mm negative or slide does not equal that of larger sizes, but for all-around requirements in student and professional fields, the 35mm SLR has no peer.

Certainly, if your learning needs demand a larger camera, you will use one. If you have an option, the 35mm SLR deserves careful research and testing. There are many excellent brands and models. The one you buy will be based on personal taste, cost, recommendation, testing, completeness of lenses and system, weight, adaptability to your hands and shooting methods, and a few other factors that you might include.

Whatever camera you own or use, the really important thing is to make it an instrument of your own will and talent. Don't be owned by your camera.

1 Proper equipment makes successful photography more certain and easier. An 80–200mm zoom lens on a Konica Autoreflex T3 allowed the author to track the children and stop them sharply at a shutter speed of 1/1000 second.

OTHER EQUIPMENT 4

It is possible for a creative person to be enamored of equipment in such a way that *having* lovely new tools becomes a misleading substitute for *using* them. It is less likely that students will fall into this trap, but I know a professional photographer of 17 years' experience who has sunk so much money into unnecessary cameras, lenses, lights, and accessories that he struggles to make a living. If a job seems to call for a lens or electronic flash he doesn't own, he feels compelled to buy it instead of borrowing or renting it. As a result he is burdened with equipment used rarely, and is always behind on mortgage payments.

Serious amateurs may also encounter their own version of acquiring the tools of photography as a surrogate for actually using them. Their filters, lenses, lights, cameras, and gadgets are enthusiastically exhibited to friends in lieu of pictures.

Therefore, it should be comforting to know that a limited, carefully chosen assortment of photographic gear can produce an unlimited variety of images in the hands of an aware individual. A late-model, dependable camera or two with several lenses is important, but the *latest* model may offer minimum advantages beyond being a status symbol. Other equipment, such as lights, flash, tripod, etc. can be used and even somewhat aged, yet still remain quite efficient.

A hunger for opportunity to take pictures, for new visual challenges, is the primary motivation toward growth in photography. As that need is fulfilled, requirements for more and better tools always seem to be met. However, it is useful for students to know of available equipment, and to make wise choices within limited budgets.

TRIPOD

Though a tripod is necessary with a view camera, and very useful with some heavy large-format reflexes, it can also be helpful to 35mm photography. As noted, almost any photograph made with a tripod-mounted camera is likely to be sharper than a similar picture taken with a hand-held camera. Make the comparison for yourself, shooting at 1/125 and 1/60 second. Enlarge two negatives equally, or project the slides on a screen, one after the other. Your test will be even more convincing if you shoot comparison images at 1/30 and 1/15 second. Later in this book when available-light photography is discussed, you will note that I suggest hand-holding a 35mm camera at slow shutter speeds as a useful technique to

2 With a 4x5 view camera on a tripod you are able to compose precisely, particularly when the subject is static. The side of a barn in Utah in low afternoon light was photographed with an eight-inch lens.

3 *A tripod is very functional for most cameras when the light level is low and slow shutter speeds are necessary. Surging tidewater was taken with a 4x5 view camera at one-half second and f/22.*

practice *for necessary situations*, but your own tests will show that sharpness must be compromised in return for authenticitiy of lighting or mood.

The value of a tripod with a 35mm camera is beautifully illustrated in a book called *These United States* by Fred Maroon, published in 1975. His full-page and double-page photographs are exceptionally sharp, and the color is excellent in dim light or bright sun, because Maroon used a tripod for almost every picture.

Obviously, a tripod is indicated in low light levels indoors, at dusk, or at night, particularly with slow films, or when you choose not to add flash or floodlighting. Even in sunlight, a tripod is often necessary when you use close-up lenses or a macro lens and are focused a few inches from the subject.

You need the depth of field available at the smallest apertures, and these are usually combined with slower shutter speeds. When there is time, and you can shoot from a static position, images exposed from a tripod are generally superior.

In general, the heavier the tripod, the steadier it will be. However, a sturdy tripod for a view camera, while more than adequate for a 35mm camera, will prove too heavy and bulky for easy carrying. Therefore, if you use a tripod weighing more than 4 or 5 pounds for a large camera, it will be convenient to have another smaller model for hand-held cameras.

There are many types of tripods from which to choose. Some brands may be obscure but quite satisfactory and economical. Here are features a long-lasting tripod should include:

Aluminum construction with three-section legs

Center elevator column for fast up-and-down adjustments

Separate handle controls for tipping and panning (horizontal movement) of the head, which should also rotate to vertical position for 35mm cameras

Control handles that fold flush to the tripod

A total length, when collapsed, of around 24 to 30 inches

Optional features:

Reversible rubber or spiked tips on the legs

Capability to mount camera at the bottom of the center elevator column for shooting close to a subject

Two-section center column for additional height

Maximum extension height of at least six feet

Crank-operated center column, though some prefer the push-pull type.

4 *Though special lenses offer perspective control on 35mm SLR cameras, the view camera offers the greatest correction. This was taken on the 4x5 format for a bank brochure. View camera movements are illustrated in chapter 11.*

Mount a camera on a tripod before buying, and go through the motions of shooting. Be sure that control handles do not extend into your face, making it difficult to use the viewfinder. Compare features and craftsmanship as well as prices and weight. A well-made tripod should last indefinitely.

FILTERS

You may wish to refer back to this section when reading future chapters about photographic techniques.

Filters alter the intensity and/or the color of light that registers as an image on film. It is entirely possible to take pictures regularly without needing a filter if you do not meet situations that require one. Unsophisticated photographers may ascribe "magical" powers to filters, especially when a scene

includes clouds or blue sky, but filters are likely to have a limited, albeit important, value to your photography. Filter effects can be functional or decorative, which means you use a filter for *correction* of tones to look more normal, or for *contrast* to accentuate the pictorial effect by lightening or darkening certain tones. In the latter category, imagination plays a vital role.

Filters for Black-and-White Films

Filters are used with black-and-white films primarily to lighten or darken tones by several means. A tinted filter absorbs (or subtracts) colors other than its own from the light rays entering a lens. Thus a red filter blocks blue and green, but passes red and orange onto the film. A green filter blocks reds and other warm colors, but passes greens and blue greens. A yellow filter blocks blue, but passes colors close to it in the spectrum. Filters are made in various degrees of color saturation, and affect film accordingly. A light yellow filter, for instance, will pass more blue than a dark yellow, an orange, or a red.

When you take pictures outdoors, there are several main colors: blue sky, green foliage, and brown earth tones. Since most black-and-white films are slightly more sensitive to blue than to other colors, blue tends to register lighter in a print than it appears to the eye. This is also because daylight is dominantly blue, as explained later. Therefore yellow, orange, and red filters are most often used to correct or darken skies. The deeper the color and the closer it becomes to red, the more it blocks blue; a red filter holds back green as well. Thus a light yellow filter (such as the K1 or K2) may produce a sky tone in a negative and print that looks approximately as we see it. A darker yellow, an orange, or a red filter absorbs so much blue that skies can be dramatically darkened, and clouds may stand out in distinct contrast. The strongest such effect is produced by the red filter. When used with infrared film,

5 *To darken blue sky for cloud contrast, use a yellow, orange, red, or polarizing filter with black-and-white film. A yellow filter was used for the scene of West Thumb Lake in Yellowstone National Park.*

6–6a *A polarizing filter helps eliminate reflections as shown by this pair of pictures taken from the same camera position. It is easy to see what the filter does through an SLR camera lens.*

a red filter can create an almost black sky and light gray or white foliage, because this filter blocks almost all greens.

In a predominantly green setting, a green filter lightens its own color, darkens blue sky to some extent, and blocks red, making the latter appear very dark in a print. A green filter also gives a pleasing appearance to flesh tones, but is unnecessary for most portraits.

Keep in mind that a "blue" sky varies photographically in different areas of the United States. Western skies, especially where the air is clear and elevations are somewhat above sea level, will usually register accurately without filters. Over the past 25 years of taking pictures in the West, I have rarely used a filter with black-and-white films, except the polarizer noted below, which was used to darken the sky for dramatic effect.

Polarizing filters. When revolved in front of your eye or while attached to a camera lens, the polarizer alternately darkens a blue sky and shows it normally. The invisible chemical structure of a polarizing filter gives it the ability to block light rays approaching the lens at an angle of about 30 degrees. This capability can be seen as the filter is revolved, and the effect is easily previewed through the lens of an SLR or view camera. Thus you can control the tonality of a sky from normal to noticeably darker. The polarizer works equally well with color films, *without* altering colors in any way except to deepen them.

A polarizing filter is also used to cut reflections from the surface of water or metal, and when photographing at an angle through windows. If you shoot perpendicular to glass, the polarizer is less effective than when you shoot a window from one side. In many situations, black and white or color, this filter is useful to capture detail the eye and lens could not record without correction. Simply place the filter over an SLR lens and rotate the outer ring

7-7A *These comparison photographs illustrate another function of a polarizing filter which darkens the sky, but does not affect colors.*

8 *Fast film and bright light may require an exposure beyond the f/16 and 1/1000 second limits of most SLR cameras. Use a 2X or 4X neutral-density (ND) filter to reduce effective film speed without affecting color or subject tonality. A 2X ND filter here permitted correct exposure on Tri-X.*

(which is made in two joined parts) until you see through reflections to the extent you wish.

Neutral-density filter. These filters are made in several shades of gray and may be used with black-and-white or color films with no effect on hues in negatives or slides. In effect, a neutral-density (ND) filter is a mask to reduce the intensity of light. ND filters are available in 2X, 4X, and 8X ratings. A 2X ND filter cuts the light in half, requiring one stop more exposure (adjusting either f-stop or shutter speed). A 4X ND filter cuts the light two stops, and an 8X ND cuts it three stops. If you place an ND filter over the lens of an SLR with a through-the-lens meter, the correct exposure will automatically be indicated, and mental calculations are unnecessary.

A neutral-density filter serves two useful purposes. If you are shooting with a film that has a high ASA rating, such as 400 for Tri-X, and do not wish to use the smallest lens opening along with the fastest shutter speed on your camera, the ND filter gives you the option of choosing a larger f-stop or slower shutter speed. Occasionally, I rate Tri-X at ASA 1000 (and develop it in Acufine) for available-light indoor pictures, and must shoot outdoors in sunlight on the same roll. A 2X or 4X ND filter "tames" the film speed and allows me to shoot within the limitations of my camera's aperture (f/16) and shutter-speed (1/1000 second).

Here is a chart showing a comparison of shutter speeds for Tri-X in bright open shade with and without a 4X neutral-density filter:

SHUTTER SPEED AT ASA 400	APERTURE	SHUTTER SPEED AT ASA 100 WITH 4X ND FILTER
1/4000	f/2	1/1000
1/2000	f/2.8	1/500
1/1000	f/4	1/250
1/500	f/5.6	1/125
1/250	f/8	1/60
1/125	f/11	1/30
1/60	f/16	1/15

features by throwing them out of focus. This is the method I used to provide myself with a full range of f-stops as I shot the depth of field demonstration pictures in chapter 2.

Haze or ultraviolet filter. Atmospheric haze may not be visible to the eye, but can affect black-and-white films because of excessive ultraviolet (UV) light, especially in mountain elevations and at the beach. (Don't use a UV filter with Kodachrome at the beach or at high altitudes; it may cause a yellowish tint and isn't necessary.) Any filter you place over the lens will correct for this type of haze, but if you are not using a polarizer or colored filter, the colorless UV filter will also do the trick. Some photographers keep a UV filter over the lens all the time, primarily to protect the lens.

Deep yellow, orange, and red filters absorb both blue and UV rays even more effectively than the UV filter, but keep in mind that colored filters are effective only when there is color in the scene. You cannot darken an overcast gray sky, or cut through fog, smog, or mist by using a haze filter or any other type. Infrared film and a red filter do partially "see through" colorless haze if you care to experiment with them.

9 *A 4X neutral-density filter was used to reduce film speed and allow the use of a wide aperture to throw the background out of focus for a more pleasing portrait. It was part of a magazine story on foreign students.*

The other function of an ND filter is to better control depth of field—to control how much of a scene will be in sharp focus. As an example, an outdoor portrait with Tri-X may require a setting of f/16 at 1/1000 second, which would produce a sharp background along with the sharp main subject. By using a 2X or 4X ND filter, you could shoot at f/11 or f/8, thereby softening background

Filters for Black-and-White Films

FILTER NO.	COLOR	SUGGESTED USES
K1	Yellow	Absorbs some blue and darkens sky slightly
K2	Yellow	Darkens skies to produce good contrast with white clouds
K3	Yellow	Even greater darkening of blue for additional cloud contrast
X1	Green	For pleasing flesh tones in outdoor portraits with sky background; helps separate greens in landscape pictures
X2	Green	Lightens foliage; also good for portraits in floodlighting, especially of men
G	Yellow orange	For more dramatically dark skies; good for marine scenes
23A	Light red	Appreciably darkens sky and blue water; not recommended for flesh tones
25A	Red	Very dramatic sky effects; with slight underexposure, a "moonlight" scene may be simulated
C5	Blue	Accentuates haze and fog; darkens red
ND	Neutral density	Reduction of light intensity with no effect on colors
UV	Colorless	For atmospheric haze at high altitudes or for beach or snow scenes
Polarizer	Neutral	Eliminates some surface reflections; darkens blue sky

Filters for Color Films

Most of these filters are tinted to *correct* the appearance of colors on film, or to *convert* a specific film for use with a specific light source.

Kelvin or color temperature. The color characteristics of light are measured in *degrees Kelvin,* expressed as °K, which represents a temperature scale established by a nineteenth-century British physicist named William Kelvin. Light and heat are closely related, and low Kelvin temperatures indicate warmer light sources (toward the reds), while higher Kelvin numbers are relatively cooler and bluer.

Color Temperature of Primary Light Sources

LIGHT SOURCE	COLOR TEMPERATURE (°K)
Sunlight Electronic flash	Approximately 6000
Overcast sky light	6500 to 10,000
Photoflood bulb	3400
3200K bulb for Type B film	3200
100W lightbulb	2800–2900
Candle flame	2100

While the eye does not make distinctions as sensitively as does color film, we most easily notice the warm light of a candle or the reddish tint of the setting sun (as it's filtered through earthbound haze). Color films are manufactured to match specific light sources (explained in the next chapter), and filters for color films help coordinate lighting conditions with certain films. Therefore, if you shoot a tungsten-type film (Type A or Type B) in floodlight, it will produce approximately accurate colors, but the same film in a daylight situation will have an overall blue tint, because the color temperature of daylight is about twice that of tungsten light. In reverse, a daylight color film exposed in floodlighting will have a reddish tint that is usually objectionable.

Conversion filters. In order to make it possible to shoot the "wrong" film in the "right" light (whatever is available sometimes), color-conversion filters are made. The 85 series warms daylight to balance it for tungsten films, and the 80

10 *The young musician was photographed using floodlights into an umbrella reflector at the left and on the back wall. With tungsten color film (Type A or B), an 81A filter would be used for electronic flash, and an 80A filter would convert for use with 3200K bulbs.*

series cools artificial light to convert it for daylight films. There are also filters to correct the color of clear flashbulbs for daylight films. The chart below lists all filters that are important in general use.

Filters for Color Film

FILTER NO.	FILM TYPE	LIGHTING	SUGGESTED USES
1A (skylight)	Daylight	Daylight	Reduces bluish tint in shade and shadows, and on overcast days
UV15	Agfachrome & Anscochrome daylight	Daylight	Haze filter to reduce UV light
Haze 1	Daylight	Daylight	Reduces excess blue caused by haze and UV rays
80A	Daylight	3200K bulbs	Converts daylight film for use with 3200K bulbs
80B	Daylight	3400K bulbs	Converts daylight film for use with 3400K photoflood bulbs
80C	Daylight	Clear flash	For use with clear flash bulbs
81	Daylight	M2 flash	Yellowish filter for warming effect
81A	Type B	Electronic flash and 3400K bulbs	Corrects Type B films for use with 3400K photofloods; balances electronic flash and daylight color film
81C	Types A & B	Clear flash	Corrects for clear flashbulbs
82A	Type A	3200K bulbs	Corrects for 3200K photofloods
85	Type A	Daylight	Converts Type A film to daylight
85B	Type B	Daylight	Converts Type B film to daylight
FLB	Type B	Fluorescent	Eliminates blue-green tint emanating from fluorescent bulbs
FLD	Daylight	Fluorescent	Eliminates blue-green tint emanating from fluorescent bulbs
Polarizer	Any type	Any light	Eliminates some surface reflections; darkens blue sky
ND	Any type	Any light	Reduces light intensity without changing colors
820B	Polacolor	3200K or 3400K	Converts daylight film for use with photoflood bulbs
840B	Polacolor	75–150W bulbs	Converts daylight film for indoor use

11 In a situation where fluorescent lights and daylight are mixed, an FLD filter with daylight-type color film usually offers suitable correction.

FLB and FLD filters. Fluorescent lights vary in the amount of blue-green tint they cast on people and objects, but flesh tones look sickly in many color slides and prints unless filter correction is used. The FLB is for use with Type B films and the FLD for use with daylight films. Both are compromises, because there are various types of fluorescent bulbs, and each requires a specific filter correction. Fortunately, absolute accuracy is usually unnecessary, and even if whites are slightly tinted, an FL filter makes flesh tones acceptable. However, it does require about a one-stop increase in exposure. (See discussion of filter factors below.)

Color-compensating filters. These are known as CC filters and are made in various densities of red, blue, green, magenta, cyan, and yellow. They come

E-76, *Applied Color Photography Indoors*. CC filters are widely used in color printing, but are generally unnecessary for the average photographer.

Filter Factors

Since filters vary in density, they also vary in the amount of absorbed light that does not reach the film. A *filter factor* is a number that indicates how much to increase exposure when using a given filter. A filter factor of 2X means exposure time must be doubled, or increased by one stop. Thus a normal exposure of 1/125 second at f/11 becomes 1/60 second at f/11 (or 1/125 second at f/8) to compensate for the 2X factor. Which variation you choose depends on how fast the subject is moving and/or the depth of field you prefer. Shifting f-stops is often more convenient, because you have half-stops as intermediate steps when a factor such as 3X calls for about 1⅔ stops.

Filter Factor F-Stop Increase Table

IF THE FILTER FACTOR IS:	OPEN THE LENS THIS NUMBER OF STOPS:
1.2	⅓
1.5	⅔
2	1
2.5	1⅓
3	1⅔
4	2
6	2⅔
8	3

The difference between one-half and one-third or two-thirds stop is negligible, and the click-stop between full stops on the average SLR lens will suffice. If you use a filter on a reflex camera with a through-the-lens meter, the system compensates automatically, and the factor need influence picture-taking only in terms of practical choice of aperture and shutter speed. If you use a separate exposure meter, lower the ASA film speed setting according to the factor. As an example, with an ASA 125 film, reduce the rating to 64 with a 2X factor and to 40 with a 3X factor. Remember to reset the film speed when you stop using a filter. Filter factors are marked on filter mounts or in descriptive material packed with them.

12 *Concern about filter factors is relieved with through-the-lens exposure metering that compensates automatically. A 4X ND filter made this scene possible to photograph without overexposure.*

in close gradations, and allow the amount of color correction to be precisely controlled. A CC filter might be designated by a color film manufacturer for use to correct a specific emulsion (or batch of film) due to deficiencies in manufacturing tolerances. A filter numbered CC20Y, for instance, indicates a yellow filter with a density of .20. Specific CC filters are recommended for correcting color under fluorescent lights in Kodak Data Book

If you are shooting with a slow film (rated ASA 25 to 64) and you must use, for example, a conversion filter or an FL filter, consider changing to a faster film (such as ASA 160) in order to use smaller f-stops and/or faster shutter speeds.

Buying Filters

Filters are made in three types: gelatin, solid optical glass, and laminated optical glass and gelatin. Not all filters are available in each form, but those most commonly used offer a choice.

Gelatin filters. These are manufactured in 2-, 3-, 4-, and 5-inch squares, and are the least expensive and the most precisely tinted. On the other hand, they can be scratched most easily, and are the most difficult to handle. Buy the size slightly larger than your lens and cut it into an exact circle that can be fitted into a double-ring adapter and screwed into the front of a lens. One adapter is enough for each lens size. Store unused cut filters in their original flat packets in a camera gadget bag.

Glass filters. These are much easier to manage than gelatin, and can be screwed directly into the front of a lens. They should be handled and cleaned just like lenses. Filters of the same diameter can be screwed together into a stack and covered on each end with caps made just for this purpose. Four glass filters take up less than an inch of space and are well protected this way.

Laminated filters. These are sometimes more precisely tinted than all-glass filters, but cost more and require more care.

Step-rings. Should you have lenses that require different sizes of filters, there are step-up and step-down rings to adapt one size filter to another lens diameter. Avoid buying duplicate filters if possible, to save money and avoid weight.

Filter selection. Buy only the filters you will need, and wait until they are required. If you want a basic set, here is a recommendation:

1A skylight filter to warm shadow areas in color shots made on overcast days, and to protect the lens

2X and 4X neutral-density filters for added control over film speeds and depth of field

An FLD filter for use with daylight color films and fluorescent light

Conversion filters for use if and when needed

Filters for effects. As one means of personal expression and for unusual photographic effects, you might experiment with yellow, amber, pink, pale blue, red and other colored filters over the lens to completely tint color slides or prints. For instance, if the warm light of sunset is not strong enough, a yellow filter will amplify its normal appearance. Or a red filter may add drama to a desert setting, just as a blue filter can underline the mood of a rainy day.

Among contemporary photographers, Pete Turner is noted for his tinted pictures, though his effects are usually accomplished by copying a normal slide with a filter between it

13 *Though no filter was necessary to photograph mirrored columns in a hotel lobby, experiments with colored filters and color film (either negative or transparency) might have produced some offbeat images here.*

14 *A prism lens with three facets on a Rolleiflex created an unusual triple image.*

15 *A soft-focus or diffusion lens over a reflex camera lens allows you to see diffused definition and reduced contrast as you shoot.*

and the light source. One might even copy an appropriate black-and-white print with a colored filter over the lens to achieve a unique type of slide for various purposes. There are other special-effect filters such as those that produce a rainbow, or diffuse only one area of an image. For descriptions, write for a brochure from Spiratone, Inc., 135-06 Northern Blvd., Flushing, N.Y. 11354.

SPECIAL-EFFECT LENSES

There are several lenses that screw into the front of a camera lens in the same way a filter does. One of these is a *prism lens* which depicts a scene as two, three, or more overlapping identical images. The number of images depends on the number of facets or equal sections included in the prism lens. The use of such a lens can be exciting or contrived, depending on the subject and how appropriate the prism is to it. David Douglas Duncan produced a complete book of prism images of Paris a few years ago, but the use of a prism lens is generally limited because it is so specialized.

Another such lens is actually a filter. It gives a fog effect to a scene by softening the image and adding a fine texture similar to the grain of an enlarged negative.

There are also *soft-focus* or *diffusion* lenses, usually limited to portraits. Hasselblad makes one called the Softar which can be adapted for 35mm SLR cameras. Since camera lenses are so sharp, and soft-focus portraits have a place in photography, a diffusion lens may occasionally be useful. However, diffusion can also be achieved by various means when a negative is enlarged.

CAMERA BAGS AND CASES

This is a subject where personal opinions prevail, and I'll record my own.

"Never-ready" cases. For all 35mm cameras there are snug-fitting cases popularly known as ever-ready cases—

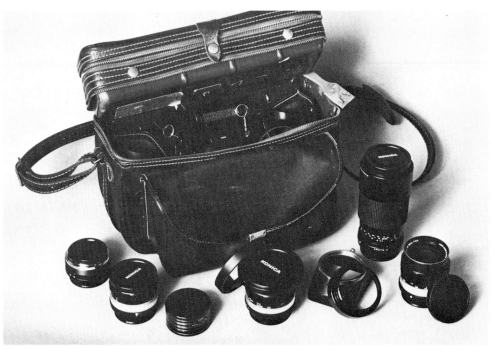

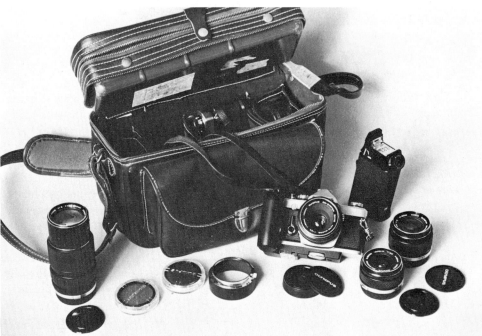

16–17 *In identical shoulder bags the author carries two fairly complete SLR camera and lens systems. Two Konica Autoreflex bodies and an assortment of lenses are shown in figure 16. Two Olympus OM-1 bodies, the one in the foreground with motor drive attached, plus lenses, are shown in figure 17. The top compartment of the case (no longer manufactured) holds extra lenses and filters.*

which you should avoid. If you can possibly buy a camera without the case, do so, because it is merely in the way. A case adds weight to carry, makes loading and unloading film a chore, and dangles about while you shoot. Protect your valuable camera in a shoulder bag or something similar, and steer clear of never-ready fitted cases.

They are the mark of the amateur, which is not snobbery, but an editorial observation.

Shoulder bags. The most expedient way to store and carry 35mm and larger-format hand-held cameras is in a bag hung from one shoulder, sometimes called a gadget bag. These are made in an assortment of sizes, shapes, and prices. Choose one with enough com-

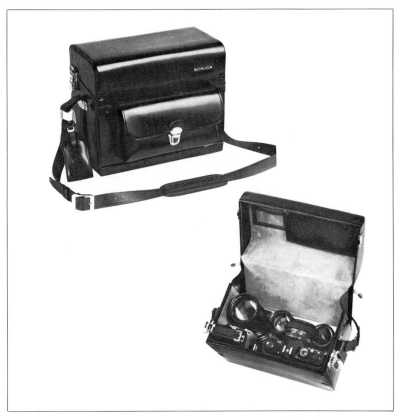

18 *Many camera companies make fitted cases for their equipment similar to this one for the Konica Autoreflex T.*

19 *An excellent miniature clamp for SLR cameras is 3½ inches long and weighs only 2½ ounces; it is available from High Sierra Manufacturing Company, Midpines, California 95345.*

partments to fit your cameras, lenses, meter, film filters, and other supplies. Take your equipment to a camera shop, and try it in several bags. In this way you'll find which is most efficient, at a price you can afford, and a total weight that will not cripple you. My shoulder bag with two SLR bodies, five lenses, film, and assorted gadgets weighs

about 14 pounds, but less when I carry one camera with lens around my neck. I've carried this bag loaded all day on hikes in mountains and through cities, and while I admit it tires one shoulder (I switch back and forth), it has compensations.

With a shoulder bag your hands are free to operate a camera, change film, or whatever. Lenses and accessories are always at hand, and you can wear the bag while you shoot, especially in circumstances where you are moving about. It is very risky to set down any container of equipment that may be worth $1,000 or more in a park, an office building, or any place where you are working.

As an accessory to a shoulder bag, you might investigate a photographer's jacket with an abundance of pockets, advertised in camera magazines. I have not used one, but friends active in photojournalism find such jackets quite practical when covering parades, riots, or any subject that necessitates their movement.

Fitted equipment cases. Fitted cases look like suitcases and are usually made of aluminum. Inside, a foam rubber filler is hollowed out in places to fit snugly around cameras, lenses, meters, and other equipment. Such a case protects equipment very well when carried or shipped, but it can be difficult to hang onto or keep track of when working in a crowd or mobile situation. I suggest a shoulder bag as being more practical at first, and when you have more gear and know better the type of photography that you'll be doing, you can consider a fitted equipment case. Keep in mind that it must be carried by a handle and that it calls attention to itself and must be monitored all the time.

Other cases. A variety of other containers can be bought to carry lighting equipment, accessories, and large quantities of film. As you collect more gear, you need more cases for it. Be sure they are as small and lightweight as possible. The photographer-as-pack-mule is too common a sight.

1 *From the Matthew Brady Collection in the Library of Congress, a cemetery gate on the battlefield at Gettysburg was photographed in July 1863 on a glass plate while the emulsion was still wet. The process was slow, and fingerprints can be seen at the edges of the print.*

In the earliest days of photography, images were made on thin sheets (or plates) of metal that were coated with chemicals sensitive to light. Around 1851 metal was replaced by glass which was spread with collodion, a viscous solution that dries into a tough film. However, glass plates had to be exposed before they dried, and developed at once. Working outdoors meant taking along a portable darkroom. Various chemical combinations tried the patience of photographers at different times. Experiments were being made on dry-plate processes, but none was successful until 1871 when gelatin was used instead of collodion. This discovery was revolutionary; now plates could be coated well before exposure and processed long afterward. In addition, the new gelatin-bromide plates were far more sensitive to light, and exposures could be made in a fraction of a second. For the first time, photographers could hand-hold their cameras, and the era of the snapshot was born!

Since glass plates were heavy and broke easily, experimenters began searching for another material. Among them was George Eastman who devised a way of coating paper with chemicals (called the *emulsion*) and stripping the gelatin and emulsion away so it could be sold in rolls. He called this "American Film," and it caught on quickly, because roll film for 48 negatives in the 4x5 size weighed only as much as 12 glass plates. In 1888 Eastman introduced a simple

2 *Typical family group photographed in Europe before 1900 on a glass dry plate in a daylighted studio. Reproduced from a copy print.*

3 *Enlargement from a negative exposed in a No. 1 Kodak camera invented in 1888 by George Eastman. Original size of the circular image was 2½ inches. Location was probably Rochester, New York, based on the "Rochester Lager Beer" sign in the background. (Courtesy George Eastman House.)*

box camera called the Kodak. Roll-film technology improved, and though glass plates were in use into the 1900s, photographic film as we know it has improved in every decade since the mid-1880s.

FILM TERMS

Here are terms—words and phrases—that photographers should know in order to understand exposure and development:

Emulsion. A thin layer of light-sensitive material, usually silver hal-ide; emulsion is coated on a transparent base for film, and on a paper base for printing papers.

Silver halides. Tiny crystals or grains of silver which darken when exposed to a sufficient amount of light. Shades of gray are produced in the emulsion according to its sensitivity, the size of the halide crystals, the thickness of the layer, and the amount of light that affects it.

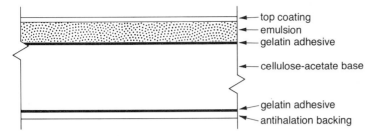

top coating
emulsion
gelatin adhesive

cellulose-acetate base

gelatin adhesive
antihalation backing

4 *CROSS-SECTION OF BLACK-AND-WHITE-FILM*

Film base. A strong, flexible plastic (usually cellulose acetate or mylar) onto which the emulsion is coated.

Antihalation backing. A dye coating on the back of the film base which helps prevent light rays from reflecting back through the emulsion.

Halation. Dispersal of intense light rays around bright areas of an image, the effect of which is to decrease image sharpness.

Grain. Individual, microscopically small particles of silver which give film its sensitivity to light and ability to form an image. Larger particles of silver, sensitized by light first, are characteristic of "fast" films. Smaller silver crystals are sensitized less quickly, and are indigenous to "slow" films, also called fine-grain films.

Graininess. A fine, granular texture that appears in a negative, print, or slide resulting from the clumping of silver grains during development of the film. Graininess is also influenced by film speed, negative density, and degree of enlargement.

Latent image. The invisible image left by the action of light on photographic film or paper. When processed, the latent image becomes a visible image, either as a negative, or as a positive black-and-white print or color transparency.

Film speed. A number, usually an ASA rating or an exposure index (EI) rating, that indicates the relative light sensitivity of a specific film. The higher the number, the more sensitive or "faster" the film.

Fog. The darkening of a negative or print, or lightening of a slide caused by: (1) exposure to light leaking into film containers or any light other than the image-forming light that comes through the lens, (2) overdevelopment, (3) aging or outdated film or paper, or (4) storage of film or paper in a hot humid place.

BLACK-AND-WHITE AND COLOR FILM CHARACTERISTICS:

Black-and-white and color films share a number of characteristics as well as chemical distinctions. These technical points help describe film and its ability to make pictures. Eventually, one has the "feel" of several films, and technicalities are absorbed into day-by-day shooting practices.

Emulsion Speed

It's easy to be overly concerned about film speed when beginning in photography, because very fast films seem de-

5 *Film speed should be chosen for best results according to the type of light, mobility of the subject, and degree of enlargement. Tri-X was useful for reflection in Disneyland bank window exposed at 1/125 second and f/8.*

sirable for available light pictures, and very slow films are recommended for enormous enlargement. Both of these facts are true, but when you become familiar with the versatility of one or two types of film (along with developer combinations and printing processes), you will be confident of results under a variety of lighting and subject conditions.

A film-speed rating, or ASA number, suggested by the manufacturer may be quite satisfactory for many photographers, but relative for others. The term *effective film speed* indicates a revised ASA rating, because the one printed on the film box or cartridge may not be precisely related to the needs of all photographers. I suggest that you begin with the manufacturer's ASA figure, unless someone convinces you otherwise. As you become experienced with exposure and standardize development practice, you may evolve an effective film speed of your own. The image quality of negatives and slides is also influenced by differences in shutter mechanisms, metering techniques, and lighting. Mechanical shutters are subject to slight variations that may modify the appearance of negatives or slides, but there's no problem if *your* shutter is consistent. Electronic shutters are theoretically more consistent, but may vary slightly from one camera to another.

Other factors may influence film speed. Techniques of reading an exposure meter, described in the next chapter, may give film the appearance of being faster or slower, depending on the type of meter and its use. Developers also influence film speed, as do developing time and practice. This is amplified in chapters 6 and 8. Backlighting (when you shoot into a light source) and the light-and-dark contrast of a subject may require an increase in or reduction· of film speed. Again, there is more about this in the next chapter.

Slow films. These range from ASA 25 (or lower) to approximately ASA 80. Slow black-and-white films, because of their fine grain structure, can be enlarged considerably without showing graininess. However, a slow film has more inherent contrast than a fast film, and this can be a handicap under some conditions, as explained below. When the light level is adequate, a slow film is assurance of medium-high contrast, and a capacity for greatly enlarged negatives or slides.

Medium-speed films. From about ASA 100 to 250, a film falls between slow and fast, has good grain structure, medium inherent contrast, and is appropriate for many subjects and conditions. There are color-negative and slide films, plus black-and-white films, in this speed range.

Fast films. From ASA 250 to 400 is the fast-speed range, and in this range Kodak Tri-X is the favorite of many professionals. Rated at ASA 400, Tri-X produces slightly less contrast in a given situation, compared with slower films such as Plus-X and Panatomic-X. This means it is slightly easier to achieve shadow detail in bright sunlight with Tri-X, though of course much depends on exposure and development. In enlargements greater than about 8x10, graininess is more pronounced in fast compared with slower films, but with proper exposure and development, grain should not be a problem. In actual practice, I feel that if grain shows in a print, it belongs there because lighting conditions, development, or degree of enlargement made it so.

Superfast films. There are only a few superfast films in the ASA 1000 to 3200 range (see chart), and these are for special purposes. Superfast films are designed for use in very poor lighting

6 *A slow film may be desirable for its rendition of* ▶ *fine detail, especially for enlargements greater than 11x14 inches from 35mm films. Contrasting textures were photographed in a California redwood grove with an SLR and 35mm lens.*

Black-and-White Roll Films

NAME OF FILM	ASA NUMBER	SIZES
Slow Films		
Adox KB-14	20	35mm
Adox R-14	20	120
Adox KB-17	40	35mm
Adox R-17	40	120
Agfa Isopan IFF	25	35mm & 120
Agfa Isopan IF	40	35mm & 120
Ilford Pan F	50	35mm
Kodak Pantomic-X	32	35mm & 120
Medium-speed Films		
Adox KB-21	100	35mm
Adox R-21	100	120
Agfa Isopan ISS	100	35mm & 120
Ilford FP4	125	35mm & 120
Kodak Plus-X Pan	125	35mm & 120
Kodak Verichrome Pan	125	35mm, 120, & 110
Fast Films		
Agfa Isopan Ultra	200	35mm & 120
Ilford HP4	400	35mm & 120
Kodak Tri-X	400	35mm & 120
Superfast Films		
Agfa Isopan Record	400 to 2000+	35mm & 120
Kodak Royal-X Pan	1250	120
Kodak 2475 Recording	1000 to 3200+	35mm

Black-and-White Sheet Films (or Cut Films)

NAME OF FILM	ASA NUMBER
Kodak Plus-X Pan Professional 4147	125
Kodak Super-XX Pan 4142	200
Kodak Super Panchro-Press 6146—Type B	250
Kodak Tri-X Pan Professional 4164	320
Kodak Tri-X Ortho 4163	320/200 Tungsten
Royal Pan 4141	400
Royal-X Pan 4166	1250
GAF Super Hypan	500

Special-Purpose Black-and-White Films

NAME OF FILM	ASA NUMBER	SIZES
Kodak High Contrast Copy 5069	64 (Tungsten)	35mm/for line copying
Kodak Contrast Process Ortho 4154	100/50	4x5 sheets
Kodak Contrast Process Pan 4155	100/80	4x5 sheets
Kodak Professional Copy 4125	25/12	4x5 sheets
Kodak High Speed Infrared 4143	(See film instructions)	4x5 sheets & 35mm
Kodak Kodalith Pan 2568	6	4x5 sheets

Note: Most of special-purpose films are for various kinds of copy work, either continuous tone (half-tone) or line. High-contrast copy film in 35mm is useful when you do not wish to use a larger size, but Kodalith in 4x5 sheets offers higher contrast negatives.

conditions when you can't or don't want to add artificial light, or they are used for obvious grain effects. Eastman Kodak says in a booklet about films approximately what I said above, "Grain is usually acceptable in the type of pictures for which the film is designed." In other words, if you *need* a fast or superfast film, or must make huge enlargements that accentuate grain, it will appear appropriate to the photograph.

Fast color films show increased graininess and the same characteristics as do black-and-white films.

Some of the films listed may be hard to find except in the largest and best-supplied shops. However, products of Eastman Kodak (often called "The Great Yellow Father" because of the predominance of its yellow packing boxes) are generally stocked everywhere, and these films offer consistently excellent quality. If you cannot experiment with other brands, the handicap is minimal.

Color Sensitivity of Black-and-White Film

Films are divided into two classifications according to their sensitivity to certain light rays (or wavelengths) in the visible spectrum. (Ultraviolet at one end and infrared at the other end of the spectrum are the *invisible* wavelengths of light to which film is sensitive as well.)

Orthochromatic films. The main characteristic of orthochromatic films is insensitivity to red, which means you can develop an ortho film under a deep red light without fogging it. Except for special-purpose portrait and high-contrast ortho films, they are used infrequently by the average photographer.

Panchromatic films. "Pan" means that film is about equally sensitive to all colors. About 99½ percent of the films used by professionals and students are panchromatic.

Film Contrast

In the study and practice of photography, you hear a lot about contrast as a property of film, prints, development techniques, and media reproduction.

7 *Most films in black and white offer suitable contrast on an overcast day such as this one in Baja California. Taken about 1950 with a Rolleiflex and the fastest film of the era rated at ASA 100.*

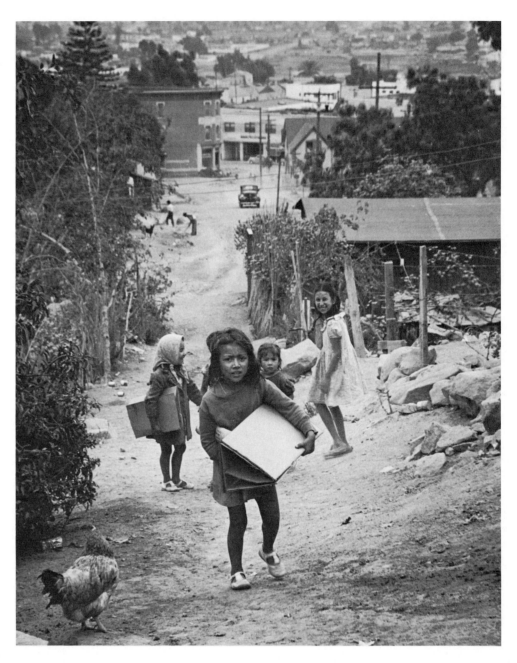

Let's begin with a few definitions for words that sometimes are confused:

Contrast. It is the *degree of difference* between the darkest tone and the lightest tone in a negative, print, or slide. The darkest tone may be black, and the lightest may be pure white, depending on the subject, lighting, exposure, and development. A scene or subject with a wide range of difference between darkest shadow and brightest highlight is said to be "contrasty." A negative or slide that reproduces such a subject is also usually contrasty.

Density. In a negative or slide density relates to the amount of developed silver (or dye) in any area, and is a measure of the "light-stopping power" of that area. Another way to put it: Density is the blackness or darkness of an area in a negative or slide that determines the amount of light that will pass through it.

Transmission. The amount of light that gets through a given negative or slide area *divided by* the total amount of light that hits that area is referred to

8 *A full range of tones depends on proper exposure and development which are part of the photographer's craft. This weathered log was taken with a 4x5 camera.*

as transmission. Thus a transmission of 85 percent means that 85 percent of the light hitting any specific part of a negative or transparency gets through it.

Opacity. This term turns transmission upside-down, and refers to the total amount of light that hits a given area *divided by* the amount of light that gets through that area. Opacity relates directly to density; the words actually describe the same thing, but are written in different ways or math formulas.

Gamma. The relative contrast in a negative *due to development* is described as gamma. In chapter 8 some of the above terminology will be tied together and more fully explained in charting film development time and temperature in relation to shadow detail and highlight detail you want to obtain in a negative.

It is easy to become tangled in terminology that describes the quality of a negative. For instance, "contrast" and "density range" may be used almost interchangeably, but there are distinctions. The density range in a negative, from the blackest to the most transparent areas, might be wide, and yet con-

trast within the scene on a print might be relatively low. In other words, the amount of light that gets through a negative may produce a high- or low-contrast print, depending on the subject, lighting, development, and density range.

Realizing that image quality in a print or slide starts with the film, but is also a product of exposure, development, and printing techniques, it sometimes seems more difficult to understand the theory than to actually shoot, process, and print pictures. The jigsaw puzzle *will* fall into place; for the moment, let's return to film characteristics.

Film Latitude

Latitude is the ability of a film to compensate—within somewhat narrow limits—for mistakes of exposure and/or development. If you over- or under-expose (and/or over- or underdevelop), negative or slide density is affected accordingly. Black-and-white film latitude allows you to make an acceptable print from a negative that is too dense, or lacking in density, by matching the negative to a grade of paper or variable-contrast filter that will produce both a good black (or the darkest tone) and a good highlight (or the whitest area).

The latitude of black-and-white films and of color *negative* films can be depended upon to a greater degree than the latitude of color transparency films. Depending on the brand of film, a one-half-stop error in color exposure may produce an acceptable slide, but one stop of over- or underexposure usually results in color that is too pale (washed out) or too dark, with degraded shadow detail.

As mentioned previously, in situations where lighting or exposure determination is tricky, you may *bracket* exposures. Starting with the exposure the meter indicates, you shoot a half-stop and a full stop on either side of it, over and under. When your technique is advanced enough, this should not be

9 *With excellent technique, modern films are still* ▶ *limited in terms of the highlight-to-shadow range they can record. Exposure here favored the highlights, which reduced shadow detail slightly. SLR camera with 50mm lens.*

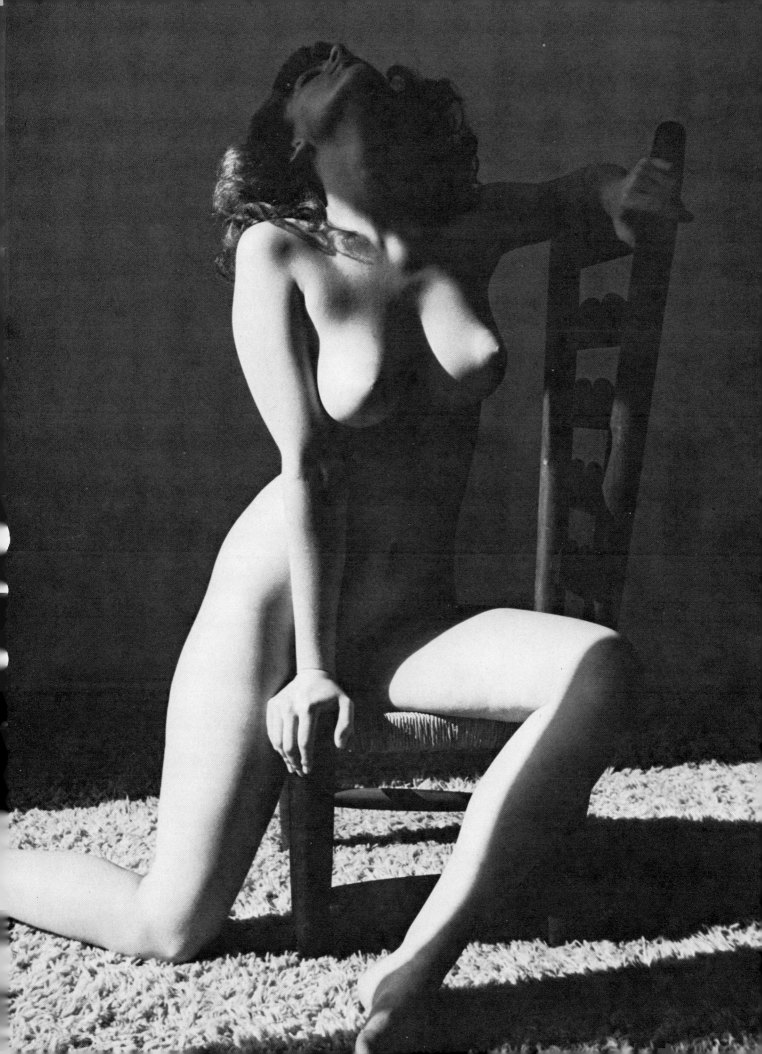

necessary often, but it can be insurance that color slides will be "right on," taking advantage of the film's latitude in the process.

It is film latitude that makes possible inexpensive cameras with few exposure controls. When negatives from such cameras are printed, inconsistencies of exposure can be rectified to some extent because of the film's ability to handle extremes of lighting and subject contrast. Film latitude can be measured sensitometrically, but not visually. You should be aware of it, but not become dependent on it, because that may lead to carelessness in exposure and development.

Graininess

Graininess has been covered previously. It should be added that graininess is influenced by film exposure and development. Both overexposure and overdevelopment boost graininess, which is another reason to work methodically.

In a fine-grain developer, fast 35mm black-and-white film can be remarkably grainless when enlarged to even an 8x10 print. However, when graininess is a consideration there are these alternatives:

Use a slow, fine-grain 35mm film

Shoot the subject with a format larger than 35mm and medium-to-slow film

In 35mm color, use Kodachrome 25 which is grainless

Use a minimum exposure and development combination that gives you a normal negative without excessive density

Beginning photographers may be overly concerned about grain. Be aware of how and why graininess shows up in negatives and slides, but don't allow worry about grain to inhibit your photography. Viewers are conditioned to understand that fast films and minimum lighting conditions result in images with more than average grain. In situations where grain is inevitable, it looks natural.

Resolving Power and Sharpness

Resolving power. This describes the ability of a film to render fine detail measured as closely spaced lines by laboratory methods, expressed in "lines per inch or millimeter." Slow, fine-grain films have higher resolving power than fast ones. Special emulsions are made especially for copy and engraving work, to resolve the greatest number of lines per millimeter.

Keep in mind that people with good vision can distinguish 150 lines per inch at the most, which is equivalent to six lines per millimeter. Therefore, if a film's resolving power is greater than the naked eye can perceive, it can be realized only in extreme enlargements. You need be concerned about this property of film only when a subject requires extreme detail.

10 Even fast black-and-white films do not show a distinctive grain pattern with enlargement to 8x10, so this portrait was printed with a "grain" texture screen for pictorial emphasis. Camera was a 35mm SLR with 100mm lens.

11 *A fast 35mm film makes excellent sharpness possible with a hand-held camera, as this portrait by Tom Carroll demonstrates. Light from a nearby window was beautifully soft.*

Sharpness. This characteristic is also known as *acutance*, and is not always directly related to a film's resolving power. Sharpness is affected by the chemical and physical properties of the emulsion, especially the thickness of its coating on the film backing. Some slow films are known as *thin-emulsion* films, and because of this, they are capable of rendering greater sharpness than faster films with heavier emulsion coating.

Film sharpness can be measured accurately only under the best of conditions. The camera must be on a tripod, the lens must be a sharp one, focusing must be accurate, and exposure and development must be exact. It is unnecessary to take the trouble to test several films, because those you can find easily are all quite satisfactory. When you must plan enlargements to poster-size, use a slow, fine-grain, thin-emulsion film.

Black-and-White Film Summary

A student should experiment with slow, medium, and fast films. Team up with two friends; each of you shoots one roll of the same subjects, using different kinds of film. Develop them according to manufacturers' directions with added advice from someone you trust who has used the same films and developers. Make comparison enlargements to stretch the limits of resolving power and sharpness of each film, but make 8x10 prints of *full negatives* as well, especially in 35mm size. If your tests are uniform, you should see the difference in film contrast in 8x10 prints, and other properties will show up in enlargements of portions of a negative. Such an exercise will give you a more vivid impression of how modern films respond than almost anything you can read about them.

MORE ABOUT COLOR FILMS

We tend to think of photographic images in color as dating from the 1930s when Kodachrome was invented by two professional musicians, Leopold Mannes and Leopold Godowsky. However, pioneer photographers such as Edward Steichen and Alfred Stieglitz, shot a more primitive form of color in the early 1900s, at which time some critics decided prematurely that color photography would give painters a real run for their money. Beginning in the 30s, black-and-white negatives were exposed through three different filters, and from these *separation negatives* (separating yellow, cyan, and magenta in a scene), a color print was made.

Mannes and Godowsky perfected a process of combining layers of emulsion in which dyes were sensitive to specific colors. During development, this transparency film is exposed to white light and reversed, so that the image we see and project is positive rather than negative. Thus there are negative color films and there are reversal films which are developed as slides or transparencies.

The various characteristics of film described before apply as well to color films with certain specific differences, primarily in their response to the spectrum and their latitude. Color negative films are made in a limited range of speeds, with similar contrast and grain characteristics. Color slide or transparency films are available in a wider range of speeds, with contrast and grain characteristics parallel to those described for black-and-white films.

Color Negative Films

Compared with black-and-white negatives, color negatives are a mystery. The colors are complementaries of those in the actual scene, and there's a color mask of light orange over the entire image. You can evaluate the density of the negative and decide if it will print well, but you cannot tell if the colors will be correct until you find the proper filters and make a print. In addition, color printing papers are available in only one contrast, which means that basic exposure and development must be good or excellent in order to assure an acceptable print. (Black-and-white printing papers offer a long range of contrasts to match negative contrast

and density.) However, as noted in chapter 12, color printing materials and techniques are much easier today than even a decade ago.

When color negatives are appropriate. Neither the average professional photographer nor the student is likely to shoot color negatives as often as black-and-white negatives or color slides. Black-and-white photography is the best basic training medium, and allows the student to learn camera, exposure, and composition techniques, with the advantage of follow-through in the darkroom to process film and make enlargements. In comparison, shooting color transparencies is excellent background for seeing and for becoming comfortable with a camera, but the follow-through steps are missing, along with some of the technical disciplines. Developing color slides is largely a mechanical operation. Printing color slides has only recently become a practical option with the introduction of Cibachrome papers and chemistry.

As a way of learning basic photographic skills, shooting color negatives lies between working with black and white and making color transparencies. Color-negative film processing is again a mechanical operation with far less opportunity for creative control than is offered by black-and-white development. Printing color negatives, as mentioned, is a skill in itself—one that can be exciting and creative, but is also exacting, and does not offer opportunities equal to working in black and white.

Making color slides from color negatives is also a laboratory procedure. It is certainly possible to handle this process in a home or school darkroom, but why bother, unless you wish to manipulate the color or the image in a way that a commercial lab would not do.

Black-and-white *prints* from color negatives are a definite plus for this material. They are almost as easy to make as prints from black-and-white negatives, and because of this, some photographers shoot color negative film in order to have a choice later for the final image. From a color negative, one can

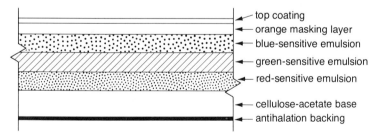

top coating
orange masking layer
blue-sensitive emulsion
green-sensitive emulsion
red-sensitive emulsion
cellulose-acetate base
antihalation backing

12 *CROSS SECTION OF NEGATIVE COLOR FILM*

Color Negative Films			
NAME	ASA RATING DAYLIGHT	ASA IN 3200K FLOOD W/80A FILTER	ASA IN 3400K FLOOD W/80B FILTER
Agfacolor CNS	80	20	25
Fuiicolor N100	100	25	32
GAF Color Print Film	80	20	25
Kodacolor II	80	20	25
Ektacolor VPS	100	25	32
Sakura Print Film	80	20	25
Eastman 5254 and 5247	100	80	80
Vericolor II 4108	100	80	80

13 *Print made from a color negative on normal variable-contrast enlarging paper with a #3 filter. Reds print darker than normal, but special paper is available for black-and-white pictures from color negatives.*

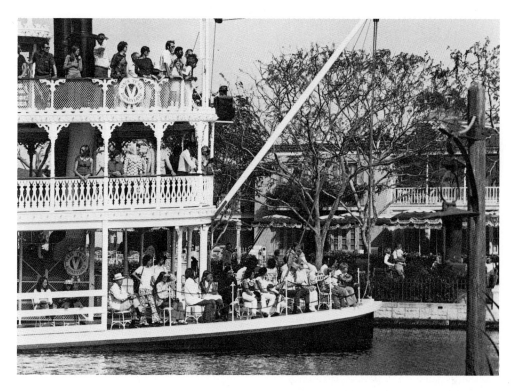

make or have made a color print or a slide, and can quickly make an acceptable black-and-white print on conventional enlarging papers, or on a special paper for this purpose.

Notes about color negative films. Kodak makes the most commonly available color negative films. The Kodacolor emulsion is used by amateur photographers in their instant-load cameras, but is also available in 35mm. The Ektacolor VPS is preferred by professionals for its slightly greater speed, and for the printing qualities of the negative. Agfacolor, GAF, Fujicolor, and Sakura are similar in characteristics to Kodacolor II.

Eastman 5254 and 5247, Kodak's commercial color negative films, are used primarily for 35mm motion pictures. In recent years various companies have purchased these films (5247 is newer), spooled them in 36-exposure cartridges, and sold them under an assortment of trade names, or merely by number. These films may be exposed at ASA 100; both are balanced for tungsten light, and need no filter indoors. In making slides or prints from negatives, the companies offering the films for sale to the public will color

correct if a filter was not used in shooting daylight pictures.

The most reliable supplier in my experience, on the West Coast at least, is RGB Color, 816 North Highland Avenue, Hollywood, California 90038. I mention these films and that outlet primarily because the cost of film, processing, and 36 slides is considerably less than shooting a slide film such as Ektachrome. In addition, you have a color negative from which to make black-and-white or color prints. Many professionals shoot 5254 or 5247 in their work or during leisure time, and many students find that they can buy more film and get more slides on a budget, which is a training advantage.

Color slides from 5254 and 5247 are made on Eastman duplicating film which has physical and color characteristics very similar to Ektachrome-X. If you shoot 5254 or 5247, you should become familiar with one or two other slide films as well for comparison. The same might be said for comparing other negative films, if color prints are the final product. The convenience of faster processing for slide films may have a bearing on the choice of 5254 or 5247 color negative films, but students should know of them, because their combined qualities are appropriate for many kinds of photography.

14 *Reflected light from a concrete deck filled the shadows of this double portrait, a situation that any type of color film can handle well.*

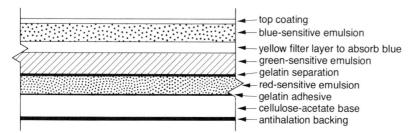

15 *CROSS-SECTION OF POSITIVE TRANSPARENCY (SLIDE) COLOR FILM*

Color Slide Films

NAME	ASA RATING	ASA IN 3200K FLOODLIGHT W/80A FILTER	ASA IN 3400K FLOODLIGHT W/80B FILTER
Daylight Slide Films			
Agfachrome 64	64	16	20
Fujichrome R100	100	25	32
GAF 64	64	16	20
GAF 200	200	50	62
GAF 500	500	125	155
Kodachrome 25	25	6	8
Kodachrome 64	64	16	20
Ektachrome-X**	64	16	20
Ektachrome Professional**	50	12	16
Ektachrome 200*	200	50	64
High Speed Ektachrome**	160	40	50
Slide Films for Artificial Light			
Kodachrome 40, Type A	40	ASA 25 in daylight w/85 filter. ASA 32 w/82A filter & 3200K light.	
Ektachrome 50*	50	ASA 40 in daylight w/85B filter. ASA 40 w/81A filter & 3400K light.	
High Speed Ektachrome, Type B**	125	ASA 80 in daylight with 85B filter. ASA 100 w/81A filter & 3400K light.	
Ektachrome 160*	160	ASA 100 in daylight w/85B filter. ASA 125 w/81A filter & 3400K light.	

Note: Kodachrome Type A balanced for 3400K floodlights; High Speed Ektachrome Type B, Ektachrome 50 and Ektachrome 160 are balanced for 3200K floodlights.

* *Available in 35mm and 120 rolls; these are latest E-6 process films.*

**To be discontinued

Color Transparency Films

The average amateur uses a negative film because it has more latitude for exposure error than a transparency film, and because color prints are more popular to show and preserve in albums. The professional may shoot color negative materials if a client requires color prints for layouts, evaluation or display, but far more jobs call for transparencies. The reason: for reproduction on a printed page in a magazine or on a billboard, better-quality color and sharpness are produced by transmitted light (light passing through a slide image) than by reflected light (light thrown back from a printed image). However, first-class color reproduction in print media is possible when prints (called "reflected art" in the trade) are superb —meaning they are also very costly.

A color slide is a "first generation" image, which means that the film exposed in the camera is projected directly on a screen, viewed on a lightbox, or reproduced in printed media. Prints from black-and-white or color negatives are "second generation," meaning one step removed from the original material exposed in the camera. Thus color fidelity is less complicated to achieve in a slide, and since slide film processing is a regimented process of chemicals, time, and temperature, shooting transparencies is valuable primarily for the original images themselves. In other words, learning to develop slide film may be useful to some photographers, but latitude for manipulation is slim, and this skill is not one a student needs to master except for specific purposes. Later we will cover techniques for printing directly from slides.

Characteristics of slide films. Kodachrome 25 is the slowest slide film, has the most inherent contrast, and accentuates warm colors. This film is grainless, and has become the standard by which other color slide films are often judged. However, its higher contrast and slow speed make it a second choice in some situations. For magazine and book reproduction, Kodachrome 25 is excellent—when light levels are adequate.

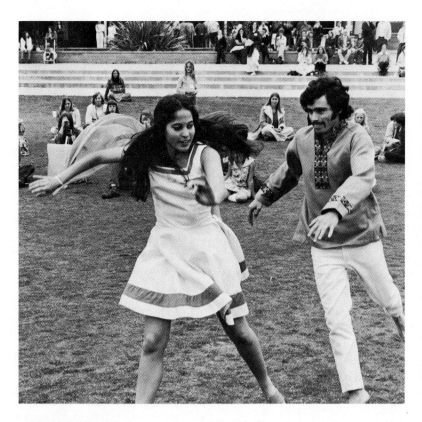

16 A fast slide film such as High Speed Ektachrome Daylight is useful to help "freeze" fast action, especially on a cloudy day. In this situation a skylight filter warms the colors pleasingly.

17 Indoors with existing light a fast film such as High Speed Ektachrome Type B (the speed of which can be boosted with special processing) may make additional light unnecessary. In this situation, electronic flash bounced from the ceiling would have been safer, but not as moody.

Kodachrome 40, Type A, has the same characteristics as K25, but is used with floodlights.

Kodachrome 64 has color properties similar to K25, but exhibits some graininess with above-average enlargement. Ektachrome-X and High Speed Ektachrome have been favorites for years, but they are being discontinued in 1977. In their place are Ektachrome 50, 64, 160, and 200, the new E-6 process films which Kodak says have "improved color reproduction of flesh tones, oranges, yellows, reds, and neutral colors. The new films also offer significantly better sharpness and finer grain for each speed range, plus improved resistance to scratching." Ektachrome 50, 64, 160, and 200 show less contrast than Kodachrome, but much more latitude to exposure variations. While Kodachrome processing requires very expensive equipment, chemical kits are available from Kodak to process all Ektachrome films in the average darkroom. This can be an advantage to save time and money if you shoot color pictures in sufficient quantity. For several rolls a month, it will be more economical to have Ektachrome processed professionally. However, the E-6 process (replacing E-3) can greatly reduce darkroom time—to 30 minutes, depending on your equipment. In addition, for the first time, all Ektachrome film sizes (35mm, 120, and sheet films) have the same emulsions, and can be developed in the same chemicals. This is of particular interest to photofinishers.

High Speed Ektachrome, and the new Ektachrome 200 are adaptable to shooting action indoors or out, and the older film can be "pushed" to ASA 400 (Daylight type) or ASA 320 (Type B) by Kodak, by custom labs, or by the photographer. It is reasonable to assume that all the new E-6 emulsions will also lend themselves to boosted ASA ratings and push processing, though precise data is not ready from Kodak as I write this. Boosting film speed accentuates grain, but is a valuable technique where light levels are low and more light cannot be added, indoors or outdoors—at dusk, for instance.

There is also a new (E-6) Ektachrome slide duplicating film 5071 with reduced contrast characteristics, and it is

available for the first time in 36-exposure cartridges. Similar earlier products were sold in bulk rolls only.

GAF films are fast, somewhat grainy, and tend toward warm tones. The contrast and color of Agfachrome 64 are closer to K25 than any other film. In addition, this film holds its warm tones in shade and shadow areas more readily than Kodak films, which show a bluish cast and require a skylight 1A filter for correction. Agfachrome 64 results are impressive, and the only drawback is having to send it to New York for processing. This affects photographers in the West and South more than those who live in the New York vicinity.

Color Film Latitude

Small errors of exposure can be handled by transparency films in general, but the latitude of positive films is less than that of negative films. When there is room for doubt, it is preferable to *overexpose* negative color films. With slide films, err toward *underexposure*, which results in reduced shadow detail but increased color saturation, another way to describe color brilliance. Some photographers rate color slide films at a higher ASA number than is recommended by the manufacturer in order to assure slight underexposure and greater color saturation. They may rate K25 at ASA 40 outdoors, and Ektachrome-X at ASA 80 or 100. I suggest you experiment with increased slide-film speeds and judge the results according to your needs. I have found in shooting Eastman 5254 and 5247 that rating it at ASA 125 rather than ASA 100 gives me color saturation I prefer, but my equipment and variations in film processing and slide printing can all affect such results. Make your own tests for awareness and satisfaction.

Color Film Storage

Negative films. Color negative films are similar to black-and-white films in terms of stability, and may be stored at room temperature, or in any cool, dry place. The exception is Varicolor II which should be refrigerated before use and processed as soon as possible afterwards.

18 When color slide film speed is boosted, grain is also increased, but this is no drawback if the picture might not otherwise have been taken. Al Paglione used a Minolta SR-T 101 to shoot the Statue of Liberty from a New Jersey waterfront viewpoint.

Slide films. These are much less stable than negative materials, and should be stored in a refrigerator almost until the time they are to be used. If refrigerated, a slide film will generally produce quite normal and acceptable color at least six months after its expiration date. Refrigerator temperatures restrict the aging of color dyes, while storage in a freezer will halt these potential changes. However, film must be removed from a refrigerator a few hours before use to avoid moisture condensation on the emulsion. Take film from a freezer 24 hours before use to allow it to thaw, because it is brittle when frozen, and could crack.

Store rolls of film in their original canisters after exposure, to protect against light leaks and humidity. When humidity is excessive, store film in canisters placed in a larger container with a top; insert a packet or two of silica gel to keep the air dry in the outer container. Avoid excessive heat as well, for it can cause distorted color before or after the film is exposed. It is quite feasible to carry fresh slide film without refrigeration on a trip that lasts several months, if the film is protected from heat and humidity, but all color film should be processed as soon as possible after exposure. This is not an ironclad rule, either, for on a European tour I carried several brands of slide film more than a month before they were processed, and no changes in color were apparent.

USE OF BULK FILM

Various 35mm black-and-white and color films are sold in bulk lengths such as 50 and 100 feet. By using a daylight film loader from which a quantity of film is rolled into a 35mm cartridge, photographers can save a considerable amount of money compared with buying film in cartridges. However, there's a catch; rolling your own film can result in scratches from various sources.

You must use new cartridges, you must keep the film exit of the bulk loader dust-free, and you must be sure that even new cartridges are spotlessly clean along the lips through which film enters and exits. If you shoot 10 or 12 rolls of a specific film in a month, the savings may be worth the risk of scratches. Otherwise, using factory-rolled film is worth the extra cost.

POLAROID LAND FILMS

For serious use beyond the Polaroid Land cameras, Models 195 and 180, Polaroid manufactures a 4x5 film holder, Model 545, which slips into any 4x5 camera, and the Model 405 pack-film holder, which fits most 4x5 cameras. There are several black-and-white films for the 545 holder, and the 405 back takes all 3¼x4¼ pack films. Several other companies make adapter backs for the Hasselblad, Bronica, Kowa 66, Rollei 66, and RB 67 cameras, using pack or roll films, and producing the same size image you see in the viewfinder.

Polacolor Film

The latest version of instant color film is called Polacolor 2 and is rated ASA 75 in daylight. It yields a full color print in 60 seconds, and is capable of both brilliance and subtlety, depending on the subject. The film can be used in artificial light with an 80A or 80B filter, but its speed is then reduced to about ASA 25. Instant color prints are very

19 *Still life was photographed with a Model 195 Polaroid Land camera and Polaroid 105 film which produces a fully developed negative in 30 seconds.*

20 *Accessory backs for Polaroid films are made for several large-format single-lens reflex cameras. Lighting and composition are previewed on instant prints.*

21 *The author's self-portrait with an inexpensive Polaroid Super Shooter loaded with Type 105 film from which a cropped enlargement was made.*

tures for more than a year, using a Model 180 camera. With this film, I have been able to save time and effort, producing instant prints and negatives that can be washed and dried, ready to print in about 30 minutes if necessary. Type 105, which is less expensive per print than 55 P/N, has numerous advantages, and the Model 405 pack-holder for it is worth serious consideration by any student using a 4x5 camera.

Another Polaroid film, Type 107, rated at ASA 3000, has the distinction of being the fastest light-sensitized material in general use. Prints from this film are full scale, and one would choose it for photography with a minimum of existing light, or extremely fast shutter speeds. Type 107 is marketed primarily for Polaroid cameras with maximum apertures of about f/8. Such a camera automatically stops down to around f/64 in bright sunlight, which gives the average amateur extraordinary depth of field along with minimum worry about accuracy of focus.

In addition to Type 55, there are other black-and-white films for 4x5 cameras, plus Type 58 Polacolor which produces excellent prints. Type 51 is a high-contrast material with very limited tones between black-and-white. It is rated at ASA 125. Type 52 is a full-scale film rated at ASA 400, and Type 57 is the superspeed ASA 3000 film.

As an aside, you may eventually use the very specialized and versatile Polaroid MP-3 or MP-4 cameras which are attached to a copy stand, include a set of lights, and adapt to 4x5 or pack films. These expensive cameras are popular in industry for recording and scientific work.

Photographic film has its own "personality," and is always dependent on exposure and development to provide optimum quality. Photographic ideas become successful images when the right film is used at the right time, after which it is skillfully processed for negatives, slides, or prints. Experiment with just those films that interest you. Then settle down to several which best suit your taste, style, and requirements.

convenient for checking lighting, color, and composition before making a conventional photograph. Reproduction in printed media is certainly possible, but as mentioned previously, transparency materials are usually preferred.

Among the black-and-white films are two of special interest to the professional and student. The 55 P/N (in 4x5 size) and the Type 105 (pack size 3¼x4¼) are both positive/negative films. With 20 and 30 seconds development respectively, you get a print and a fully developed negative that has merely to be cleared in a simple chemical solution of sodium sulfite. The tonal range of 55 P/N and Type 105 negatives is equivalent to conventional films processed in a darkroom, with the minor exception of special developing practice. I have been shooting Type 105 pic-

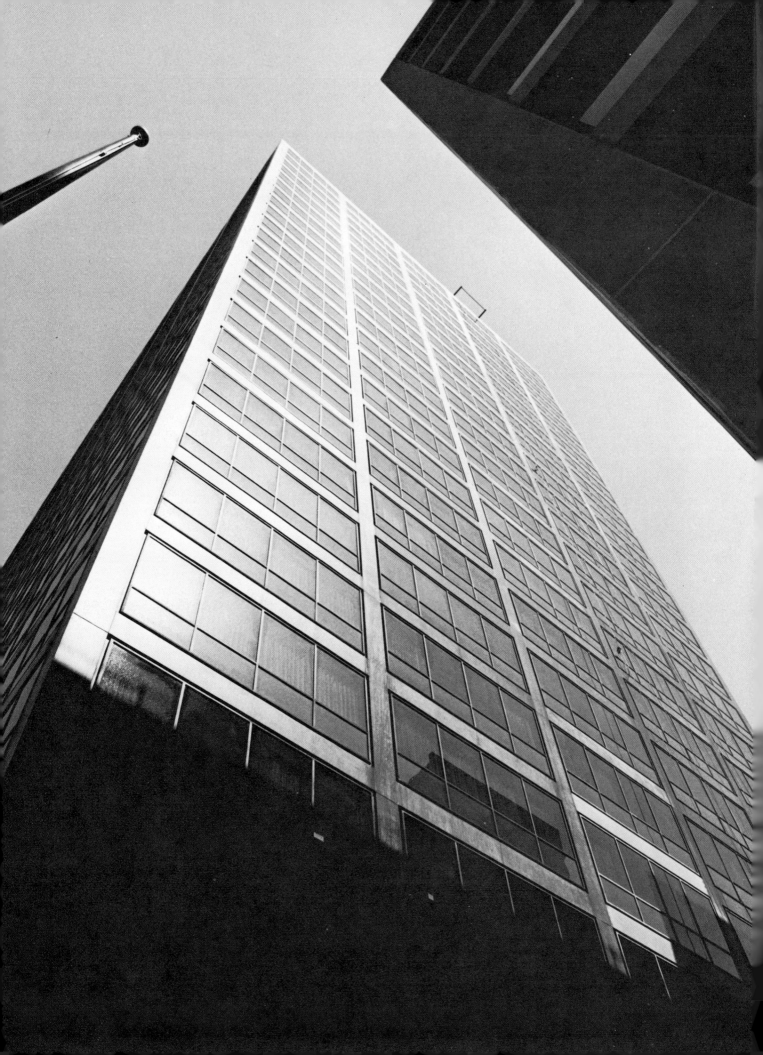

EXPOSURE TECHNIQUES

1 Most built-in exposure systems in single-lens reflex cameras will handle this situation with ease. Exposure here was automatic with Olympus OM-2, 24mm Zuiko lens, and Plus-X film.

Exposure theorics in relation to f-stops, shutter speeds, and film are explained in chapter 1. In this chapter we explore exposure as applied to practical and creative photography.

HOW AN EXPOSURE METER WORKS

An experienced photographer with an innate knack for his or her craft can guess the correct exposure for many lighting situations, and produce an excellent negative or slide. However, using an exposure meter is really safer and more consistently accurate. Most 35mm single-lens reflex cameras include a built-in meter.

An exposure meter, whether built-in or hand-held separately, operates by means of one or more light-sensitive cells. When light strikes such a cell, it generates an electrical impulse that activates a needle or set of light-emitting diodes (LED). Strong light moves the needle or LED lights into a higher range of the exposure scale, while weak light

is indicated within a lower range. There may be a simple + or − sign on the scale within a camera finder, or a series of f-stops or shutter speeds if the camera includes an automatic exposure system. Most hand-held meters use a series of numbers that the photographer translates by means of a separate dial to determine correct exposure for a specific subject and intensity of light.

Light-Sensitive Cells

Photo cells made of selenium have been in use longest. Selenium is intrinsically light-sensitive and does not require battery power, but does require a relatively large cell area for operation. Meters using a selenium cell are accurate and dependable, but are limited in their ability to measure very dim light. A number of hand-held meters use selenium cells, but this type is rarely built into cameras because of size requirements.

A later development is the cadmium

2 TYPICAL SLR BUILT-IN EXPOSURE METERING SYSTEM

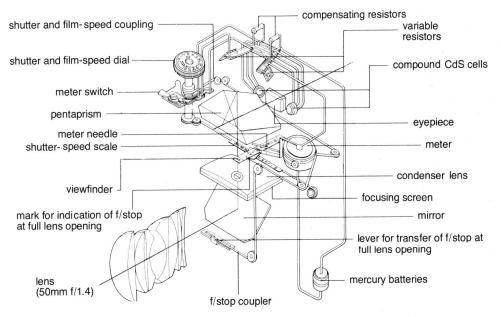

shutter and film-speed coupling
shutter and film-speed dial
meter switch
pentaprism
meter needle
shutter-speed scale
viewfinder
mark for indication of f/stop at full lens opening
lens (50mm f/1.4)
f/stop coupler

compensating resistors
variable resistors
compound CdS cells
eyepiece
meter
condenser lens
focusing screen
mirror
lever for transfer of f/stop at full lens opening
mercury batteries

3 TYPES OF EXPOSURE METERS

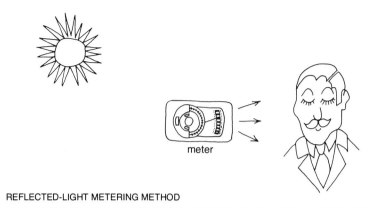

REFLECTED-LIGHT METERING METHOD

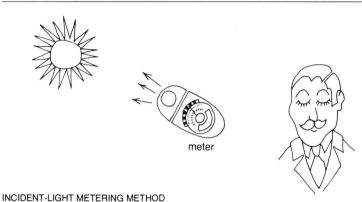

INCIDENT-LIGHT METERING METHOD

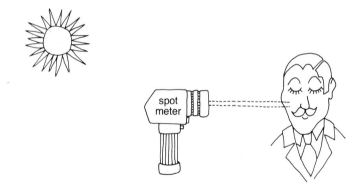

SPOT METERING METHOD

sulfide (CdS) cell which can be much smaller than the selenium type because it is battery powered. In addition, the CdS cell is far more sensitive than a selenium cell to low light levels. Most cameras with built-in meters use CdS cells either behind the lens, attached to the mirror, within the dome (SLRs), or above the lens (compact rangefinder cameras). Hand-held meters with CdS cells are also very sensitive. Some are capable of reading exposures in light levels so dim that it is difficult for the human eye to distinguish detail.

CdS cells have one disadvantage: they are prone to "go blind" for a short time after being pointed at a strong light source. This means the CdS cell is temporarily stunned, and becomes sluggish or inoperative for a minute or two after being pointed at the sun, for instance. The length of time for recovery depends on the duration of exposure and the characteristics of the meter itself.

A third type of cell is called silicon blue, which is relatively new in meters. It is slightly more sensitive than the CdS type, but does not suffer from light "blindness."

Setting a Meter

Because an exposure meter measures light intensity in the same way for any film, the meter, or the camera into which it is built, must but be set for the film-speed rating of each specific film. Once this is done, the needle or LED lights will give you the proper exposure for a scene, with the variations and exceptions discussed below.

TYPES OF EXPOSURE METERS

Meters are designed to operate in several ways; which you use depends on the camera you own and personal taste.

Reflected-Light Meters

This type of meter works by measuring the light reflected from a scene or object, and *averaging* this reading to indicate proper exposure. In other words, the meter "reads" a full scene, or a portion of a scene, depending on how close you are to the subject and the angle of receptivity of the meter. The meter then indicates an exposure that takes into account the brightest and the darkest tones, averaging them into what is known as an *18-percent gray*. Techniques for using a reflected-light meter, the type built into all SLR cameras, are explained below.

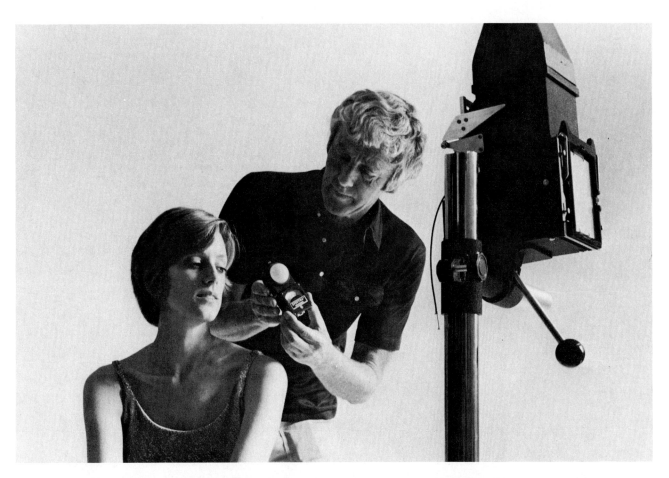

4 *In a studio with daylight illumination off-right, Peter Gowland aims his incident-light exposure meter at the light source from a position by the model's face to take a proper reading. The camera is a 4x5 twin-lens Gowland-flex, invented and manufactured by the photographer.*

Incident-Light Meters

Instead of pointing the meter at the subject as you do with a reflected-light type, you aim an incident-light meter at the light source. The meter measures the intensity of light falling on the subject, a reading that is usually taken with the meter close to the subject. An incident-light meter has a translucent dome covering the entrance to the cell. The dome "sees" light in the same pattern that the light falls on a subject, such as bright on one side where the light is strongest, and shadowed on the other side. The incident-light meter averages total light intensity rather than the specific light reflected back from the subject to the lens.

Spot Meters

This is a special type of reflected-light meter that is designed to measure only a small portion, or spot, of a scene. Most spot meters are made with a small finder which is aimed at the precise spot you wish to measure. You may determine the reflectivity for the highlight and shadow side of a face separately, from which you arrive at an average or proper exposure through experience.

Dual-Range Meters

One type of built-in camera meter is convertible for wide or narrow readings. By operating a switch, you can make an averaging reflected-light reading of the *whole* scene viewed by the lens, or a *limited portion* of that scene in the center of the image. The latter is called a "spot" reading, though it includes much more of the scene than a separate spot meter does. However, it may be helpful to aim the camera with the meter set for spot exposure to get an approximate determination of a segment of the image in relation to other areas measured individually.

5 *A reflected-light meter would be overly influenced by the window brightness in this situation, and would indicate an exposure causing the model to be too dark. Therefore an incident-light reading was more accurate.*

The other dual-range meter is hand-held, and more common. Such a meter will make reflected-light readings when the opening to the light-sensitive cell is uncovered, and incident-light measurements when a small plastic dome is shifted to cover the meter cell. Relatively inexpensive meters as well as expensive ones are manufactured to give you both kinds of exposure operation, and it is often useful to read a scene both ways, and make a comparison.

WHAT IS "IDEAL" EXPOSURE?

Remember the analogy in chapter 1 between bread being toasted and film being exposed to light? It was followed by a short list of the elements that must be accounted for—and juggled—in order to achieve "ideal" exposure. Quotes are used around *ideal* because it is often elusive, debatable, and influenced by personal taste.

A black-and-white ideal negative in-

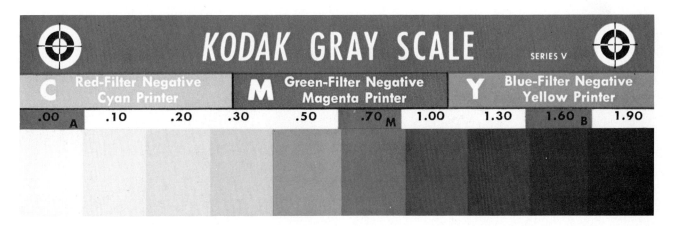

KODAK GRAY SCALE SERIES V

| C | Red-Filter Negative Cyan Printer | M | Green-Filter Negative Magenta Printer | Y | Blue-Filter Negative Yellow Printer |

| .00 A | .10 | .20 | .30 | .50 | .70 M | 1.00 | 1.30 | 1.60 B | 1.90 |

6 *Gray scale offers a consistent range from white to black for exposure reference.*

cludes as much detail as possible in both the shadow and highlight areas. The same can be said for a color negative or slide. If one chooses the proper combination of f-stop and shutter speed to suit a specific film, it would seem to follow that a camera, lens, and meter operating at peak efficiency should produce an ideal negative or slide each time the shutter release is depressed. Unfortunately, that expectation is only a dream.

The reason is easy to understand: In the real world, man-made or natural subjects are seen with a much greater range of tones than can be recorded on film. In purely hypothetical figures, with deep black at one end of the scale and brilliant white at the other, let's say there are 100 identifiable steps or tones in a scene. The best photographic film, negative or positive, may be able to precisely record only 75 of those steps. Therefore, depending on exposure, some of the tones are bunched together either in the shadow area or in the highlight area, resulting in a loss of detail.

In practice, the photographer must find a reasonable, or personal, compromise to attain his or her ideal exposure for a full-scale scene. How and where to compromise will be suggested shortly.

How an Exposure Meter "Sees"

An exposure meter is merely an instrument that requires interpretation to be used correctly. Whether it's the incident or reflected type, a meter tries to average all the tones (or hues) of a scene into what is known as an 18-percent neutral gray. You can buy an 18-percent gray card in a photo-supply shop, and many photographers use one to help achieve an average exposure. The theory is that an "average" subject reflects 18 percent of the light falling on it. Bright subjects reflect more than 18 percent, and dark subjects reflect less.

Thus a meter is designed to scan a subject and indicate the proper exposure for an average 18-percent gray scene. If the subject happens to average more than 18-percent reflectance, the meter indicates an f-stop/shutter-speed combination that results in underexposure. If the scene is darker than 18-percent gray, the meter indicates settings that result in overexposure. In effect, the meter responds to the intensity of the light and the reflectance of the subject, and then reduces both of these to a common denominator of 18 percent.

Here's a simple illustration of an exposure meter at work: Imagine four large squares in a line, edge-to-edge. One is white, one is light gray, the third is dark gray, and the last one is black. Each square reflects half or twice as much light as its neighbor; thus, white could be f/11, light gray f/8, dark gray f/5.6, and black f/4. If you take a meter reading from an 18-percent gray card and use that f-stop/shutter-speed setting to shoot the four squares, you should get proper tonality for each of them in a negative or slide, with allowances for the latitude and capacity of

7 *This is the first in a series showing exposure variations for a contrasty subject. All exposures were shot on Tri-X and developed for the same time in Microdol-X. Here, the camera meter indicated 1/250 second at f/8.*

8 *Taken moments after figure 7, exposure was 1/250 second at f/4. The print required a low-contrast filter. Shadow detail is improved with the additional two stops of exposure, but highlight detail suffers.*

9 *Meter reading for the row of books alone was 1/250 second at f/11, or one stop less than the exposure for figure 7, in which the surrounding dark area influenced the reflected-light meter built into an SLR. Reduced exposure provided improved detail in the subject.*

10 *Some minutes after figure 9 was shot, the light had shifted and was less intense. Exposure was 1/125 second at f/6.3, quite an increase over that for figure 9, but the resulting negative and print are similar in tones.*

11 *With the sun shifted there's more reflected light, but the total illumination level has dropped; exposure was 1/125 second at f/4. Exposure manipulation has its limits; it cannot substitute for "enough" light.*

12 *Later when the light is more evenly distributed, total intensity is unchanged, because exposure was identical with figure 11. The reader is urged to shoot a similar series, and keep a record of exposure data for study.*

13 *A high-key scene is often produced when snow covers the land. Carl E. Moser's winter landscape in color won a Kodak Snapshot Award.*

the film. This applies to both incident- and reflected-light meters.

However, since an incident-light meter measures only the light falling on the subject, you must decide whether the tonality of your subject is average or not. No matter where you place the incident-light meter in front of the four squares, you'll get the same reading.

This is obviously not so using a reflected-light meter, the type found in a single-lens reflex camera. If you hold the meter, or the camera with a built-in meter, in front of each square separately, you will get four different exposure settings. If you photograph each

square by itself at the f-stop/shutter-speed combination indicated for it by the meter, you will end up with four images with very similar gray tonality. The meter computes each square in terms of a *standard gray subject* of 18-percent reflectance, and signals an increase of exposure for the black and dark gray, and a decrease for white and light gray, in order to average each square to the neutral gray it is programmed to seek.

To paraphrase the above, those *high-key* subjects and scenes, that are

brighter than the average neutral gray, will be too dark in a slide and under-exposed in a negative if you expose by the meter reading for 18-percent gray. *Low-key* scenes and subjects will be too light in slides and overexposed in negatives by the neutral gray card standard.

To compensate, you compromise. Adjust your f-stop and/or shutter-speed settings to give more exposure for high-key bright subjects, and less exposure for low-key dark subjects. Techniques for compromising are covered below.

ANALYZING TONALITY AND CONTRAST

You will hear and read a lot about high-key, low-key, high-contrast, low-contrast, and average tonality in relation to lighting, films, development, and exposure. Your judgment about how to translate these terms into practice improves with experience. The photographer makes decisions all the time concerning exposure. Let's examine some typical situations.

The Range of Contrast

There are many subjects and scenes that include a variety of light and dark objects, and/or varying intensity of light, resulting in a scale of tones that may be high, medium, or low contrast.

14 Tom Carroll "exposed for the highlights," he says, meaning that he stopped down about one f-stop from the meter reading, "for full dramatic effect." He anticipated the silhouette effect as well as the bright texture of water as being strong elements of design in his picture.

The photographer needs to be aware of lighting and contrast to make sensible decisions about exposure.

High-contrast situations. The world is full of these, including snow and beach scenes, strongly sidelighted subjects with dark shadows, and places where there's bright sun on a wide range of subject tonality. At a beach the brilliance of sand and surf is at one end of the tonal scale, with dark rocks and unilluminated shadows at the other end. If there is more sand and surf in your picture than darker subjects, you must compensate by giving one-half or a full stop more exposure than the meter indicates, to avoid underexposure. If bright and dark subjects are evenly divided, you may follow the meter reading.

As an example, Tom Carroll photographed a private fishing boat from another boat, and chose to shoot into the sun for dramatic effect. His camera was loaded with Panatomic-X, and his meter reading was f/11 at 1/500 second. Tom shot at f/11 and 1/250 second, knowing that the intensity of the sun caused the meter to signal what would have been an underexposed negative. His two best frames illustrate a difference in pictorial interest, as well as the results of exposure. In one, the path of sunlight on the sea and spray is an appropriate frame for the silhouetted boat. In the other, spray from his chase boat looms up in front of the fishing boat, adding a visually exciting texture to the picture. At 1/250 second, incidentally, the passing spray blurred decoratively in the foreground.

In another high-contrast situation, photographer Jill Krementz framed author Eudora Welty in the Jackson, Mississippi room where she worked and slept. A meter reading from camera position was dominated by window light. Knowing that details outdoors would be lost, but opting for details in the room, Jill set her 28mm lens aperture at f/5.6 rather than f/11, as the meter signaled. In this way, she picked up highlight details in keeping with the lovely mood of the room. Jill might have fired a diffused electronic flash to

15 *Jill Krementz, noted for her fine photographs of authors, pictured Eudora Welty in her Jackson, Mississippi, office-bedroom at work. Jill calculated exposure for detail within the room, knowing that the outdoor scene would be overexposed and unobtrusive. Photograph © 1976 Jill Krementz.*

better illuminate dark areas and capture more outdoor detail at a smaller f-stop, but the effect would have been too obvious and synthetic to suit her quite individual type of realism.

Personal interpretation goes hand-in-hand with expert photographic technique, as these examples show. Both Carroll and Krementz gave particular attention to shadow details, allowing the sun and the window to "burn up," or become overexposed in a limited way. If however, the highlight area of a scene or subject is where you want detail to appear, you should aim your meter at that area, and expose accordingly. The entire negative or slide may exhibit minimum exposure, but you determined beforehand that shadow detail was less important than achieving well defined highlights. For just such an effect, I exposed for only highlights in the scene along the

California coast near Pismo Beach. Using Tri-X, my camera meter indicated an exposure of 1/1000 second at an aperture smaller than f/16, which is the minimum opening on the 50mm lens I used. I compensated by adding a 2X neutral density filter to reduce light intensity and allow me to expose at f/16. I was not interested in showing the separation of rocks and their shadows. I liked them as combined forms surrounded with specular highlights from the water. In such a high-contrast situation, shadow detail was not obtainable, but the effect I preferred did not call for it.

When a high-contrast negative is printed, it is possible to achieve *some* highlight and shadow detail through choice of paper or filter grades, and other manipulations. You can't do this with a color slide, so your original exposure should be carefully determined with personal taste as one criterion.

Exposure compromises. When shooting black-and-white or color *negatives*, overexposure is easier to handle while printing than is underexposure. In a compromise, lean toward a larger f-stop or slower shutter speed, knowing that overexposed highlight detail can be partially recaptured in the print. Underexposure provides too little shadow detail in a negative, and it is difficult to restore this detail in a full-scale print. All of this is covered in chapter 10.

When shooting color slide film, underexposure is preferable if compromise is necessary—just the reverse of the above. By choosing or adjusting exposure to achieve good highlight details, shadow detail may be diminished, but overall color saturation (or intensity) is often enhanced, or is at least quite acceptable. When a slide is projected, detail in the dark areas is amplified more than you expect, and the same detail can be retained on a printed page with expert reproduction.

Exposure compromise usually (but not always) involves an adjustment of one stop more or less. Half a stop is more noticeable in a color slide than it is in a negative. One-and-a-half or two stops may be required in very high-contrast scenes, such as the one Jill Krementz photographed. Later I will explain the technique of bracketing to include a range of exposures when there is time and the situation demands it.

Please keep in mind that technical guidance and your mastery of exposure are aimed at giving you the ability to personally interpret a scene or subject. First you discover how to juggle f-stops and shutter speeds in terms of pictorial detail, depth of field, subject movement, etc. Then you develop your individual taste and talent in using those techniques to create the most striking and exciting images possible. In other words, your decisions about highlight or shadow detail are responsible for photographic effects that may be stimulating and creative.

In his book *The Negative*, Ansel Adams has written extensively about exposure, and about what is called the zone system for the control of contrast.

16 *A 2X neutral-density filter and an exposure of 1/1000 second at f/16 produced a silhouette of the rocks along with an effective highlight pattern on the water in this high-contrast scene.*

In high-contrast situations, there's also an axiom to remember for black-and-white pictures: Overexpose and underdevelop. In other words, expose for the shadows and develop for the highlights. Chapter 8 explores this axiom in detail. However, unless you are shooting and developing one sheet of film at a time, or a roll in which there are almost identical contrast situations, you have to compromise. This you do on the basis of what's important, highlight or shadow detail.

17 *Average contrast was achieved through placement of the lights, and exposure was made with a reflected-light meter.*

18 *On a cloudy day full detail in the leaves was possible by using a normal reflected-light meter reading, and developing the Type 105 Polaroid film for 45 seconds instead of 30.*

This is a method of placing specific tonal areas of a scene at specific points of an exposure-meter scale, and it is well worth knowing. If you use a camera with a built-in meter exclusively, zone system exposure is not directly feasible, but you will benefit by being aware of what is happening as you adjust for exposure.

Average-contrast scenes. There are many situations in which extremes of brightness and subject reflectivity do

not strain the film's capacity. Indoors, when you can control the light, average contrast with fully detailed highlights and shadows is not difficult to achieve. My still life of glassware is an example. A spotlight at the right combined with a floodlight nearby were placed according to hand-held meter readings to provide a manageable balance between light and dark areas. The tonal scale was compressed to avoid extremes, and the exposure (with a view camera) was easy to determine.

Outdoors in subdued light, subjects with a limited range of reflectivity can be photographed by exposure readings that need little or no manipulation or compromise. This explains why an overcast or hazy day is a favorite of photographers, especially for portraits. Not only do subjects not have to squint because of bright sun, but also the range of contrast is reduced. Black-and-white and color film are able to record detail in highlights and shadows, as shown in the picture of broad leaves on a cloudy day. Though there are highlights on the leaves, they are muted. Detail of the grass in shadow is minimal but adequate. The picture was taken with a Polaroid Model 180 camera on a tripod, using Polaroid Type 105 film, which provides a well-developed negative as well as a print. When the enlargement was made, the tonal scale was not extreme and was easy to handle.

While high-contrast light is termed *hard*, medium-contrast light is called *soft*. This does not mean that the light is weak or dim. Soft light is often diffused—outdoors by clouds or other natural phenomena, and indoors usually by reflectors. Sunlight reflected from a light-colored wall, for instance, may be soft and beautiful for portraiture. At sunrise and sunset the light is usually pleasantly soft, providing average-contrast scenes that are not difficult to meter. In such a case, if you make an exposure reading for bright and dark subjects separately, the f-stop/shutter-speed settings between the two will often be about the same as an average reading of the complete scene. Film records average contrast

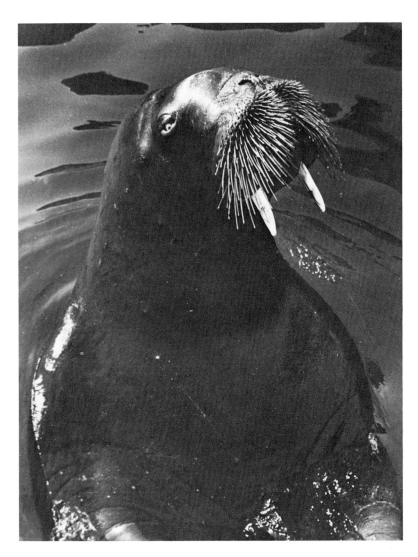

19 *A dark subject against a fairly dark background produces a low-key scene for which exposure was slightly less than normal, and development of the negative was slightly increased.*

and subject reflectivity very well, because the limits of its capacity are not strained.

Low-contrast scenes. Compared with a medium- or average-contrast scene, in which shadows are distinguishable, the light and the range of subject reflectivity in a low-contrast situation is *flat*. Such light is usually weak and indirect, causing shadows that do little to delineate form. The range from minimum highlights to shadows is short. A rainy day often produces flat light which can be subtle and pastel in color, but may require a contrast boost during black-and-white printing.

Here are some useful guidelines for exposure in low-contrast situations:

1. Underexpose and overdevelop black-and-white film. If you're shooting individual sheets of film, it's easy to segregate them. If your low-contrast subjects are on a roll of film with other types of lighting, simply expose according to the meter and develop normally. However, it may be possible to shoot an entire roll in the same flat lighting. If so, underexpose about one stop and overdevelop about 20 percent. You might even shoot half a roll for special processing, leave a few blank frames, and shoot the other half normally. In the darkroom you can cut the roll by estimating where the blank frames are, and develop each half for different times. Underexposure with extra development expands the tonal scale to give you better highlights and shadows.

2. As a compromise if low-contrast scenes cannot be processed separately, overexpose by half a stop to give highlight areas more density, and develop normally.

3. If *both* lighting and subject matter are low contrast, underexpose half a stop or a stop from the average meter indication. As an example, imagine a book with dark covers and other dark objects on a fairly dark background illuminated by window light on a gray day. In trying to bring this subject to the 18-percent gray standard, the meter will signal overexposure. A negative will be too dense and a color slide will be too light. Hence the need to underexpose.

The side of a rock cliff in Oregon, photographed on a very cloudy day, is an example of low-contrast light on a subject of almost normal contrast. Since this was made on 4x5 sheet film, I could underexpose about one stop and increase development about 20 percent to expand the scale of tones for better contrast in the print. Keep in mind that many low-contrast scenes may need exposure adjustment, but only to improve contrast on a limited basis. Chances are that you will want to maintain the low-key mood or effect, as I did with the rock wall, because it is appropriate to the situation.

20 *A wall of rocks on an overcast day was given* ▶ *one stop underexposure, and the 4x5 negative was developed about 20 percent more than normal.*

21 *Exposure bracketing with a built-in camera meter is demonstrated in this and two other pictures. The bright sky and concrete deck influenced the exposure, making the figure too dark.*

22 *Exposure reading was made with the camera a few inches from the model's dress. The result was three stops more than that for figure 21, and the scene is washed out.*

23 *Compromise exposure between that for figures 21 and 22 resulted in adequate detail. Clouds can be given additional exposure during enlargement. Bracketing variations in color or black-and-white are usually more subtle.*

MORE EXPOSURE TECHNIQUES

While a photographer in training is trying to concentrate on composition and pictorial content, problems of exposure often seem annoying. With experience comes confidence plus intuition that guides you in *feeling* that certain meter readings are odd, strange, or curious. Then you make mental computations to assist your equipment, which we know is reliable only in relation to your ability to interpret and use it.

Following are additional pointers to help you gain confidence about exposure—which you will have inevitably, I assure you.

Bracketing

This term refers to a kind of exposure insurance for situations when there is enough time to shoot several frames of the same scene at varying lens and/or shutter-speed settings. Here's how:

1. Shoot the first picture using the f-stop and shutter speed indicated by the built-in or hand-held meter; in other words, use the average exposure without manipulation.

2. Shoot at least two more frames of the same scene; one should be twice the exposure and the other half the exposure of the first. For example, if the first picture is taken at f/16 and 1/60 second, take the second picture at f/11 at 1/60 (twice) and the third at f/16 at 1/125 second (half).

3. You might also bracket on either side of the original exposure in half stops, making a total of five exposures, if you feel that additional negative or transparency quality might result.

Whether you choose to change the diaphragm opening or the shutter speed to bracket, the effect on exposure is the same. These options depend on subject movement, depth of field, film speed, and so on. It may also be useful to bracket more than one stop in either or both directions from the original exposure, if lighting or subject contrast seems to require it. Though bracketing may seem an expensive way to achieve good exposure, keep in mind that film is cheap compared with time, and many

24 *Carl Schultz gave this backlighted scene about one stop more exposure than the meter indicated to achieve more shadow detail without being concerned about full detail in the leaves. A Polaroid Model 195 camera was used with Type 105 positive/ negative Land film.*

computing exposure. Dependence on the inherent latitude of a film can lead to carelessness in technique. Since ideal exposure is more a theoretical goal than a consistent practice, be as precise as possible in interpreting an exposure meter, realizing that film latitude is there, but brain work is a lot more effective.

Handling an Exposure Meter

Speaking of brain work, a photographer can exercise a lot of exposure control in the way an exposure meter is aimed, particularly a hand-held meter. If you point a meter, hand-held or built-in, at a scene that is predominately light or dark, you should be careful not to allow the major tonality to overly influence the meter reading. As an example, don't aim the meter at a bright sky, or let the sky dominate an exposure reading, because you will get underexposure. If you are photographing a backlighted face, move close to it for an accurate exposure settings. Otherwise the light source behind the face will indicate an exposure setting for itself, and you'll have a silhouette of the face. If there are dark rocks and bright water in your scene, don't aim the meter at one or the other and use that as the overall settings. Aim the meter at water and rocks separately if possible, and determine an average by the method mentioned earlier. The manner in which you use an exposure meter is a vital part of photographic technique.

Reflected versus Incident Metering

At one time there was an ongoing debate by photographers over the merits of reflected- and incident-light meters. When 35mm single-lens reflex cameras became the most popular type for serious work, the debate subsided, because these cameras all use built-in reflected-light meters. Even so, many photographers carry a separate exposure meter to check various lighting and contrast situations after, or instead of, determining exposure through the camera lens.

Champions of reflected-light meters say this method is better because the

photographic opportunities cannot be repeated. Some of the best professional photographers habitually bracket exposures in planned situations, in order to have a choice of slides or negatives. It's really an economical way to "buy" insurance.

Film Latitude

As discussed in chapter 5, film latitude refers to the ability of a film to compensate for exposure errors—to be improperly exposed and still provide an acceptable negative or slide. Though you should be aware of this characteristic, it is wise not to count on it when

25 *William Buckley used an incident-light meter in front of the model for proper exposure compensation for dark background. Linhof Super Technika IV view camera with Polaroid 405 Pack Film Holder and Type 105 film.*

reflectivity of subject matter varies greatly, and it is best to read both bright and dark objects separately, and then decide on the correct exposure.

Partisans of incident-light meters claim that the intensity of light is more important to measure, and reflectivity of subject matter comes afterward.

Most photographers who prefer a hand-held meter (rather than one built into the camera), use one that offers both incident- and reflected-light readings which they may compare in an effort to find proper exposure.

Really ardent photographers carry an 18-percent gray card, and hold it at an angle parallel with a scene or subject in order to make a reflected-light reading. Kodak sells gray cards and gray scales on which are a graded series of tones for exposure-testing purposes. If you need a standard of comparison while you learn, by all means try a gray card. However, the average person learns to use today's excellent equipment efficiently through experience. Exposure is determined by using the built-in camera meter or a hand-held meter, but using both in my opinion is unnecessary. The same can be said for using a gray card, except in instructional situations.

Taking pictures is the goal of the trained photographer. The least amount of equipment and the fewest number of steps to assure good exposure free the hands and the mind to concentrate on the *content* of each exposure. What you see, how perceptive you are, how agile and imaginative and excited you get— these are important. If one meter together with experience in mentally manipulating what the meter indicates can result in consistently good exposures, no other tools are needed.

Years ago I used only a hand-held reflected-light meter. When I bought my first SLR with a built-in meter, I carried the separate one for months to double check. Eventually, I discovered I was gaining little, and the built-in meter was quite adequate, so I put the separate meter away. I work as lightly as possible. I trust my equipment, I keep it in good shape, and I know its

26–27 Ideal exposure for figure 26 would be slightly more than normal, with reduced development if feasible. Figure 27 called for normal exposure and development. Variations are based on built-in camera meter readings. Some automatic-exposure cameras include an exposure compensation dial.

quirks and my own. I make exposure mistakes, of course, but mostly because I am in a hurry and careless. If I take my time, or if I choose to bracket, my built-in meter is just fine with no outside help but my own awareness in using it.

Exposure and Film Development

Except for Kodachrome, which is always developed by an automated process that is never altered, film development is closely related to ideal exposure. This has been mentioned in the material preceding; but for now, assume that film development is normal except when otherwise indicated. Exposure manipulations may be made independently of film development, or along with it. It is usually impractical to manipulate roll-film development time when a variety of picture situations are included on a single roll.

Reciprocity Failure

Color slide films in particular, and black-and-white and color negative films to some extent, tend to lose some of their sensitivity to light during exposures longer than about five seconds, or shorter than 1/1000 second. This is called *reciprocity failure* (or reciprocity departure), and the physical reasons for it are somewhat obscure. Loss of film speed varies with different types of film, and in the printed sheets that accompany rolls or boxes of film most manufacturers recommend a reciprocity factor number for very long and very short exposures. You will find, for instance, that one color negative film is labeled "L" for long exposures, and another "S" for short ones.

Reciprocity failure affects not only the speed of color slide films, but the color balance as well. Therefore, it may be necessary to give additional exposure by using the factor number, and to use color-compensating filters to correct for the color shift involved. When making long time exposures (or very

short exposures with electronic flash) using any type of film, be sure to check the data sheet with the film for the manufacturer's recommendations. For instance, a 20-second time exposure may require a reciprocity factor of 2, which means you must expose for 40 seconds, or open the aperture one stop.

Reciprocity failure is also involved in shooting close-ups, when the distance from lens to film is extended beyond the normal focal range of a camera. This is discussed in chapter 12.

Making Exposure Tests

We learn from mistakes as well as successes, and both can be experienced in an organized way through a series of exposure exercises or tests. Here are some suggestions:

1. Choose an outdoor scene of normal contrast. Set your camera on a tripod, and using a normal lens (or one you use often), make an average exposure reading. Take a picture at that precise f-stop and shutter speed.

2. In the same light from the same spot, bracket your exposures by full stops in black and white or half stops in color, on both sides of the average exposure. Over- and underexpose at least one frame each by one, two, three, and four stops from average. Keep written exposure records.

3. When color slides are processed, project and compare them. Note the effect of each half stop more and less exposure for the scene of normal contrast. If you have the time and inclination, make the same test of a high-contrast and a low-contrast scene. Observing the steps of difference in your pictures will have lasting value as you contemplate exposure thereafter.

4. Develop black-and-white or color negatives normally. Make a print from each of the frames of your test at the same exposure time on the same normal grade of paper (or with the same normal variable contrast filter), and develop each picture for the same length of time. Again you will have a vivid comparison series, showing how exposure influences a variety of high-, average-, and low-contrast subjects.

5. Make a separate series of bracketed exposures with a reflected-light meter reading (in the camera or separate), and by an incident-light reading, all of the same subject, from the same camera-on-tripod position. Again, keep a written record of exposures by frame number, indicating which was the average exposure from which your tests varied. Compare results by projecting slides or making prints uniformly, as directed above. Analyze the characteristics of each metering method according to the type of light and the subject contrast.

6. Note how much over- and underexposure is acceptable in color slides, after you have chosen one that you consider an ideal exposure for that situation. If you bracketed by half stops, the differences may not be very apparent until exposure was increased or decreased by a full stop. The type of film, subject, and lighting are all involved, however, and no universal rule is possible.

7. As you print a negative series, you will discover how much over- or underexposure is manageable by choosing the paper grade or filter required to achieve tonality as close as possible to that of the ideal negative.

From this controlled series on which you have recorded exposure data, you will consciously and unconsciously benefit. You may want to wait on the above series until you have read chapter 10, unless you are already grounded in printing techniques. As you shoot controlled exposure tests, keep in mind that in effect you are adjusting film speed by over- or underexposing. Later, when backlighting is discussed, dividing the normal film-speed rating in half is recommended. At that time, you should already be aware of the effects of such procedures.

28–31 Exposure settings are often closely tied to ▶ subject movement as demonstrated in this series. Beginning with figure 28, shutter speed was increased as follows: 1/30, 1/60, 1/125, and 1/250 second. The SLR camera was hand-held, and aperture settings were changed in each case. The texture of fast-flowing water is seen in different aspects.

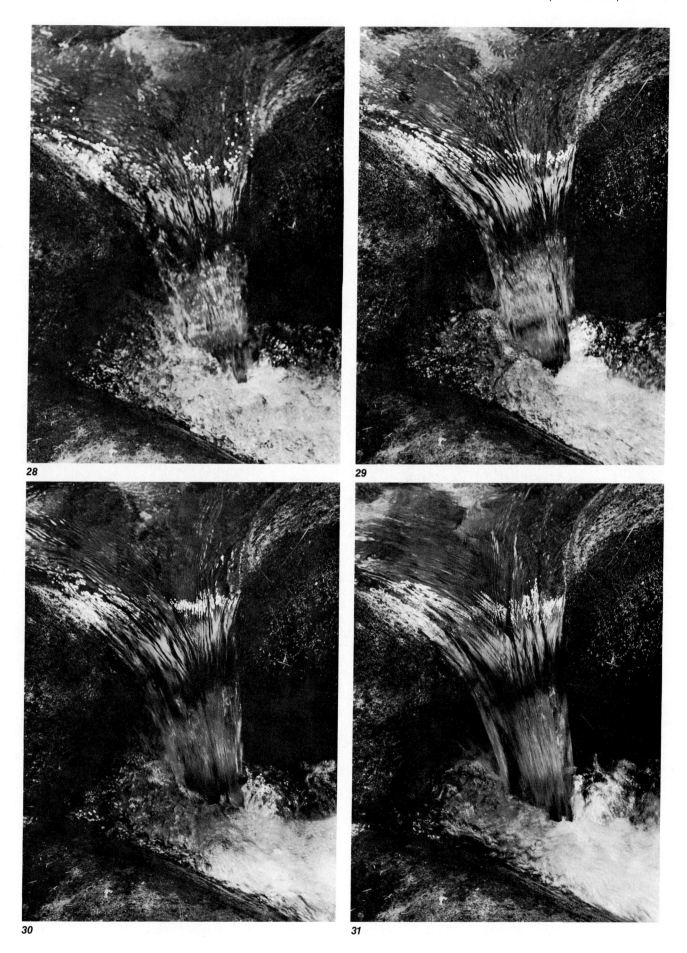

28

29

30

31

32 *Long exposures should be bracketed, especially at night. Tom Carroll used a 21mm lens at f/8, and exposed for one, two, and four seconds. The print from the two-second negative is shown here.*

SUMMARY

With proper exposure, the inherent contrast of a scene or subject may be photographed to appear very close to actuality in a print or slide. The appearance of contrast may also be altered by exposure manipulation and/or film processing. In many situations the photographer has exposure choices that serve to influence his or her interpretation of the scene or subject.

High-contrast subjects are more frequently found than low-contrast ones. A compromise exposure will aim to retain highlight detail in color slides, and will usually favor shadow detail in black-and-white or color negatives. By experience you become familiar with the capacity of certain films, with processing manipulation, and therefore with exposure options.

The type and intensity of the light *and* the contrast range of the scene or subject must both be considered in making exposure decisions. Your goal is to *compress* the range of contrast when it is extreme, and *expand* it when the range is short.

Exposure is subjective and objective as well. Your personal feelings about a subject are important in making exposure decisions. If you visualize a print or slide before you shoot, this effort can help you immeasurably to determine an f-stop and shutter-speed combination to make "ideal" exposure more of a predictable reality.

1 *Light is the photographer's medium, creating beauty, clarity, mystery, and many other moods. Seldom is light as subtle as in this landscape by Steve Crouch, who combines expert technique with outstanding vision.*

ABOUT LIGHT

In an oversimplified introduction to light, the word that makes life—and photography—possible, consider the three P's:

1. *Poetic*, the way some types of light make you feel.

2. *Physical*, the scientific aspects of light in which the electromagnetic spectrum of energy plays a dynamic role. All light is included according to wavelengths in this spectrum. We are primarily interested in the visible spectrum as experienced in a rainbow, in the effects of colored light, and in the color temperature of light. Physics is a fascinating subject, but we don't need much technical depth in the field to take pictures well.

3. *Practical*, the really important approach to light, and the emphasis of this chapter. Photographers must be aware of what light does to form and to film. With experience, this awareness gives you a sensitivity to light that is comparable to the musician's "ear" for sound, or the writer's instinctive feeling about words.

No matter what the source of light may be for photography, from a tiny flashcube to the sun itself, *applied* lighting (floods, flash, or any source that one can manipulate) is predictable. *Ambient* lighting, that which occurs naturally in any location, can be analyzed using the principles of applied lighting, in order to give the photographer better control in taking pictures. In other words, as you learn to handle lighting in a studio, you are preparing yourself to recognize and influence all types of lighting, because the effects of light on form and color are universal.

LIGHTING PRACTICE

In the last chapter we considered the intensity or brightness of light as it relates to exposure. Here we will be concerned with the *direction* of light as it falls on a form or face. Later in this chapter we will discuss the *sources* of light, such as sunlight, window light, floodlight, light from flash units, and even candlelight.

Outdoors we observe and photograph the effects of light on fields, mountains, rivers, buildings, people, and innumerable other objects. Indoors, we take pictures of furniture, still life, and especially people. Some form of portraiture is required of most photographers; fortunately the human face and head serve perfectly to demonstrate the ways that light coming from various directions changes the appearance of a form. Therefore, a model is the subject

2 *It is misleading to think that photographing an egg with one light is a simple matter. In his middle years, Edward Steichen photographed a cup and saucer many times, exploring light, form, and technique.*

for the lighting exercises that follow. Inanimate objects have also been photographed with the same lighting, to demonstrate the predictability I mentioned.

Light from Many Directions

For the exercises illustrated and described here, a simple and basic setup was used.

Background. The background was a plain off-white wall of the author's living room.

Light sources. Light sources were three floodlights consisting of 500-watt reflectorflood bulbs in sockets attached to clamps, three folding light stands, ond one 36-inch Reflectasol umbrella reflector. Complete data about this equipment are included later in this chapter.

Model placement. The model was seated on a stool with a low back that would not show in the pictures.

Camera. The camera used was a 35mm single-lens reflex equipped with a 65–135mm zoom lens that made it easy to change image size without moving the tripod on which the camera was mounted. The normal 50mm lens on a 35mm camera can be used for portraits, but a longer-focal-length lens is preferable because its angle of view is generally more flattering to a face. A focal length such as 85mm, 100mm, 105mm, or 135mm helps you keep a comfortable distance from the subject, and also diminishes distortion. A person's nose and chin will tend to jut forward in proportion to the rest of the face when a short-focal-length lens is used. The zoom lens for these exercises was varied between 85mm and 120mm.

Details and variations of each lighting setup are covered below. Notice how changes in the direction of the light(s), the number of lights, and the tonality of the background affect the model's appearance as well as the mood of the portraits. Photography students should be familiar with such a series of exercises. A feeling for the placement of lights, and the quality of the light itself, is continuously useful for all subjects, whether the light is under your control or not. Based on what you learned from indoor lighting practice, you might wait for the sun to move, choose a different camera angle, or ask a model to move outdoors. In a way, it's like learning to play scales on a musical instrument, after which you can go on to advanced compositions.

Front light (figures 3 and 3A). One floodlight was positioned as close as possible to the camera. It is easy to place a light source when a face is the subject, because the nose becomes a sort of "sundial." There's just a wisp of shadow under the left side of the nose in this photograph, but you know the light was not dead center because of the shadow at the left.

Front light flattens form. Shadows, which accent form, are at a minimum. Flash-on-camera creates this type of front lighting, and while it is sometimes expedient, it is rarely commendable. News photographers often must use their flash attached to the camera to capture fleeting subjects when time is limited. The skillful photographer often detaches the flash and holds it above the camera to avoid flat front lighting, as in figure 10. Another antidote to flash-on-camera is to bounce (reflect) the light against a ceiling, as noted later in more detail.

Notice also in the front-lighted still life (figure 3A) that the contours and holes within the larger form are poorly separated from the total shape. It is often a basic goal of lighting to *separate* one form from another, in order to see each more clearly, or to create an artistic effect. By the placement of light, by choice of lens and camera angle, or by selection of ambient light that is suitable, separation of shapes and colors is within the photographer's control. All of this will seem much less academic once you have completed exercises in lighting.

3

3-a

4

4-a

Front light plus background light (figures 4 and 4A). The floodlight beside the camera is positioned precisely as it was in figure 3. However, another light illuminates the background and allows us to see the model's head more clearly. It also reflects a slight highlight at the back of her jaw at the left. No longer is the front, or main, light casting a "pasted-on" shadow. The effect is improved, but hardly comparable to more flattering placement of the lights, which follows.

To achieve this more acceptable kind of front light on location, find a brightly lighted background, or position the model in front of a window partly diffused by a translucent drape or blind. In any case, if the model is far enough from the background, the shadow of a front light might be dissipated, particularly when the light is raised and the shadow falls lower behind the subject.

5

5-a

6

6-a

Bottom light (figures 5 and 5A). The floodlight is several feet below the camera lens, aimed up at the model's face. It is still slightly to the right of center, as you can see by the position of the shadow on the nose and the wall. This type of lighting is usually reserved for bizarre effects, and is sometimes used to make individuals (such as alleged criminals) look suspicious. Bottom light may be useful to accent some forms of still life, but is not recommended for portraits except as an occasional accent light.

Bottom light with background light (figures 6 and 6A). The main light has not been moved from its place in figure 5, but the addition of a background light helps to make the model look less sinister. In a situation where people are photographed over a lighted viewing table, this type of light might give a picture distinction, but it always has unfavorable connotations.

7

7-a

Sidelight (figures 7 and 7A). The same floodlight is now about four feet from the right side of the model's face, at a level with her head. Sidelighting, often found outdoors at sunrise or sunset, can be very useful for some subjects, including portraits, because it is generally dramatic. Though the face is divided down the middle, such an effect may be interesting, and can usually be improved by the addition of another light to "fill" the shadows. (See figure 9 for an example of fill-light usage.) Sidelighted buildings, mountains, and other natural forms are often worth looking for photographically.

8

Sidelight with background light (figure 8). A portion of light "spilled" onto the background in figure 7, but in this picture the model's head is much better separated from the wall. Again, a slight highlight appears on her jaw at the left, and the additional light very faintly illuminates the shadow side of her face, but this will not be noticeable in the reproduction.

9-a

Sidelight with background light plus fill light (figures 9 and 9A). The position of lights in figure 6 is unchanged, but a third light, reflected into an umbrella about three feet from the model's face illuminates or fills the shadow side. Though this effect is not flattering, the girl's features are more distinct, while shadows are minimized.

In each example of this exercise, the main or key light position is dominant, while the secondary or fill light is placed to illuminate shadows or produce highlight accents. It follows that the fill light must be less intense than the main light. If both lights were of equal intensity, the effect would be flat, or conflicting shadows would be created.

The relationship between the highlight and shadow illumination is called the lighting *ratio.* A ratio of 2:1 means the highlights are twice the intensity of the shadows, a soft ratio. A ratio of 3:1 is pleasant for portraits, and higher ratios (such as 6:1) indicate relatively dark shadows. For my purposes, I have not tried to specify lighting ratios for specific pictures, though they can be obtained by individual meter readings of highlight and shadow areas. Judging light-and-shadow balance *visually* is a more satisfactory method.

Therefore, in basic lighting practice, the fill light is either farther from the subject than the main light, or it is less intense by reason of its wattage or the fact that it is reflected. Even if the fill light is aimed from a position next to the lens (when the main light comes from a different angle), two sets of shadows are noticeable. Under or beside the nose and around the eyes, these double shadows are easily seen. This conflict can be avoided by reflecting the fill light from an umbrella or other light-colored surface. Reflected light casts soft shadows, and in many portrait situations, both the main and the fill lights are reflected for a more pleasing effect.

Direct a key light at a model, and shift a direct fill light around to become more aware of multiple shadows that may "chop up" a face. Experiment at the same time with one direct and one reflected light, varying their distance from the subject. By moving a light just a few inches, the appearance of a face can be improved, or distracting shadows may be cast. As you learn the subtleties of lighting that result from the direction, intensity, and type of illumination used, your photographic technique becomes more satisfying and professional.

10

10-a

Top light (figures 10 and 10A). The main floodlight here is directly above the camera about three feet from the subject. It is far back enough to prevent the eyes from becoming dark sockets with little detail, but the heavy shadow "hanging" under the nose and chin are unpleasant. Some of the light has brightened the background, which is not illuminated separately.

Top light is common anywhere that lighting fixtures are in or on the ceiling of a room or office or when the summer sun is overhead during the noon hours. When the room is large and there are few reflecting surfaces to fill the shadows, it is practical to add a reflected light to brighten faces. A small bounced electronic flash is useful for this purpose, and an example is shown later.

11

Top light—variation (figure 11). The single floodlight has been moved close to the model to illustrate how awkward it is when the nose shadow and top lip almost touch. Note that the eye sockets are also darker, which is typical of overhead lighting.

12

13 *Top light is often functional to bring out form in sculpture. Fill light at right and some background light were reflected to help define the form. The camera was a Bronica with a 135mm lens.*

Top light with fill and background lights (figure 12). Even with a soft reflected fill light from the left, and another light on the background, the effect is still rather harsh; top lighting is not a favorite for portraiture. However, the same arrangement of lights is often excellent when photographing sculpture or other small objects with definite indentations that help define

the entire form. In figure 13, note the dark shadow at the base of the piece, indicating the main light was above, with a fill light at the right.

Forty-five degree light (figures 14 and 14A). As soon as the main light is shifted into the area between the front and the side, it is usually more suitable for portraits, and still lifes as well. Of course, the shadows here are too dark, but the form of the face is more interesting, or better revealed, than in previous lighting examples. The term "45 degree" is not meant literally, but represents an angled position above the model's eye level. Decades ago portraits of movie stars were lighted with a similar nose shadow, and the style was known as "Paramount lighting." Probably someone at Paramount Studios was the innovator.

Forty-five degree light with fill and background lights (figures 15 and 15A). The umbrella reflector served to fill the shadows which are now pleasantly soft. This photograph would be an acceptable portrait, except for the straight-front pose of the model. An angled variation is shown in figure 18.

Backlight (figures 16 and 16A). One floodlight is placed left of center behind the model. Some light spills on the background, and a slight amount is reflected into her face from surrounding walls. Without fill light, the effect is a silhouette.

Backlight is usually used as an accent in portraiture, but numerous subjects and scenes benefit from the drama this type of ambient light creates. A number of backlighting examples are distributed throughout this book, because it is so important to photography. Still-life arrangements of food and small objects usually have a backlight as the main source, with other lights to illuminate shadows.

Imagine Tom Carroll's photograph (figure 17) of the kids wading through a pond lighted from the front. Form would be indistinct and perspective flattened. Lighted from the side, the figures would have separated nicely from the background, but the terrain is flat, and would not have been very exciting. However, with the sun at left

14

14-a

15

15-a

16

16-a

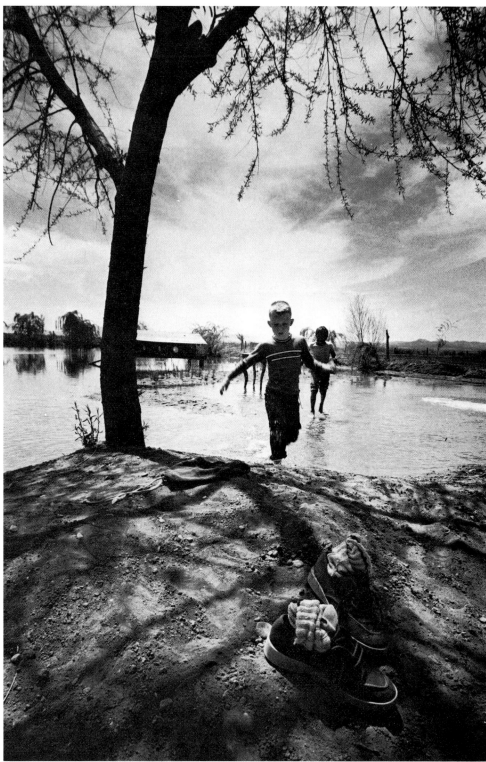

17

front and out of the picture, the tree branch shadows make the foreground interesting along with the sneakers, and the children stand out distinctly against the landscape. Tom used a 21mm lens on a 35mm camera for complete sharpness from foreground to infinity, and he gave the scene one stop of exposure more than his meter reading, to get shadow detail. Back-lighting gives a rather ordinary setting additional visual appeal.

18

18-a

Backlight with fill light (figures 18 and 18A). An umbrella reflector, which appears as a white accent dot in the model's eyes, was positioned as close to the camera lens as possible. It should be apparent that this fill light was on the left by noting the shadow side of the nose. The fill light is really the main light here, and as you will see, there are better ways to pose the model in relation to the beautiful potential of reflected illumination.

19

Forty-five-degree light—variation (figure 19). A short sequence begins here with the main light above and to the right of the model whose face is turned in what will become a more interesting pose than looking straight into the lens. Compare this with figure 14; only the pose is different, including a slight turn of the torso to the right.

20

20-a

Forty-five-degree light with fill light and backlight (figures 20 and 20A). Again the umbrella reflector was added to brighten the shadows, while a third light from the left in back puts highlight accents on the model's hair and cheek. If you wonder what happened to the dark shadow on the shoulder seen in figure 19, the backlight wiped it out completely. This is closer to appropriate portrait lighting than anything previously illustrated, because shadows are under control and features are seen pleasantly.

Forty-five-degree light with fill light, backlight, and background light (figure 21). Only the background light was added to the arrangement in figure 20, but the contrast and separation it provides improves the portrait considerably. A light-colored background for portraits is often useful, but background tonality and contrast is often suggested by the mood and the subject.

21

Reflected main light (figure 22). Though the pose is the same as in figure 21, the reflected light from the left now dominates, while the direct 45-degree light is gone. The backlight for accent remains, but there's no light on the background; highlights are thus more apparent. The results of using a reflected main light are more flattering than the effect observed in figure 20. Direct light, sometimes diffused by translucent materials, may be most ap-

22

23

23-a

propriate for some types of portraits, of men in particular, but indirect, reflected light is usually preferable.

Reflected main-light variations (figures 23, 23A, 24, and 25). As further evidence that reflected light is beautiful, the model is turned at more of an angle than in figure 22, and the umbrella light is used alone in figure 23. A background light was added in figure 24 for better separation. The same arrangement of lights was used for figure 25, but the model's head was turned toward the camera lens. The last two in this series were the favorites of the model, though all the pictures were taken as lighting examples and not specifically for her.

Light as an Expressive Tool

The foregoing illustrations are basic variations of applied lighting, also found in natural or existing circumstances. It is good to know *how* a picture is lighted, or to be visually responsive to the light in a scene, but it is more important to know *why* the lighting is successful or not. Each individual may follow the principles and techniques discussed, but each will come up with emphasis or sensitivity based on personal taste and the dictates of the subject.

The direction of light, the balance, and the type of light source you choose

24

25

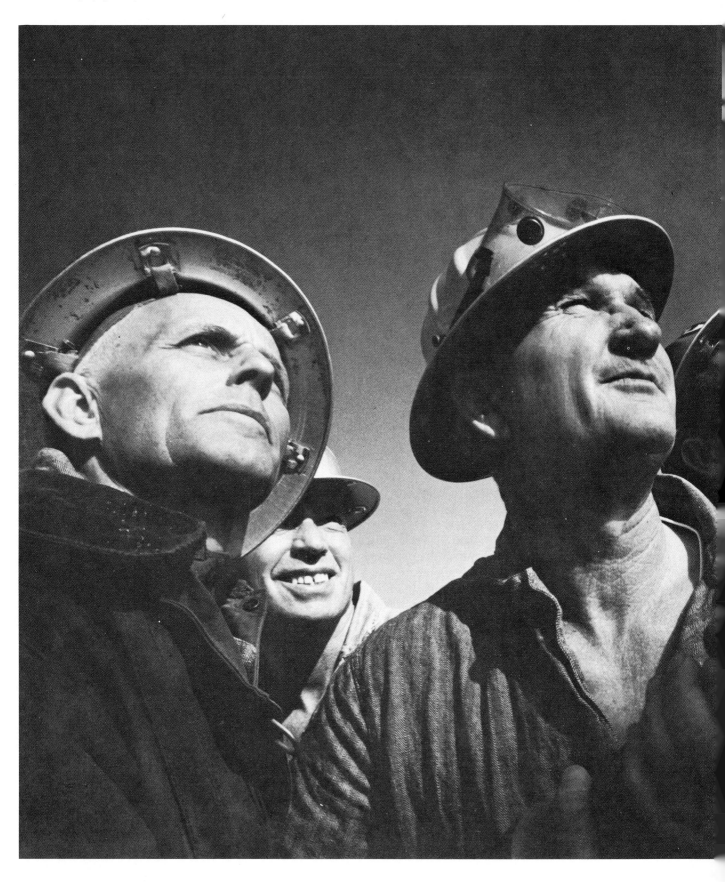

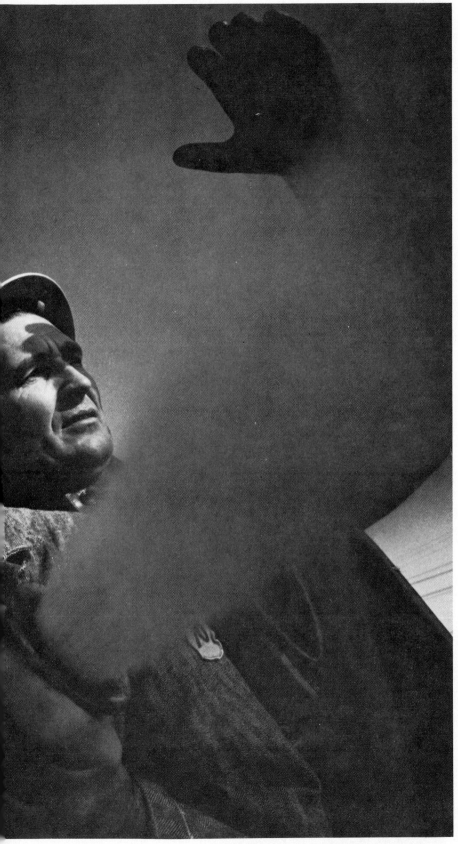

all combine to represent your own *quality* of lighting. For portraits it may be soft and mellow, and for small objects or certain scenics, it could be strong and dramatic. These are characteristics of good lighting, not formulas. Just as a creative cook interprets a recipe, a creative photographer sees a lighting effect and captures it, or arranges light sources for functional and aesthetic reasons filtered by knowledge and personality.

There are photographers who are known as masters of light, such as Phillippe Halsman, Gjon Mili, and Edward Weston. Most fine photographers *recognize* beautiful and effective lighting, while others equally skilled apply lighting with visual impact. As you study the work of outstanding photographers, consciously analyze the light with which they chose to make images. With practice—and mistakes—plus such observations, your confidence will increase. Lighting will become more intrinsic, and less a barrier to cross.

AMBIENT LIGHTING

We will return to applied lighting later in discussing flash techniques, but while the emphasis on the direction of light is fresh in your mind, I want to relate it to ambient, or existing, light situations.

It is not always possible to say for sure whether light is applied or existing. This is especially true for some kinds of environmental portraits, because reflected or diffused flash or floodlighting can be designed to imitate the natural light from windows or other sources. However, in the following examples the kind of existing light is usually apparent.

Top front light (figure 27). Every directional aspect of light shown in the portrait demonstration is merely an imitation of the sun. Look at the shadows on this antique house, and you will recognize that the sun is high overhead and slightly to the right of center. The forms, textures, and tonality of the house and surroundings are clearly

26 *Both the upward camera angle and the sculptural quality of the sunlight contribute to impact in Tom Carroll's photograph of oil refinery fire fighters. It was taken with a 21mm lens on a Leica.*

27 *High angle of the sun accents form and texture here. The camera was a Konica Auto S3 compact rangefinder model with a 38mm lens.*

28 *Low side lighting is essential for sand dunes and other landscape situations where shadows are expressive.*

seen in a quality of light that is acceptable, if not ideal.

That's the crux of natural, existing, or ambient light, whichever you care to call it; it does not always come from precisely the direction you want for a specific subject. It may be too harsh and high-contrast at one time, and too soft and shadowless at another. It is often too weak or too intense, or the sun sets too soon, or fails to show itself behind banks of clouds in early morning when you want it. The latter situation happened to me some years ago after I drove all night to be ready for early morning sun on the massive sand dunes of Death Valley. The morning was overcast until the sun was too high in the sky to show the dune patterns well.

Despite the misfortunes of natural lighting that photographers have to put up with, frequently the light is desirable, dramatic, and exciting or at least appropriate. Sometimes serendipity takes a hand. On other occasions you wait out the sun, clouds, or rain until the light improves.

Sidelighting (figure 28.) A travel photographer I know schedules nearly all the important shots of places he visits either during the first hour after sunrise or from an hour before sunset until the dusk is too deep to see through. This type of sidelighting is a favorite of all scenic photographers because of the way it shows form, and for the warm glow it adds to color pictures. Even if you use a slow film and must mount your camera on a tripod for longer-than-average exposures, sidelighting with its long shadows is usually an asset. During the winter in the Northern Hemisphere, the sun reaches only half as high in the sky as it does in summer, and this sort of sidelight can also be exploited.

The Death Valley view was taken late in the day, and dune shadows were even more pronounced as the sun went down further. The wind-blown sand texture in the foreground is obliterated when the sun is high, and one dune fades into another unless there are shadows to separate them.

29 *Mt. Everest by Norman Dyhrenfurth.*

Figure 29 is another example of sidelighting taken in a very esoteric location by Norman Dyhrenfurth. He led a party up the side of Mt. Everest some years ago, and this shot shows one of the base camps from which they climbed. The terrain is well defined in this light, but the very dark sky was not the result of using a red filter as it might have been near sea level. The atmosphere is so clear at 20,000 feet and higher that the blue of the sky is deeper, and because of Norman's minimal exposure for the snow, the sky appears dramatically dark.

Sidelighted portrait (figure 30). Tom Carroll, using a 135mm lens on his 35mm camera, knew the subject's face and hat would be surrounded with black when he photographed a writer beside an open door. Tom wanted to show the strong character features of the face; in this interpretive portrait, more balanced lighting is unnecessary.

30 *Strong side lighting and dramatic contrast created by Tom Carroll.*

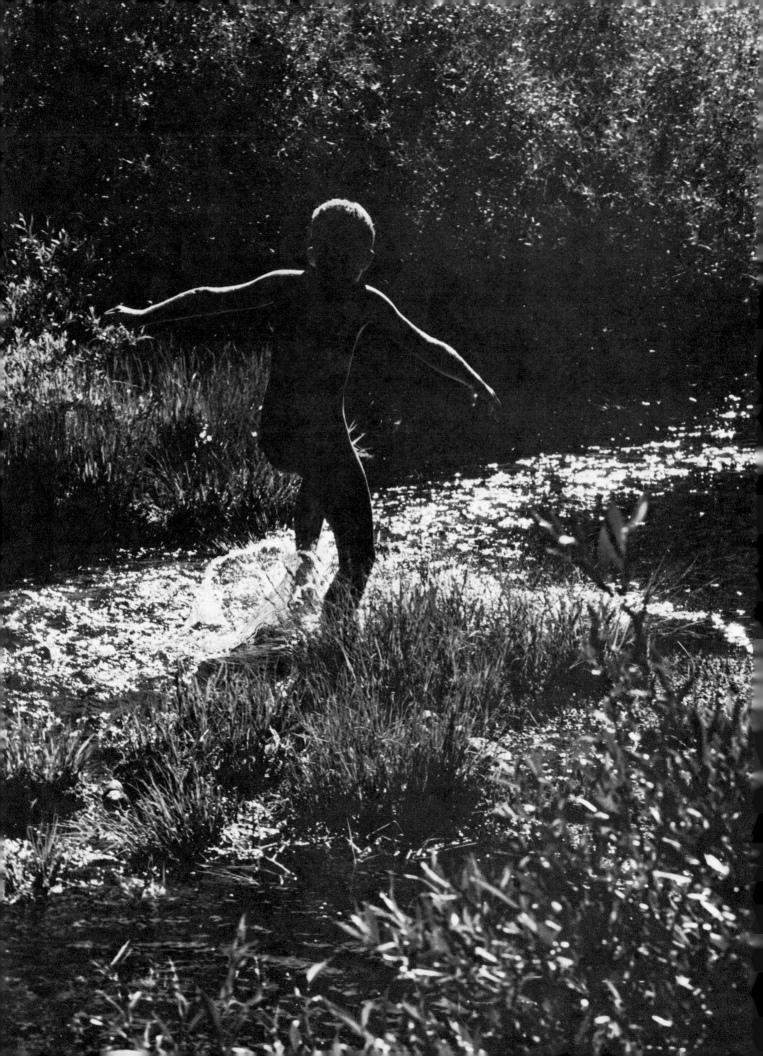

Backlighting (figures 31 and 32). When you shoot into the sun or other light source, the edges of a subject are accented by what is called a *rim light.* In color or black and white, this kind of situation calls for a minimal exposure in order to get detail in the bright areas. Shadow detail in the figure or foliage is unnecessary. In fact the boy separates better from the background because his body is so dark. The picture was shot with a 2¼x2¼ Bronica camera and 135mm lens at 1/500 second, and it illustrates well the dramatic appeal of backlighting.

Figure 32 was an unposed situation found by Everett McCourt in a neighborhood hotel. Backlight from the window outlines the lady, and also gives the photograph an atmosphere that fits the setting. McCourt exposed at f/11 for the interior, knowing that the view through the window called for f/16, but outdoor detail was extraneous. The picture won a Kodak/Scholastic Award.

Diffused light (figure 33). The ranch couple in Wyoming were seated in what is known as open shade, which is usually desirable for pictures of people. The sun was shining on another side of their barn, but on the shady side they were illuminated by bright, diffused light from the sky. In open shade there are no strong shadows, but form and textures are seen very clearly. I composed carefully with a 4x5 view camera, a slow and very exacting way to take portraits.

There are many examples of existing or ambient light in this book. Some of them illustrate other facets of photography, but look at them several ways. Analyze the shadows to determine the direction of the light. Think about the quality of light in relation to the subject and the mood portrayed. As you take pictures, you can expect to meet challenging lighting that is not ideal. Adjust your camera angle, choose lenses, use filters, set exposures, and call upon any means you wish to make the most of a situation when lighting cannot be changed, but images are worth making.

I have intentionally avoided mentioning the ancient adage, "Shoot with

32 *Everett McCourt titled this "Grab Shot," a reference to quick, candid reportage.*

◀ **31** *Backlight with exposure for the highlights.*

33 *Open shade is usually a welcome portrait lighting.*

the sun coming over your shoulder,'' because it is inappropriate for the aware photographer. If sunlight from behind you works, use it. But from that direction it may be flat, and a picture might have more impact if the sun came from one side of or even from behind a subject.

If you need experience taking pictures in "poor" lighting conditions such as during a rain, after dusk, or on a hazy day, by all means experiment in both black and white and color. Many memorable photographs have been taken in unconventional lighting situations. Similar conditions that may be strange or unappealing to you now will become familiar and desirable in the future.

AVAILABLE LIGHT

Someone (it may have been writer Bob Schwalberg) once claimed that available light really meant "available darkness." The term usually refers to situations where the light level is low, or dim, and slow shutter speeds and/or large lens openings are necessary to get usable images. Authentic available light is always a challenge in terms of holding a camera steadily, focusing accurately, and getting sufficient depth of field. Of course, it is advisable to boost the light level by using floods or flash on some occasions, but there are times when you cannot do so, or when applied light will disturb or destroy the realism of a setting.

Low light levels occur most often indoors when room lighting or window light is fairly weak, and outdoors at dusk or at night. However in these days of large lenses, fast films, and high-energy development of film, there are many available-light situations when you can shoot at 1/30 second or faster. This is a relatively safe shutter speed for the average photographer—with steady nerves.

Very Slow Shutter Speeds

Later in the discussion of night photography, there is a logical recommendation for using a tripod when slow shutter speeds or time exposures are indicated. The same may be said for shooting indoors in low light levels, especially if more than minimum depth of field is desirable. However, there is an arbitrary distinction: Many available-light situations are mobile or in some way make using a tripod difficult or impossible. Therefore, one learns to brace the camera in order to shoot at 1/30 second or slower when no other approach is feasible.

Bracing the camera. There are several ways to steady a camera without a tripod. The most obvious one is to set the camera on a steady base, such as a chair, a shelf or a flat rock, any of which become a substitute tripod. You may not have an ideal camera position under such circumstances, but it is better to have a sharp image that might be cropped later, than to have a blurred image or none at all. Most 35mm or hand-held cameras will adapt to a firm base, but a view camera obviously needs a tripod.

A second way to anchor a camera is by means of a clamp. Various shapes and sizes are available with screws that attach to the tripod socket in the camera base, and a tightening clamp mechanism by which you can fasten a camera to the edge of a door, chair, table, or other stationary spot. Professional photographers carry such a clamp with their equipment for those occasions when a tripod is not feasible and there is time to anchor the camera.

A third way to steady a hand-held camera is to brace yourself against a wall or doorway with one shoulder and arm pressed to the stationary surface. Many a half-second exposure has been made this way inside a cathedral where most of the light is coming through stained-glass windows. For the photograph of conductor Zubin Mehta (figure 35), I stood in the wings of the auditorium bracing my 35mm camera and

34 *Thirty-five millimeter SLR was braced by placing photographer's elbows on a counter, allowing a 1/15 second exposure at f/6.3 with a 35mm lens. Hand-held slow shutter speeds are a calculated risk.*

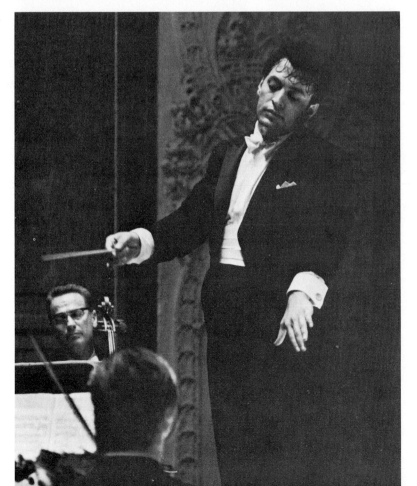

its 135mm lens against a wall. I shot at 1/30 and 1/60 second, hoping to catch his movement when it came to a peak and paused for a fraction of a second.

There are photographers who boast of being able to hold a 35mm camera steadily for long exposures, such as ⅛, ¼, and ½ second, simply by bracing both arms against their chests and holding their breath. Sharp pictures are possible in this way, but they are not predictable. There is inevitably a small amount of camera movement that is magnified as negatives or slides are enlarged. Therefore, in a pinch, handhold as long an exposure as required in order not to miss a picture opportunity. Otherwise, brace the camera on a tripod, clamp, or other solid base, because better quality is guaranteed.

35 *Camera was braced against a wall for a 1/60 second exposure of conductor Zubin Mehta.*

The Journalist's Light

News photographers and photojournalists are noted for their use of available light, mainly because they must take pictures where the light is not ideal, and adding more light is not feasible. Two editorial portraits are examples of outstanding available-light photography. In figure 36 Reed R. Saxon caught famed photographer W. Eugene Smith during a talk he gave about his book, *Minamata*. Reed used a 105mm lens on a Nikon, and shot wide open at f/2.5 at 1/125 second. He chose to take his chances with depth of field in favor of a shutter speed that would avoid camera and subject movement. The Tri-X film was developed in D-76 with Crone: C Additive that helps reduce contrast, and is described further in the next chapter.

36 *W. Eugene Smith by Reed R. Saxon.*

Figure 37 was taken by White House photographer David Hume Kennerly while President Ford was reading at Camp David. Window light was high contrast, but Kennerly's feeling of reality is typified in this portrait which is faithful to his goal to "document truthfully" the presidency, both for current news release and for history. An informative article in the February 1975 *Popular Photography* is worth researching to learn more details of Kennerly's expert journalistic approach to photography in a unique job situation.

37 *Windows at left and right lighted President Gerald Ford, forcefully photographed by David Hume Kennerly.*

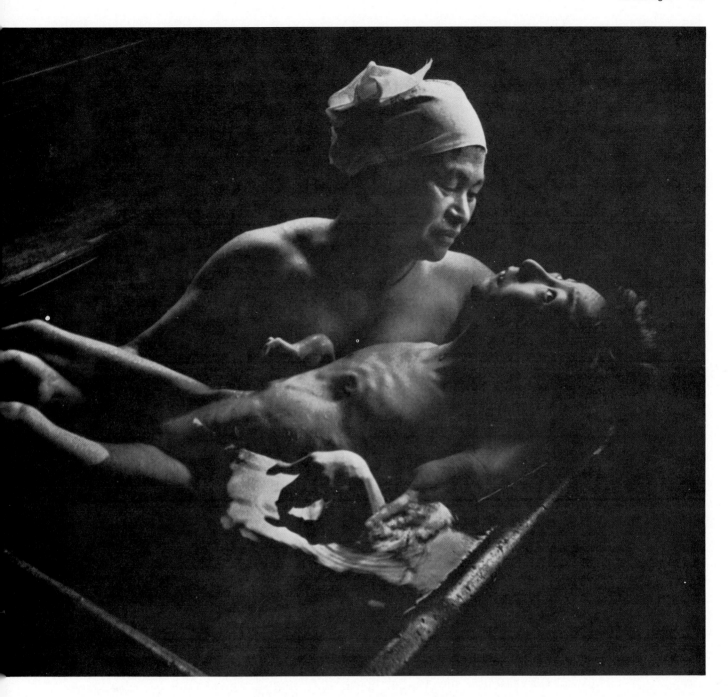

38 From Minamata *by W. Eugene Smith.*

A third example of available light, figure 38, is from W. Eugene Smith's book, *Minamata*, a long picture essay about a Japanese town cursed by mercury poisoning. Anyone interested in photojournalism should be familiar with Gene Smith's pace-setting photography, much of it published in *Life* over several decades. Smith is a master of available light, though not all of his situations are backlighted as gracefully as this photograph of a Japanese mother tending her crippled son in a warm water pool. Gene Smith is noted for his integrity and ability to capture nitty-gritty reality without imposing his presence on the subjects. Patience and empathy go hand-in-hand with camera skill, as evidenced by all of Gene Smith's memorable body of work.

NIGHT PHOTOGRAPHY

Two principles covered in chapter 6 are involved with photography at night, whether you make time exposures or hand-hold the camera. One is bracketing, and the other is reciprocity failure. Lighting contrast must also be considered in relation to determining the most important subjects in a scene as a guide to exposure.

39 *Eight-second time exposure on Polaroid Type 105 film in Model 180 Polaroid camera.*

The Light at Night

Indoors or out, you can be reasonably certain that the light at night exists in uneven areas, large or small, surrounded by blackness, or in a series of small spots that become streaks on film if they are moving. Let's examine some specific cases that are typical.

Indoor time exposure (figure 39). Rooms in the average home are not consistently lighted, so you must decide by a meter reading whether the exposure for the film and subject requires a tripod or not. If you are using a fairly fast film, such as High Speek Ektachrome Type B boosted to 320, or Tri-X at 400, and a lens opening between f/2 and f/4, you may very well shoot at 1/30 or 1/60 second with a hand-held or braced camera. Your decision depends on how much depth of field you want, how much subject movement there is, and the general interpretation of a scene in terms of mood and sharpness. Many room-lighted pictures are taken at home without a tripod, though slow films usually require one. Such was the case with figure 39, taken with a Polaroid Model 180 camera on Type 105 film which is rated

at ASA 75. In order to shoot at f/8 in this room, the meter indicated 8 seconds of exposure; therefore the camera was tripod mounted. My wife held still miraculously for the 8-second interval, and I was able to record sharpness from foreground to background. Room light is most intense near lighting fixtures, and additional exposure was given the model and the lamp when the Type 105 negative was printed.

Outdoor time exposures (figure 40). When a night scene requires more than a one-second exposure, it's time for bracketing. For one thing, a meter may be more strongly influenced by patches of bright light, or by areas of darkness; to assure a successful picture, you should make a series of exposures. It is good practice to choose a suitable aperture and vary the interval during which the shutter is open. The camera belongs on a tripod, or clamped firmly to a steady support. For this patterned photo of highway traffic, I shot from a bridge using a 35mm lens on a 35mm camera, set at f/5.6. The built-in meter did not move, even though the film used was Tri-X, so I began with 2 seconds and shot a series of frames at 3, 4, 5, and 6 seconds. The background was similar in several negatives at longer

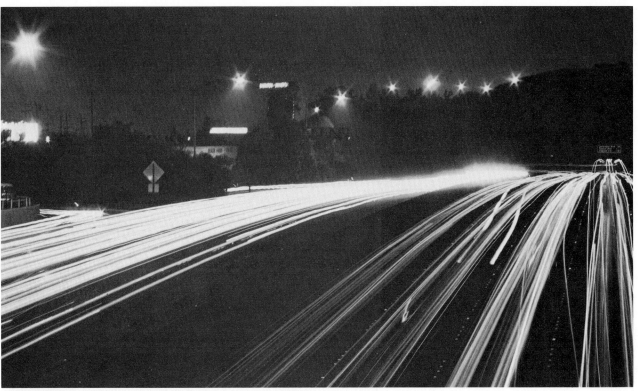

40 *Light patterns require backeted exposures for a variety of effects.*

41 *Night scene in London at 1/60 second.*

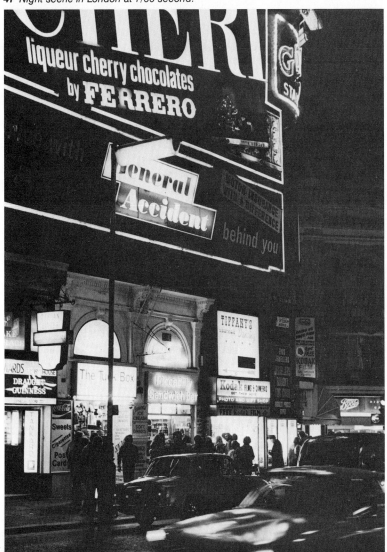

exposures, but the headlight/taillight pattern was most interesting in the 5-second image.

A great variety of night scenes, near and far, can be photographed with the same bracketing technique. If you use a slow film, and exposures extend 10 seconds or longer, remember that film response is diminished due to reciprocity failure, and extended exposures may be necessary. For moving lights, you may choose to shoot at wide lens openings for shorter periods, to control the build-up of light patterns. Experiment at night, because the nature of the subject will often dictate the exposures within your bracketing range.

Outdoor hand-held exposure (figures 41 and 42). If a scene is bright enough, by reason of signs or street lighting for instance, and your film and lens are fast enough, it is quite possible to shoot with a hand-held camera at night. The London street scene (figure 41) was taken on Tri-X with a 50mm lens on a 35mm camera; exposure was 1/60 second at f/4. The movement of people was arrested, but the car in the foreground blurred, adding a pleasant pictorial emphasis. The brightest lights were given extra exposure when the picture was printed using a normal filter.

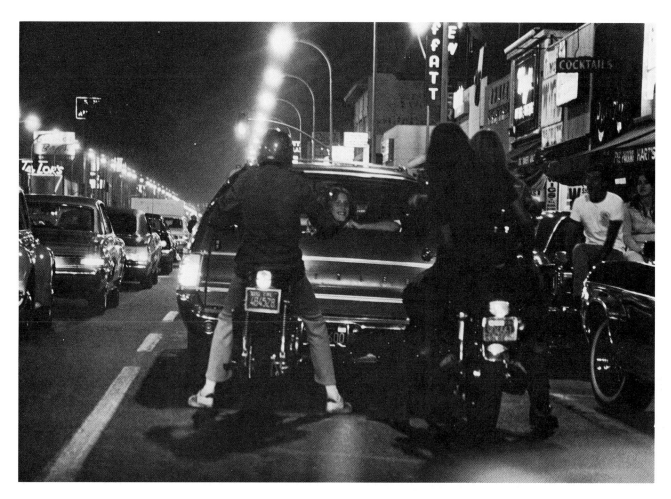

42 *Exposure of 1/30 second through car windshield.*

Figure 42 was shot through the windshield of my car, with the camera braced on the car's dashboard. I used a 35mm lens on a 35mm camera, and exposed at 1/30 second at f/4 on Tri-X rated normally at 400. The focus is slightly soft in the foreground, but sharp enough throughout. The same scene photographed with a slow color film would have required perhaps ⅛ or ¼ second, a firm camera, and reliance on shooting when subject movement was minimal. It can be done by exposing enough frames of the same subject, with the reasonable certainty that one of them will be sharper than the others.

Moving the camera (figure 43). When conventional photography at night is not possible for various reasons, or if you wish to experiment with special effects, intentional camera movement is worth trying. Whether the lights in a scene are stationary or moving as they were in this amusement park, estimate the f-stop based on the film speed and

brightness of the lights, set the shutter-speed dial on B, and make a time exposure for a few seconds or more. While the shutter is open, manipulate the camera rather slowly through one or more movements that may overlap. Plan the resulting patterns as well as possible, but realize that serendipity will determine whether you record images that are worth saving and showing. With Tri-X, I set the lens at f/4 and swung the camera through several slow arcs for about two or three seconds. Some of the patterns were very jumbled, but this one is exciting to me.

Moving a camera with the shutter open is even more effective with color film. Lines and spots will overlap to create unpredictable and colorful effects. This technique worked for me one evening while taking a bus tour of London. Knowing I could not shoot from a window and get sharp time-exposed images, even when the bus paused, I pointed the lens at traffic patterns, and jiggled the camera gently. The abstract waves of colored lines and

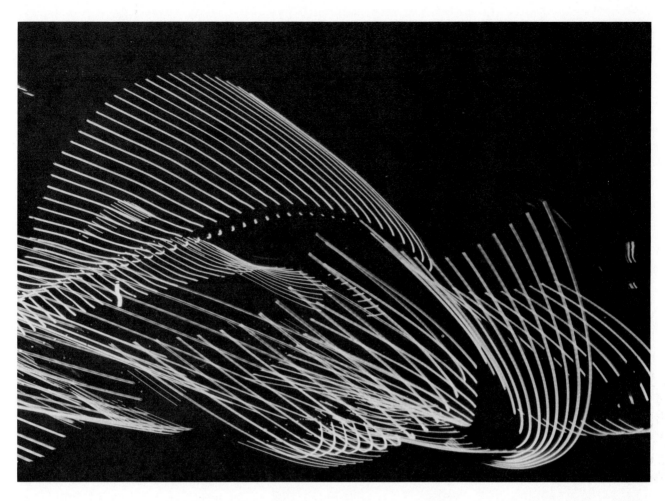

43 *An experiment in serendipity.*

shapes on my slide film were painterly and delightful.

While careful control at night and with time exposures is obligatory, even if you bracket to find the proper exposure, you must still take chances. Think of long-exposure situations as an adventure, and enjoy the challenge of a chance to get pictures that may be one-of-a-kind.

LIGHTING EQUIPMENT

In a well-equipped photographic studio there are many sizes of versatile, specialized, sophisticated, and expensive artificial lights that are necessary to meet the needs of advertising, commercial, or portrait assignments. Professional photographers need plenty of wattage designed into spotlights, diffused multiple floodlights, or super electronic flash units that may be raised and lowered by electric motors. Banks of lights with their accessories, voltage regulators, and mobile stands may be familiar to you in a school studio setting.

All the above equipment can be found in camera shops and manufacturers' catalogues when you need it. No matter how elaborate a light source may be, however, the effects you get with it are based on the principles described earlier. Superior equipment merely makes refinements and subtleties of lighting easier to achieve.

It is more fitting in this book to briefly discuss lighting equipment that is basic and reasonably priced, which a student may expect to own for long-time use. Cameras and accessories are far more expensive than floodlights and electronic flash units; a good selection of the latter may be purchased for a few hundred dollars. Some of the available items are described in the following sections.

44 Herbert Borgmann, while a student of the author at Brooks Institute, symbolized a fellow student using a large floodlight and a view camera. The assignment was a visual interpretation of the school.

Types of Lighting Equipment

Floodlight bulbs. These are made in 250-watt and 500-watt sizes with conventional bases. Photoflood bulbs are rated at 3400K for Type A color films and any type of black-and-white film. There are also 3200K bulbs for use with Type B color films, or any black-and-white film. The latter cost more, but are recommended because they last much longer than regular photofloods, which darken as they near their three-hour limit.

Reflectorflood bulbs. These are also manufactured in both 3400K and 3200K ratings, but they are designed with a built-in reflector. Below, I'll mention why I feel they have advantages.

Floodlight reflectors. Made in various diameters up to about 12 or 14 inches, these reflectors are used with bulbs that do not include a built-in reflector. Most brands have a heat-resistant handle with which to manipulate the light, plus a clamp and a length of electric wire. One advantage of using such reflectors is being able to control the light by snapping on a diffusing screen or flat pieces of metal called *barndoors*. The main disadvantage of floodlight reflectors is carrying them conveniently, because they tend to be bulky, even if the bulbs are removed and the reflectors are nested.

Quartz light units. In many ways, these are the most modern and efficient types of floodlighting. A quartz bulb is only a few inches long, and the reflector around it may measure only four inches in diameter. Therefore the whole unit is compact, though the average one is rated at 600 watts. Bulbs are available in either the 3200K or 3400K rating.

Quartz units cost more than some floodlight reflectors, and bulb replacement is more expensive, but the bulbs are long lasting. The quartz light is popular for improvised studios or on location because it is small, portable, and powerful.

Light stands and booms. Collapsible lightweight aluminum stands that telescope to 18 or 20 inches are quite

adequate for the lighting equipment described previously. Heavier steel stands may be preferable for larger lighting units. Check camera shops and catalogues for all of the above equipment, to compare prices and features.

To elevate a reflectorflood bulb or a reflector over a small set or a model's head, several types of booms are made which are mounted on a light stand. At one end of a boom is a socket with a counterbalance at the other. A boom light is standard equipment in some portrait studios, but may initially be unnecessary for the average photographer.

Spotlights and spot bulbs. A spotlight projects a fairly narrow beam of light compared with a flood, and most have a focusing mechanism for varying the width of the beam. For still life and for some kinds of portraiture, a spotlight might be handy, but it is a specialized unit that need not be included in a beginner's kit.

There is a reflectorspot bulb made by General Electric, which may serve very well when a beam of light is required for small objects, sculpture, or as an accent light on a model's hair. Though the GE spot is rated at only 150 watts, several of them are inexpensive and take the place of more elaborate spotlights until the latter may be essential.

A Home-Built Lighting Kit

It is easy to assemble an individual, portable floodlighting unit that may include one or two quartz lights but can be fitted into a compact case. At a hardware store buy a standard light socket with an on–off switch, a wooden handle made for a file, and a brass threaded connector to attach the handle to the socket. At a photo-supply store buy a clamp, such as the Alligator brand, which has a divided arm that fits around the socket. The jaws of this particular clamp open to fasten onto a light stand or a door, and it can also be set firmly on a flat surface. Attach 15 or 20 feet of electric cord to the socket, and put a plug on the free end.

Using reflectorflood or spot bulbs in such a home-built unit, you have practical, economical, easily carried lighting equipment. Several of these plus a couple of quartz lights, light stands, and other miscellany can be packed into a custom-made fiber case designed around the contents. My own portable lighting kit is seen in figure 44. The case was manufactured by Industrial Fibre Products, 3680 South Main Street, Los Angeles, California. Similar custom-case service should be available in other large cities.

Ready-Made Lighting Kits

Various companies sell floodlight reflectors or quartz lights in cases holding two or more units. Smith-Victor Corporation offers a number of ready-made kits, while Lowel-Light Manufacturing Company in New York City has a more expensive, but very compact unit called the Tota-Light. This consists of a slim folding reflector around a tungsten halogen lamp (a short tube similar to the quartz type), rated from 500 to 1000 watts.

For additional data on kits and all artificial lighting equipment, refer to the *Popular Photography Directory* or *PhotoGraphic Magazine's Equipment Buyer's Guide*. There are dozens of different units from which to choose according to size, light output, type of lamp, and cost.

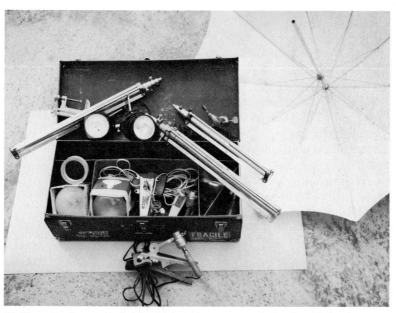

45 *The author's portable lighting kit includes quartz and photoflood lights, homemade clamp units, stands, wires, and an umbrella reflector.*

Reflectors

A large sheet of white cardboard, or a sheet of Masonite covered with crinkled aluminum foil can serve as a portable reflector indoors or out. However, an umbrella-shaped reflector is easier to carry and more efficient, because it is parabolic rather than flat.

Umbrellas are manufactured by various companies, though the Reflectasol made by Larson Enterprises, Incorporated, Fountain Valley, California is probably the best known among professionals. These reflectors fold toward a center pole exactly like a rain umbrella, and are made in round or square shapes, from about 30 inches to 4 and 5 feet across. A double clamp is used to attach the open umbrella to a light stand. Any sort of floodlight or electronic flash can then be clamped to the umbrella pole and pointed into the center of the umbrella. As you saw in the lighting exercises, and will see below in the section on electronic flash, a reflector, especially the convenient umbrella, is a must for many types of indoor lighting.

ELECTRONIC FLASH UNITS AND TECHNIQUES

Some readers may have an aversion to flash because they have seen so many undistinguished pictures (mostly snapshots) made with this light source. Others may realize that *any* artificial lighting is used by the aware photographer because the ambient light is not suitable for a variety of reasons. It is not feasible for most of us to work in a studio or a setting with a beautiful north light, and if we had such an ideal place, would we stop taking pictures after dark? Chances are we would use floods or flash if natural light were inadequate, and the average studio takes this choice a few steps further by electing to shoot with floods or electronic flash for nearly all situations. The reasons are obvious: Artificial light is consistent, always available, and adaptable to many types of control. In addition, different sizes of lighting units may be aimed at a subject from many directions.

Shooting with floodlights has advantages in a stationary situation at home, in a studio, or on location. You can see how light affects form before you make exposures, and you can use floods to augment daylight under certain circumstances. (Mixing artificial light and daylight will be covered below.) However, for mobile, active subjects when you must be on the move, and for certain portrait and still life situations, electronic flash is a welcome tool.

Electronic Flash Principles

An electronic flash or EF unit—which is synchronized with the shutter (set on "X") of a camera—consists of a flash tube that is good for at least 10,000 flashes, a capacitor in which electrical energy is stored, a power supply such as batteries or AC, and other components and circuitry that vary from one unit to another. These are the outstanding features of electronic flash:

1. *Speed.* The average flash interval is about 1/1000 second, which will "freeze" most types of action. Some large studio units may flash at 1/500 second, but this is fast enough for most purposes. Many small units with thyristor circuitry (see below) are capable of extremely short flash times, such as 1/20,000 or even 1/50,000 second.

Also involved in the speed of electronic flash is *recycling time.* When you fire the flash, an electrical charge ignites the gas-filled tube for a fraction of a second. Circuitry within the unit immediately builds up another charge of power, and the unit is ready to be fired again. This cycle takes from half a second to eight or nine seconds, depending on brand and design. Recycling time is most important to news photographers, or to anyone who must shoot in fast sequence.

2. *Repetitive operation.* Before electronic flash units were small, powerful, and portable, photographers used flashbulbs. Architectural and industrial photographers, for instance, had to use

46 The ability of electronic flash to freeze action makes it a favorite of news photographers such as Bud Gray, former staffer on several Los Angles dailies. Fast recycling time is also a prime asset of EF.

flashbulbs for enough light to cover large areas. The bulb had to be removed from its reflector and replaced each time an exposure was made—a time-consuming and relatively expensive chore. Today electronic flash does these jobs. Not only does a unit recycle in a few seconds, but some offer more light output than the largest flashbulbs ever did. With steady use, even the cost of a large unit is amortized in a few years. The same may be said of tiny units which benefit photographers who shoot only a few rolls of film a month.

Electronic flash power rating. There are three ways to compare the light output of an electronic flash unit.

1. *A watt-seconds (WS) rating* represents the amount of electrical current a capacitator can store. A rating of forty watt seconds is average for small portable units, though some are rated at up to 100. Larger studio units begin at around 200WS and range up to 1000WS.

2. *A beam-candlepower-seconds (BCPS) rating* is a more uniform rating of light output; exposure information with most types of film includes a guide based on the BCPS of various units.

3. *A guide number (GN)* is a figure that relates the ASA speed of a film to the light output of an electronic flash unit. Guide number tables are often included in EF instruction booklets, and you can calculate a guide number with a dial built into many small units. By dividing the guide number for a specific EF unit by the distance in feet from camera to subject, you get the f-stop at which to shoot. There's more about flash exposure later. Many small units are advertised in terms of their guide number for Kodachrome 25, because this film is automatically processed without manipulation, and comparisons are consistent.

Sources of electrical power. Small portable units, the kind most photographers are likely to use at first, are powered by dry-cell batteries. The alkaline type last longest and are easily replaceable. Rechargeable nickel-cad-

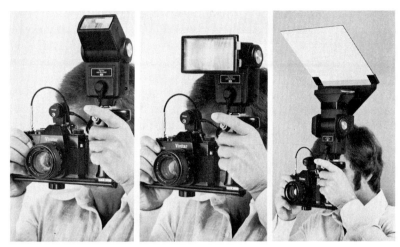

47 *Versatile Vivitar 283 electronic flash unit tilts for bounced light* (left), *and has accessory wide-angle and diffusion filters* (center); *a bounce-light card can be attached* (right), *and the light sensor is removable.*

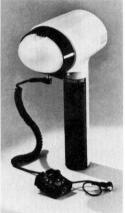

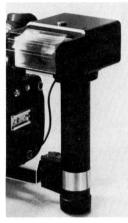

48 *Typical compact electronic flash unit with energy-saving thyristor circuit mounts conveniently into camera accessory shoe.*

49 *Honeywell Auto/ Strobonar electronic flash with "Strobodome" diffuser and Strobo-Eye sensor in foreground.*

50 *Ascorlight Auto 1600 electronic flash with tilting reflector in several positions.*

Manual or automatic operation. To make an exposure with a manual EF unit, you calculate the f-stop, using the shutter speed stipulated for X-synchronization on your camera. The lens opening is most important, because it determines exposure more than the shutter speed, which is more involved in how much ambient light registers on the film in addition to the flash. Guessing f-stops by guide number is workable, but old-fashioned.

Just a few years ago an automatic EF unit was relatively expensive. Today the price has been reduced to a point where this type is first choice among most photographers. An automatic EF unit includes a small electric eye or sensor which measures the light reflected from a subject and instantaneously quenches the flash for correct exposure, depending on the f-stop used. More versatile automatic units allow you to shoot at several specific f-stops, which is handy when depth of field and close operation are priority considerations. Automatic operation requires a certain amount of interpretation, in the same manner that an automatic exposure camera must be guided by the user, but it is faster and takes most of the guesswork out of flash photography.

There are two types of automatic EF units. The older type quenches the light, but dumps the unused electrical power. The newer type with a thyristor circuit quenches the light, but saves the power and returns it to the system. This not only extends battery life considerably, but provides much faster recycling time. For instance, if you are shooting a subject only a few feet from the camera, less light is required. An automatic unit with a thyristor circuit needs only a portion of its full energy, and in quickly quenching the flash, the flash interval may be as small as 1/50,000 second. Recycling takes place in less than one second. This feature makes it possible to shoot close-ups of a hummingbird in flight, or something equally rapid.

mium (nicad) batteries need not be replaced regularly, but they cost more and must be charged monthly to keep them in working condition. High-energy dry cells are heavier and more costly, but last much longer than small batteries and provide faster recycling time. These are rated at 67½V, 240V, and 510V, and are carried in a separate power pack usually hung from the shoulder. If you have a small unit, it is my recommendation that alkaline batteries are the preferable source of power, unless you need the high-energy type for faster operation.

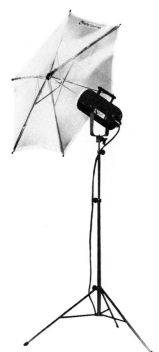

51 *One-piece Strobosol X8000 studio electronic flash has umbrella shaft hole through its center, and is easily portable.*

52 *Rollei E250 is a medium-sized self-contained electronic flash unit.*

53 *Vivitar photo eye activates an off-camera flash unit as main EF is fired.*

Portable or studio units. The average photographer chooses a *portable* EF unit, but faces a variety of designs. A one-piece unit includes batteries, and can be mounted in the accessory shoe of a 35mm camera. These are available with a number of power ratings; select the one that seems to best fit your photographic needs and budget.

The larger one-piece unit has a rectangular flash head and a tubular base in which batteries are installed. Such units are usually more powerful than compact designs, but must be mounted to a 35mm camera on a separate bracket. This tends to become bulky, and camera handling is not as efficient, but such elongated units may have other advantages, such as tilting heads for bounced flash.

Two-piece portable units usually include a high-energy battery pack on a shoulder strap, and a flash head that is attached to the camera accessory shoe. These units cost more, but are generally more powerful and sometimes more versatile than compact models.

There are dozens of portable EF units on the market, and new ones are being introduced regularly. Shop for one carefully: gather some printed matter about those that interest you most, and make comparisons. Half a dozen brands and perhaps a dozen models are equally worthwhile.

Large electronic flash units, or studio models, are powered by AC only. Within the flash reflector of a studio unit is an incandescent light, called a *modeling light*, which guides the photographer in placing the flash. The largest units have a rectangular power pack into which several flash reflectors can be plugged. This pack is often on casters, and there are usually provisions for controlling light output, such as half-power or quarter-power, when a subject is close. There are also one-piece studio units that include the flash head and all other components. A one-piece unit can be mounted on a lightstand as you would a floodlight. A unique one-piece EF unit is the Strobosol X8000 which includes a shaft hole through its center into which a re-

flector umbrella can be positioned. Rated at 225WS, and weighing only seven pounds, the Strobosol X8000 (from Larson Enterprises) can be adapted to both studio and location photography.

There are also custom-built studio units with up to nine flash heads behind a large diffusing material. You may pay $5,000 for such a unit, but there's a sizable investment in any electronic flash for studio work. Check with other photographers and with dealers for further details.

Photo eyes and slave units. It is easy to use two or more EF units at a time, and no wires are necessary to connect them. Separate slave units are available which include a flash head and power source, plus a photo eye that fires the flash instantaneously with the primary unit that is attached to the camera. A slave unit is mounted on a stand or clamp and positioned up to 20 or 30 feet away, depending on its specifications.

Two or more conventional EF units may also be positioned away from the camera and fired by a plug-in photo eye in each. Several photo eyes are available that require no batteries or power of their own, but use light-sensitive materials in their tiny circuits. Therefore, multiple-flash lighting is no more complicated than floodlighting when circumstances make it appropriate.

Flash Photography Techniques

All the principles of lighting practice explained and illustrated early in this chapter apply directly to electronic flash (or flashcubes and bulbs). The tendency is to mount the flash unit on the camera and shoot; the result is flat front lighting. When this technique is unavoidable, use it. It is never very artistic, but many pictures are taken with the flash on the camera that cannot be obtained any other way.

In more leisurely circumstances, position electronic flash as you would floodlights. You may even mount a

small flood next to the EF unit as a modeling light. Otherwise, you must guesstimate how the light will affect the subject's form.

Whenever possible, use an umbrella or other reflector to soften the light. This may be difficult if you have only small portable units, because there is about a two-stop reduction in illumination when any light is reflected, compared with using it directly. If you use a reflector with a small unit, a guide number of 40 or 50 means you will have to shoot at large lens openings, such as f/2, the disadvantage of which should be obvious. Therefore, if you plan to make studio-type setups with EF, begin with more powerful portable units, such as 100WS, and your options for exposure will be more favorable.

Electronic flash has a Kelvin temperature of around 5600 degrees, which means it is balanced for daylight color films, and should not be used with tungsten-type films without the proper correcting filter.

Bounce flash. One of the most effective ways to use EF is to aim the unit, either mounted on the camera or on a separate stand, at a ceiling which acts as a large reflector. Instead of the objectionable flat front light of direct flash, the illumination is softer, and several people

55 *Compact Spiratone electronic flash unit mounted on Rowi ball-and-socket for bounce lighting.*

at different distances from the lens will be lighted fairly evenly. Bounce flash is a favorite for portraits when a more studied lighting arrangement is not feasible. It is also quite useful when the existing light needs a boost; for example, in an office with overhead fluorescent lighting. In such situations, one bounced EF unit gives negatives or slides additional brilliance.

In the average room or office, with a light-colored ceiling eight or ten feet high, there's a rule of thumb for bounce exposure. Divide the guide number by 10 and open up two stops. Example: If the guide number is 110, dividing by 10 gives an indicated aperture of f/11. Opening the diaphragm two stops to f/5.6 should give you a working bounce-flash exposure. The tonality of both ceiling and nearby walls can influence the lens opening, so it is best to make a series of exposure tests for your own unit. You may use the same exposure guide to bounce electronic flash against a light-colored wall for a sidelighting effect. In an average-size room, the light will reflect back from the opposite wall to help fill the shadows.

Many late-model EF units compute bounced exposures automatically, and some have attachments to diffuse or bounce the light on a self-contained basis.

Flash-fill outdoors. In bright sunlight that creates dark shadows, it is possible to fill the shadows with an EF unit. However, this technique is difficult with any camera that has a focal plane shutter, because most synchronize on

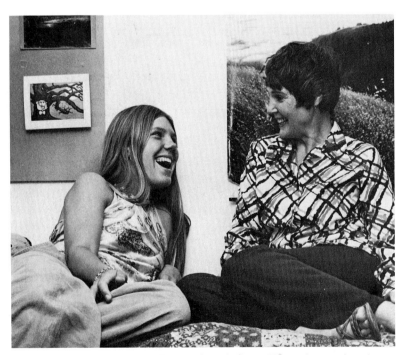

54 *One of the author's portable EF units (seen in figure 55) was bounced against a ceiling to achieve this pleasing illumination.*

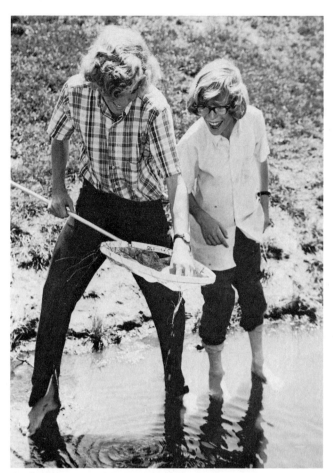

56 *Small EF unit on the camera lightened the shadows in a backlighted situation outdoors. Exposure on Plus-X was 1/125 second at f/16.*

57 *Jim Cornfield photographed Dodgers announcer Vince Scully using a Honeywell Strobonar EF unit with Strobodome diffuser. Exposure was calculated to balance light indoors and out.*

"X" at 1/60 second. Those that synch at 1/125 second are an advantage. Two problems arise:

1. Only the slowest films permit 1/60 second exposures in sunlight, even at f/16. With a faster film such as High Speed Ektachrome, Plus-X, or Tri-X, use a 2X or 4X neutral density filter to reduce effective film speed, or switch to a slow film. You may also turn to a camera with a between-the-lens shutter that synchs for EF at any speed. Examples are some Hasselblad models, special lenses for other medium-format SLR cameras, the Rolleiflex, and compact 35mm rangefinder cameras.

2. You are exposing for two light sources at the same time. If the sunlight exposure is 1/60 second at f/16, for instance, calculate the EF exposure by guide number to be a theoretical 1/60 second at f/22. Shadows will be brighter, but they should not be filled to the same intensity as the highlights, because the total light will then be too flat. To help achieve at least a 2:1 balance, use a small EF unit, stay back from the subject a suitable distance, or diffuse the flash with white facial tissue. You may also choose a longer focal length lens to increase camera-to-subject distance. The goal is to illuminate the shadows, but not eliminate them.

Indoors, or anywhere the existing light and the flash are of about equal intensity and a slow shutter speed such as 1/30 or 1/60 second is used, you may get a blurred or double image known as a ghost image. The shutter (any type) is open long enough to record the subject by existing light and flash in two positions if the subject is moving. Sometimes this can be interesting, but it's usually annoying.

Mixed light sources. When shooting black and white, a mixture of flash, flood, and daylight will not pose a problem other than potential ghost images. However, with color film the varying color temperatures of the light sources will match one type of film, but not the other. Therefore, electronic flash mixes better with daylight than does floodlight, if you use a daylight color film. In an indoor location where there are large windows that influence exposure, using floodlights to augment the illumination will give you overly blue results with daylight films, and overly warm results with tungsten films. Either switch to electronic flash or block the window light in order to achieve the correct match of light and film.

Flash meter. A very handy piece of equipment for those who use electronic flash on a fairly large scale is an electronic flash meter. This is a hand-held item into which you plug a cord from an EF unit. When you press a button on the meter, it fires the flash, and exposure readings are indicated on a dial, by either the incident or the reflected method. In a photographic studio setting, or on location where one large EF unit is the source of light, the meter offers precise exposure data. One of the best and most reasonably priced is the Calumet M-100.

Flashbulbs and Flashcubes

Since these are rarely used by the serious photographer today, little need be said about them. Some types of flashcubes mounted in an adapter that fits into the shoe of a 35mm camera might be expedient for certain types of photography. Guide number directions are included on the flashcube carton. However, there is no opportunity to use a flashcube in the bounced mode nor as a multiple source of light, and these pictorial limitations lead most photographers to choose electronic flash or floodlighting.

59–59a *Changing light affects form, composition, and pictorial impact.*

60 *Outdoor reflected sunlight can be ideal for portraits.*

THE QUALITIES OF LIGHT

Chiaroscuro refers to the distribution of light and shadows in a picture. Deep variations and subtle gradations of light and shade help to delineate character, add drama, and enhance the pictorial value of a photographic image. Chiaroscuro is used to describe painting more than photography, but in either medium it denotes an expressive quality of light which is often important to a visual statement.

With technicalities aside for the moment, think of light as the photographer's pallette. Light is often integral to mood, and is always the "painter" of form. Light need not always be soft and mellow to be beautiful; sometimes a stronger, directional light is more appropriate. However, it seems obvious that the quality of light can make or break a picture.

To end this long chapter, here are some case-history photographs that point up only a few of the poetic and practical qualities of light.

Figures 59 and 59a. A matching pair of pictures—that don't match. Taken from the same position in an artist's studio, the contrast and separation of shapes in figure 59 are dependent on their own tonality. When the sun shifted later in the day, chiaroscuro became more important to the subject. As light changes, the pictorial impact and the basic design of a photograph is enormously altered. French Impressionist Claude Monet demonstrated this well in his series of paintings showing the effects of changing light and seasons. He worked with dots of color to show form, but his observations are valuable to any serious photographer.

Figure 60. Shadowless lighting has the appearance of a studio setup, but it's not. The model was standing opposite a bright wall that became a natural reflector for sunlight. Her head was turned to minimize shadows. The portrait was made with a 35mm camera and a 100mm lens on Tri-X. This is an example of ideal portrait light, the kind worth searching for outdoors or carefully creating with a reflector indoors.

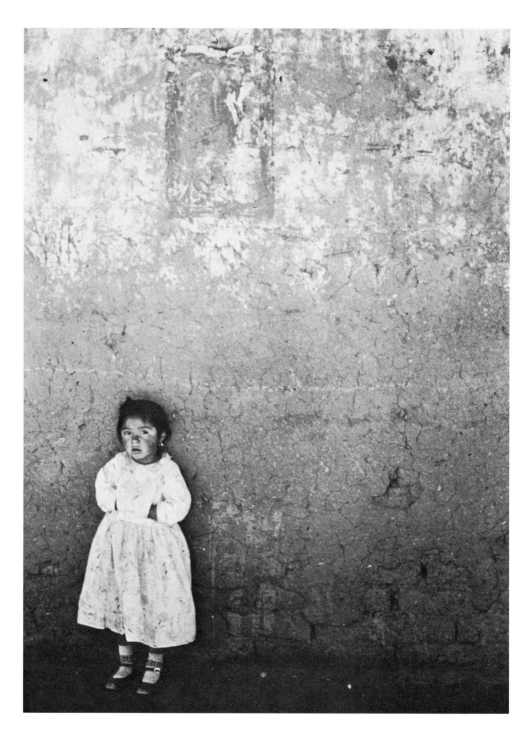

Figure 61. Gordon Parks captured this image of a little girl and a textured wall in Peru around 1959, and it is included in his book *Moments Without Proper Names* (Viking 1975). The mood of loneliness is amplified by the indirect, pale light. In bright sun this picture would have been much less effective.

62 *Light offered lovely modeling of the subject and contrasts in Tom Carroll's refinery photograph.*

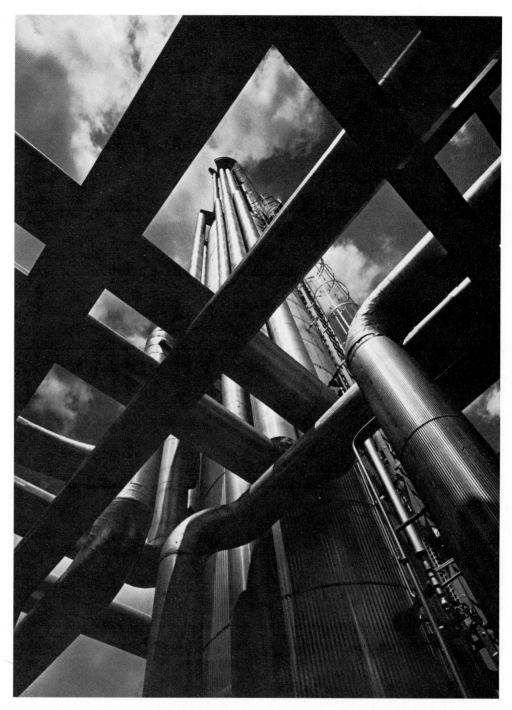

Figure 62. Of his refinery picture, Tom Carroll comments: "Shooting from dark to light gives great depth to an illustration, and here the aluminum insulation which I wanted to feature glows in the sunlight that was diffused by the clouds." To which might be added that the silvery glow in Carroll's picture is a special quality of light that comes from both subject matter and lighting. Subtle gradation of tones is often a photographic goal, with form and detail working together harmoniously. A painter can make such light and tone transitions with a brush and pigment, but a photographer must either find them or create them with light.

The quality of light is often strained, and it does not always fall gently from heaven. Fortunately, when sharp perception guides a photographer, the marvelous pallette of light is unlimited. Many pictures are outstanding because of the light itself. It is our expressive tool.

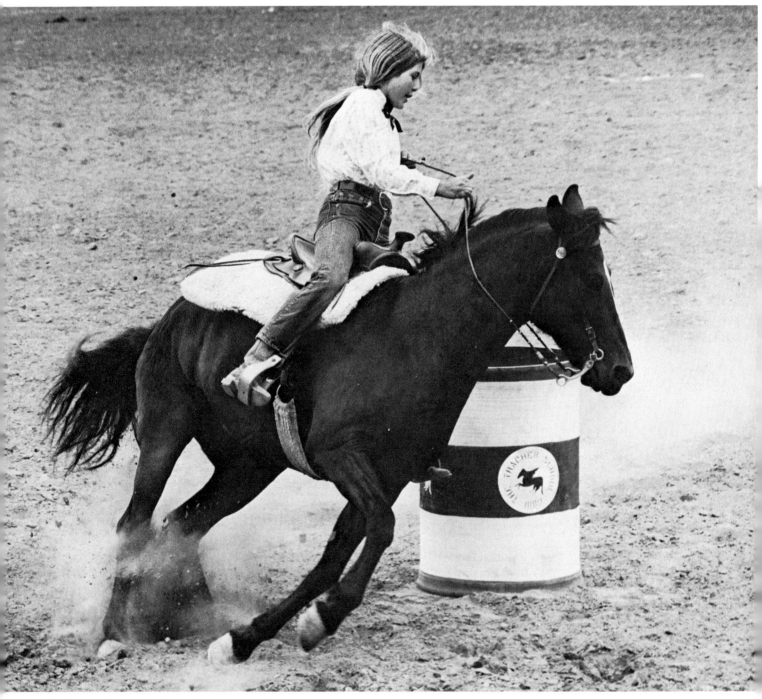

1 Print quality begins with negative exposure followed by good development practice and skillful enlarging. Rider was photographed with a Konica Autoreflex T, 80–200mm zoom lens, and Tri-X exposed at 1/1000 second.

Some terms explained in chapter 5 are germane here. There are also several references to the development of film in relation to its speed, graininess, contrast, and gradation or tonality. It should be apparent that film is only a roll or sheet of coated plastic (with individual characteristics and monetary value, of course) until it is developed. Therefore, processing the film is closely allied to exposing it, and the photographer who does his/her own darkroom work not only maintains control over quality, but also becomes more careful and aware when using a camera.

Let me elucidate a moment about "quality." It means:

1. A proper combination (and choice) of time, temperature, and developer to achieve the most brilliant and easily printable negatives possible. Your images may be mere exercises at first, but they will soon have far greater personal importance in your life.

2. Cleanliness, which results from a disciplined routine that may be elusive and frustrating to beginners, but eventually becomes comfortable and intrinsic.

3. Follow-through with filing and indexing negatives to assure almost instant availability, while avoiding dirt and scratches, which are the prime enemies of good technique.

Black-and-white film development requires that you understand certain theories. With practice it becomes an easy routine. Top-notch-quality negatives are guaranteed (if film exposure is correct) and repeatable, and you may expect to read while developing film, and still be sure of proper processing. This may sound exaggerated, but it is based on more than 30 years of darkroom experience, beginning in a makeshift operation under a Hawaiian pineapple field. I had a small darkroom there within a large army complex, and fretted for months over dirty negatives and inferior prints. One day I decided, after reading some books on photography, that clean, brilliant 35mm negatives were possible, despite my flawed record. I had four rolls of film that were particularly important to me, and I took what was then extravagant care in developing and handling them. My struggle to be precise and spotless paid off; I still have an album of 8x10 Hawaiian prints preserved in a closet to prove the point. From that time, I realized that precision processing was possible to anyone who cared enough. It is far easier than repairing a carburetor, playing a concerto, or even learning to type with ten fingers.

FILM DEVELOPMENT TERMS AND THEORIES

You recall that film emulsion is a light-sensitive material that forms an image in various tones of gray, black, or white, according to the amount and intensity of light that is projected onto it through a camera lens. Within the emulsion are grains of silver halide. Areas of this image-forming material that are affected by light are converted into a graded image during development. Areas unaffected by light are dissolved away, leaving clear portions of film that will appear black when the image is printed on photographic paper. A film

negative image, therefore, is a reversal of tones representing the scene photographed; darkest areas are most transparent, and brightest areas in the film are most opaque or dense. In between are the middle tones, representing a range of grays that are neither bright highlights nor dark shadows.

Measurement of Film Density

In the 1800s, glass plates and roll-film materials were inspected during development by the light of a red darkroom lantern. These emulsions were orthochromatic and insensitive to red, so photographers could make a visual judgment when development was "right," and stop at that point.

A couple of English scientists who enjoyed photography as a hobby decided that this technique was too inexact, and after years of experiment came up with a method of charting film development according to mathematical measurement of image density, i.e., opacity and transparency. These men, Hurter and Driffield, plotted development density in nine steps, resulting in a simple graphed line known now as the H&D curve.

Before explaining this further, perhaps a quote from Driffield may help to take some of the curse off theoretical data that sometimes seem to get in the way of taking pictures. Mr. Driffield wrote, "The photographer who combines scientific method with artistic skill is in the best possible position to produce good work." He and his part-

ner maintained that a fine artist can shoot a good picture, but if that person is also scientific—or precise—in method, the negative of that image will also be outstanding. When the H&D theory was announced, many photographers laughed at assuming rigid controls, but in due time they became dependent on the H&D research because panchromatic films made inspection impractical. Time and temperature development as practiced today is still measured by H&D theories.

The H&D curve. Figure 2 is a typical, simplified H&D curve diagram. Negative density at the left increases from bottom to top, while exposure is charted along the bottom of the graph. The time, temperature, and agitation of negatives during development affects the H&D curve in terms of *contrast* between the bottom left "toe" and the top right "shoulder" of the characteristic curve.

Hurter and Driffield divided the curve into three parts. At bottom left the concave segment or toe, represents underexposure. The center straight line section indicates density increase or *gamma,* and the top right convex shoulder represents overexposure. The steeper the slope of the straight line portion, the higher the gamma will be, and the greater the contrast of the negative *due to development.* That phrase in italics is important, because total negative contrast is due to various factors such as subject contrast, development contrast, and the optical system of an enlarger and camera. Thus gamma here refers to *development* contrast only.

Densitometry. Let's begin with the word *sensitometry* which is derived from two Latin words meaning "sensitivity" and "measurement." In the language of *Practical Densitometry* (Kodak Pamphlet No. E-59) from which some of this information was gathered, sensitometry is the determination of the photographic characteristics of a light-sensitive emulsion. *Densitometry* is the use of an instrument called a densi-

2 *TYPICAL H&D CURVE*

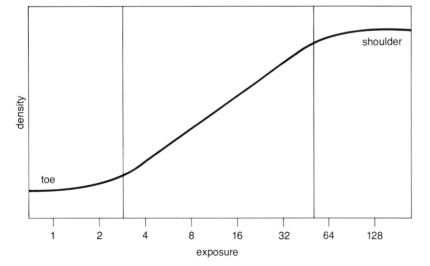

tometer to obtain the data for that determination. One word implies the other: Densitometry is part of the practical application of sensitometry. Together the words spell out a way to understand the relationship between film exposure and development.

Contrast index. This is a more modern term for the measurement of development contrast within a roll or sheet of film. Contrast index indicates the *average slope* of the straight portion of the H&D curve, also called the *characteristic curve,* that is desirable for a particular picture-taking application, such as portraits or scenics. Both contrast index and gamma are expressed in numbers relating *density* (the amount of developed silver in any area of negative) to *transmission* (the amount of light that gets through a given negative area *divided by* the total amount of light striking that area). *Opacity* (the total amount of light striking a given negative area *divided by* the amount of light that passes through that area) is simply the reverse of transmission. Density, transmission, and opacity are tied together in a logarithm (with which I choose not to burden you or myself) through which gamma is determined.

Gamma, or contrast index, may seem confusing at first, but when a negative is evaluated in a densitometer, we have a precise measurement of its density or opacity (which describe the same thing in different ways) in relation to exposure and development. Kodak's pamphlet simplifies it this way: "In any negative, the density differences we see are there because the different areas received different amounts of exposure. We can say that, with any given degree of development, the density anywhere in the negative depends on the exposure at that point." That relationship is shown in figure 3 for three pieces of film on which is recorded the same image made at three identical exposures. The samples were processed at three different developing times, producing three different gamma curves, or contrast-index values. (The term contrast index (CI) has replaced gamma in most Kodak data sheets.)

The film graphed by line A in figure 3 was developed for three minutes, producing a negative of soft gradation with a gamma of 0.5; it is described as "thin" or "flat" because its image is pale and contrast is minimal. Printing a thin negative is frustrating and irritating. However, the natural tendency to overexpose or overdevelop film simply to avoid thin negatives should be restrained. When in doubt, and no other alternative seems feasible, overexposure or overdevelopment is preferable to underexposure or underdevelopment, because "heavy" (dense) negatives are somewhat easier to print than thin ones. But proper exposure and development, through awareness of light, contrast, metering systems, and all of the ingredients of photography, is consistently possible. Yes, we all make mistakes, but only a fool expects them to be lucky mistakes.

The piece of film graphed by line B in figure 2 had five minutes' development, and its gamma of 0.8 shows a good density relationship. In fact 0.8 is an excellent median gamma value for 35mm and 120 films, while 0.9 (slightly more density) is representative of sheet films. Line C in figure 2 shows a gamma of 1.5 which indicates excessive density in the negative. It was developed for 11 minutes.

Keep in mind that the developing times mentioned in the above examples are all symbolic. However, you will find that film and developer manufacturers

3 *TYPICAL GAMMA CURVES*

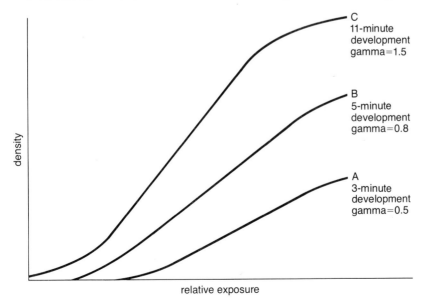

C
11-minute
development
gamma=1.5

B
5-minute
development
gamma=0.8

A
3-minute
development
gamma=0.5

density

relative exposure

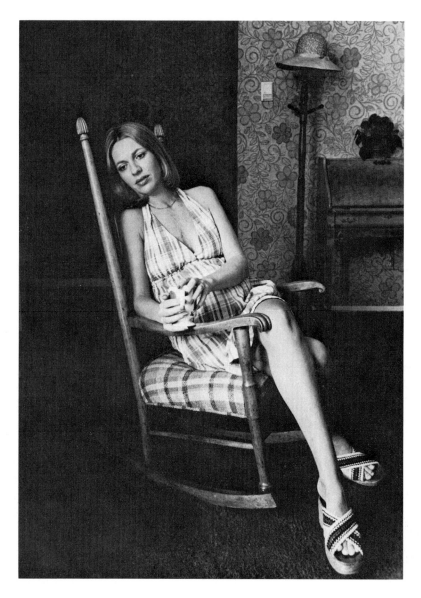

4 *Film was developed to a gamma rating to accentuate bright areas and allow shadows to create contrast with minimum detail.*

build far more rapidly in more heavily exposed areas. Thus there is a faster gain in contrast in more heavily exposed areas during early stages of development, until a point is reached where continuing development results in a diminishing increase of gamma. Eventually the build-up of density is equal over the entire negative.

Interpreting Gamma

Usually a photographer works with time-temperature-gamma charts or tables for a specific film-and-developer combination. By studying a gamma curve, you can discover how rapidly contrast increases for the film and developer at hand. This is especially valuable if you need to know approximately how much additional contrast a negative will exhibit if a period of development is reduced or extended beyond the recommended interval. If you know that a roll of negatives is uniformly underexposed or overexposed, you have a guide from development tables to compensate for some, but not all, of the error in exposure. Such tables also show the relationship between time and temperature, because the warmer a developing solution, the shorter the processing time.

Inherent contrast of an emulsion is also involved. You will find that slow, higher-contrast films require less development time, while fast, lower-contrast emulsions are developed longer. Choice of a developer may also be made according to inherent film contrast, with "soft-working" developers more appropriate to slow, higher-contrast films, and formulas that produce more contrast being better matched to some fast films. These choices, however, depend on the subjects you shoot and your personal taste regarding films and developers. This comes with experience.

Gamma is also affected by agitation during film development. In processing roll film, the tank used is lifted and turned at regular intervals, usually for 5 seconds every 30 seconds, a process called *agitation*. Sheet film hangers are lifted, drained, and returned to the developer every 30 seconds to agitate them.

may show time-temperature-gamma charts in their literature. If you know that a certain gamma value is indicated for the film/developer combination in use, the published information is useful as a guide. As we shall see, developing practice, based on manufacturers' data, will give you time-temperature figures to fit your personal needs and taste.

In figure 3 it is clear that gamma increases as developing time is lengthened. Silver halide particles in negative areas that received the most exposure begin developing first, while fewer particles are affected in the less-exposed portions of the image. As the development process converts grains of silver halide into shades of gray and black, negative density continues to

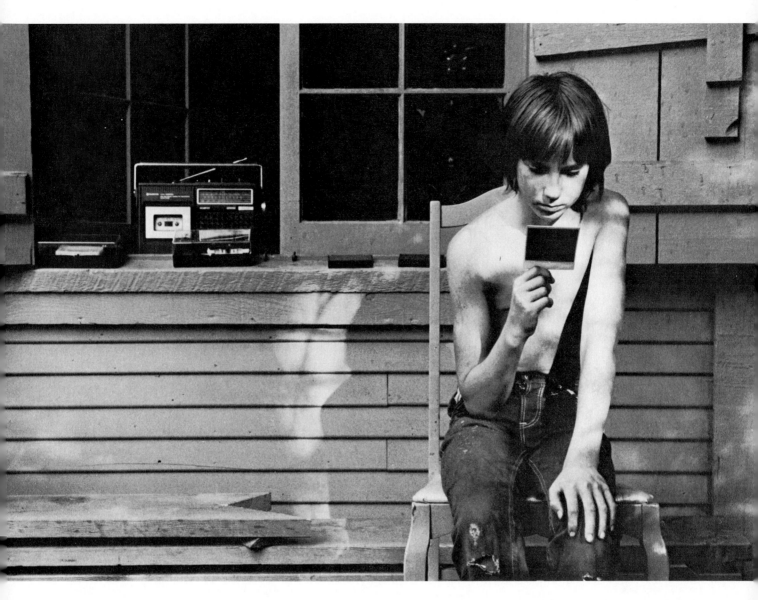

5 *Grain is usually not a problem with 35mm films when development is for a minimum time to allow both highlight and shadow details to print. Youngster was observing development of his first SX-70 print.*

Agitation during development brings fresh solution to the film emulsion regularly, and helps remove chemical by-products formed as the developer reacts to exposed silver halide particles. Without agitation, negatives would be undesirably flat (lacking contrast) and sometimes mottled because development was not uniform. Improper agitation may produce streaks in the negative. These conditions will be discussed again when actual film development is described.

Gamma and grain. With any type of film, grain size increases as the film is developed to higher gamma values. In other words, if you overdevelop film,

or overexpose and develop it normally, density is increased, thereby making it grainier. Silver grains have a tendency to form in clumps as development continues, resulting in more noticeable grain when the negative is enlarged. Fine-grain developers are able to restrict this clumping action, but the basic phenomenon still exists, and excessive development means a more prominent grain pattern.

Gamma and contrast. When film is developed to the proper gamma, it has good shadow detail, good middle tones shown on the straight-line part of the gamma curve, and printable highlights in the shoulder portion. If for any reason the gamma value is increased or decreased, gradation suffers. Overde-

6 *Bright water in scene was exposed and developed on a 35mm roll, and could be printed easily on normal paper, according to a routine that photographers establish through experience.*

veloped film may show good shadow detail, but highlights are harder to print. Underdeveloped film has a decreased toe, meaning that blacks are difficult to print, and highlights are soft without the sparkle they should include. While you can correct some of these effects, as explained in the next chapter, it is far better to aim for a correctly exposed and developed negative, for brilliance, gradation, and graininess will be superior.

Gamma in general. If a densitometer is not available to you for precise analysis of negative gamma, don't worry about it. Gamma has been discussed as a theoretical means of evaluating and comparing black-and-white negatives, but the real basis of judging the success of film development is visual.

Expose your film as carefully as possible, taking into account the type,

direction, and intensity of light, the reflectivity of the subject, and the contrast range you are photographing. Follow the meter reading as often as possible, making manual adjustments only for extremes, as explained in previous chapters.

Develop your film at first according to the manufacturer's time-temperature recommendations. After a few rolls, you will make your own interval adjustments, based on the printability of the negatives. Perhaps someone may suggest an increase or decrease of time that sounds valid (as I will later for Kodak films and developers). Experiment until you get the time-temperature ratio you prefer. If the ideal gamma is supposed to be 0.7 or 0.8 for a 35mm film, and you develop to 0.65 or 0.75, the difference will show up only when you print. The numbers can be ignored before, during, and after you learn to process film satisfactorily, if you rely on visual judgment and get full-scale prints. Should you learn these steps with the aid of a densitometer, evaluating the results will be more precise, but eventually, you will know if negatives are okay simply by inspecting them.

FILM DEVELOPERS

There has long been a marvelous mystique circulating among photographers about film developers. Films, cameras, and printing papers have evolved considerably in the past century, and certainly there are modern developer formulas, but some are more than 100 years old and still in use. One of these is called *pyro*, named from the chemical pyrogallol in it—which is poisonous. It was introduced back in 1851, and an ABC formula version (in three separate solutions mixed before use) originated in the 1890s. Pyro deposits a brown tint on negatives. It is inherently coarse grained, and it reduces the effective emulsion speed of a film; thus pyro is appropriate only for large-size sheet films. It was a favorite of Edward Weston, who contact printed his 8x10 negatives with no worries about grain. If you

7 *Four-by-five film was developed in D-24 for a few minutes longer than normal to synchronize with exposure decrease for subdued lighting. Full negative was enlarged to 8x10.*

have a chance to study a Weston photograph, you will see amazing gradation and brilliance. However, easier, safer developers are more desirable today.

Developing Chemicals

There is one formula I shall give later that requires mixing separate chemicals, but in general photographers may rely on ready-packaged developers available in ample variety. Even so, you should be familiar with the names of chemical developing agents which are listed here briefly:

Metol. Also known as Elon, Pictol, Rhodol and Plenetol, metol is the most widely used "normal-contrast" developing agent. It can be used alone to develop films to low or high contrast, but it is most often combined with hydroquinone.

Hydroquinone. Older than metol, hydroquinone can also be used alone, but mixed with metol, the resulting formula has characteristics usually superior to either agent by itself. Trade names of metol-hydroquinone formulas include D-76, DK-50, D-19, Dektol, and MQ.

Sodium sulfite. Sodium sulfite is used in many developer formulas to provide the proper alkalinity.

Other chemicals such as phenidone, sodium carbonate, potassium bromide and carbonate, and special ingredients not announced by manufacturers are also found in developers. Keep in mind that knowing a formula is useful for comparisons, but test results are the payoff.

8 *Fine-grain developers are available for optimum results with various black-and-white films. Kodak's Microdol-X was used here with Plus-X film. No grain is visible in actress Yvette Mimieux's pretty face.*

Choosing a Film Developer

Because this is a topic subject to personal, justifiable prejudice, I will approach it briefly. There are three types of film developers:

1. *Fine-grain developers.* Various companies make fine-grain developers. The one I am most familiar with is Kodak's Microdol-X which has been around for decades. I have found it quite satisfactory with both Plus-X and Tri-X, but there are those who claim it is not as efficient as their own favorite formulas. I use it full strength and replenish it as directed. I have read that diluting it 1:3 improves grain and softens contrast. Developing time is ex-

tended, but using three parts of water to one part of Microdol-X has the advantage of fresh developer each time you need it. If you use it 1:3, be sure to move the stock solution to smaller containers regularly, in order to reduce the amount of air above the developer. Unless stored in completely filled bottles, developing solutions tend to oxidize, indicated by turning brown and losing their potency.

Another fine-grain developer is the one-shot type. You add to water a specified amount of stock solution that comes ready-mixed in small bottles, and throw away the mixture after each use. The one-shot developer is recommended for thin-emulsion, fine-grained films such as Panatomic-X or Adox KB-14.

Other fine-grain developers include Agfa Rodinal, Beseler Ultra-Fin, Edwal FG7, Ethol T.E.C., Ethol Blue, and H&W Control 4.5. A few of these are called *compensating developers,* meaning they produce relatively low contrast, and they are designed for slow films.

The one formula I've found excellent for 35mm, 120, and especially 4x5 films is Kodak D-23, which you must mix yourself. It is fine-grained and produces very even contrast with a full range of tones. You need a small darkroom scale to measure chemical powders. Here is the formula:

Water, about 125°F	24 oz (for 1 qt)	96 oz (for 1 gal)
Elon developing agent	¼ oz	1 oz
Sodium sulfite, desiccated	3 oz, 145 grains	13¼ oz
Cold water to make	32 oz	1 gal

Average development time is 10–12 minutes in a tank and 8–10 minutes in a tray at 68°F. Add Kodak Replenisher DK-25R at the rate of ¾ ounces per roll (or four sheets of 4x5 film) processed. Discard developer after about 100 rolls of film have been developed in one gallon.

There's a similar Kodak formula for D-25 in which sodium bisulfite is added at the rate of ½ ounce per quart,

9 *Jim Cornfield developed 35mm Tri-X in D-76 to achieve excellent contrast in this wide-angle editorial portrait of Los Angeles County's coroner.*

Full data on D-23/D-24 can be found in a Kodak booklet called *Processing Chemicals and Formulas.* I recommend D-24 primarily for 4x5 and other sizes of sheet film, and suggest Microdol-X or other ready-mixed brands of fine-grain developer for 35mm roll film. Details about D-24 are here because the use of this developer is not widespread, though it is a highly satisfactory formula.

2. *General-purpose developers.* Heading this list is Kodak's old standby D-76. Like the other developers named below, D-76 produces medium-fine grain with somewhat higher contrast than Microdol-X. D-76 used straight or diluted (preferable for reduced contrast) has been extremely popular among photographers for many years, and is often used as a standard of comparison. I'm not fond of it because films developed in D-76 are too high contrast for my taste. However, it and the others below are quite satisfactory for roll and sheet films. Other brands include Kodak DK-50 and HC-110, GAF Isodol and Permadol, and Ilford ID-11.

3. *High-energy developers.* The term "high energy" usually refers to formulas designed for boosted film speeds. My favorite is Acufine, the makers of which suggest you rate Tri-X at ASA 1200 and develop for 4¾ minutes at 70°F. I follow their time-temperature recommendation, but prefer to rate Tri-X at ASA 1000 for negatives slightly more dense.

Among photographic experts there has always been a certain amount of debate about the technicalities of boosting film speeds, on the basis that you lose shadow detail, increase highlight density, and shorten the range of gray tones in between. In theory, all of that may be so. In practice, being able to take pictures indoors in dim light without flash or floods, or anywhere the light level might require the largest lens openings, makes using boosted film speeds a distinct asset. There are few professional photographers, photojournalists in particular, who do not

2 ounces per gallon. My formula included ¼ ounce of sodium bisulfite per quart, and 1 ounce per gallon to mix what I dubbed D-24, which is finer grained. Development time for D-24 at 68°F averages 12–14 minutes. This formula is nontoxic and nonstaining on the film, inexpensive, and offers beautiful results. Here is the DK-25R replenisher formula:

Water, about 125°F	24 oz	96 oz
Elon developing agent	145 grains	1 oz, 145 grains
Sodium sulfite, desiccated	3 oz, 145 grains	13¼ oz
Kokak balanced alkali	290 grains	2 oz, 290 grains
Cold water to make	32 oz	1 gal

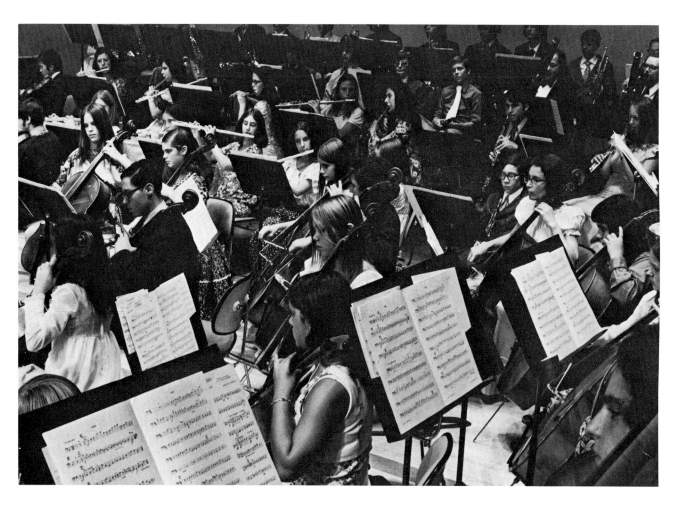

10 *In situations where the light level is low, black-and-white film speed can be boosted for development in special formulas such as Acufine. Tri-X was rated at ASA 1000 in a 35mm SLR camera with a 28mm lens; exposure was 1/60 second at f/5.6.*

rely on a developer such as Acufine, UFG, Diafine, or Microphen regularly. I have come to trust Acufine quality in all kinds of situations where I can shoot at 1/60 second instead of 1/15 second, for instance, or where I do not wish to make myself conspicuous with flash.

Speaking of Acufine because it is the most familiar and easily available, the developing times and temperatures recommended by the manufacturer are reliable. The same cannot be said for Kodak's figures. In addition, though contrast is increased slightly in Acufine, you are most likely to use it with a fast film such as Tri-X which is not inherently a high-contrast emulsion. With the Tri-X/Acufine combination, I have found quality to be excellent. Shadow detail is satisfactory and highlights are easily manageable when printing. If you have or expect the need for boosted film speeds, a high-energy developer can be a blessing.

The same company that makes Acufine also makes Diafine. It's a two-solution developer with the same developing time for all films. You develop in part A and then in part B; chemical development stops itself at the proper point. Tri-X may be rated at ASA 2400 when developed in Diafine, but I suggest a careful test before you use this developer for serious work. I'm sure others have found it efficient, but negatives have always been too thin in my experience with it.

There's one more advantage of boosted film speed coupled with a high-energy developer. You can take pictures with a small electronic flash unit (such as 40WS) mounted on top of a 35mm camera, pointed at a ceiling for bounced light, and be able to use smaller apertures for greater depth of field. A rule of thumb I have found is that with my 40WS EF unit, using Tri-X rated at ASA 1000 and developed in Acufine, I can shoot at 1/60 second at f/8 in average rooms. If this combination appeals to you, make some tests

and record the f-stops you use in several indoor situations. Bounced EF can be slightly monotonous if used too often, but in many situations it is an ideal compromise.

Summary

Beat the mystique of film developers by experimenting until you find a combination(s) you like. Then stick with it. Let others praise their magic formulas, and be fickle. You zero in on the developer(s) that gives you negatives that print easily under many contrast circumstances. Then concentrate on taking pictures, knowing that your darkroom activities will be predictable.

OTHER FILM CHEMICALS

Only a few other solutions are involved in film development. One is a fixer or *hypo* which is used after the developer has been rinsed from the film. Hypo stops development and removes unexposed silver as well as the antihalation backing on film, seen as a pale pink before it is dissolved. Both Kodak and Dupont manufacture hypo with a hardening agent in it that makes film less vulnerable to scratching. There are also quick-fix hypo solutions, usually supplied in liquid form, which decrease the time necessary for fixing. To accurately determine how long hypo is

11 Typical film developing equipment includes metal tank and reels, square tank in background in which to heat or cool solutions, interval timer, scissors, beer-can opener to open 35mm cartridges, thermometer, filter funnel, film-drying squeegee, windshield wiper, stainless steel clips, sponge and towel.

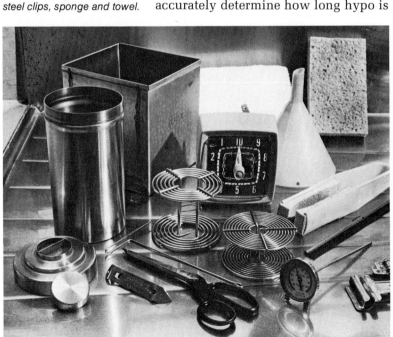

useful, buy a tiny bottle of a chemical such as Edwal Hypo-Chek. When a drop of this darkroom aid turns milky in the hypo, the latter should be replaced.

Though a stop bath or *short-stop*, consisting of a small amount of acetic acid in water, is necessary when printing (to neutralize the developer and prevent hypo contamination), *don't* use an acid short-stop when developing film. Rinsing the film in plain water is quite adequate; use of acetic acid, even in very diluted solutions, is likely to cause microscopic pinholes in the film which appear as black dots on prints.

After the film is developed and fixed, another chemical is recommended to neutralize the hypo before the film is washed, thereby greatly reducing wash time and saving water. Orbit Bath and Kodak Hypo Clearing Agent are relatively inexpensive, may be used for films and prints, and are a must for efficient darkroom work. Follow printed directions and save time.

Note: It is advisable to mix and use *separate* containers of hypo and hypo neutralizer for films and for papers. Each of these solutions for film should be filtered after use, while this practice is not necessary with papers. Contamination of solutions by minute particles of dirt is less likely with separate containers.

FILM DEVELOPING EQUIPMENT

Darkrooms are somewhat like kitchens: a simple, functional area with a minimum of equipment is often sufficient to get the job done right, but large, luxurious models do exist. Basically, you need an area that can be completely blacked out in which to load film developing reels. Thereafter, you can work in a bathroom or kitchen, on any surface that is resistant to chemical stains and is easily cleaned. Nearby running water is essential, but it need not be in the same room. It is also preferable that room temperature be around 70°F, but cooling or heating solutions is easy. More about home darkroom layout appears in the next chapter. You may load film reels in a dark closet, and proceed with the steps outlined below.

Basic Equipment for 35mm and 120 Films

Developing tank. Least expensive and versatile are plastic tanks and reels which break when dropped. Loading a plastic reel by feeding film into a continuous spiral is not difficult if the reel is completely dry. However, most plastic tanks will take only one or two 35mm rolls at a time.

It is recommended that you use a stainless-steel tank, such as the Nikor or Kindermann. They are made in various sizes to hold from one to seven or more 35mm reels at one time. Whatever investment you make in a tank and reels will pay dividends in convenience. Stainless-steel tanks and reels do not wear out, and you can usually sell them for almost their original price if you "go out of business."

A two-reel or four-reel stainless tank has a tightly fitting lid with a small cap over a lighttight fill-and-drain hole. Reels are purchased separately for 35mm or 120 film. They are not adjustable, but they provide excellent circulation of solutions and can be dried quickly. Wet film will wind back onto a stainless steel reel very simply if you unwind it to inspect negatives. Buy at least two 35mm reels as a starter, and more if your volume increases. Reels are stacked on a stainless lifting rod that comes with the tank. Tanks holding six and more reels do not have a pouring spout, but it's unnecessary.

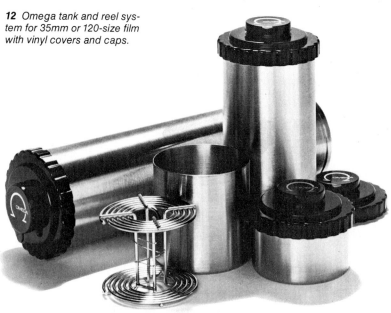

12 *Omega tank and reel system for 35mm or 120-size film with vinyl covers and caps.*

Thermometer. Various brands and types are available, but inexpensive thermometers are likely to be off a few degrees one way or another. Weston Instruments and Eastman Kodak make thermometers with a round dial on top and a long stem that can be lowered into a developer bottle or tank. They are more expensive and more accurate. If you buy an inexpensive model, check it with one that is correctly calibrated, and make allowances in using it. One degree plus or minus for a developing solution won't ruin your film, but precision gives more predictable results.

Funnel. Buy a funnel with a stainless-steel mesh screen in it to filter developer, hypo, and neutralizer as they are poured from tank to bottle. Use another without a filtering screen to pour solutions used for printing.

Timer. You can use a watch or clock, but it is easy to forget when you begin timing, so an interval timer is preferable. The most practical is a wind-up model which you set for a specific interval. To start it, you pull a lever in the back, and when the time is up, the lever rises and a bell rings. It's easy to time one-half or one-quarter of a minute with such an instrument, and since you can set it for an hour or more, it's also useful in the kitchen for cooking.

Film washer. Water should enter the top of a film-washing container and drain from the bottom, because hypo is heavier than water, and this method is most efficient. You can wash film in a developing tank, but circulation of water is not very good. There are several brands of film washers on the market, some of which force water into a container for fast washing. You may also put holes along the bottom edge of a plastic or stainless container to improvise a washer. Check at your camera shop for recommendations.

Film squeegee. There are several types, shaped like a pair of tongs. One type has soft rubber blades imbedded in each leg, and the other uses soft sponges. The rubber blades are prefera-

ble because dirt adhering to sponges can more easily cause scratches on film. If you use a sponge squeegee, keep it scrupulously clean by constant rinsing. An ordinary automobile windshield wiper blade, short and straight if you can find one, is also a good squeegee. I use a sponge squeegee on 35mm film only to wipe the water from sprocket holes, and wipe the remaining moisture away with a wiper blade. A soft rubber squeegee should do both jobs on 35mm film and work as well on 120-size film.

Sponge. A medium-sized kitchen-type sponge is valuable for wiping working surfaces during and after developing.

Scissors. Household scissors are necessary to cut film from spools and clip the leader from 35mm film before inserting it into a reel.

Film-cartridge opener. Kodak sells such a device, but you can just as well use the rounded end of a beer-can opener to flip the end from a 35mm cartridge.

Film clips. Stainless-steel clips are preferable as weights on the ends of drying film rolls. Special clothespins are available with a metal clip at one end which fastens over a wire on which film is hung to dry. The latter clips may also be used as weights.

Containers. Developer should be stored in special plastic bottles sold in camera shops. They are opaque and airtight. Brown glass bottles are also okay, but hard to find now. Don't use plastic bottles made for household bleach because you're never sure if the former contents are completely gone.

Improvise a container in which to place hot water or ice water to warm or chill developer and hypo. I use 5x5x5 stainless-steel tanks bought decades ago in which 4x5 film is developed. Anything deep enough to hold a developing tank while it is heated or cooled will suffice.

DEVELOPING 35MM AND 120 FILM

There is no way to overemphasize cleanliness and order in relation to film development. Filtered solutions, clean containers and work surfaces, and meticulous habits are absolutely essential to prevent dirt and scratches on negatives before, during, and after processing. All of these things become routine if you begin carefully. When you have spent long intervals spotting prints to remove scratch and dirt marks, a majority of which are preventable, you will be motivated to maintain sanitation just short of a hospital operating room.

Preparation

1. Pour developer into the tank, and check the temperature. Warm or cool the solution to 68°F or 70°F, the latter being a more convenient standard temperature at which to work.

2. Pour hypo into another tank and raise or lower the temperature to within a few degrees of the developer.

3. Place the top adjacent to the developer tank so that you can find it in the dark. Set your interval timer for the number of minutes the film is to be developed.

4. Once your film reels are loaded in the dark (instructions follow), they should be placed in the developing tank and the top put on. Start the timer immediately.

It is feasible to place reels in an empty tank and pour developer through the lighttight top, but this practice is slower and is not recommended, because the film is not immersed evenly. However, if you must load reels in a closet and bring them to a lighted room to work, adding developer afterward is not that risky. It would be better, however, to take the tank of developer, the top, and the timer to the closet with you, and start the film in a full tank as described.

5. Cap the developer bottle as soon as you have poured out enough solution for the film at hand.

13 *Open film cartridge with blunt end of beer-can opener.*

14 *Cut leader off film in straight line.*

15 *Insert film end into center of reel and be sure it is curved for a better starting position. Bow the film slightly to assure easier loading.*

16 *Revolve the reel with one hand, allowing film to unroll held and bowed in the other hand. Handle film by the edges only. Listen to hear film click into spaces between reel segments as loading begins properly.*

Loading a 35mm Stainless-Steel Reel

Remove the cap at the end where the *short* portion of the spool sticks out by prying it off with a beer-can opener or other device. Slip the film from the cartridge and cut off about four inches of the leader. Some cartridges are not re-usable, and can be discarded.

At this point you load the reel, which is not difficult—once you practice or have experience doing it. However, for the beginner, the process is often tricky and frustrating. I highly recommend that you use an outdated roll of film, or even render a good roll otherwise use-less, and practice loading a reel with the lights on. Follow the directions and photographs (figures 13 through 19)

17 *Continue to revolve the reel until film is loaded. If the film jumps "off track," you will hear the difference; back up, and re-reel it.*

18 *Cut spool off the end of film roll as close as possible to the binding tape.*

19 *End of film should click into place; if it doesn't, it may touch adjacent film and prevent even de-velopment. Listen and feel (with dry fingers on the edges and back of the film) throughout the load-ing process.*

while observing your movements, and alternate loading with your eyes closed, until you become proficient. In the dark you must accomplish the whole process by feel and sound; practice will assure a smooth operation. With almost 30 years' experience, I still go through awkward moments loading a reel sometimes because I slip up on some tiny manipulation. I am not trying to alarm you about this procedure, because it becomes routine. I merely want to forewarn you that it requires specific hand movements which eventually become automatic and fast.

The full routine is described in the photographs and captions which are detailed enough to encourage expertise. Loading a reel properly is an important bridge between taking pictures with awareness, developing film carefully, and later training your visual judgment about fine print quality.

Loading a 120-Size Reel

This is duck soup compared with loading a 35mm reel. The principle is the same, except that a 120 reel has a clip in the center which makes starting the roll easier. In addition, a 120 or even a 220 roll of film is shorter and wider than a five-foot 35mm roll, and easier to manage. Pertinent points are illustrated in figures 20 through 24.

20 *Starting to load a roll of 120-size film for development, pull off tape that attaches film to paper backing.*

21 *Fit the film end into clip in center of reel. With fingers be sure film is centered, and shift it even a few millimeters if necessary.*

22 *Revolve reel with one hand, and allow film to unspool held lightly in the other hand. Bow the film to assure its being taken up evenly in the reel.*

23 *Continue revolving reel until full roll is loaded. If uneven feeding of reel occurs, pull out a length of film, and re-reel it.*

24 *Throw spool and backing paper away, and click the end of film into the reel, touching it lightly to be certain it does not touch film next to it.*

Film-Loading Tips Reviewed

Point number one is: Never touch the film emulsion side with your fingers or any other materials. Hold film by the edges only. If you must touch the back of the film, do so lightly. It is less vulnerable than the emulsion side, and dry fingers will usually not leave marks, because the backing is eventually dissolved away.

Point two: Wherever you load film reels, make a habit of placing your equipment in the same location each time, so it will be at hand and easily found in the dark in a familiar spot.

Film Developing Procedure

1. Lower reels into the tank of developer, and jiggle the lifting rod a few times to shake off air bubbles that may adhere to the film surface. Start the timer, and put the top on the tank. Turn the lights on.

2. Immediately agitate the film tank: lift the tank, turn it upside down, and rotate it a third to half a revolution as shown in figure 25. Lift, invert, rotate, and return the tank to the upright posi-

25 *Handling of film developing tank during agitation is shown in triple exposure. Agitation begins with tank right side up, side #1 facing you* (left). *As tank is inverted* (center) *and returned to upright position* (right), *it is revolved half a turn so side #2 faces outward. Each time the tank is turned upside down, it is rotated 180 degrees.*

tion 15 times at the beginning of development. Afterward agitate the tank five times every 30 seconds. Agitation practice may vary according to the film or developer you use. Kodak recommends the routine described above, while the makers of Acufine suggest 10 seconds of agitation at first, followed by five seconds each minute. I have been using 15 times to start and five times every 30 seconds with Acufine and Tri-X for many years, so religious adherence to some directions is not mandatory.

Proper agitation assures evenly developed film. The tank should be inverted gently, and five agitation movements should take about five seconds. However, if you're reading or answering the phone, and forget to agitate at one 30-second interval, don't despair. You will not notice the difference in your negatives. Should you neglect several intervals, contrast and uniformity of development may be affected.

Rotating the tank as it is inverted is additional insurance of even development, especially of one-tone negative areas such as sky. An excessively repetitive pattern of agitation without rotation increases the risk of streaks in sky areas, for instance.

3. When development is complete, turn out the lights (assuming you're in a blacked-out area), remove the top of the tank, lift out the reels, and rinse the film in running water for 10 seconds. Shake the reels on the lifting rod, and lower them into the tank of fixer. Jiggle the rod several times to disperse air bubbles. The lights may be turned on within 15 seconds after the film has been completely immersed in hypo.

If you use the fill-and-pour method, when development time is up, pour the solution back into its container, and run water into the tank immediately. Swirl the water in the tank for about 20 seconds, drain it completely, and pour in the fixer. Swirl the solution in the tank to dislodge air bubbles, and remove the tank top. From this point on you can agitate occasionally by lifting the reels on the rod.

4. Pour replenisher into the developer, and return the developer you just used to the bottle via a filter-funnel. Cap the bottle, and mark on it the number of rolls developed. A date should also be recorded on the bottle, showing when the developer was mixed. Follow manufacturer's directions about discarding the developer, but 50 or 60 rolls per gallon seems a reasonable limit, even if the recommendation is higher. You can use Microdol-X four or five months if properly stoppered and stored, and Acufine at least three or four months. Discard excess developer left in the tank when the bottle is full.

5. Film should remain in the hypo about twice as long as it takes to clear the backing off completely. Five minutes longer will cause no harm, but excessive fixing tends to bleach a negative slightly, and makes it more difficult to wash efficiently.

6. You may inspect your negatives after 15 seconds in the fixer, but evaluation is more positive when most of the backing has dissolved. It is easy to roll the film back on a reel in the light. Use a consistent light source to inspect negatives, wet or dry, for more accurate comparison and judgment.

7. When fixing is complete, pour the hypo back into its container (this chemical is reusable), and rinse the film in the tank by filling it with water and discarding the water at least three times. Surface hypo is removed, and the neutralizer that comes next will last longer. If a longer rinse time is stipulated by the manufacturer of the neutralizer, follow it.

8. Pour neutralizer into the tank, and agitate the film periodically for the interval suggested by the manufacturer of the neutralizer. Return the neutralizer to its bottle, and keep a record of the number of rolls processed in it.

9. Wash the film in a washer made for the purpose, or improvised as described above. In 70-degree water, five minutes is the average wash time suggested by makers of most neutralizers. Water flow should be vigorous, but can be adjusted so the washer does not overflow. If tap water is very cold, wash the film at least twice as long as normal. Avoid water warmer than 75°F because it can affect the emulsion in a faint wrinkled pattern known as *reticulation*. My tap water has been 80°F in summer, and no reticulation has occurred, but the film and chemicals you use may be different from mine.

10. While film is washing or before, rinse the tanks and other equipment thoroughly in warm water, and stand or hang them to drain. Sponge off work surfaces as you proceed to prevent chemicals from drying into a white powder that is easily distributed to contaminate other areas.

11. After film is washed, leave it on the lifting rod, and fill a tank with water into which you put a wetting agent such as Photo-Flo. You may mix a wetting agent and water for repetitive use, but instead I suggest you get a medicine dropper and add fresh Photo-Flo to the tank of water each time. Ten drops to a tank with three or four reels in it is sufficient. Jiggle the lifting rod to circulate the wetting agent, and let the film soak about one minute. A wetting agent helps reduce surface tension on the film, and water drains or evaporates more quickly and evenly.

12. Remove the film from the reel carefully. If part of a 35mm roll rests on a clear work surface or in a sink, that's okay, but don't drag it around. Stretch a strong wire in a place where air circulates freely, but people do not. With clip-clothespins, attach the film to the wire to dry. Place a weight on the bottom, such as another clip or two.

13. Dip a squeegee into the wetting agent, squeeze excess water out, and

26 *Use squeegee sponge lightly to remove moisture from sprocket holes of 35mm film. It is not necessary to use a sponge with 120-size film if a windshield wiper or flat squeegee is used.*

27 *Wipe film with windshield wiper or similar squeegee in one continuous sweep on each side. Repeat from bottom to top on back of film if necessary, but avoid repeated wiping of emulsion side.*

wipe the film from top to bottom. *Have a squeegee of your own*, so you are responsible for its cleanliness. A sponge with invisible dirt in it can scratch your film easily, and blaming someone else is no solution. After squeegeeing, wipe the film once or twice with a windshield wiper. *Do not allow film to drip-dry without wiping it*, no matter what promises you read on a bottle of wetting agent. Watermarks on the film inevitably occur in such a case, though they are not supposed to.

Weighting the film as it dries prevents it from curling, especially in warm, dry climates. While drying, film goes through various contortions that disappear completely, but dry 35mm film always has a slight bow in it from edge to edge. If the bow is excessive, place each roll under a weight for a few hours when it is dried and cut, and it will flatten.

Ideally film should dry in a dust-free area, but a certain amount of foot-traffic may not matter. In warm weather a roll of 35mm or 120 film may be fully dry in 30–45 minutes. Accidentally splashed water or chemicals are even more hazardous to drying film, because they

leave splotch marks that may not show up until the film is enlarged. If such marks do occur or if a roll should fall to the floor, wash the film again, place it in wetting agent, and re-dry it. Some of the marks will disappear, and perhaps all of them if you're lucky.

Occasionally, you may wish to dry 35mm or 120 film in minutes, so you can proof and print it quickly. If so, there's a product called Yankee Instant Film Dryer available at camera shops. It smells like alcohol, and after washing, film in reels is soaked in it for two to four minutes with agitation. Use of a wetting agent is eliminated. Squeegee sponges should be dipped in the Instant Film Dryer and squeezed out before application to film. Finishing touches with a windshield wiper blade are okay, but you must be quick, because film surfaces dry fast. In warm weather, drying time may be as little as 5–10 minutes. Yankee Instant Film Dryer is reusable, and should be filtered on return to the container.

14. Clean your work area and any equipment remaining; wipe work surfaces with a towel. A hospital-operating-room point of view in this regard will stand you in good stead. Negatives that require little or no print-spotting are worth all the fussy effort you make.

Though 35mm film has been stressed in the above directions, any roll film is developed by the same steps. A simple exception: 120 film need not be squeegeed with a sponge; use of a windshield wiper blade alone is sufficient, because there are no sprocket holes to clear.

Evaluating negatives visually. The appearance of a wet negative and a dry one is somewhat different, because film "dries down." This term means that image density seems to increase slightly when a negative is dry. If you realize this, you will take it into account when evaluating wet negatives, either smiling or cursing over them. Reserve final judgment about negative quality until you can view dry negatives on a light box or table, or by a consistent light source.

28 *Serious photographers such as Murray Smith, develop their own film with meticulous care, consistent with camera technique and printing practice. Smith is a real estate executive with a talent for decisive grab shooting.*

Archival processing. This term refers to extended washing and careful storing of negatives to assure their preservation for 50 years or longer. Unless hypo is *completely* removed from a negative, the negative will tend to fade or stain after a few decades. Following the directions of most manufacturers is evidently suitable for a minimum 25-year period, because I have negatives that old which are chemically stable so far. I did not use extended washing periods, so I cannot predict how long my negatives will be unaffected.

Eastman Kodak has literature on this subject, and on the archival processing of prints for 100-year preservation. Check Kodak booklets for further details.

Negatives should also be stored in chemically inert materials that will have no effect over the years. The letter envelopes I use, mentioned later, are not ideal. If you wish to improve on my system, check at your camera shop for their best storage materials.

Other Methods of Film Development

Plastic-tank developing. Should you use a plastic tank, agitate the film by alternately revolving the reel clockwise and counter-clockwise. Agitation intervals remain the same. Remove only a few inches of film from a plastic reel for inspection, because it doesn't slide back when wet.

Deep-tank developing. Deep tanks are used by large studios or photofinishers where the number of rolls to be developed is high.

Tray development. It is possible to develop 120-size negatives in a tray of solution, but 35mm rolls are too long. This is an antique method of development during which you hold each end of the film in your fingers and run it through the developer by alternately lifting one hand and then the other. If you do not have access to a tank and must use a tray, remember that the whole process takes place in complete darkness. In addition, you can develop only one roll at a time. Good luck!

Sheet-film development. Using 4x5 film as an example, you must have 4x5 stainless-steel hangers. One sheet of film is loaded into each hanger in the dark. (It is possible to develop several sheets of film at one time by shuffling them slowly in a tray of solution, but the possibility of scratching and finger marks is much too certain.) You also need stainless-steel or plastic tanks into which a number of hangers can be immersed at one time.

Load the film in hangers and place them in the developer at the prescribed temperature. At 30-second intervals, lift the hangers all at once and allow them to drain a few seconds held horizontally. Dip them in developer twice again, tipping them once to the right and once to the left to drain. Agitation in this manner assures even development.

Figure 29 shows a wood cover I made long ago to place over a tank of 4x5 film hangers so that I could turn on the light in my darkroom during the development process.

When development is complete, rinse the film in hangers under running water (or in a tank of plain water if a tap is not handy), and place the hangers into a tank of hypo. Lift the hangers half an inch several times and drop them back to rest on the edges of the tank in order to remove air bubbles from the film surfaces.

Soak the film in a hypo neutralizer, wash it in a tank with holes along the bottom edges, place the film in a tank of wetting agent, and hang each sheet separately to dry. Use of a windshield wiper blade to remove water from sheet film is highly recommended.

When films are dry, place each in a separate negative envelope. Number negatives by batch and individually,

29 *Light shield made by the author to cover 4x5 film hangers during development.*

30 *Light shield box removed from stainless steel tank and hangers for agitation, in complete darkness, of course.*

31 *Flower close-up taken on Polaroid Type 105 film which is developed with print in 30 seconds; negative is easily washed and hung to dry.*

tank of sodium sulfite solution to remove its gummy chemicals. When negatives are clear, pour the solution into another container because it is reusable, and use the tank and its insert that holds eight sheets of film as a washing container. Or leave the film in the insert and place the latter into other film washing equipment where it fits. Hang and dry Type 105 as described for sheet film.

Type 55 P/N Polaroid film is 4x5 and handled exactly the same way as Type 105, except that you may wash it in 4x5 film hangers if they are available.

Film development by inspection. It is possible to inspect panchromatic film while it develops, using a dark green safelight with a 15-watt bulb in it. Halfway through the developing interval, hold the film about 18 inches from the safelight. If your eyes are accustomed to the dark, and you have learned by experience to evaluate the very faint image you see, inspection is a useful means of precisely adjusting film processing. Some photographers train themselves to inspect 35mm and 120 film, but the process is slow and painstaking. Inspecting 4x5 sheet films is more feasible, and a useful adjunct to time-temperature processing for control of contrast and density. Years ago I developed 4x5 films in D-24 by inspection routinely, and feel that my negative quality benefitted. Today I would use a time-temperature method at first, and not resort to inspection unless a more meticulous system was indicated. However, inspection may be appropriate for extremely careful photographers using a view camera with concern for each exposed sheet of film.

and maintain a filing index system for sheet film alone. Details on filing negatives are below.

Film packs and Type 105 Polaroid film. A film pack has a dozen or more sheets of film in one container. It is exposed in a film-pack adapter that slips into the back of a view camera in the manner of an individual film holder. As pictures are taken, pulling a paper tab draws the exposed sheet to the back of the adapter, and a fresh sheet faces the lens. The adapter has a dark slide that allows you to remove the whole pack at any time.

Pack-film sheets are thinner than individual sheet film, and harder to handle during development, but the developing procedure, using hangers, is the same. Developing times for pack film may be shorter than sheet film; check printed data.

Type 105 Polaroid film is a thin 3¼x4¼ sheet that is cleared in a special

Rectifying Negative Extremes

Many negatives that are too thin or too dense can be printed by matching them to the proper grade of enlarging paper, or the correct variable-contrast filter. Make the best print possible before attempting chemical manipulation. If you find negative transparency or opacity too extreme, chemical assistance may then be necessary.

Chemical reducer. Several companies sell small packets of negative reducer which you mix with water. A strip of 35mm film can be soaked in water and then in a reducer while you watch opacity diminish to a more manageable point. The reducer acts like a bleach that slowly dissolves some of the silver in the film emulsion in equal proportion over the entire negative or strip. When reduction is sufficient, you fix and wash the negatives again before hanging them to dry.

Chemical intensification. Thin negatives are soaked in intensifier to help build density to some degree. Intensification is not as effective as reduction, but if necessary, buy the chemicals and experiment.

In both intensification and reduction, remember that a wet negative does not appear to have as much density as a dry one.

DEVELOPING COLOR FILM

Processing both color negatives and color transparencies is generally a mechanical operation involving many steps and chemicals handled with specific disciplines. Kodachrome, as you may know, cannot be developed by an individual, because it requires extensive, expensive machinery. Ektachrome and Agfachrome can be developed in private darkrooms with comparative ease. Negative color films are not complicated, requiring only a few more steps than black-and-white films.

However, until you master black-and-white processing and printing, let a professional lab develop your color. Unless you plan to manipulate color by various darkroom methods to achieve an individual artistic approach, concentrate on taking pictures and gaining control over black-and-white in all its aspects, and use your time more profitably, while specialists handle your color processing. In due time, if the ramifications of color seem appealing, then give it a whirl.

Eastman Kodak and several other companies make available a variety of booklets and charts with complete instructions for developing color negatives and slides. Check for the latest literature in your camera shop. Chemistry changes and processing steps are sometimes simplified. Developing color films may be a challenge, but it's not much fun unless you intend to add a personal touch.

NEGATIVE FILING

A photographer without a careful filing system for negatives, prints, and slides wastes an enormous amount of time finding pictures taken in the past, and may also risk damage to negatives not cared for properly. The prevalence of disorganization among photographers may be high because the urge to get out there and shoot more pictures is stronger than the urge to preserve those on hand. Besides, early photographs may be mostly exercises, and such negatives or slides rarely seem to have much permanent value. Thus negatives, slides, and prints (discussed in the next chapter) are deposited in odd boxes, drawers, or someplace equally obscure. When you finally shoot images worth preserving, there may be no filing system underway. Begin your system early and avoid regrets.

Storing Negatives

A roll of 35mm film should be cut into strips of six frames for contact printing. Various types of transparent folders and sheets are available in which to store these, or you may use my system. Each roll is stored in a standard 9½-inch letter envelope which is numbered. I also record the type of film and developer, the date when negatives were shot, and a brief description of the contents. These data are written on the first envelope when there is more than one in a series of negatives from the same location or job. See figure 32 which includes my index notebook.

Each roll of film is *numbered* separately on the envelope where it is stored. In a small notebook I list roll

32 In the author's negative filing system, each roll of negatives is cut into strips of six frames and stored in a business-size envelope labeled with number and description of contents. Index notebook in which all negative rolls are listed is the key to efficient retrieval.

33 In the author's system, negative envelopes are stored in discarded 500-sheet enlarging-paper boxes.

numbers and the same brief description of subject matter—*plus dates*. The top of each page in this negative index is also dated to match the first roll on that page, all of which makes it much easier to find negatives taken in the past. This is especially valuable if you shoot similar subjects more than once. I may describe a set of negatives like this: "L.A. Zoo, 2nd time, w/fisheye lens, 9/14/75." Each contact sheet has the same roll number penciled on the back. Thus, any print with a roll and frame number, can be ordered or referred to individually.

Envelopes holding 35mm negatives are stored in old 500-sheet paper boxes on the outside of which is marked the roll numbers inclusive. In this way I can find the negative for a picture taken 10 years ago within a few minutes, via the dated index page, assistance from my memory, and a systematic filing method that has been consistent for more than 25 years.

Color 35mm negatives are filed along with black and white, but index entries are in red. These negatives are used to make color prints, black-and-white prints, or slides occasionally, and are easy to locate.

I use a separate index and numbering system for 120-size negatives which are stored in 6½-inch letter envelopes and the same type of 500-sheet paper boxes. An "R" precedes all 120-size negative numbers, which is a hangover from the days when I used a Rolleiflex. Since frame numbers on 120 film are tiny, and each roll repeats the 1–12 figures, I number each negative with a fine pen and India ink, from 1 to whatever figure is necessary for a related series. In this way there is only one R2345-22 file number, for instance, immediately identifiable as a 120-size negative, and findable by date and number in my separate index notebook.

34 An alternative negative filing system uses special sheets into which strips are inserted for viewing without touching the negatives. At the bottom are individual 120-size and 35mm negative storage envelopes in which important negatives may be protected.

35 *Slides may be numbered and stored in boxes or projector trays when an edited selection will be shown regularly. The author's index notebook for color transparency rolls is also shown.*

36 *Slides may be filed and displayed in plastic folios with separate pockets; back of plastic is frosted for viewing.*

A third numbering and filing system is maintained for 4x5 negatives. An "F" precedes the number for a group of negatives, and each envelope, containing one sheet of film, is numbered beginning with #1. Therefore, a print marked F-276-12 is plainly a 4x5 negative listed in a third index notebook.

Your own index and filing system may be a variation on mine, for the manner in which you store negatives should fit your personal needs and taste. Details are not important. A simple *system* is important. This may sound premature to you if photography has a minor priority in your life now, but I urge you to establish a filing system in spite of your feelings that picture-taking is tentative. No matter how much or how little you shoot in coming years, you will be thankful that negatives (plus prints and slides) have been preserved with care, and are quickly available. Any other approach serves to downgrade the efforts you now make to learn, improve, and gain real photographic confidence.

Filing Color Slides

Each roll of film should be numbered and indexed, individually or as a series of related rolls. Use a separate index notebook for color slides. In a stationery store, buy an inexpensive rubber stamp set that includes numerals. Stamp the roll number on each slide, which is already frame-numbered. In this way, if you send a slide somewhere, you can keep an exact record of it, and if you forget where you shot a scene, you can check your index and find out quickly. Of course, roll numbers can be inked on each slide by hand if a rubber stamp seems unnecessary.

There are more ways of filing transparencies than negatives. I'll mention a few, but again your choice is less important than doing it.

1. File slides in the boxes in which they come from the processor, numbering and dating each box.

2. File slides in separate envelopes or transparent plastic pages with indi-

vidual slide slots. These pages are usually punched with holes along the edge, and may be stored in a three-ring notebook for reference and safekeeping.

3. File slides in projector trays that are numbered in sequence and indexed. Kodak Carousel trays come with an index sheet on which you can write brief descriptions of all 80 or 140 slides therein.

4. Store slides in metal boxes made especially for this purpose. Inside the box is a series of metal slots that separate slides, and an index card usually accompanies each box. A record can be kept in your master slide index about which slides are in which box numbers or tray numbers.

Any of the above methods for slide storage and filing can be efficiently managed. Without a system, slides become mixed, scratched, and lost with the greatest of ease.

37 Metal boxes such as this Kodak compartment file offer convenient slide storage, and can be stacked.

38 Various types of slide viewers are made, most of which use cool fluorescent bulbs. The author made this one some years ago; two daylight tungsten bulbs are mounted inside behind the opal glass.

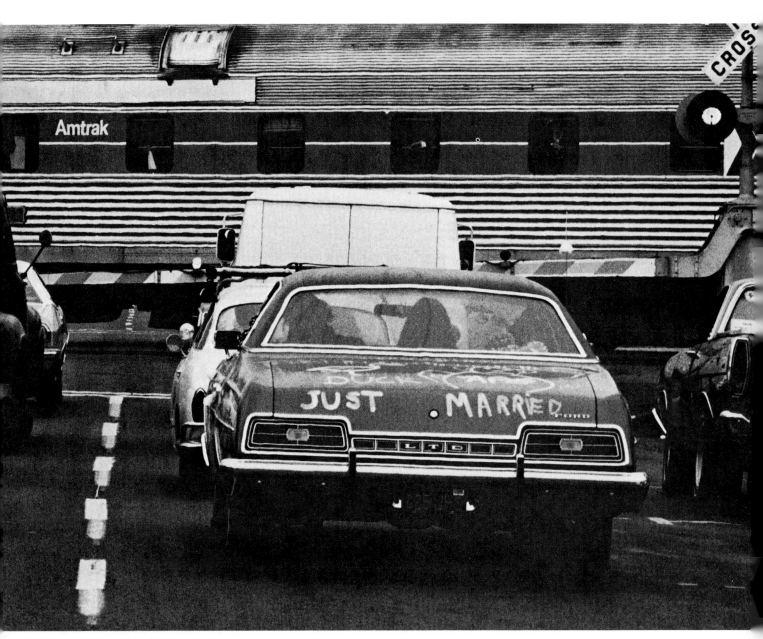

1 *The irony of Paul C. Ebhardt's telephoto shot was emphasized by an excellent print with deep blacks and clear highlights.*

BLACK-AND-WHITE PRINTING

Almost everything you know about taking pictures comes together in the darkroom when negatives are contact printed (or proofed), images are edited, and enlargements are made. As a photographer, you will not truly be able to evaluate your visual sensitivity unless you make your own prints. Were you to shoot only color slides, you would enjoy only a limited capability to crop them; and perhaps you would play around with colored filters, textured screens, or combined images, but the learning process is somewhat confined.

Making black-and-white enlargements extends the skill necessary to photograph effectively, for personal satisfaction, for sale, or for communication of information. The continuing experience of printing inevitably influences how you see through the viewfinder of a camera. Your feelings about composition, lighting, and even choice of subject matter are all improved and refined when you develop your film and enlarge the best of your negatives. Having to make a lot of prints from a few negatives for a commercial purpose is a chore, but the challenge of making one or two fine enlargements from a negative is exciting. No matter how many years you print, each batch of negatives is a new adventure. In many ways black-and-white printing is the payoff for all your photographic effort, and all the theory you absorb. If you go on to color printing, there is an added dimension to the excitement, along with a slower, more expensive, and more tedious process. Much of what you learn making black-and-white enlargements can be applied to color printing when that time comes.

THE DARKROOM

Your own darkroom work area may be fairly temporary and improvised in a bathroom, kitchen, or bedroom. As mentioned before, you need a place large enough to set up trays and other equipment, where the floor is stain-proof or covered, with comfortable air temperature and circulation, and with space to store materials and to move about. If you don't freeze or constantly perspire, your solutions will stay within a useful temperature range. Of course, any darkroom area must be lighttight, though thin cracks of light under doors or around windows are often tolerable for printing papers, if not for films.

Fully opaque window blinds are available, and may be mounted within homemade light traps along four edges. Opaque paint may also be used on glass where its appearance is acceptable. In years past I used bedrooms in several homes and apartments as a combined office and darkroom, by blacking out the areas with opaque blinds. In these situations I found that running water is not necessary in a functional darkroom, though it is certainly desirable. Trays or other containers of water can be carried from an adjacent bathroom where prints and negatives are washed in the sink or bathtub, using appropriate washing equipment. This sort of arrangement may not have been especially convenient, but it was quite efficient.

Makeshift darkrooms can also be set up and dismantled in a kitchen or

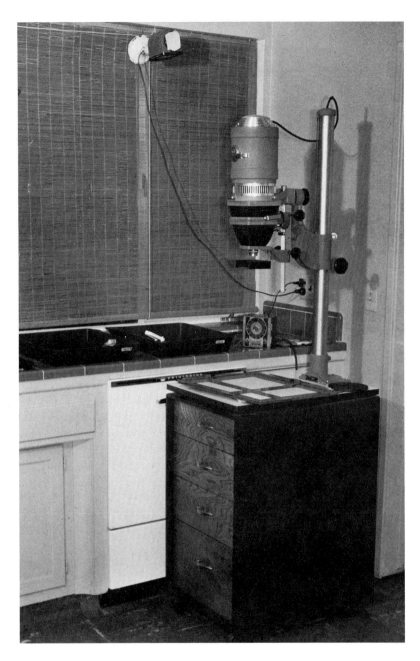

2 *Harvey Hill photographed his rolling storage chest, used when the kitchen becomes a temporary darkroom at night.*

When you are familiar with the essentials of a darkroom, you will be able to devise your own variations of window-blackout, ventilation, lighting, wall and floor protection, and layout of work surfaces.

A Custom-Made Darkroom

For those fortunate enough to have the space, especially where running water already exists or can be installed, here are a few pointers for darkroom design. The size and shape will depend on circumstances, but a limited area is preferable to a large expanse, because you will be more comfortable walking only a few steps between the enlarger and the trays.

Plan a dry side and a wet side in the darkroom. Along the dry side(s) should be a solid surface at a convenient height for one or two enlargers, plus shelf or drawer space for paper, negatives and other equipment. Nearby is the wet side, at a distance great enough to protect the dry side from accidental splashing. Here on a stainproof surface are your processing trays and a sink. Under this area are shelves for bottles, tray storage, a wastebasket, and other equipment.

A sink should be at least six or eight inches deep, and large enough to hold an 11x14 tray. Hot and cold water coming from one tap can be regulated by a special temperature control, but unless you are processing color film and prints, you can use a thermometer and regulate the water manually.

Pegboard on the wall over the sink can be outfitted to hold reels, tanks, and many other items on hooks or small shelves. A viewing light with a diffused 40-watt bulb in it can be installed over the place where the tray of fixer will stand during printing. One safelight goes over the developer tray and another one or two over the enlarger area or wherever you will be working in the dark. Safelights come in various shapes and sizes which you should check in the local photo-supply shop. A yellow filter specified by the maker of the enlarging paper you use is installed

bathroom by storing an enlarger elsewhere, and providing a place to store paper and other equipment, either in the improvised darkroom or nearby. An amateur photographer-friend of mine built a rolling chest of drawers high enough to keep his enlarger on top. The drawers hold paper and equipment, and the whole rig, with the enlarger covered, is kept in a spacious service porch. At night he rolls this self-contained unit into the kitchen, spreads his trays along the sink area, attaches a safelight or two, blacks out several windows, and he's ready to print.

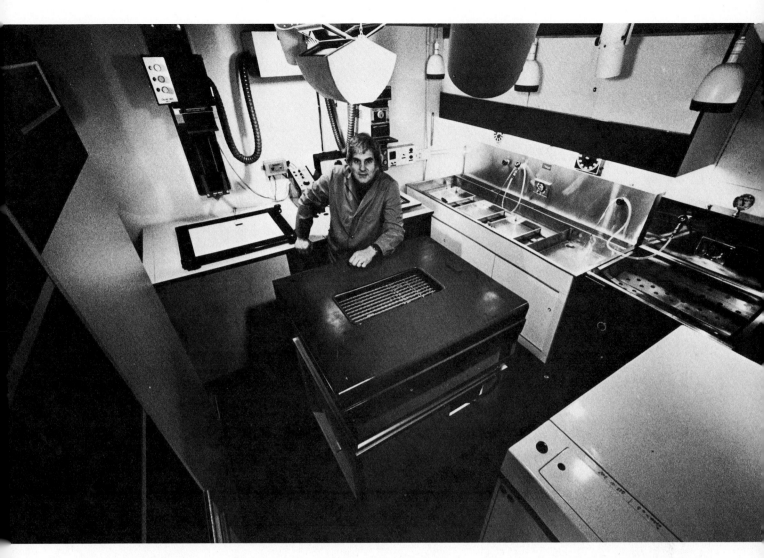

3 Tom Carroll's ultramodern darkroom includes negative dryer (left), enlargers with color analysers built in, sinks, automatic film processor (right corner), and print dryer (center). Carroll designed and built the darkroom, using many standard components.

in most safelights. When your eyes become accustomed to the darkroom thus lighted, you will be surprised how bright a place to work it can be.

A snap-on work light should be mounted over the enlarger area. In the well-equipped darkroom there is also a separate paper trimmer, a ventilation fan made with a light-trap in it, rubber pads or discarded strips of carpeting on the floor for comfort, a lighttight door, a radio, and for real convenience, a telephone or phone plug. Various darkroom plans are available in Eastman Kodak and other literature. Plan yours for efficiency, but luxuries are not required to assure first-rate print quality.

My own darkroom (figure 4) is 12 feet long and 5 feet wide. Work surfaces were designed for standing and sitting convenience. I stand at the enlargers, and sit while developing prints. A tele-

phone is stretched from my adjacent office. A fan in the wall between office and darkroom transfers fresh air from the former. In summer I have the benefit of an air conditioner in the office, and in winter I use a small electric space heater on the darkroom floor. The walls are pale tan, because when a darkroom is blacked out for film development, or when prints are made under safelights, there is no need for dark walls or furnishings. Electrical outlets on the dry and wet sides were installed with separate switches for the safelights and room lights.

If you convert an area or build a darkroom from scratch, it should fit you and your working habits. Think carefully about what you really need, and plan the space for easy movements and

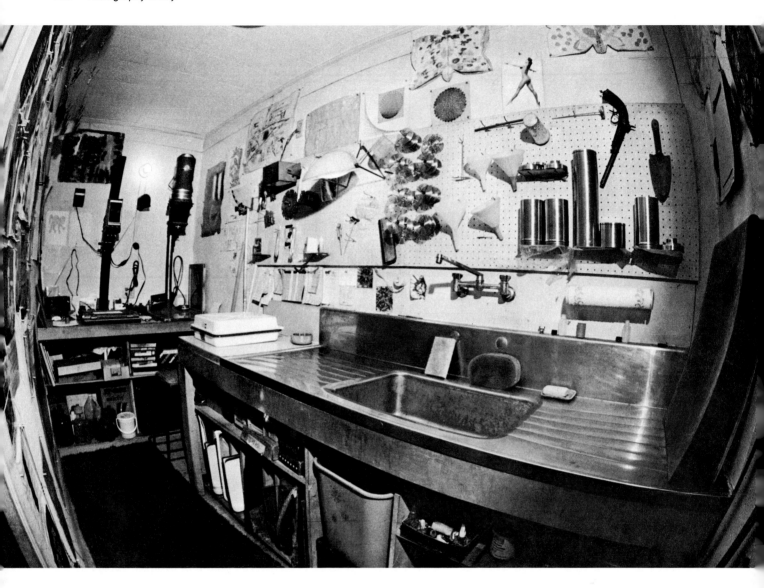

4 *Fisheye view of the author's present darkroom "decorated" with children's paintings and posters.*

handy storage. Part of a garage or the corner of a kitchen may work fine if your equipment can be accomodated, and there is air, darkness, and elbow room. Wherever you work, *keep it clean!* Sponge the surfaces, dust the corners, sweep the floor and be fussy about dirt. Your negatives and prints will be spotless, and you'll have more time to get out there and shoot pictures.

PRINTING EQUIPMENT

On the dry side of the darkroom is the equipment for exposing prints, and on the wet side, the equipment for processing them.

Enlargers

Let's start with the most important instrument in your darkroom, the enlarger. As you probably know an enlarger is actually a projector for negatives. In the enlarger head is a special lightbulb, under which may be condensers or a diffusion device. Beneath the head is the negative carrier, and under that, a bellows by which you focus an enlarging lens. By adjusting the head of the enlarger up and down, you project a varying-size image of the negative onto printing paper which is usually held in an enlarging easel that rests on the baseboard of the enlarger.

A number of enlarger brands are available, made in the U.S. and abroad. These include Omega, Beseler, Durst, Vivitar and Bogen. Designs and prices cover a fairly wide scope to fit different budgets.

35mm and 2¼x2¼ enlargers. Though some models are made for 35mm negatives only, it may be advisable to buy one that also accommodates 2¼x2¼ negatives. Chances are the price differential is not great, and even though you may be using only a 35mm camera now, you may eventually wish to shoot also with a larger-format camera such as the Hasselblad, Bronica, Kowa, Rolleiflex, Yashicaflex, or Mamiya C330. Modern enlargers are built to last decades, so preparing for the future makes sense.

Larger-format enlargers. The next size up from 35mm/2¼x2¼ is 4x5, and the cost is considerably more. It may seem logical to buy a 4x5 enlarger, and use it for smaller-size negatives, if you shoot 4x5 as well as 35mm, for instance. This is possible if the model you choose includes accessory condensers for small-format negatives. However, an enlarger designed for 35mm and 2¼x2¼ alone is smaller and more efficient, so avoid converting a 4x5 model if working in that size is only a marginal possibility.

Condenser enlargers. Within the lamphead of an enlarger are two or three condenser lenses with one flat and one convex surface each. These are placed to project a beam of light through the negative and lens to the printing paper. A condenser system provides the best contrast and definition for small-format negatives. Keep the condensers clean by wiping them regularly with a soft cloth or tissue. Dust and nicotine haze (if you smoke in the darkroom) tend to collect on condensers, reducing their efficiency.

Diffuser enlargers. Instead of condensers, the diffuser enlarger uses a sheet of etched or opal glass to spread the light. This system is usually used for printing color negatives and slides, or for black-and-white portraits, because definition is softened by reduced contrast. A condenser enlarger is recommended for most black-and-white printing, and condensers can be replaced by a piece of diffusing glass if you print color.

Color head. Some enlargers are made especially for printing color, with a filter drawer in the head, a diffusing system, or perhaps a built-in filter

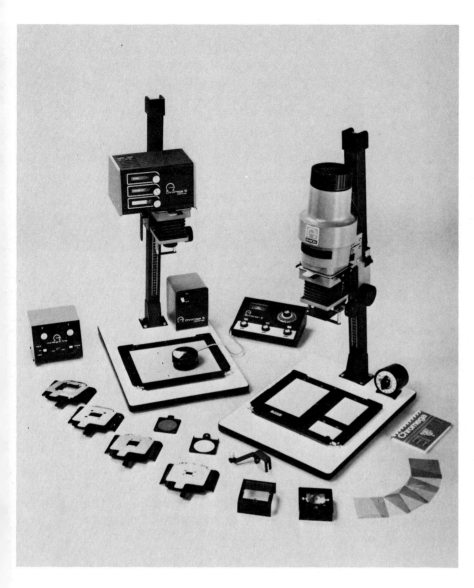

5 *Medium-priced Omega B-600 enlarger* (right) *with colorhead* (left) *and accessories.*

6 *Vivitar Model E-36 enlarger.*

7 *Several manufacturers offer enlarger color heads with built-in variable filtration.*

arrangement, plus a negative analyzer. However, it would be preferable to have a condenser enlarger for black and white, and add a separate color head to convert it for color. This is possible with several brands. You may also print color negatives and slides very nicely with a modern condenser enlarger such as the Omega B-66, without adding a color head.

Focusing options. Most enlargers are focused manually as image size changes, but there are auto-focus models which adjust focus automatically as the enlarger head is raised or lowered. The auto-focus enlarger is very convenient, but more costly than the manual type.

Old or new, an enlarger may work very well for you if its light-projecting system is *even*. This is not a problem with fairly new models, but older ones should be checked if you buy one used. Without a negative in the carrier, and in the dark, turn the enlarger on and raise it for an 8x10 image. Examine the corners of the light pattern projected; if they are slightly darker than the rest of the rectangle, the condensers may need adjustment or the lens itself may need replacement. This situation may be incurable, which would indicate buying a different enlarger to get a perfectly even spread of light through a negative.

Be sure the enlarger head moves smoothly along the column on which it is mounted, and test the focusing mechanism as well. It should be smooth enough to allow minute adjustments easily. There should be a swiveling holder for filters beneath the enlarger lens. Variable-contrast filters or an image diffuser are placed on or in this holder.

Enlarging Lenses

I once used a homemade enlarger fashioned from an ancient folding camera mounted on a horizontal track, aimed at a vertical easel for the paper —and it worked fine because I had a relatively good enlarging lens. In other words, if an enlarger operates well enough, it might be a vintage model and quite satisfactory. However, no enlarger is any better than the lenses used on it.

To illustrate this, many years ago a picture agent in New York remarked that my black-and-white print quality left a lot to be desired. I was slightly offended as well as surprised, because I was using a quality enlarger with a name-brand lens. Even so, I decided to test a newer lens, and the first comparison prints I made dramatically demonstrated the agent's perception. A better, newer lens gave me brighter, sharper enlargements with improved tonal gradations. This was also surprising, but gratifying.

The moral of this story is: Buy the best enlarging lens you can afford because the difference in quality is much more noticeable than among camera lenses. The sharpness of a lens on a $200 camera is much closer to that of a lens on a $600 camera than is the performance of a $40 enlarging lens and a $75 enlarging lens. These are relative figures, but the disparity of results is actual and quite visible.

For small-format negatives you should match the focal length of the enlarging lens to each size as follows:

35mm negative	50mm lens
2¼x2¼ negative	75mm or 80mm lens
4x5 negative	135 to 150mm lens

8 *Tom Carroll, like many fine photographers, finds printing a creative challenge. He used a hand-held 400mm lens at a picnic for a company magazine.*

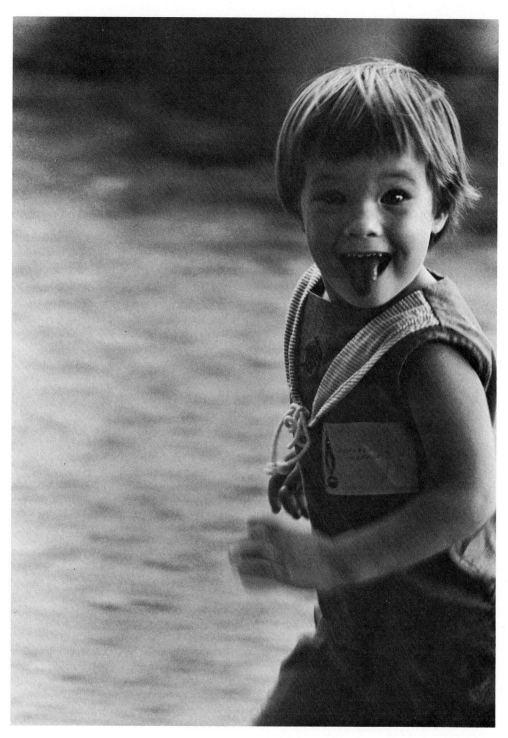

While it is possible to print 35mm negatives with a 75mm lens on some enlargers, the maximum image size with the enlarger raised as high as it will go may be only 8x10. In reverse, a 50mm lens used with a 2¼x2¼ negative will vignette the corners, which means they will be dark on a print, because the focal length of the lens is not long enough. Therefore, you should use two different enlarging lenses for two negative sizes.

Don't try to adapt a camera lens to an enlarger. An enlarging lens is a specialized formula for projection, and a camera lens is not designed for this function.

Note: Be sure that the lens is mounted precisely in your enlarger so that it is exactly parallel to the baseboard and easel. Otherwise, it will be difficult to maintain sharp focus

over the entire projected image, even with the lens stopped down. For average printing, you should be able to work at f/8. If the image projected from your enlarger is not sharp over its entirety unless you stop down to f/11 or f/16, there's a flaw somewhere in the system. Check it out.

Enlarging Easels

You could lay a piece of enlarging paper on the baseboard under the enlarger lens, and project a negative onto it, but the paper would probably not stay flat, and you'd have trouble locating the paper in the same spot each time you printed.

Therefore an enlarging easel is a very useful item, and there are a lot of them on the market. The simplest models are not adjustable. You slip a piece of printing paper under thin borders, using an easel made for 5x7, 8x10, or 11x14 paper.

Next in line are easels with at least two adjustable borders, usually at the right and bottom. You can crop satisfactorily with this type, but you cannot center the image on the paper with equal margins.

An easel with four adjustable borders is preferable, even if it costs more, because it can be a lifetime item. The one I own was purchased used 25 years ago, and may be 30 years old now, but still works perfectly. Try to find a four-way-border easel that takes up to 11x14-size paper, and is priced within your budget—a used one can be just right.

There are also borderless easels in several sizes with slight retaining bars along two edges to hold the paper

firmly. With such an easel you make a "bleed" print without margins, and crop it later with a paper trimmer if necessary. A bleed print for exhibition can be very effective. However, if you submit prints to publication, it is preferable that they have borders from ⅛-to-¼-inch wide in which crop marks can be made.

Choose a solid easel with adjustment capabilities as complete as you can afford, and printing will be more pleasurable.

Enlarging Timer

It is possible to turn an enlarger on and off with a hand or foot switch, and time printing exposures by counting or watching the second hand of a clock, but that's the hard way. Preferable is a timer into which the enlarger cord is plugged. Such a timer works electrically, and you merely set a dial for the number of seconds the enlarger is to be on, after which the timer turns it off.

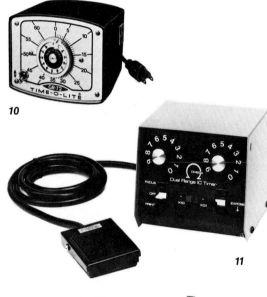

10

11

9 Saunders Omega borderless easels.

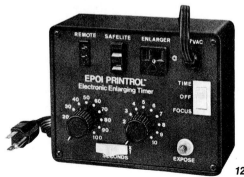

12

10–12 Three types of enlarging timers.

13–14 Two types of enlarging safelights; colored filters are changeable for different papers.

Such equipment costs from $25 up to several hundred; the more expensive timers are transistorized with extra controls that you can do without. The Time-O-Lite is an old standby with darkroom enthusiasts, and it is available in several models. A used timer in working condition is fine. Avoid trying to time enlargements by counting, however, because that method is too inaccurate and makes it too difficult to achieve precise print quality.

Safelights

Check safelight sizes, shapes, and prices at a camera shop. Choose those that hang on a wall or from a ceiling, according to the layout of your darkroom. Most safelights take a 15-watt bulb. At a distance of three to four feet from your enlarging paper, the light is usually safe. If in doubt, lay a coin on a segment of enlarging paper, and place it under a safelight for at least three minutes. Develop the paper; if the light is safe, not even the faintest image of the coin will appear.

Focusing Magnifier

As an aid to sharply focusing the image of a negative in an enlarger as it is projected to an easel, it helps to use some sort of magnifier. One type is designed to enlarge the grain pattern in the negative so you can focus it sharply with the magnifier. If this has been recommended, try one, but you may discover it is difficult to center your eye in the magnifier. The model I experimented with some years ago was too frustrating, and I turned to something simpler that magnifies only slightly, but brightens the image by a mirror system,

making it quite easy to adjust focus. My Mirano Easel Viewer cost only a few dollars, but may no longer be available. Others that allow you to focus on a portion of the image rather than the grain include the Magna Sight and the Dot. Purchase a magnifier provisionally, and try it for your own convenience.

Printing Exposure Meter

It would be nice to have an instrument with which you could read the projected image of a negative and determine the exact exposure time for a given f-stop, paper, and developing time. Such exposure meters are available in theory, but in practice there are circumstances that make the procedure a bit complicated. Primarily, you run a few tests to calibrate the meter for a specific paper. However, as negative contrasts vary and your paper developer ages, the calibration must be adjusted, or you must make manual changes.

I suggest that you hold off buying a printing exposure meter until you are quite familiar with enlarging. At that point, if you wish to experiment with one, you will be in a much better position to judge its performance. Perhaps you will find the model you use makes it easier to determine exposure, and saves both time and paper. These meters run from $20 to perhaps $150, and are not necessary as you learn to enlarge.

Dry-Side Incidentals

Negative brush. Invest in the softest quality brush you can afford to remove dust from negatives. One model has an antistatic device in it, while others are either flat or round. Keep the brush clean and it will last indefinitely.

Compressed air. You can buy a small can of compressed air with a tube that attaches to the nozzle. It may be useful for blowing dust from negatives, but I feel that human breath is just as efficient if you keep the negative dry. There are also small rubber bulb-shaped devices for blowing air, but I still prefer lung power.

15 An enlarging focusing magnifier used to assure sharpness.

Scissors and marking pencil. Handy scissors allow you to cut negatives apart or cut enlarging paper into test strips. A soft Eagle draughting pencil (#314) is needed to record file numbers on prints and contact sheets.

Negative sleeves. Occasionally you want to segregate a strip of 35mm negatives in its filing envelope, and individual glassine or polyethylene sleeves are available. I put each 2¼x2¼ negative I print in its own glassine envelope to protect it, and make it easier to find later. Exposure data can be written on a negative sleeve—while it is empty—with a grease pencil.

Paper trimmer. You need at least one trimmer which can be stored in the dark-room for cutting paper as you print, or be brought to the darkroom from elsewhere when required. Eventually, separate trimmers for darkroom and another workspace might be more convenient. Buy a trimmer at least 14 inches square that will cut 11x14 paper.

Contact-Printing Frame

The basic contact-printing frame has a split back with spring holders. An 8x10 frame is adequate, but I suggest starting with one 11x14, because it is easier to use when contact-printing a roll of 35mm negatives. You need open only the larger section of an 11x14 frame.

There are also special printing frames into which you slip each strip of 35mm film where it is held firmly in place. It takes longer to use one of these compared with a conventional contact-printing frame, but contact prints look better. Be sure yours allows frame numbers to show through; mine has etched edges that blot out these important data.

Wet-Side Equipment

Trays. Molded plastic trays in 8x10 or 11x14 sizes are durable and relatively inexpensive. Developer will stain white plastic, but a chemical tray cleaner

16 *Molded plastic trays are made in various sizes by several companies.*

bleaches most of this away, or you may use household cleanser with a scouring pad. Using an 11x14 tray for 8x10 prints will speed up your darkroom work, because it is easier to handle two prints at a time. The amount of developer for the larger tray is only a few ounces more than for 8x10.

In my darkroom I store fixer in one 11x14 tray that stands at the edge of my sink all the time, and is shifted to the right when I print. I cover the fixer with another inverted 11x14 tray when not in use, and use the cover tray for short-stop while printing. A separate tray is necessary for developer (and only for this purpose), and another for storing prints in water after they have been fixed. Depending on your space, 8x10 trays for all of the above purposes would be quite adequate. Label your trays with waterproof tape so they are always used for the same chemicals. Short-stop and fixer can both contaminate developer.

Print tongs. Manipulating enlargements in developer with your fingers is feasible, but presents certain problems. Fingers tend to stain or mark prints, and fingers may be allergic to chemicals. Print tongs save fingers and prints, and allow you to keep your hands dry longer. There are tongs made of plastic, stainless steel, or other materials. Check and choose those that seem most handy for you. One pair should be reserved strictly for developer, and another for short-stop and hypo.

18 *Tray syphon for print washing is easy to store.*

17 *A selection of darkroom accessories from Kodak.*

Thermometer. An inexpensive model that lies flat in the developer tray is useful in extremes of temperature. When it's cold in my darkroom, I mix the developer with 70°F water and place the developer tray in another tray of warmer water. This type of water jacket will keep developer between 68°F and 75°F for quite a while. Short-stop and fixer need not be warmed in most non-Arctic circumstances.

Interval timer or clock. An old electric clock with a face easily visible under a safelight is the best instrument by which to time print development— which *must* be timed. You might instead, also use the interval timer that you used for film development; just wind it up and set it for two hours, or whatever its limit is. Other timers with large faces are available for printing, but a simple electric clock runs indefinitely, and tells you the time as well.

Print Washer

You may run water into a tray full of prints that is placed in a sink, but they won't be thoroughly washed. A print washer should provide movement of the prints as they wash; with some washers, water enters the washer under pressure. The water usually drains along the bottom. Various models are available for about $15 and up. Round, flat, or vertical, simple or complex, choose a washer that fits your space and budget. Testrite, Yankee, Paterson, Richard, Arkay, and Capro are some of the brands you'll find.

Print Dryer

Relatively inexpensive print dryers work fine, and allow you to dry perhaps four 8x10 prints at a time. The larger the dryer, the faster you get the job done. However, you don't need a motorized model costing in the hundreds, unless you are really busy, rushed, or rich. For about $30 you can get an Arkay dryer they say will dry 30 8x10s an hour. For about $90 there's the Burke & James Rexo Model 66 which flips over, and takes four 8x10s on each side. I've used one for years, and I simply time prints (about seven minutes on each side where I live) with an interval timer that rings, while I do something else. A motorized version is faster, but you have to stay there and feed it the whole time, after you pay about $500 for it.

It is also possible, after soaking them in a wetting agent, to lay prints on cheesecloth or blotters and allow them to air dry. Sometimes they dry flat, and sometimes not. If you use resin-coated (RC) paper, it dries without wrinkles, but may curl. Get advice at a camera shop or from a friend about print drying, because it's a category dominated by personal taste—and prejudice.

19 *Ken Whitmore's decoratively grainy photograph of Mary Tyler Moore was shot on High Speed Ektachrome processed into a negative and printed on grade 4 paper to accentuate contrast.*

It is also advisable, no matter how you dry prints, to place them under a weight when they are dried. This assures they will stay flat, or become flat if they have curled slightly. Metal weights with handles are available, or you can make one from several pieces of 1x12 lumber glued together and finished. A wood or hardware handle goes on top. Weighting prints pays.

Dry Mount Press

A wonderful and expensive piece of equipment, the dry mount press, is most useful for mounting exhibition prints. There is probably one at school to use,

or find a friend who owns one. Of course, if you will dry mount pictures often, you might share the expense of a press with a few other people.

CHEMICALS FOR PRINTING

Paper Developers

Various paper manufacturers recommend their own developer brands and formulas, but many photographers use Kodak Dektol with all types of papers. Dektol is sold as a powder to mix in various quantities. It is efficient to mix a gallon of stock solution, from which you pour off about 10–16 ounces each time you print, depending on the size of your tray. The stock solution lasts several months, even with air in the bottle. If it turns medium to dark brown, throw it away and mix a new batch.

Dilution. Most directions say 1:2, meaning one part of Dektol to two parts of water. Try it, you may like it. However, I recommend using Dektol to water 1:1, because it produces better contrast, especially better blacks. Enlarging exposure time is geared neatly to a 1:1 mixture, so you can develop 1½ to 2 minutes normally. I mix 16 ounces of Dektol with 16 ounces of water, and like the results. The solution will last about three hours or 25 8x10 prints, whichever comes first. When the developer discolors slightly, it's okay, but the darker it gets, the less effective it becomes, until you only think you are getting good blacks and rich tonality. Quality becomes degraded even though the developer still works, so beware of stretching it too far. Paper developer is a minor expense, and you can afford to mix a fresh solution at regular intervals during a day of printing. Otherwise, all other quality controls could turn out to be futile. Prove this for yourself by making a print in nearly exhausted developer, and another identical print in fresh developer. There is a distinct difference.

Short-Stop or Stop Bath

As you print, there should be a tray between the developer and the fixer trays, with half an inch of water in it, to which has been added about 1½ ounces of 28 percent acetic acid for each 32

20 *Grant Heilman's thorough-bred mares and colts in Kentucky were photographed with a medium-format SLR.*

ounces of water. You can buy acetic acid full strength and dilute it to 28 percent, or 28 percent ready-mixed. Be careful, because it can injure the skin if not washed off immediately.

Short-stop or stop bath neutralizes developer on printing paper, stops development fast, and helps prolong fixer life. After you have made a number of prints, feel one in the short-stop. If it is very slippery, the stop bath is exhausted. Throw it out; don't try to add more acetic acid. Kodak makes an Indicator Stop Bath which turns dark when worn out, but regular acetic acid lasts many hours in short-stop.

Paper Fixer

This can be the same hypo used for film—but in a separate container—or you may use a quick-fix chemical, or a fixer formulated for paper only. In any case, use something like Edwal Hypo Chek to test the fixer, and switch to a new batch when needed. Five minutes in fresh hypo at 70°F is sufficient for most single-weight papers, but the time lengthens to 10 minutes as the hypo ages. RC papers take only a minute, and you should follow directions for them.

21 *Five or six strips of 35mm film will fit on a sheet of 8x10 paper for contact printing. Enlarging paper for contact proofs is fast, and variable-contrast filters add versatility.*

Hypo Neutralizer

Again you can use the same chemical, in a separate bottle, that you used for film. Depending on the brand used, follow directions about immersion time in the neutralizer and washing time afterward. A neutralizer saves time and water, both important these days. RC papers do not require use of this chemical.

Wetting Agent

No matter how you dry prints, electrically or by air circulation, it pays to soak them in a wetting agent after washing. The best of these is GAF Flexigloss solution mixed 1 ounce to 2 quarts of water. You can replenish this stock solution many times, adding half an ounce of Flexigloss for about 25–30 8x10 prints. should you happen to dry prints glossy, Flexigloss or something similar is a necessity for a proper gloss. However, most photographers dry glossy papers for a matte finish, as discussed later.

PRINTING PAPERS

There are two basic types of paper, one for contact printing and the other for enlarging. The former is much slower, somewhat less expensive, and in many cases unnecessary to stock. Many photographers need to contact print their negatives only for proofs, and they use enlarging paper for this because it's faster, and always on hand. However, for a large quantity of contact printing, use contact paper of the surface, texture, and weight desired.

Enlarging Papers

Kodak, Dupont, and Ilford supply most of the papers you will find stocked in camera shops. They're all good, and many are interchangeable in terms of characteristics:

Surface texture. Ask in a camera shop for a sample booklet of papers, and compare the surfaces, which run from glossy or semiglossy to matte and silk textured. To simplify things, I have long used only two surfaces: glossy for all photographs to be reproduced or for display, and matte (either Varilour DL or Polycontrast G) for portraits or prints to be sold or given to individuals, not for reproduction. If you want to adventure into exotic surfaces, by all means try samples of whatever appeals to you, but keep in mind that a simple, fine-toothed matte paper such as those mentioned will be universally acceptable.

Glossy paper is appropriate for reproduction and exhibit, but should never be dried glossy (called ferrotyping) because its hard shine is also brittle, subject to surface flaws if you don't gloss it expertly, and objectionable to look at on display. *Unglossed, a glossy surface paper has the longest scale of tones possible, and offers the best rendition of your carefully made negatives.* Except for the basic whiteness of the paper stock (Dupont's papers are slightly whiter than Kodak's at this writing), there's little or no difference in glossy papers available.

Tone and base color. There are warm-tone and cold-tone papers, and those with the most pronounced textures are almost all warm, while smooth and glossy papers are a neutral cold

22 *Portraits are often appropriate on warm-tone paper which has a finely textured surface. Dupont Varilour DL paper was used here.*

color. Individuals you photograph may appreciate a warm-tone matte paper which is used conventionally by portrait studios. Glossy papers appear slightly warmer if developing time is short, or if they are air-dried. The longer you develop a print, and the warmer the dryer, the colder its tone will appear.

The basic whiteness of a paper was mentioned before. I like the Dupont brilliance, but Kodak and Ilford papers are very similar.

Printing speed. Contact-printing papers are relatively slow, as mentioned. A hypothetical ten-second exposure on contact paper may be only five seconds on regular enlarging paper, and three seconds on rapid enlarging paper.

Most graded enlarging papers (see below) are slower than rapid variable-contrast papers. The latter are excellent if you wish to print in the least amount of time, but require slightly more control to avoid overexposure.

Weight. Single-weight papers are adequate for most applications, but most warm-tone matte papers are available only as double weight, which is more stable and feels better to handle. Glossy papers are made in both single and double weight. The latter is somewhat more sturdy, though all the prints for this book were made on single-weight glossy paper to save money, weight, and space. Try both types and alternate as you wish.

Graded papers. The most important decision you will make in regard to enlarging papers is in the realm of contrast control, As you know, the scene you photograph and your negatives are subject to varying degrees of contrast ranging from deep shadows to bright highlights. The limits of film and developer to record contrast extremes have been discussed; now you have an added tool to produce brilliance and tonal gradation in your prints.

Both enlarging and contact papers are manufactured in a series of contrast grades from 1 through 6. In general the numerical gradations are defined this way:

GRADE	CHARACTERISTICS
1	Very soft, meaning that the tones of a high-contrast negative or subject are compacted; highlights are easier to print, but blacks are more difficult to obtain.
2	Normal contrast, for "normal" negatives, which is a classification of rather wide latitude, as you shall discover.
3	Medium-high contrast, for negatives of medium-low contrast; highlights and shadows are separated, and the tonal scale is extended. Many "normal" negatives may print with more brilliance on a grade 3 paper, depending on exposure and developing time.
4	High-contrast paper for low-contrast negatives.
5 & 6	Very high-contrast papers for extremely thin or low-contrast negatives. These papers tend to extend the tonal scale as far as possible for a negative in which there are no distinct blacks or highlights, but the effort is usually a compromise. However, a grade 5 or grade 6 paper can save some negatives that would otherwise not be printable; used with normal or high-contrast negatives, these papers tend to eliminate gray tones, leaving whites, dark grays, and blacks only. This can be very effective for some subjects.

Grade 1 is called a *soft* paper, while grades 3–6 are *hard* papers, indicating an increase of contrast and a reduction of gray halftones to match a negative or for effect. Graded papers are manufactured in many surfaces and tones, and for special purposes. However, except for a grade-5 glossy paper which is a lifesaver for very thin negatives, you may prefer to use enlarging paper with built-in variable contrast.

Variable-contrast papers. Rather than buying and storing boxes of glossy and matte paper for each contrast grade you may need, it is possible to buy *one* box of variable-contrast (VC) paper for each type or surface, and control contrast with a set of filters. Each filter is a slightly different color, producing a varying series of contrasts on one basic paper. VC papers are manufactured with double emulsion layers sensitive to different colors of light. Yellowish filters correspond to grades 1 and 2,

23 *Dupont and Kodak variable-contrast enlarging papers with their respective filter sets.*

while filters become more magenta as they represent grades 3 and 4. There are several reasons why VC enlarging papers offer advantages you do not get with graded papers, and these will be noted.

As for cost, VC papers and graded papers are very similar. However, for VC papers you must buy a set of VC filters for between $20 and $30 as a one-time investment. There are Kodak Polycontrast filters with these numbers: 1, 1½, 2, 2½, 3, 3½, and 4; and Dupont Varigam filters numbered 0, 1, 2, 3, and 4, plus a special order #00. Either set of filters may be used with VC papers made by both manufacturers.

Each brand of filters has its advantages. Half-steps of contrast are easier with Kodak filters. To obtain a half-step with the Dupont filters, you give equal printing time to two separate filters between which the half-step occurs. Actually, this isn't difficult, though you must be careful not to jiggle the enlarger when switching filters.

Each Kodak filter requires a slightly different exposure time as you switch from one to another. For instance, a 6-second exposure with a #2 filter in-

creases to 8½ seconds with a #3, and 20 seconds with a #4 (which is very dense in both sets). However, exposure times for the Dupont filters remain uniform, except for the #4 filter, which is a distinct convenience. Kodak sells a small exposure computer for 25 cents, showing the exposure changes, but switching filters with the Dupont set is faster. In addition, the Dupont #4 filter requires exactly twice the exposure of the others in the set. If you expose 5 seconds with a #3, you know to double that for #4.

I own and have used both brands of filters for more than 15 years. I wrote a book called *How To Use Variable Contrast Papers* (Amphoto 1970), and I recommend starting with VC enlarging papers, rather than the graded type. I think that the Dupont Varigam filters have a slight edge over Polycontrast filters, both for their uniform exposure times, and because switching a full grade of filter when printing is more prevalent than moving only one-half grade up or down.

As for the papers, I prefer Polycontrast Rapid over Polycontrast for its extra speed and colder tone, though Varilour is my present favorite because of its very white base and extreme

24–25 *Latitude of Varilour is demonstrated by the similarity of figure 24, developed 45 seconds and figure 25, developed 1½ minutes. Subjects are Charleton and Lydia Heston.*

VC printing details. In addition to being able to stock only one box of paper for each weight or surface of VC paper used, there is another enormous advantage these papers offer: One negative can be printed with two or more filters to match segments where contrast may vary. For instance, figure 26 was printed with a #2 filter for the upper portion, and a #3 filter for the lower part where contrast needed to be boosted. Multiple filters can also be used to add contrast accents in a print. As an example, you might use a #2 filter for the major exposure of a negative, followed by a few seconds with a #3 or #4 filter which accents the blacks and darker tones. Using the #4 filter for this purpose is a common technique in VC printing; whites and lighter grays are hardly affected, while blacks become deeper, adding brilliance to a print.

If you contact print negatives on VC paper, the same type of contrast manipulation is also possible. The entire set of negatives may receive a basic exposure with a #2 filter, after which you mask off the normal negatives, and give denser ones another exposure with a #3 or #4 filter. The reverse is also possible: Mask some of the negatives and expose the remainder with one filter. Switch masking, and expose the rest with another.

It is okay to place VC filters *under* the enlarger lens in the holder usually provided there. In ideal practice, any filter should be above the lens if possible, to avoid any effect on the image projected, and some enlargers have a shelf or drawer in the lamphead for this purpose. However, tests have shown me that VC filters, if kept dust free, have no noticeable effect on enlargement definition, despite the validity of theory.

Since the contrast grade of a VC paper is approximately #2 *without* a filter, print a normal negative with a #2 filter and without, and compare results for yourself. VC paper requires about half as much exposure time without a filter as with, and many normal negatives can be printed without a filter if saving time is important. In addition,

latitude. The latter is illustrated in Figures 24 and 25, showing the same negative exposed for two different intervals. Figure 24 was developed only 45 seconds, while figure 25 was developed the recommended 1½ minutes. Even so, Varilour's latitude provided an acceptable print when overexposed and underdeveloped.

26 *Print was made using a #2 filter for the lower portion and a #3 filter for the child's face where more contrast was needed.* ▶

27 *A grade 5 Bovira paper "saved" this picture made from a negative of low density, also called "thin."*

28 *Eight-by-ten enlarging paper with 35mm negatives spread over it is used for a contact print in an 11x14 frame under the enlarger light.*

removing the filter to "burn in" a dense section of a negative is also good practice. More on this below.

VC filter numbers approximate grades of paper with the same number. However, a #4 filter does not produce quite as much contrast as a grade-4 paper. As noted, I use a grade-5 (Bovira) paper for those unfortunate thin negatives which do not respond to a #4 VC filter. A grade-5 Kodabromide (Kodak) or Valour Black (Dupont) would also be satisfactory, though Bovira paper (made in Germany) has a richness of tone quality all its own.

Kodak RC paper is also available in variable contrast. This type of paper fixes, washes, and dries more quickly than conventional types, and is popular among photographers who can save time and need no dryer. The paper can be laid out to air dry and, if weighted for a short period, should dry flat.

My views about enlarging papers are frankly opinionated, but fortunately all the products available can be used quite successfully. I prefer VC papers because contrast manipulation is more versatile with them than with graded papers. I like the Dupont filters, but worked for years with a Kodak Polycontrast set. In the long run, your printing technique can be perfected with any paper and chemical combination you enjoy using.

CONTACT PRINTING

For purposes of this book, contact printing is limited to making proofs. Set up your trays, adjust developer temperature as close to 70°F as possible, and lay your negatives emulsion side *up* on the glass of a contact printing frame. If you use a special printer with grooves for each strip, they are inserted emulsion side *down*. Turn out the light, and place a sheet of 8x10 paper (enlarging paper is suggested) emulsion side down over the strips of negatives. Film and paper tend to curl slightly *toward* the emulsion side, which is the *shiny* side of paper and the *dull* side of film. When film meets paper, emulsion-to-emulsion, images are correctly oriented.

Turn the printing frame face up, and expose the paper to light. You may use the room light or any white lightbulb for this purpose, timing with a clock or by counting. Exposure with enlarging paper will average 3 or 4 seconds.

It is very efficient to place the contact-printing frame on the baseboard of an enlarger, set the lens at f/8 or f/11, set the enlarging timer for 3 or 4 seconds, and add a VC filter to control the contrast of your contact prints. Be sure the enlarger head is high enough so the open, empty negative carrier throws a beam of light large enough to cover the entire printing paper. Hold back one or more thinner negatives by covering them, give dense negatives more time by masking the others, or adjust contrast by using filters as mentioned above. Don't expect beautiful uniformity in a contact-print proof of 36 negatives or even 12 negatives 2¼x2¼. If they are all "readable" as small positives, editing your pictures will be easy enough.

With a soft pencil, lightly mark the roll number on the back of each contact sheet. Experiment with exposure time until the paper develops in 60 to 90 seconds. Process the contact sheets as described later for enlargements, attempting to get as much tonal depth and brilliance as possible with what is often a diversity of image characteristics.

You will learn by practice to lay out strips of negatives, perhaps with a slight overlap, so they assemble comfortably on a piece of 8x10 paper. Place and lift the printing paper gingerly if you are making more than one proof, so the negatives will not be disturbed. Contact proofs are an absolute necessity if you wish to protect negatives and edit properly. They become a permanent record of everything you shoot, and should be indexed and filed separate from negatives.

PRELIMINARY PICTURE EDITING

Fixed and dried contact-sheet proofs are more convenient to edit, but examining them with a small magnifying glass while wet is quite feasible. If editing dry proofs, use a grease pencil to indicate the frames you want to en-

large. Add crop marks on the proof if such guidance will be helpful to you later in the darkroom. If proofs are wet, jot down the frame numbers you want to blow up on a separate sheet of paper; later mark the frames you enlarged on the proof when it's dry. In this way you have a lasting record and valuable reference. Suppose you send most of the enlargements away for gifts, sale, or exhibit; by referring to marked contact sheets you will know which pictures in a series you blew up. A client perusing a marked contact sheet knows *your* choices of pictures when reediting at another time and place. Otherwise the client must refer to enlargements of the pictures, and check their file numbers, to be sure which of very similar images you enlarged. A system of marking will be appreciated by yourself and others.

There are several types of magnifying glasses with which to edit 35mm or 2¼x2¼ contact proofs. An ordinary reading glass is okay, but magnification is limited. A glass mounted to a flashlight is fine, but slightly unwieldy. A "lupe," or small 8X magnifying glass, such as that made by Agfa, is probably the best tool because it enlarges detail clearly.

29 *An 8X magnifying glass enables you to see fine detail in 35mm contact proofs, and slides.*

Editing Practice

Examine each frame on each proof sheet carefully. At this point you have come to an important stage in your photography, deciding which negatives are worth printing and which are not. Composition, expression, emotional impact, and many other ingredients of successful picture-taking (discussed in later chapters) are all considered when pictures are edited. Make at least one enlargement of a marginal negative to better analyze its worth. As you become more experienced, you will be able to tell more about the ultimate quality of

images from contact proofs. At the same time, you are learning to be more ruthless in eliminating the obviously poor pictures, while positively identifying the best ones.

The whole editing process is based partly on acquired concepts and partly on instinct. Your taste may be influenced by other photographs, by paintings, or by things you hear or read. At any rate, careful study of contact sheets not only leads you to make enlargements of your best efforts, but helps guide you when taking pictures as well.

MAKING ENLARGEMENTS

There are four main steps in enlarging: composition, exposure, print development, and judging print quality.

Composition

The next chapter is entirely devoted to the principles and elements of composition, particularly in terms of taking pictures, and it will help to have read this material before spending much time enlarging. Certainly, you can get the hang of making a good print whether picture content is satisfying or not, but at the same time, you should be trying to compose and crop your negatives as skillfully as possible.

Cropping. The most important way to revise and improve the composition of a picture is by eliminating nonessential elements along any or all of the edges, called *cropping*. You judiciously enlarge only the area of a negative that best expresses the idea or design you had in mind while shooting. To accomplish this, you raise and lower the enlarger, and evaluate the varying compositions that result. You may also change the shape of a picture by adjusting one or more margins of the easel to create a narrower horizontal or vertical rectangle, or perhaps by approaching a square format. Everything depends on the total effect you wish to present in a finished print. You may also improve an image by trimming the print when it is dry, but the closer you come to a strong and effective photograph while enlarging, the more efficient are your efforts.

30 White strips have been placed along the edges of a print to illustrate how a picture can be improved through cropping.

The ability to compose successfully on an enlarging easel takes time. You must visualize the negative image you see as the positive picture it will become. You must also realize where light and dark patterns appear, while being aware of the lines and shapes that can be manipulated for a more dynamic composition. Minor up or down movements of the negative have subtle implications in a finished photograph. Placing a face in a portrait or a mountain in a landscape, or correcting a horizon line to be horizontal are only a few of the ordinary challenges faced each time you make prints.

Experiment and seek alternatives patiently. If you discover that a section of an image may be a stronger picture than the whole negative, don't hesitate to raise the enlarger and try it. If the negative is sharp and its contrast is fairly normal, you'll get a reasonably good print, even if you use only half of a 35mm negative. Don't worry if a certain amount of grain appears because you are projecting a 16x20 image, but printing only an 8x10 portion of it. Grain often looks indigenous to a picture, and will not degrade an otherwise striking composition. Move the printing easel around slowly and deliberately, trying for the most effective interpretation of the subject in your negative. This is the essence and the enjoyment of making prints. It is the creative payoff that starts when you look through the viewfinder of a camera and ends when you mount and hang your own photograph, or see it used in another satisfying manner.

Exposure

Composition is aesthetic and difficult to define in universally understood terms, but exposure of an enlargement and subsequent print development are both predictable operations. Judgment of print quality is both an art and a craft, and determining how long a negative should be exposed for optimum brilliance and tonal gradation is the first step along the way.

Preparing the negative. Place a strip of 35mm negatives, or an individual 2¼x 2¼ negative in the negative carrier, emulsion, or dull side, down. Dust it with a brush and blow on it on both sides, using whatever method you prefer to eliminate all specks of lint, dust, or dirt. Handle negatives gently, because they can be scratched so easily. Hold the carrier at an angle to a work light and inspect both surfaces of the negative for specks of dust. The negative carrier should be the glassless type; the older style glass carrier is a menace because it collects dust and dirt, and is very difficult to use.

Insert the negative carrier, and secure

32 *A soft brush, a bulb-blower, or a can of compressed air may be used to remove dust from a negative before it is printed. Care here saves annoying spotting time later.*

it by whatever means used in your enlarger. Turn out the work light, and switch on the enlarger. Open the lens to its widest aperture for viewing and focusing. If there is a safelight on nearby, you may want to turn it off to view the negative, but this is not usually necessary. Some enlarging timers will switch off safelights automatically when the enlarger is turned on.

If the surface of the printing easel is light-colored, it is an appropriate surface on which to focus and compose. Otherwise, insert a sheet of white paper for this purpose. I use a sheet of double weight enlarging paper on which I have penciled a grid of three horizontal and three vertical lines which help in placement of horizons, architectural features, and even faces when I want them slightly off-center.

Composing the image. You may use whatever size paper you wish for enlargements, but for this discussion I will assume you are making an 8x10 print. If you wish to include the full frame of a 35mm negative, the margins must be set for about 6½x10. I begin with the full 8x10 format, and narrow in at top, bottom, or sides as the image demands. Crop as tightly as possible, eliminating any extraneous matter along the edges of the print.

Lens settings. When the negative is carefully in focus on the easel, stop the lens down to at least f/8. In this way you compensate for small focusing errors, and sharpness overall is better assured. You may print at f/5.6 or f/11 or at any aperture you wish, but the wider the lens opening, the more chance of soft focus and the smaller the f-stop used, the longer exposure time will be. A setting of f/8 is usually a good compromise.

Evaluating contrast. Until you quickly recognize a soft, normal, or thin negative in terms of potential print contrast (and exposure time which you will estimate in a moment), you must choose the grade of paper or VC filter by trial and error. It would be useful to make a full series of prints of several negatives with *each* of the VC filters or paper grades you use. Develop the prints at about the same time, and compare them. In this way you will get the hang of matching paper (or filter) contrast to the negative at hand. At any rate, choose and place a VC filter in its holder, or decide which grade of paper you need, and place your enlarging paper in the easel, unless you prefer to make an exposure test first. Remove the white paper on which you focused and put it aside for burning-in chores.

33 *Three common negative densities, from the top: not enough density or too thin, normal density, too much density or too heavy.*

34 *One method of exposure testing showing intervals of 3, 6, 9, and 12 seconds from right to left. Proper exposure falls between 6 and 9 seconds.*

Exposure testing. There are several ways to check a printing exposure. At first, it is good practice to place a full sheet of paper in the easel, and expose it in four steps, as shown in figure 34. Begin by covering all but one-quarter of the paper with a piece of thin cardboard. Expose this first segment for about 3 seconds, or whatever seems appropriate to the negative's density. Shift the cardboard to the center of the picture, and expose again for 3 seconds; move it three-quarters across the paper for another 3-second exposure, and finally lift the cardboard entirely, and give the whole print another 3 seconds. My test sheet was developed for 1½ minutes, after which it was apparent that correct exposure was between 6 and 9 seconds, represented by the two middle panels.

An exposure test such as that just described is valuable as a learning experience, when you are becoming familiar with the relationships between negative density, degree of enlargement, speed of the paper, and evaluation of developing time. However, the use of test strips is faster and more economical. Cut a sheet of 8x10 paper into strips about 2x8 inches. Lay one strip across the most important areas of a projected image, and make a single exposure on the paper grade or with the filter of your choice. You will become quite proficient at guessing an exposure with which to begin, once you have been printing awhile. Your eyes and brain combine as a kind of computer. The process involves intuition which is most reliable if the density of negatives you print is fairly uniform. When you come to a very thin or very dense negative, using a test strip is valuable, because your mental computer may not be conditioned for the "abnormal." In time, a good printer can skip exposure tests, and go directly to what is hoped will be the final print. To some purists, this may sound like heresy, but I know it to be true from experience.

35 *Photograph was made of a negative projected on the enlarging easel with a test strip (tinted gray to distinguish it) placed across the central portion of the image.*

Each print you make does not have the same importance. Pictures shot for a commercial purpose may not require the "perfection" of those you wish to exhibit or send to a publication. Therefore, as you get an instinctive feel for enlarging, the first 8x10 you make from a negative may either (a) be good enough for the purpose intended, or (b) become a full-size test from which you improve exposure, development, or local manipulation of tones. Professional photographers who are not usually plagued with tight budgets are inclined to look at the projected image of a negative, choose a filter or paper grade, set the timer, and make a print according to all of these quick judgments. If it is acceptable, they go on to the next negative. However, if it is too dark or too light, or one section needs to be held back or burned in, a professional does not hesitate to make as many more prints as seem necessary to achieve the tonal scale he/she knows is correct.

Print Development

As you slip a piece of printing paper into a tray of developer, make sure it is evenly immersed as quickly as possible. I drop the paper in face down, tap it gently in the center, and rock the tray at the same time. In a few seconds I turn the print over with tongs. If a small area has not been covered, get it wet and don't worry. A light spot that appears where the print begins to develop late will disappear and blend perfectly if it was only a few seconds behind.

Touch the print with tongs *delicately*, or you will have dark tong marks that spoil the picture. As the image begins to appear, make a mental note of how fast it is developing. In general, you will see the darkest areas of the picture rather faintly in 10–15 seconds. At 30 seconds the whole image is visible, but the light areas have no detail. In one minute some light areas are detailed, shadow detail may look just right, and the blacks may appear to be dark enough. Be patient. If the print needs 1½ minutes of development, what you see at 60 seconds is also an illusion. Under the dim safelight, a print usually looks ready to pull out before it actually is. However, highlight areas may have sufficient detail in 60 or 70 seconds, and blacks may be adequate; it is possible that development is complete. You will pull a lot of prints in this stage; some will be okay, and some will need to be reprinted because blacks are only dark gray, and exposure time must be adjusted.

A print should be moved about or agitated almost all the time it is developing. Rock the tray gently, and the solution will continuously change on the surface of the paper. The reason is the same given for film agitation, but must be more constant because development time is so much shorter than for film. If you want a demonstration of static development, expose a test strip or a full print, place it face down in the developer, turn it over, and let it stand. A number of flaws may occur such as mottled areas, splotches of white where developer did not touch the emulsion,

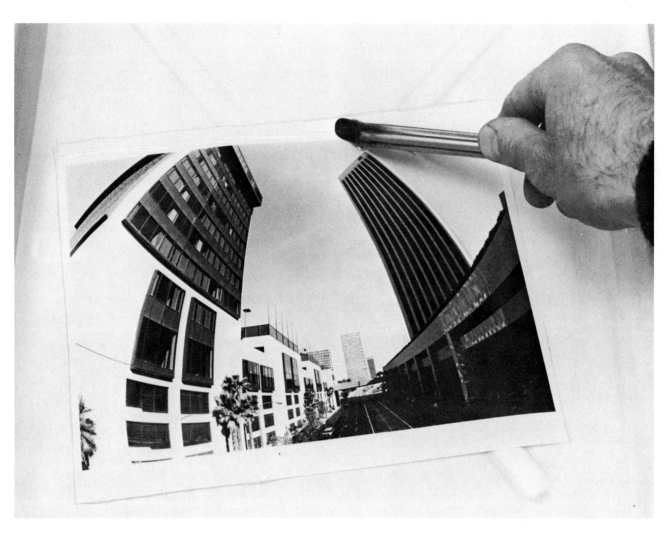

36 *In the developer, tap print with tongs only along the edges to avoid possible tong marks in the image.*

and uneven tones. The longer a print stays in the developer, the less it is subject to flaws due to standing still, and you may reduce the agitation time slightly after about one minute. However, don't stop completely, or tonal brilliance will suffer.

Most enlarging papers may be developed for 2 minutes without staining. Some excellent negatives benefit from 2-minute development, and it may become your standard if you wish. Experiment with 2½- and 3-minute development as well, to discover the limits to which you can go with the paper and developer. You will find that print quality is better with extended development in some cases, but for less artistic subjects, 1½ minutes is quite acceptable and more efficient.

For years I have added a heaping teaspoon of sodium carbonate to my Dektol/water mixture. This chemical is supposed to be an accelerator, meaning it speeds up development, but I use it for improved blacks. Give it a try if you wish, because in a 1-pound bottle it is inexpensive.

Minimum exposure and optimum development. "Ideal" film exposure, as mentioned in chapter 6, is usually elusive. Ideal exposure while enlarging is more accessible on a consistent basis. The *minimum* exposure that produces strong blacks, detailed highlights, and a full scale of tones between, should be combined with *optimum* development time which is somewhere between 1½ and 2 minutes. The type of paper and developer used influences this optimum, and you will discover it for your materials and chemicals.

Therefore, aim to develop prints for about 1½ minutes. Adjust your enlarging exposure to coincide with this development interval. At the same time,

37 *First of a series made from a normal negative on Varilour variable contrast paper, comparing the effects of Dupont VC filters. This was made with the #00 grade filter for exceptionally contrasty negatives.*

38 *Filter was #0 grade; contrast is improved, but black is still absent.*

39 *Filter was #1, and black accents are still too gray.*

40 *With a #2 filter, the negative prints satisfactorily.*

41 *A #3 filter adds more "punch" by improving the blacks.*

42 *There is even more contrast with a #4 filter, but too much shadow detail is lost.*

you must consider whether the grade of paper or VC filter used is producing the best possible combination of deep black and detailed highlights from the negative at hand. When by experiment you arrive at an exposure time that provides sparking print quality after 1½ minutes of development, you are assured that the paper grade or VC filter is correct. Otherwise you make exposure adjust-ments in seconds, and alter developing time to suit a specific picture.

On my enlarging timer is a switch with which I can add or subtract a mere half-second. This is important when exposure time is 5 seconds or less, and I mention it to point up the delicate balance between exposure and development for maximum tonality.

43 *As a print is removed from a tray, moisture carried with it is reduced by pulling it over the edge on one side and then the other.*

Completing development. While a print is developing, it seems to be ready before it really is. After you have pulled some prints prematurely, you will know exactly what I mean.

Later I shall return to judging print quality. Meanwhile, when development seems to be finished, remove the print by pulling it along the edge of the tray on one side, turn it over quickly with the tongs, and pull the other side over the opposite edge of the tray. This accomplishes a kind of fast squeegee operation that removes much of the developer from both surfaces of the paper.

Drop the print face down in the short-stop, and immediately rock the tray to affect chemical action over the entire print. The developer is neutralized and its function ends. Allow the print to float in the short-stop for 6 or 8 seconds, pull it over both edges of the tray again as described above, and drop it face down in the hypo. Agitate the paper gently to be certain it is fully immersed. In my experience, after 4 or 5 seconds in fresh fixer, a print is impervious to white light which you may now turn on, and your print is beginning to be inspected. If more than 10 seconds is suggested to you, make your own test to discover whether I'm right or not!

Judging print quality. It is advisable to have a consistent light source over the hypo tray, if possible, with which to evaluate prints. Mine is a diffused 40W bulb about two feet above the tray. Too bright a light can mislead you into thinking contrast is better than it really is. If you work in a school darkroom, judge prints by the same light night or day, should the location be outside the actual printing area.

Based on your best judgment of what constitutes a good, deep black, a detailed highlight, and a full tonal scale of grays, you experience a moment of truth for each new print. Is it suitable, or can it be improved by increasing or decreasing exposure or development, or by using a different grade of paper or VC filter? Is the amount of difference you might produce worthwhile for *this* picture? Is the photograph cropped to suit your taste? Are there areas in the print that should be lightened or darkened by local exposure manipulation?

Keep in mind that a print "dries down," which means that it will appear slightly darker when dry than it does when wet. Blacks become minutely deeper, and detail in highlights is more perceptible. Often you will continue to the next negative, knowing that after a print dries down, faint texture will be seen in highlights where you

44–45 Recognizing good print quality requires constant evaluation and comparison. Figure 44 is good; figure 45 lacks sufficient black for proper contrast.

want it. When you choose not to take the risk, make another print at a somewhat different exposure, or correct local areas by burning-in or dodging, as described below.

As you begin to print, you may wish to mount a first-class print on the wall in front of your hypo tray. (Cover the print with acetate to keep it dry.) This comparison print will remind you of the excellent tonality we always strive for. You may also fog a 2x4-inch piece of paper by exposing it to light. Develop it two minutes; when dry, it becomes a standard of black easily held above a wet print for a check. When viewing wet prints, remove them from the hypo and hold them at a consistent distance from a 40-watt viewing light.

It is no criticism of your ability if you must make two, three, or more prints from a negative to get one that is acceptable. Some pictures are easier to print than others. Sometimes I can estimate exposure, add local manipulation, develop for 1½ minutes, and everything falls into place on the first try. As you make constant judgments

about quality, your ability sharpens, and your prints are better. However, it is a matter of my professional pride to make as many prints as necessary until I have the right balance of tones, and as much brilliance as I feel the negative will produce.

To save time, the experienced printer may make a second or third enlargement of a negative incorporating corrections based on previous versions, and place the exposed paper back in the box to be developed along with the next picture. I simply place a small "X" at the bottom right of such a print, which along with the penciled file number, reminds me that the paper is exposed. Two 8x10 prints can be developed at the same time in an 11x14 tray by shuffling them constantly, so that developer is not static along any edge. You should know how long to develop the reprint that is handled along with a new enlargement, and by visual inspection and proper timing, it can be processed without distracting your judgment of the new photograph in the tray.

46 *Superb print quality by Grant Heilman combines minimum enlarging exposure with at least 1½ minutes of development. Paper grade or filter number is accurately matched to individual negatives.*

Be particular about print quality. The degree of compromise that is acceptable will become more apparent as your judgment improves. By straining your patience at first, you become a better, faster printer. When prints are dry, those marked with an "X" or "XX" (meaning second and third version from a single negative), can be compared with the original. By remembering the adjustments of exposure, filter, development, etc. that you struggled through, you can learn a lot from careful comparisons. Sometimes the original print is better than the "improvement." While wet, the second version appeared better, but later you realize it lacks certain qualities of the first. Or perhaps none of the prints you make from a particular negative is suitable when evaluated dry. In that case, put them back in your darkroom, and try again next time you print. Such a delay can be annoying, but as your standards of quality rise, your satisfaction also increases. Discussion with others about print quality is also a part of helping your discernment grow.

Study original prints by fine photographers in exhibitions at every opportunity. Even excellent reproductions of photographs by Ansel Adams, Edward Weston, and other masters can help you refine your own standards of brilliance, gradation, and sharpness. Like learning to play a musical instrument, cook a gourmet meal, or become an expert skier, the art of print-making takes time and patience. You work through the insights of disappointment and frustration to achieve finer images on paper.

PRINTING MANIPULATIONS AND EFFECTS

It is rare to make an enlargement that needs no manipulation to increase or decrease exposure in a limited area. Most often, there is a segment of the image that is fairly dense on the negative, and must be "burned in." Other areas require "dodging," which means masking them off for part of the total exposure. These skills are integral to good printing practice.

Burning-in

One of the more common pictorial features that needs more exposure is the sky area of a picture. The most expedient way to do this is by making the original exposure, and then while holding a sheet of thin cardboard or discarded double-weight printing paper above the easel, give the sky area additional exposure. Keep the masking paper moving at all times to avoid a sharp demarcation line. Twist or turn it to conform with contours of the landscape. If the original exposure was about 8 seconds, 3 or 4 seconds of burning in may be sufficient, but this is only an estimate. The actual time depends on your negative, paper, and the specific image.

Figure 47 gives the shape and dimensions of a mask I designed years ago for burning in. The two rectangular holes can be adapted to fit almost any pictorial form within a photograph by altering their size and shape with another piece of paper. By leaving only a small slit along the edge of either cutout hole, you can burn in a highlight on a face or head or along the side of a building. A sheet of 8x10 paper used to focus on my

48 *The opening in a burning-in mask can be made smaller and given different shapes by covering part of it in use. The full image of the opening is shown here as a demonstration only.*

47 *DIMENSIONS FOR BURNING-IN MASK*

49 *Corners of a print can be burned in using the mask with holes covered, or a separate sheet of paper or cardboard.*

50 *Tom Carroll burned in or "flashed" the foreground and the sky to help dramatize his refinery photograph.*

printing easel becomes the masking material used to cover parts of a hole at various angles and sizes. As I mask one cutout hole to correspond to an area to be burned in, I cover the other hole completely to avoid fogging the print.

If you use a burning-in device based on my sketch, you will be amazed at its versatility. By rotating a square hole, you can burn in a round or oval shape. This tool is useful for enlargements from 4x5 through 16x20, merely by raising it up or down between the easel and the enlarger lens. Of course, it must be kept in motion all the time you are burning in a local area. If you overdo it, a dark halo will appear around the place you wished to darken. Try again, jiggle the cardboard in a smaller configuration, and reduce your exposure time.

Carefully blending the burned in portion of a print so that manipulation is not apparent is an essential technique. Practice burning in with test strips that are more economical. Don't expect immediate success, but with experi-

ence, you will burn in difficult and intricate shapes skillfully.

For certain photographs, you may also cut custom-made masks for burning in and dodging. Project the negative on a sheet of suitable paper on the easel, and draw the contour you wish to burn-in or dodge. Cut the paper along this line, and hold it as a movable mask during part of the printing time. A landscape with mountains projecting into the sky is a typical instance when a custom-made shape will allow you to burn in the sky more efficiently, or hold back the land area as described below.

Dodging

Occasionally, an area of a print can be improved by dodging, but successful dodging is more difficult than burning in. The section to be dodged is always a dark area where you want more shadow detail, such as a face. A feature darkened within a photograph somehow blends more naturally than one which is made lighter. The latter

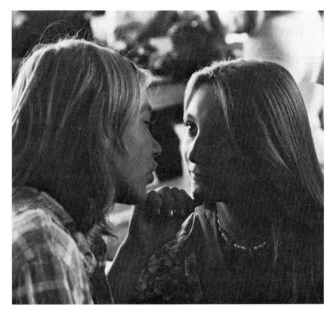

51 *Print made without dodging. Photo by Barry Jacobs.*

52 *Shadow side of girl's face dodged a few seconds during enlargement.*

often seems too obvious, and though detail may be brightened, a false note is created which may be objectionable.

In figure 53 are typical dodging tools made by cementing cardboard shapes to sections of a black coat hanger. Special shapes may be devised for some features of a print, or you may design your own basic dodging tools.

Hold the tool several inches above the paper, or at the height necessary to mask the spot to be dodged, and keep the tool in motion for the total exposure. The length of time you dodge must be determined by experiment, so the effect will be least noticeable. The shorter the interval, the more likely it is that your dodging efforts will be successful.

53 *TYPICAL DODGING TOOL SHAPES*

You may also dodge along the edges of a print to lighten one or more portions, by holding a piece of cardboard or double-weight printing paper in place, and moving it to decrease exposure for a few seconds.

Diffusion

Some portrait subjects, older people in particular, are happier with pictures of themselves that don't show wrinkles and other skin features. There are diffusing devices that clamp over or under the enlarger lens, and the amount of diffusion can be adjusted. However, it is easier to simply mount one or two layers of women's nylon hose between two thin sheets of cardboard with holes cut in them about three inches in diameter. I use two layers of hose material, and like the effect.

Set your enlarger in the usual way, and place the nylon diffuser on the filter holder beneath the lens (along with a VC filter if you use it). Make a test using the diffuser for the entire exposure, and if the image seems too soft, diffuse it for half or three-quarters of the time. The interval you choose will depend on the subject and the effect you want. Exposure time with a dif-

54 *Portrait diffused for three-quarters of enlarging time with double layer of nylon hose mounted in cardboard holder.*

© 1972 D. C. Glovner

gesso grain

lateral brush linen

canvas brush

55 *TYPICAL TEXTURE SCREENS*

fuser is lengthened slightly, and you may wish to use a higher grade of paper or higher-numbered VC filter, in order to adjust contrast which is somewhat softened by the diffusing device.

Texture Screens

For many years I felt that using a texture screen was a contrivance that didn't interest me—until I tested some screens for an article and enjoyed some of the possible effects. Figure 55 shows the variety of textures from B-G Screens sold by Don Glouner (2551 Jamestown Court, Oxnard, California 93030). Similar screens may be available from other makers in camera shops.

Screens are made by photographing very even textures in proper scale on 35mm film. The screen negative is sandwiched with your own negative in the enlarger. The texture chosen should have some relationship to the subject of your picture, but there are no limits or rules. You may also experiment with your own texture overlays by printing through materials such as window screen or lace, if the effects turn you on.

56 *"Brush Stroke" texture screen sandwiched with 35mm negative for decorative enhancement of the photograph.*

57 *Robert Bush did a masterful double printing job to create a multi-image portrait and win a Kodak/Scholastic Award.*

Double Printing

For pictorial impact, or to improve a specific image, it is possible to project several negatives onto the same sheet of enlarging paper. Images are usually combined by printing one and then the other, plotting the composition by drawing on a separate paper. Exposure times are reached by experiment to achieve proper tonality.

It is also possible to improve a scenic photograph, for instance, by printing it and then adding a dramatic sky from another negative. Cloud effects blend well with some landscapes. If the horizon line is irregular, cut a mask to separate the image areas, using the technique described for burning in and dodging. The first print or two is for practice; you should then be able to coordinate exposure times and masking for an effective blend.

Black-and-white negatives may be placed together in a negative carrier, called *sandwiching*, to be printed simultaneously. However, when areas of medium or high density overlap, they block each other, and it is often preferable to print each image by itself.

Perspective Control

Exteriors of buildings and room interiors often tilt toward a high vanishing point when you photograph them from a fairly low angle, and a certain degree of correction can be achieved when such negatives are enlarged. As you compose the image, lift one side of the easel so that tilting lines are closer to being vertical. Whether you raise one edge or another depends on the direction that lines recede in your photograph. The enlarger lens must be stopped down to f/11 or f/16 to be sure of sharp focus over the whole tilted image. The area of the picture that is closer to the lens may have to be masked a second or two to equalize exposure with the rest. Perspective can usually be corrected in this way without the manipulation being noticeable. As an amusing adjunct, lift one edge of the easle considerably, and note how the image is elongated and distorted.

58–59 *Buildings that tipped inward in figure 59 were corrected in figure 60 by raising the enlarging easel so the bottom portion of the picture was higher than the top, making lines parallel to the paper's edge.*

Toning Prints

A chemical toner is formulated to tint a print a specific color, such as sepia or blue-black. Toning should be reserved for appropriate portraits, landscapes, or other subjects when it will not seem contrived.

Selenium toner is used to give extra impact to blacks in a print, and is sometimes used for exhibition pictures. Ansel Adams discusses the process in his book *The Print,* and several Kodak publications carry details as well. Remember that toning is often a cosmetic device that may make images more interesting, but cannot take the place of good seeing through the camera viewfinder.

Accent Bleaching

When a poisonous chemical called potassium ferricyanide is mixed with water in tiny quantities, it may work wonders when used to bleach limited dark areas or highlights, lightening or amplifying accents in a print. Buy the smallest quantity of ferricyanide. Run a quarter-inch of water in a small expendable jar, and add a minute amount of orange ferricyanide powder with the tip of a teaspoon. Mix until dissolved.

Ferricyanide solution is applied with a very small brush to an area of a fixed print where you wish to lighten the tone. The chemical is a strong bleach, and if dripped accidentally on a print, immediately creates white spots where the image is eaten away. To use it properly, lift the print from the fixer under a good working light. Blow the hypo away from the spot you wish to bleach, or wipe the area with a clean paper towel. Dip the brush into the ferricyanide solution and flip off the excess into a sink, or wipe it lightly with a cloth or paper towel. With the tip of the brush, "paint" the solution on a small area to be lightened. Highlights may be given more sparkle, and shadows may be "opened" by this method.

As soon as you see bleaching occur, dip the print in fixer to stop the chemical action. If you wish to lighten the spot further, repeat the process. The danger is bleaching too much and too widely, after which a print may be ruined. Therefore, it is a good idea to practice on one print, and follow through on a duplicate when your technique is improved. You will see how the ferricyanide spreads easily into other wet areas, and you will discover how concentrated or diluted with water to mix this chemical. Start with a weak solution, and strengthen it only if bleaching is very slow.

Use of ferricyanide is specialized and probably infrequent, but when necessary, it can add sparkle to a photograph.

MISCELLANEOUS PRINTING NOTES

Everything you always wanted to know about making enlargements and skillful manipulations in the darkroom cannot, unfortunately, be included in these pages. As your craftsmanship improves, you will be motivated by your curiosity to read and experiment. Following are a few more helpful pointers that are also practical.

Special-Contrast Developers

There is a variable-contrast printing formula called Beers which uses two solutions; it is detailed in *The Print* by Ansel Adams. Beers #7 is a high-contrast developer, while Beers #1 produces low contrast with high-contrast negatives. You can give extra snap to soft negatives on normal- or high-contrast paper, or soften the effect of high-contrast negatives on grade 1 or grade 2 paper.

Adding a teaspoon of hydroquinone to a quart of Dektol diluted 2:1 improves print contrast, too. You may also use Dektol undiluted to raise contrast with thin negatives on grade 3 or grade 4 papers.

Exposure/Development Contrast Control

If you overexpose a print slightly, and develop it from 45 to 60 seconds, you shorten the contrast range and get adequate blacks and good highlight

60 *Print contrast was reduced by slight overexposure of enlargement, and development for less than one minute.*

detail as well—sometimes. Results depend on the negative. A normal negative taken in bright sunlight responds best to this treatment. Manipulation of exposure and developing time is occasionally more effective than using a softer grade of paper or lower VC filter number, because deeper blacks are possible. However, if you print with a #1 filter and accent the blacks with a #4 filter, this technique is also successful.

Hot Water Tone Booster

If an enlargement you make is fine except for one or two places that should have been burned in slightly longer, try boosting the tonality in those spots by running hot water briefly on the *back* of the print. Remember that the complete print will be developed further at the same time, but if overall tonality does not suffer, hot water sometimes brings out texture in highlight areas, and making another print is not necessary. You

may also rub hot water or hot developer over those areas with your fingers, but even in a few seconds this process may stain the print, so try it at your own risk.

Stabilization Processing

A stabilization processor is a piece of equipment in which motor-driven rollers propel a sheet of exposed printing paper through two shallow trays of chemicals which develop and fix the print in 10 to 15 seconds. This is made possible by the use of stabilization papers (available from Kodak, Agfa, and Ilford) with residual chemicals in the emulsion. Enlargements are made in the conventional way, but finished prints are processed very quickly. Tone quality is good, though conventional printing is superior. However, for making contact proof prints, or turning out prints in a hurry for classroom or commercial purposes, stabilization processing is a distinct time-saver.

Prints come out of the processor damp-dry, and will dry completely in the air minutes later, depending on atmospheric conditions. For short-term use, stabilization prints need no further fixing. To prolong the life of prints, however, they should be fixed and washed in the conventional manner.

Kodak makes a stabilization processor; a more economical model is available by mail order from Spiratone, Incorporated, 135–06 Northern Boulevard, Flushing, New York 11354. Send for Spiratone's catalogue which is full of photographic items from lenses to copy stands.

61 *Spiratone stabilization processor.*

WASHING, DRYING, SPOTTING, AND MOUNTING PRINTS

Use a convenient print washer, and be sure that prints are separated and agitated as they wash. It is highly recommended that prints be soaked in a hypo neutralizer before washing, as noted. If your washer is horizontal, place prints separately in the running water, emulsion-to-emulsion, so they will slip and slide as they wash. Water must reach the entire print if washing is to be thorough. Wash water between 65°F and 80°F is suitable. The colder the water, the longer the wash time should be. Water warmer than 80°F may soften the print emulsion to a point where it could be damaged when touched.

Drain prints on a tilted surface, and soak them in a wetting agent such as Flexigloss. Again, place them one by one, face to face, in the Flexigloss solution.

A print dryer is most efficient, but air-dried prints are often satisfactory, especially if they will be completely flattened when mounted. Use a special rubber print squeegee to remove moisture from prints before placing them in a dryer or between blotters.

Spotting Prints

No matter how careful you may be, some enlargements will be flawed by tiny white dust or lint marks on the negative. If craftsmanship is good, a dozen prints can be spotted in a few minutes, however.

Spotting means applying a special dye to the print with an extremely fine brush. Spotone #3 is the dye with which I am familiar. Practice spotting on an old print until you get the hang of blending your handiwork with its surroundings in the print, making spots disappear. Start with diluted Spotone and build up the tone by applying the dye several times lightly. Many photographers wet the brush on the tongue to keep it moist and extend the dye already in the brush.

Spotting a print is essential to good photographic practice. When you see unspotted prints, you know the photographer's respect for his/her own work needs to be improved.

Dark marks in a print, caused by tiny holes in the negative, can be removed by etching them away with a pointed blade. An X-acto knife available in art supply stores is just right for this tricky operation. When the blade is very sharp, and your finger control is refined, you can scrape a thin layer of emulsion from a dark spot, thereby blending it with the background, without digging a hole in the paper. If the latter does occur, use Spotone to correct it.

Treating Scratched Negatives

You may spend hours spotting long, thin, white scratch marks on enlargements, but it is preferable to try and eliminate them on the negatives. Scratches come from dirt in the felt lips of a film cartridge, or from dirt in the film-wiping squeegee, and occasionally from inside a camera.

In most cases a product such as Edwal No-Scratch or Vaseline will wipe out scratches. Apply the former with the tiny brush in the bottle, or the latter in a very thin layer with your fingers. Either material is supposed to fill the scratch so it disappears when the negative is enlarged. Wipe the antiscratch material from a negative after printing, and store the negative in its own glassine or polyethylene envelope. If Vaseline doesn't eliminate scratches, be prepared for tedious spotting.

62 *Print spotting is an absolutely necessary chore if craftsmanship is to be maintained.*

63 *Top right corner of fisheye scene was burned in as negative was printed with #3 filter to accentuate the contrast. Camera was Konica Autoreflex T3 with 15mm Hexanon lens.*

64 *Photographs, paintings, and prints are displayed together on the wall of the author's den. Two pictures by Edward Weston hang at the left, to the right of which is a 16x20 by Will Connell.*

Mounting and Displaying Prints

Mounting methods. Dry mounting tissue is a thin waxy paper that melts under heat and pressure to form a permanent bond between a photograph and its backing. Dry mounting is done in a special press to assure flatness. The tissue is chemically inert, and will not eventually stain the print. Liquid cements, especially rubber cement, include chemicals that will stain prints, and should not be used.

There are also new self-sticking adhesives already applied to various types of photographic mounts. Some of these are flat, heavy paper boards, and some are available as rectangles with inch-thick edges, so they will stand out from a wall. Three-dimensional mounts may also be homemade from illustration board, for instance. Check camera stores and photo magazine ads, where new products are announced regularly.

Display techniques. In addition to the stand-out mounts mentioned, photographs may also be displayed in thin metal frames sold for this purpose. To hang a mounted print, cover it with glass and attach at the top and bottom a pair of Braquettes which grip the glass and print tightly. Braquettes are made in clear plastic and in polished steel, and include a hanging hook in the back.

Whether a photograph is mounted with a border around it, or flush to the edges of the mount (called bleed mounting), is a personal decision. Both methods are appropriate for many types of display in the home or in a gallery. White borders around a print are a more traditional style, but still widely used. Bleed-mounted prints look more contemporary. Try both methods, and explore for others including the use of thin frames, until you find the styles that please you.

The disciplines of enlarging and printing your photographs are exacting, exciting, and important. Being able with your own hands, and with the aid of your own vision, to create an image on paper is the logical continuation of a process that begins when you load film into your camera. As you learn to better visualize how images will appear as enlargements in your darkroom and later on display, your artistic talent is sharpened. Shooting color slides or negatives is also a challenge, but the control a photographer enjoys with black and white is the true basis for continuous growth and satisfaction.

1 *The personal approach to composition and content is striking in De Ann Jennings' symbolic photograph taken with a 35mm SLR in a carefully chosen location. Full negative image was printed.*

COMPOSITION AND IMPACT

10

It has been necessary to cover tools and techniques in previous chapters, though I know your main interest is taking pictures. Here, and in most of the chapters that follow, the emphasis is more directly on the application of what you have learned, which is the real payoff to absorbing basic knowledge.

We know it's possible to take good pictures with a relatively inexpensive camera, because visual awareness is a lot more important than the price of a lens. Of course, better equipment gives us more creative control in any picture situation—once we are familiar with what makes a photograph impressive, exciting, moving, or successful in the first place. Now we delve into that subject, beginning with the visual elements we see in the finder, followed by a discussion of how those elements are composed, or designed, by the informed photographer.

THE ELEMENTS OF COMPOSITION

Think of the items listed below as visual raw materials. It may sound elementary to talk about a house or a tree or a human face in terms of how they relate to other forms in a scene, but this is the essence of composition. The dictionary defines *composition* as a combination of parts or elements to form a whole. More to the point, composition is the most effective arrangement of subject matter to tell a story, attract a viewer's eye, elicit emotion, communicate information, or somehow distill what you see onto a frame of photographic film. A print or slide is often composed for maximum visual *impact*, which means the elements in

a picture are arranged or recorded to move or affect the viewer in a variety of ways.

Visual Elements

Before we delve into pictorial design, we must examine the world around us in visual terms that may seem academic at first. However, once you recognize a fence post as a *line* and realize the significance of the *space* between that fence and something in the background, the elements you photograph will have more meaning in a composition. Though the elements are listed separately, they are usually seen and photographed in combination, as the examples demonstrate.

Lines and forms. It might be said that every subject is made up of lines and forms (or shapes). If you take a picture of a person walking among trees, the person may be a heavy line, and the trees are various shapes. In what position should the individual be in relation to the trees and the background to create the most effective composition? We will explore theories about that below. For the moment, start looking at your surroundings more analytically.

Figure 2 is dominated by lines both straight and curved. They group themselves to form shapes, but the linear feeling in this period school is enjoyable to study. As I composed the picture with a 4x5 view camera, I had in mind the directional variations of the lines as

2 Differences in texture and subject scale are keys to this composition.

flowers in a green field, or a bright dress in a living room setting is always a compositional challenge. In some pictures, the color itself is exciting or emotionally persuasive, and you make images that you hope pass this feeling on to viewers.

Color is a fascinating subject of study by itself. Connotations of color are important to interior decorators and clothing designers; how colors affect each other in a picture is more our concern. Color is always a part of a form, line, or texture, and it is also considered pictorially, as will be discussed.

Texture. Natural or man-made textures are part of other forms, but they may be the strongest element in a composition. We see textures and take them for granted, but when the sun is low and each shingle of a roof stands out, the texture of the roof is a visual element that may enhance a photograph. In figure 3, the sawed log makes up a major portion of the composition, but its texture and the contrasting textures that surround it are easily as important as the forms in which they are found. Sometimes a pattern of objects, such as a field of wheat or a stadium full of seats, is seen and photographed as an overall texture, which indicates that texture is a matter not only of surfaces, but also of visual repetition of elements.

Space and perspective. The feeling of space in a slide or print is merely implied, but it can be dramatized through perspective and by the placement of colors. Perspective on a two-dimensional surface depicts the sense of separation between foreground and background objects. There is normal perspective, or what appears to be normal, and there is exaggerated or dramatized perspective, usually gained by a choice of lens and camera angle. Typical examples are shots of a road or railroad rails receding into the background, or a row of buildings getting smaller as they are more distant from the camera. As we have learned, a wide-angle lens tends to exaggerate shapes

they played against each other. Notice that the decorative carved posts that run across the structure are placed below center. This creates a more interesting, less static *balance*, which we will discuss shortly.

Color. Just as balance was involved above, color—whether it is bright or subdued—is also integrated as a visual element in every picture situation. If you are shooting black-and-white film, you must mentally translate the colors in a scene into values or tones of gray. Sometimes you do this consciously, and make adjustments by varying the camera angle to lighten or darken a color, or by using a polarizing filter to darken a sky or eliminate surface reflections.

When you shoot color film, the placement or importance of a red barn, yellow

3 Lines and the forms they surround are the dominant visual elements here. ▶

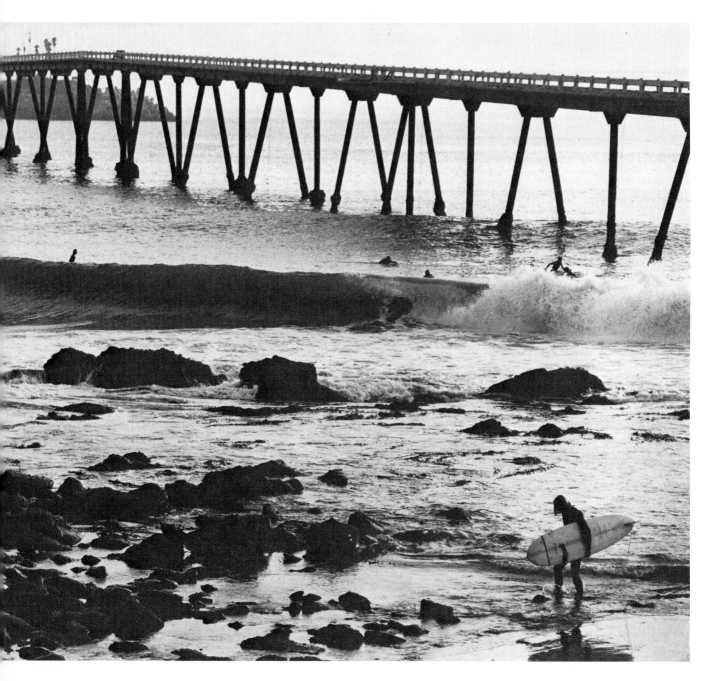

4 The relative distance from figure to pier was affected by using a telephoto lens to compact the sense of space.

and sizes, making those close to the lens seem much larger in relation to those farther back. A telephoto lens tends to compact the shapes in a scene, causing those in the background to seem larger in porportion to those in the foreground.

Figures 4 and 5 illustrate two versions of special relationships based on perspective, and neither is extravagantly dramatized. In figure 4 a zoom lens set at 150mm was used on a 35mm camera, making the pier seem closer to the surfer than it did with the unaided eye. However, the sense of space is ap-

parent, for the eye moves between the figure or rocks and the pier, and the distance stretches even further to the horizon. Had a 35mm lens been used from the same viewpoint, the expanse of the scene would have been enlarged, offering a different sense of space, and a changed relationship between the figure and the pier. Neither the 150mm nor the 35mm lens is the "right" one to use in such a situation. The choice depends on the effect you wish to create with the subject at hand.

5 *A medium wide-angle 35mm lens on a 35mm camera enabled Jill Krementz to include the lamp as part of Dr. Margaret Mead's editorial portrait.* © *1976 Jill Krementz*

ure, and eliminated the lamp above. Though a portrait may well be successful with this technique, there is a feeling of intimacy with Dr. Mead and her surroundings in Jill's version with the 35mm lens.

Another method of implying space involves handling areas of color, or placement of lines (usually vertical) in a composition. When a color is seen in the foreground and repeated in the background, the eye tends to move from front to back, achieving what painters call *plasticity*. A similar illusion occurs when vertical lines appear in the foreground and again in the background. Artists call this using *tension points,* and photographers incorporate these into pictures often without being aware of it. Study the work of some modern painters to see how they imply space without the literal use of perspective. Paul Cezanne pioneered the placement of colors to give his landscapes a spatial sense, yet many of his paintings are done in flat areas of color with little photographic reality. In some abstract paintings there is plasticity that causes the eye to weave in and out of the forms for a dynamic effect that is artistically contrived.

THE PRINCIPLES OF DESIGN

We use the basic elements discussed above, along with pictorial elements covered later, within the framework of a photographic composition. In other words, we compose lines, forms, textures, and colors, with attention to backgrounds, contrasts, expressions, mood, and so on, according to certain principles of design that function as well for painters, sculptors, architects, and graphic artists. Anyone who is serious about photography can benefit by taking separate classes in basic design. If that is not feasible, find some books that demonstrate more fully the material touched on here. I don't use the word "rules" in reference to design because it implies rigidity. Rules are necessary for tennis or traffic control, but where aesthetics is concerned, principles are more appropriate, be-

In figure 5 Dr. Margaret Mead is seen at her desk in a fine editorial portrait by Jill Krementz. Because she wanted to shoot by existing light, Jill chose a 35mm lens which gave her enough depth of field at f/5.6, yet allowed her to include the lamp above her subject's head to enlarge the area and show some of the setting. The sense of space is limited, but there's depth to the photograph. Jill might have backed off from Dr. Mead with a 135mm lens and taken a desktop eye-level view, which would have flattened the perspective, brought the background books closer to the fig-

6 *Christopher Moiles offbeat design which he titled "Feet and TV in Hospital" helped make his photograph a Kodak/ Scholastic Award winner.*

cause they are interpreted in personal ways. This is the essence of style. A photograph that is designed or composed by using certain principles and varying from others may have special qualities, and may also be experimental or created for effect.

A composition based on conventional adherence to design principles is often pleasant, and occasionally exciting, but may have the appearance of a postcard. However, you should be familiar with the conventions, and work through them toward the personal and offbeat. Picasso showed very early in this century that he could draw in a masterful and recognizable fashion, after which he made the transition to a painting style that may still shake up a lot of people. Though many of his paintings may seem bizarre, Picasso was a superb designer in form and color. I invite you to analyze some of his works to prove—or debate—this statement.

Design Elements

The dominant element. In a composition the largest, brightest, most color-ful, or most favorably placed object, form, or figure(s) is the dominant element. This may also be called the "center of interest"; it is where the viewer looks first. In a portrait the eyes are usually dominant, and in a landscape it could be a row of buildings, the sweep of a river, or distant mountains. The main action group in a basketball or football game is dominant, or the tallest building in a skyline. You may set out to place a form or series of shapes to be dominant in a composition, or it may be dictated by the subject matter itself.

In figure 7 the young lady approaching her friends is the dominant element in the composition. Though your eye may quickly stop at the expanse of white shirt on the young man, it shifts quickly to the girl because her expression and position are more interesting and important. Since I made several shots as she strode toward the group, it can be said that I placed the dominant figure consciously in this photograph—which was made as an illustration for a book on which I collaborated called *Teenagers Inside Out.*

In comparison, the lighted barber shop window is dominant in David

7 *Dominant in this composition is the figure of the young lady approaching her friends. The viewer's eye shifts from the too-prominent white shirt to the girls at right, but returns to the striding figure.*

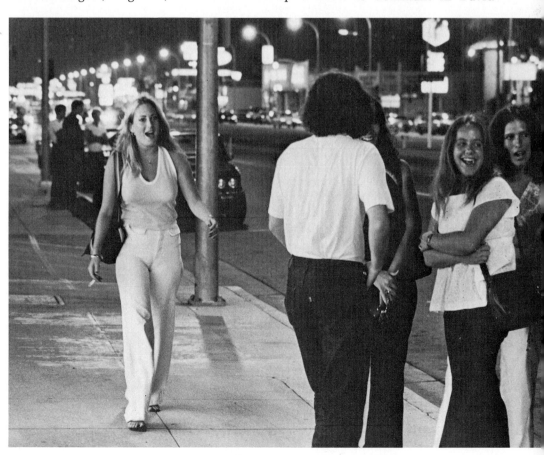

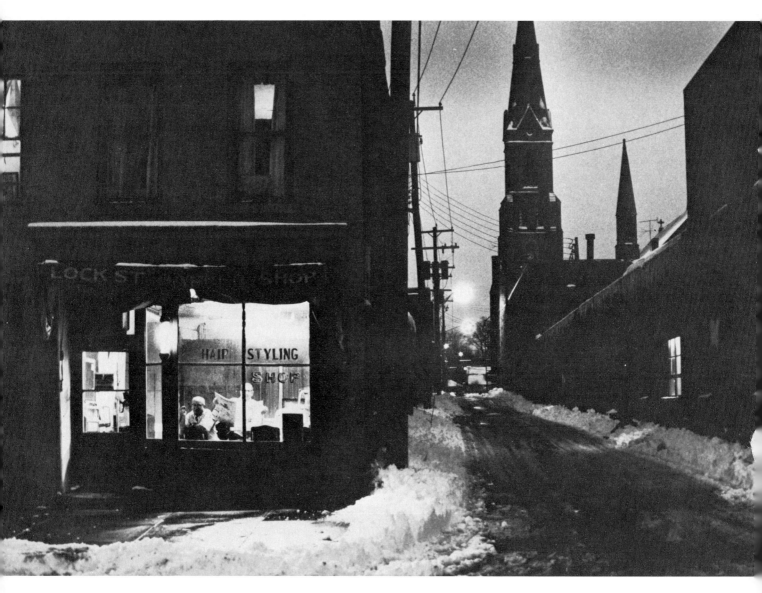

8 Analysis of David Stockton's composition shows the barber shop window to be dominant with the street and church steeple as important subordinates.

Stockton's view of a street corner in Lockport, New York (figure 8) because this seems to be the most likely manner of handling the composition. We are drawn first to the men in that window, after which we see the snow-lined street and the church steeple in the background, both of which are *subordinate* elements of the design. (In figure 7 the young people at the right are subordinate to the approaching girl.) Stockton's photo was a prize winner in the 1975 Kodak International Newspaper Snapshot Contest.

Frankly, I have always been reticent about much verbal analysis of visual subjects. To suggest that *everyone* looks at a certain composition in the same way, or by a rigid sequence, is a mistake I wish to avoid. However, in order to explain the dynamics of photographic composition, one must take certain liberties, and attempt to nail down certain visual approaches that we know are variable. In this regard, then, please understand that design is being examined in terms of principles that remain flexible even if their description sounds rigid.

Beginning with figure 9, the principle of dominance is combined with the practice of cropping to improve a composition, either in the camera, or while enlarging. This view of an amusement park from a skycar is confusing. The best potential for a dominant form is

9 *A confusion of subject matter is apparent before the dominant skycar at left center is isolated.*

10 An improvement over figure 9, the composition is still jumbled.

11 The dominant skycar is singled out in this vertical cropping, though the total image is not exemplary.

the skycar at left center, which is given a more prominent position by enlarging the negative to the composition shown in figure 10. Some of the jumble of shapes is eliminated, and the dominant skycar stands out better, though the photograph as a whole is still a reject.

By enlarging the skycar even further in figure 11, the composition is more acceptable; the dominant form is quite apparent in relation to the subordinate background material, but the total continues to be a near-miss. However, in color the skycar might separate from the background more distinctly, and with a longer-focal-length lens or a zoom lens one could achieve the improvement of figure 11 over figure 9 at the time the picture was taken. Though

this demonstration concludes with an image that I would reject for almost any purpose, by the same process one can single out a dominant in a situation that is more pleasing.

Subordinates. It is apparent that the remaining shapes, lines, colors, and textures in a composition are subordinate to the dominant one(s), perhaps not in storytelling character, but in visual priority. Some subordinates may be almost equal in eye appeal, working closely with the dominant to achieve pictorial content and impact. This relationship is shown in figure 12 where the huge ball is dominant in size and shape, while the children playing with

12 *While the size and shape of the huge ball make it visually dominant, the group of children is equally important in the composition.*

the ball are subordinate, but very important, elements in the composition. Obviously, there are infinite variations of dominant and subordinates, according to the subject matter and to personal interpretation.

Figure 13 demonstrates how closely subordinate, or secondary, elements may support and integrate with the dominant in a composition. Where does your eye go first in this Northern California landscape of marshland? Probably the dominant for most viewers is the dark background hills, especially where the setting sun glows from behind them. However, the cloud reflection in the foreground water is a close second, making this area a highly supportive subordinate element, fol-

lowed by the lines of grass around the clouds and the fence across the scene. Whether your analysis agrees with mine is academic. What is important is to help make you more aware of the relationships of subject matter in a well-designed compositon.

Balance. In general, an *inequality* of size, position, color, or contrast between the forms in a composition produces a more pleasing photograph. Equal sizes or proportions tend to be monotonous; if you divide a landscape with the horizon line in the center of the print or slide, the viewer tends to be bored in comparison with the viewer of a horizon line above or below the center. If you place a person in the center of your camera finder (figure 14), the balance is less visually interesting than if you place the model off-center (figure

13 *Note your own feelings about this composition* ▶ *as discussed in the text.*

14 *Placement of a subject like this in the finder typifies the "dead-center syndrome."*

15 *A simple off-center shift creates a more pleasing balance.*

15). This has been called the "dead-center syndrome" by an editor I know who says, "It is suffered by people who focus on a face in the center grid of an SLR finder, and simply snap the subject in that position."

Try to avoid equal divisions or placement of forms in the design of your pictures, because the average person's sense of aesthetics finds this situation unexciting. Arrange a scene or subject in your viewfinder with elements that balance each other in size (one large, several small) or have a pleasant opposition of placement, because variety in the use of design elements usually makes a more interesting composition. David Chien's narrow vertical apartment wall (figure 16) is a good example of what I mean. We can assume that he cropped off portions of

16 *David Chien visualized cropping his 35mm format in this way as he made the photograph, and variations may have occurred as he printed the negative.*

17 *Study the several ways the eye may begin viewing this composition, and the visual paths it may take from one form to another.*

his image to create the balance we see. There is a vertical line of windows in the center of the photo, but imbalance is achieved by all the other lines and the pattern of hanging garments below center. David's imaginative composition won him a Kodak/Scholastic Award in 1975.

Eye flow. This refers to the path a viewer's vision follows when looking at a picture. The eye may start at any edge with a line or form that leads into the composition, or it may begin within the image at a dominant shape or color, and move away from that toward other forms in a curved, angled, or straight path. There is no formula for eye flow in a composition to make it successful, and we are not usually conscious of it specifically as we take pictures, but it influences the impact of the image.

Visual flow is integrated with placement of dominant and subordinates and with balance.

I've chosen figure 17 for an analysis of eye flow because its dominant and subordinate elements are not decisive. In this 4x5 shot of London, taken in 1955 before reconstruction was complete in the area of St. Paul's Cathedral *(top right)*, the combination of structural shapes becomes dominant, though the atypical form of the cathedral dome may stand out most strongly for some viewers. Therefore, the visual path by which one sees this picture may begin with the dome and shift to the center remnant of a building, or it might start in the center and move toward the dome. There are horizontal window shapes across which the eye may skip,

or the composition may be viewed along an oblique path that starts near the steeple at top left and runs toward the bottom right corner. Because the design of this photograph is open to such variables, it might be termed a *record* of the scene more than an artistic interpretation.

A "record shot" may be quite sharp, pleasantly enough composed, and interesting to view, but it lacks the aesthetic impact that stems from taking a more creative approach to extract from or interpret a subject. When a photograph is more poetic, leaves more to the imagination, somehow juxtaposes forms for contrast, or includes emotional impact, it is likely to go beyond being a mere record of a scene to become a more meaningful image. As an example, figure 18 was also taken in London on the same visit. It avoids being a mere record for some of the reasons mentioned above, and it becomes

18 *There is visual intrigue in the mirror image to amplify the total impact of this postwar London scene.*

a more satisfying aesthetic image that has intrinsic merit.

Edward Weston was a master of focusing on commonplace subjects, and seeing them in an artistic manner. His poetic vision was able to abstract portions of a landscape or a man-made subject and take them far beyond a mere photographic record. Weston also had an unerring eye for composition. Though he composed on the ground glass of an 8x10 view camera and did not crop his prints, it is difficult or impossible to improve most of them by any sort of cropping. Try it. Look at a selection of Weston pictures in any of several books (some of which are listed in the Appendix of this book), or at the few examples in chapters 3 and 16. You can learn much through such an exercise, even if you disagree with me. Don't delude yourself that your own approach to photography is unrelated because Weston worked painstakingly to compose and shoot a relatively few sheets of film in a day. The practice of precise and careful composition now— and whenever possible in the future— prepares you to see and shoot far more effectively in fast-moving situations when the experience of composing slowly has helped sharpen your instinct to do it quickly.

PICTORIAL COMPONENTS OF COMPOSITION

From the raw materials of composition and through the universal principles of design, we arrive at the pictorial elements of a compositon: the subject matter itself. In this category are practical considerations about which you make continuous decisions as you take pictures. Guided by principles discussed so far, you may wait, shift your camera, or do a number of things to improve some aspect of a scene, or avoid it entirely.

Mood

Though this is discussed first, it may be more or less important than contrast or any of the other topics that follow. Because there is an infinite variety of subject matter to be photographed, in changing light from any number of viewpoints, pictorial emphasis always varies.

19 · *Family fun and spontaneity are the primary mood here, photographed with a 35mm lens on an SLR.*

20 *Amused expectation shows clearly in this informal portrait taken with a 50mm lens on an automatic SLR with Tri-X at 1/250 second.*

You may set out to create a specific mood in a photograph, but you are more likely to find it already existent. An outstanding example is Dorothea Lange's "Migrant Mother" reproduced in chapter 16. Despondency is the primary mood of this classic picture, and it evolves from the woman's expression, from the positions of her children, from the pose of her hand, and from the subdued lighting.

Though mood can occasionally be manipulated through lighting and expression, it is often intrinsic to a composition. For instance, the scene through a window in your home, when the sun is high and there's no one around, is probably just a record shot. However, if you take exactly the same view without moving the camera or changing lenses when it's foggy or raining, when the sun is low, when children outside are splashing in puddles, or when a lonely figure walks by, the mood created makes a routine composition into a memorable image.

I've chosen three pictures to typify three different kinds of mood, of which there are so many. Figure 19 has a mood of exuberance as this delighted family makes its way through Disneyland. The lineup of faces and figures is not outstanding, and the image would be better had the three people not been in the background. Even so, facial expressions and postures catch the eye as it moves from one face to another to enjoy and share.

In figure 20 my wife's mood is one of relaxed expectation, expressed in her face as well as the position of her arms and head. I tried to crop into her shoulders and eliminate the arms, but this looked awkward. I did crop into the brim of her hat because a full curve near the edge of a picture attracts more than its share of attention. By cutting into the hat, I have directed the viewer to her face more quickly. In a simplified way, this picture shows how well connected mood and composition can be. The plain sky background was also intentional to avoid distraction from her face.

21 Features of the landscape and the lighting combined to create drama in Kay Lombard's view of Yellowstone National Park.

The dramatic mood in Kay Lombard's Kodak/Snapshot-Award-winning photograph (figure 21) is a product of the steam arising from the ground at Yellowstone National Park, plus backlighting and darkening of the sky by a deep yellow filter. Backlight amplifies mood in many situations; contrast (see below) between light and dark also adds to the impact of Mrs. Lombard's photo.

Mood can be ethereal or strong, dynamic or placid, mysterious or quite obvious. Make a list of mood possibilities for yourself, and attempt to photograph or symbolize as many as you have time for, as a stimulating self-assignment. Some of your pictures may appear to be synthetic, but others could have pictorial impact you admire.

Contrasts

Contrast has been mentioned in terms of light against dark. In addition there are contrasts of large vs. small, bright vs. subtle color, and regular vs. irregular shapes. Static vs. dynamic is another form of contrast in composition, exemplified in Tom Carroll's photograph of the young lady leaping over the camera in figure 22. Not only did Carroll choose a dramatic camera angle and use a 21mm lens on his Leica, but also the strong movement of the figure is in contrast with the static sky background. Action is always an eye-catching pictorial element, and Carroll's use of the low angle is an excellent model of journalistic creativity.

22 A low camera angle plus dynamic action are the unusual elements that contrast Tom Carroll's foot-fighting photo with more conventional approaches.

23 Light and dark, near and far, small and large—all of these contrasts are illustrated at this refinery, photographed with a Bronica and wide-angle 50mm lens.

In figure 23 there is contrast of values with the dark out-of-focus figure against the light refinery equipment, plus a contrast of sizes, or scale, because of the small figure in the background and the pipes towering over the man in front. The tilting equipment also adds drama, since diagonal lines are often more dynamic than straight ones.

Finally, there's a contrast of textures in figure 24. The model's skin seems smoother when surrounded by rough earth and gnarled vines. In addition, her static pose has its counterpoint in other shapes which have visual movement.

Perhaps you have seen landscape or seascape pictures without human or animal forms, and they seem somewhat empty. A figure or two not only adds

24 *Human form and texture seem more rounded and smoother in relation to their visual surroundings.*

contrast to open space, but adds the feeling of life on a natural stage by which the viewer can better identify with the scene.

Backgrounds

Confusing backgrounds are responsible for more image failures than camera movement, and rank about equal to careless placement of people and objects or faulty timing. A background should be as simple as possible and/or out of focus, or it should play a meaningful role in the composition. All sorts of junk seem to turn up behind people you photograph, often because you are intent on expression and action, and the background is ignored. I continually find myself shifting my body or the camera to place faces, figures, or other

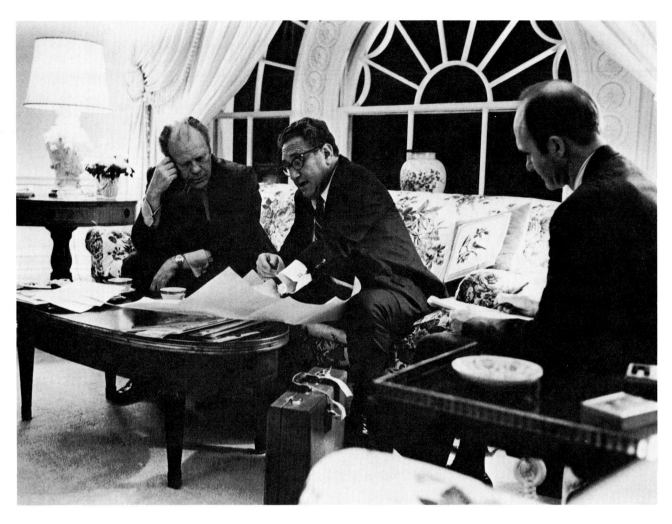

25 *While White House windows are busy in the background of David Hume Kennerly's picture, they were unavoidable, and give the scene authenticity.*

subjects against plainer, or less objectionable, backgrounds. If I cannot move easily, I attempt to vary the subject's position. If this is not feasible, I may use the largest aperture that is practical to throw the background out of focus. Switching to a longer-focal-length lens helps accomplish the same thing, because, as you remember, short-focal-length lenses offer greater depth of field at a given aperture than longer ones. In bright sun, there's a good case for using medium- and slow-speed films in order to retain better control over backgrounds that may divert the viewer.

I'm not going to show examples of confusing backgrounds, except to mention figure 9 in this chapter, which illustrates a classic mess. Backgrounds are sometimes integral to picture content; many environmental portraits by Arnold Newman are fine illustrations of this. In a less formal way, the same may be said for David Hume Kennerly's

spontaneous shot (figure 25) of President Ford conferring in the White House family quarters with Henry Kissinger and his deputy, Brent Scowcroft. Though the background windows and the lamp are somewhat competitive with the dominant figures, they add authenticity to a setting that few of us will ever visit. As an outstanding photojournalist, Kennerly has learned to make compromises where backgrounds are concerned, and to concentrate on mood and other forms of pictorial impact.

26 *Examples of architect Welton Becket's extensive work displayed on the wall behind him become a sort of "stage setting" for this environmental portrait with a 28mm lens on an SLR.*

The background and surroundings in figure 26 are further examples of how these elements can be organized to enhance a composition. The scene is the office of the late, great architect Welton Becket. His environment and a display of buildings designed by his firm on the wall behind him all add up to a more meaningful editorial portrait than if I had used a plain or anonymous setting.

Additional Pictorial Considerations

Although this chapter is about composition, that subject has many ramifications. My goal is to help and encourage you to make the most of the technical and aesthetic knowledge gained here, in the classroom, and from other sources. This means taking better and more effective, satisfying, and meaningful photographs for whatever purposes you have in mind now and in the future. Therefore, the following points are included. They are not all in the realm of composition; they are related, however, to making the most of your talent and aptitude with a camera. These points are not covered in order of importance.

Framing. This technique includes shooting through, under, around, or over a foreground shape or objects that partly or completely frame the main picture area. A porch or bridge across the top of the image, leaves and branches hanging down or at the side of a landscape, or a piece of playground equipment in the foreground beyond which you see the primary activity are all examples of framing. In figure 23 I shot from behind a silhouetted figure to frame the refinery in the background.

Framing often adds interest and a sense of space to a composition. It may

27 *A slow shutter speed produced a motion pattern in Fred Luhman's photo of a track meet in Denver, taken originally in color.*

also be defined as using an "interrupting object" or figure in the foreground beyond which you see the pictorial dominant and subordinates. Framing someone between several other people adds impact to an image, whether the foreground figures are in or out of focus. Be aware of situations where framing can add a change of pace to your photography.

A feeling of motion. It is often useful to capture action sharply on film in daylight or with flash. However, if you can use a slow shutter speed and allow action to blur, the result may be a vivid sense of motion which adds impact to the image. The eye does not see blur as it is created on film, and thus the pho-

tographer gets credit for being imaginative. In figure 27 Fred Luhman panned his camera at one-half second to enhance the speed of two high-hurdle runners at a Denver track meet. The blurred symbolism in his photograph won a Kodak/Snapshot Award for Mr. Luhman.

Some years ago Ernst Haas shot bullfights in color with slow shutter speeds, and set a pace for many interpretive photographers. With a lot of blurred motion and skillful anticipation of patterns, you can create color images that are closely related to paintings.

Point of view. In motion picture terminology, point of view (POV) indicates the position of the camera, and in still photography commonplace scenes may be interpreted with greater visual thrust when they are shot from a POV that is unusual. I once heard a photographer tell of an assignment where a couple of movie personalities were posing for the press. "There were about six other cameramen there," he reported, "and it would have been futile to line up with them and get the same pictures. So I roamed around the edges and behind the subjects, looking for an unusual point of view. Some of my pictures were spoiled by confusing backgrounds, but I did get some edge-lighted portraits that were different."

When the opportunity exists, while traveling or around home, challenge yourself to see a subject in a way that others may not have photographed it often before. Shoot and keep moving; change lenses and locations for a new perspective. Notice how the background changes as your literal and/or optical POV are altered. Figures 28, 29, and 30 show a variation on the POV theme. For all three pictures I used a 50mm macro lens on an Olympus OM-1 camera, and Tri-X film. Of the several frames I shot relating cactus and desert background, figure 28 has the best pictorial impact. There is contrast, a sense of space, and interesting textures.

For figure 29 I moved closer to a clump of cactus, knowing the background would be in soft focus. The change of POV helped me exploit the material at hand. Finally, I focused within a foot of the backlighted spines, taking advantage of the macro capability of figure 30. When you explore differing points of view with several lenses, the potential is even greater.

Another point needs to be made in terms of POV and camera handling: Remember to shoot verticals, even though the natural tendency may be toward the horizontal format. In many situations, the subject matter requires that you hold the camera vertically, but remind yourself to vary from the hori-

28 *The camera was held at waist level and the foreground shadow was included as part of this composition to demonstrate changing point of view.*

29 *The SLR is now at eye level and the background is slightly out of focus for better separation from the cactus.*

30 *When the POV becomes a close-up, background becomes anonymous, and the arrangement of small details is more important.*

31 *Nature's arrangement of the subject seems to suggest a horizontal format...*

32 *...but experiment with the vertical is often worthwhile for many subjects.*

zontal position if the change is not so obvious. Figure 31 is horizontal because the composition seems to stretch naturally in that format, but I shot figure 32 from the same position, both as an exercise for this book, and to compare the results when prints were made. Which format is better may be a matter of opinion; the purpose here is a visual reminder not to be monotonously horizontal.

Emotional impact and content. These are not part of compositional structure per se, but we all attempt to evoke *feeling* of some kind from viewers of our photographs. Some of the strongest, most exciting images we remember from books, magazines, exhibitions, or personal contact are recalled because of our emotional response to them. Professional photographers, and others who seek photographic opportunities widely, seem to have an advantage because a variety of emotions are indigenous to wars, competitive sports, people in the news suffering or enjoying various experiences, and similar picture-worthy subjects. W. Eugene Smith has specialized in focusing on emotional content in his photographic essays such as "A Spanish Village" and "Country Doctor," and in his book, *Minamata.* From Bud Gray, a friend and ex-newspaper-photographer, I have a large collection of emotion-laden prints taken when personal tragedy struck ordinary people. Other photographers, such as Elliott Erwitt, Paul Fusco, Henri Cartier-Bresson, Gordon Parks, Dorothea Lange, and many more, are noted for capturing those "decisive moments," as Bresson called them, when people are affected by sometimes disturbing circumstances.

With this in mind, I have sometimes felt sorry for myself, because the opportunities to shoot similar subjects have too seldom been mine. However, I realize (and hope you will, too) that this attitude is superficial. Though we may rarely focus on war, famine, or allied visual drama, the ordinary world around us is full of emotion. A routine situation, such as a birthday party, a touch football game, or a visit to a local museum or an airport where people come and go can afford us chances to

33 *Instant involvement is assured through expression and stance in Tom Carroll's coverage during the making of a TV movie.*

capture the gamut of emotion from joy through sorrow. We must be aware of the possibilities and be prepared to snap them spontaneously.

When something happens to make people react, their faces tell a story, and your photographs of those moments can be outstanding. An instinct for timing comes from experience. Momentary involvement with the subjects should sharpen your sense of anticipation, but involvement must be limited or else you will watch and react within your own heart and mind, but you will neglect to take pictures. A capable photographer learns to stand off emotionally in order to produce negatives or slides as his/her first priority. I'm not suggesting that we be callous; I'm merely say-

ing that concentration through the finder of a camera is a learned behavior that can be developed. Look through Gene Smith's *Minamata,* or study a tremendously moving book by Donald McCullin titled *Is Anyone Taking Any Notice?* to discover how trained, sensitive photographers can be empathetic, marvelous photoreporters. There are many other examples, less heavy and often humorous, that illustrate the same thesis. Tragedy is only one aspect of human existence.

In more everyday terms, I've chosen three photographs to symbolize emotional impact. Tom Carroll explains that the people in figure 33 were actors and actresses whom he directed for a reaction to another scene he had shot. Their expressions and body language combine to make a visual point.

34 *The nature of this subject, more than its composition, creates mystery and intrigue to hold viewer interest. By Everett McCourt, another Kodak/Scholastic Award winner.*

Figure 34 by Everett McCourt uses the surroundings of an abandoned hotel room to emphasize a feeling of malaise we cannot fully define. In contrast, figure 35 is a result of an unexpected moment when a bird zoomed in at my subject as she was reading to me. She shouted and cringed as I snapped one frame before the bird flew away. Emo-

tional reaction here was fleeting, but in many instances, it prevails long enough for you to shoot carefully and repeatedly.

Simplicity. Effective design and composition thrive on simplicity. The most direct, restrained, and uncomplicated way you can view a subject through the camera finder will usually create the best picture. Study all kinds of photo-

35 *Facial reaction and the reason for it are both clear in this spontaneous moment.*

graphs you admire. Most of them tell a story with uncluttered simplicity. Examine your own pictures, and you will find that those which leave lasting impressions are usually the most simply composed. As you shoot, be conscious of what you want to express, and eliminate any elements that distract from that goal.

COMPOSITION BY CROPPING

The most efficient means of composing a photograph is through the camera finder. Some photographers, using equipment ranging from 35mm to 8x10, seriously attempt to shoot pictures that do not have to be cropped. You can recognize the full-negative 35mm format in many picture books today. Filling the negative as you shoot can be a terrific

36 *Two L-shaped pieces of white cardboard are useful for cropping a print.*

discipline, but trying to maintain such a purist approach when enlarging a negative or projecting a slide may be an unnecessary compulsion. It is far more common to crop an image, and by removing extraneous material at one or more edges, improve it. Sensitive cropping enables you to concentrate on the essentials, and eliminate any elements that seem unnecessary.

The easiest way to crop a print is with a pair of "L's" made from thin white cardboard. Cut each L long enough to cover the size of print you're cropping, and move the L's around the image to decide if any of it can be trimmed to advantage. Figure 36 shows cropping L's in use, though the area they surround is not a significant one.

The full image being cropped in figure 36 is shown in figure 37. It was taken in a small English town, using

37 *Composition from the full 4x5 negative taken in a small town north of London.*

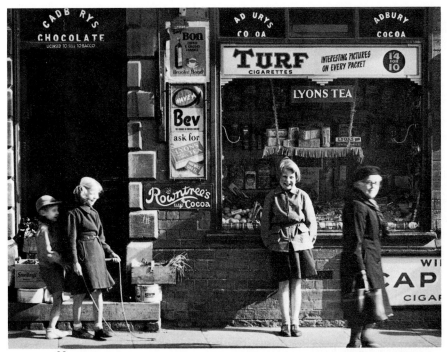

38

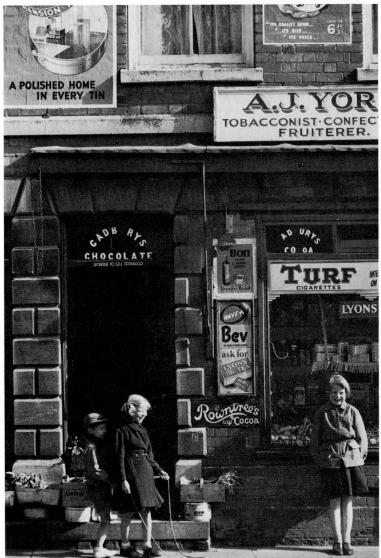

39

a 4x5 view camera, and the complete negative was printed.

A Cropping Exercise

As an exercise in composition, which I would encourage you to try occasionally, I have cropped figure 37 five different ways.

Figure 38. The dominant figures and a portion of the storefront are interesting enough to stand alone.

Figure 39. This is the first of three vertical croppings, which is atypical, because the average photograph may not be subject to as many variations. Here there is a pleasant balance of rectangles behind and above the children.

Figure 40. From a design point of view, the figures are too low in the frame, but this cropping is pictorially offbeat and captures interest because of its content.

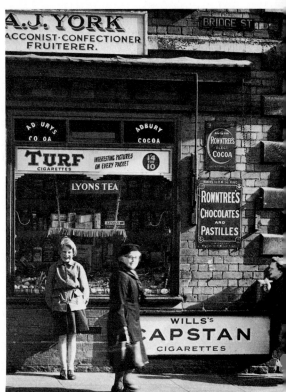

40

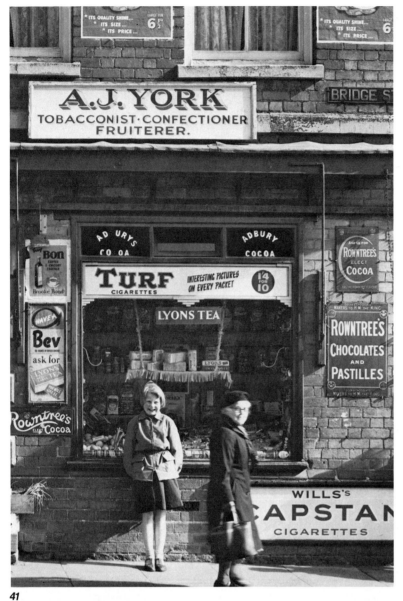

41

42

Figure 41. Again the figures are somewhat low, but notice how the horizontal signs at the top, in the middle, and at the bottom help the eye flow, and create a useful balance. The composition is "busy," but less so than the original in figure 37.

Figure 42. This version is reduced to a geometric arrangement of rectangles that is only partly related to the full image. A dark horizontal area divides the picture in the center, but the top and bottom are adequately connected by the vertical pipes and by repetitive shapes.

While the aim of this exercise was not to eliminate extraneous subject matter, it does demonstrate the value of looking for *pictures within pictures* while shooting and afterward.

The Continuous Search

A developing photographer may seem to be in a squeeze between taking pictures quickly, and staying with a situation long enough to exploit it fully. A few decades ago I heard someone comment that a certain *Life* staffer shot 2,000 negatives on a story that ran about eight pages in the magazine, and culminated in perhaps 15 images. This practice was called "machine-gunning," but whether it was careless or profound is not the point. When covering a very mobile subject, you are likely to shoot more than when the search for composition is concentrated on something more static. In either case, you make exposures until you are satisfied you have what you need, or until conditions change to a point where you must stop and focus elsewhere. This whole process is subjective in relation to your personal fulfillment, and objective in terms of practical accomplishment. When my wife and I shot the illustrations for a children's book called *Beautiful Junk,* we made about 1,200 exposures on four separate days. Only 53 of these appeared in the final book, but we worked efficiently, shot until we were reasonably certain we had exhausted each situation, and knew that film was

43

43–44 *An ancient metal sink half buried in sand is seen from two camera angles a few paces from each other. Explore and experiment as you take pictures to exploit both mental analysis and aesthetic feelings.*

cheaper than time. In comparison, there are times when I have exposed one 36-frame roll of film during a whole afternoon of pictorial exploration. Each negative or slide was made with studied deliberation, sometimes from a tripod. The discipline of precise composition creates its own restraint.

SUMMARY

Photographic composition means editing through the viewfinder, slowly or quickly, depending on the subject, and cropping during enlarging or by applying strips of tape along the edges of a slide. Figures 43 and 44 emphasize the value of trying variations on a theme, and combining both intellectual and instinctual concepts of design. Both are full-negative images, and I'm not sure which I prefer. I shot them to demonstrate the point I make here.

Figures 45 and 46 illustrate the pictures-within-a-scene theme that is related to the cropping exercise above. From a large plot of daisies I extracted figure 45 which is a haphazard composition. By narrowing my view, I could make a more pleasing pattern of flowers, as seen in figure 46, which is an improvement, but obviously not a picture of lasting value. Even so, it should help you remember to persist in the continuous search for greater visual impact.

45 *We are constantly required to edit pictorial material, and to be selective, which is the essence of individual artistic talent. From a huge expanse of daisies, this patch was snapped first.*

46 *By getting closer and grouping fewer flowers, a more effective composition was possible.*

SPECIAL PHOTOGRAPHIC TECHNIQUES

1 Close-up or macro photography is most expedient with cameras that let you view through the lens, such as the SLR. A 55mm macro lens on a Konica Autoreflex T was hand held a few inches from the busy bee.

Photography is a very versatile medium. With a camera you can record a direct and honest view of the world around you, as things happen, or you can create situations for a purpose. There is straight photography, which means little or no manipulation of camera or film, and there are techniques in the camera and/or in the darkroom that require offbeat imagination. In later chapters are details of these and other approaches related to commerce, communication, and personal expression. In this chapter some special techniques are described. Most of them are functional, but a few challenge your artistic instinct. If these techniques seem esoteric to you now, perhaps in the future they will be more useful.

CLOSE-UP PHOTOGRAPHY

In this category are pictures taken closer to a subject than is usually possible without special lenses or attachments for conventional lenses. The normal lens of a single-lens reflex camera focuses to about 18 inches. Negatives or slides shot between that distance and an inch or two from a subject are products of close-up photography, also called *macrophotography*. *Macro* comes from a Greek word meaning "long or large." A macro lens, as we learned, will focus to close distances, enabling you to photograph a bee, such as that in figure 1, large enough on a negative so that in an 8x10 print it is several inches long. In other words, through macrophotography you can enlarge objects or details to bigger-than-life dimensions.

Before continuing to equipment and techniques for macrophotography, here are some definitions:

Macrophotography or photomacrography. Photographs enlarged to life-size or larger than life, up to about 10x. Confusion arises whether a life-size or 1:1 image *on the film* (negative or slide) constitutes a macro photograph, or whether the film image may be less than 1:1 as long as the enlargement (printed or projected) from it is 1:1 or larger. Actually, the distinction is academic. If a lens or a lens-and-accessory allow you to focus closer than a normal lens would, you will be into close-up photography, and you'll get as close to a subject as your needs and equipment will permit.

2 Photomicrograph of 75X enlargement of an ephedra stem shot by Story Litchfield with Polaroid Type 105 film through a bright field microscope.

Microphotography. Though the term sounds as though it means taking pictures through a microscope, it actually refers to reducing a subject to the size of a frame of film, e.g., microfilms.

Photomicrography. Ultra-close images taken with a camera mounted on a microscope (by means of an adapter) used instead of a conventional lens.

Close-up Equipment

Cameras: The most practical camera is one with through-the-lens viewing. A view camera or large-format SLR is feasible for close-up work, but the 35mm single-lens reflex with a built-in exposure meter is the most versatile. Equipment described below is for the 35mm SLR.

Lenses: Specialized macro lenses were mentioned in chapter 2. Accessory lenses and rings or tubes are covered below. The average macro lens has a focal length of 50mm or 55mm and a maximum aperture of f/3.5, and may well serve as a normal SLR lens for many purposes. In addition, during the past few years dozens of new macro-focusing zoom lenses have been introduced by many manufacturers. Vivitar's Series 1 70–210mm f/3.5 lens was first; it focuses down to 3 inches from the front element for a 1:2.2 ratio. Other such lenses are available from Konica, Pentax, and Soligor, to name a few. Soligor offers five different zoom ranges, all including macro-focusing.

3 Vivitar close-up tubes for Konica Autoreflex with automatic exposure capability; supplied in three widths for a variety of macro ranges. Photographed with an Olympus OM-1 and Zuiko 50mm macro lens.

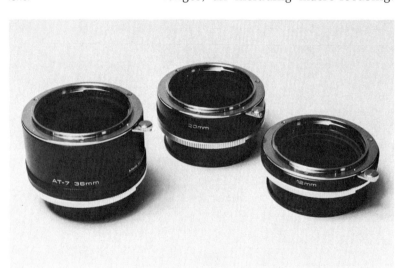

Most of the new macro-zoom lenses are lighter in weight and shorter than their predecessors, and are worth investigating for their modern optical wizardry. Though they may be costly, their multiple functions preclude having to buy other lenses of individual focal length.

Reverse adapter. This is a metal ring that mounts to an SLR camera body in order to fit a normal lens (or other focal lengths if you wish) to the camera in a reversed mode. When the front element of a lens is closest to the film, it is capable of slightly more magnification and better sharpness. However, the diaphragm is no longer automatic, and must be set manually according to meter readings. While this is a slower way to work, close-up photography is generally meticulous, and the inconvenience is minimal. When purchasing close-up equipment, ask to try a reverse adapter on your camera, and compare its capabilities with those of close-up rings and attachment lenses.

Close-up rings. Also called *extension tubes*, these are usually made in sets of three of varying width. One ring or more is mounted to the camera body, and a lens is mounted to the ring, extending its distance to the film plane. Many such tubes are manufactured to activate the automatic diaphragm of a camera, which is a distinct asset. The wider the ring or tube, the greater the magnification for macro work. SLR cameras with built-in metering systems automatically compensate for adjustments in exposure using close-up rings or attachment lenses. However, because a tube lengthens the distance from lens to film, relative apertures of the lens are decreased, and exposure increases are indicated by the meter. For instance, at f/11 with 50mm of extension tubes, a 50mm lens is actually operating at f/22, and you will be using lower shutter speeds or time exposures. An advantage of close-up rings over attachment lenses is optical superiority, since the latter theoretically alter definition of the camera lens. However, the difference is usually slight.

4 *Numbers 1, 2, and 3 diopter close-up attachment lenses, for use primarily with single-lens reflex cameras.*

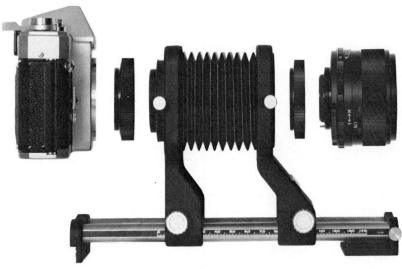

5 *Typical bellows equipment by Vivitar attaches to a tripod; camera body is mounted at one end and appropriate lens at the other for very versatile focusing.*

6 *Glenn Edwards, while a student at Brooks Institute, cross-lighted the coins to accentuate their shallow images, and photographed them with a 4x5 view camera and 6-inch lens.*

Close-up attachment lenses. These are individual segments of glass ground to varying degrees of magnification described in diopters, the term used for eyeglasses. Made in sets of three or four, a set of close-up lenses costs slightly less than extension tubes, and adding one or more to a lens does not alter automatic diaphragm operation. As with rings or tubes, you can focus to about 1:2 with close-up lenses, which are easy to use, but may not produce as sharp a negative or slide as other equipment.

Bellows. Mounted on a single or double track, a bellows is attached to the camera body at one end and a lens is mounted at the other. Bellows are made in several sizes to extend a lens six inches and more from the film plane. Choose a bellows particularly for very close work, 1:1 and larger, for the specific purpose of this equipment is to provide great flexibility. You must work from a tripod with a bellows, which is often sensible when using attachment lenses or tubes, though the latter allow you to hand-hold the SLR. Special cable releases are made for some bellows to allow semiautomatic diaphragm operation; otherwise you stop down and open up manually. You may also place a slide-copying attachment at one end of a bellows, and control image size by changing the distance from slide to lens. As noted in chapter 2, certain 100mm and 105mm macro lenses are available primarily for use with extension bellows.

Close-Up Techniques

For any of the applications of macrophotography, there are four main considerations that contribute to successful pictures.

Lighting. Existing light is suitable if it's bright enough and sufficiently directional to show proper detail in the subject. The bee in figure 1 was photographed in afternoon sunlight that allowed an exposure of 1/250 second at f/22 using a macro lens on a hand-held SLR. Most outdoor subjects are taken with natural light, and a reflector may add shadow detail if necessary.

7 *One 150W reflectorspot set low at the right brought out form and texture; a close-up lens was used with a 50mm camera lens. The camera was on a tripod.*

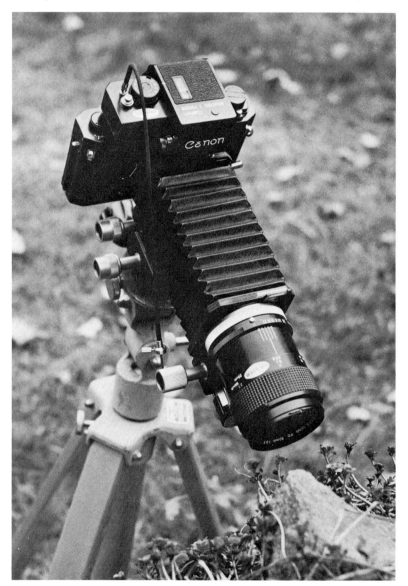

8 *Mike Matzkin photographed his Canon camera and bellows with macro lens in position for taking enlarged nature details.*

Working in artificial light, the closer you focus to a subject, the more important it becomes to place the main light at a level low enough to accent surface form and texture. This is sometimes called cross-lighting, illustrated in figure 7, a picture of orange slices taken with two close-up lenses on a 50mm camera lens. A single 150-watt reflectorspot at the right was aimed to bring out detail with enough shadow area for form. A reflector would have brightened the shadows but seemed unnecessary here.

Irregular form and texture is relatively easy to light, but flat, smooth objects, such as a slice of bread or a coin, require careful placement of lights. As you work, you will find that raising or lowering a light even an inch can bring out the appearance of texture more clearly. It is often possible to keep your eye at the viewfinder and adjust a light with one hand as you observe the effects. Through experimentation, you will soon realize how to control the subtleties in black and white or color, lighting techniques for which are almost identical.

Camera stability. Tracking an insect or photographing flowers in sunlight, you may have to be mobile, and use of a tripod can be avoided if shutter speeds are fast enough. Otherwise, a tripod is a welcome ally to close-up photography. The size and type are not as important as the reliable sturdiness of your equipment, for the tiniest camera movement during a relatively long exposure will ruin the results. Very short tabletop tripods and certain clamps may be improvised for macro work indoors or out.

Depth of field. You recall the optical principle that the closer you focus with any lens, the less depth of field you have. In ordinary situations, you can expect depth of field to shift in terms of feet; when you are a foot or less from a target, depth of field may be measured in fractions of an inch. Therefore, it is inherent to macro work to shoot at small apertures, and many macro lenses stop down to f/22 and f/32 for this reason.

9 *The outer skin of a pineapple taken with a macro lens and enlarged to 8x10 becomes an intriguing picture puzzle.*

10 *Tiny circuitry of a tape recorder photographed with a close-up tube and 52mm SLR camera lens in daylight as an exercise in abstract design.*

When focusing closely, visual determination of sharpness through the camera lens is the only method. As you stop down the lens to check depth of field, the image darkens; therefore, it helps to work in relatively bright light in order to see accurately enough how much of the image will be sharp. If the light is too dim for convenience, and more cannot be added, focus as sharply as possible with the lens aperture wide open, stop the lens down completely, and hope for the best. By moving the camera an inch or two away from a subject, you can improve depth of field, even if you must crop the slide or negative for the final picture.

Exposure. As noted, the metering system within a single-lens reflex will compensate for exposure in macrophotography. There is usually an exposure factor table with close-up lenses and extension tubes if you wish to compute this yourself, or check the meter. Because you should shoot at small lens openings which are further reduced in effectiveness by the added distance from lens to subject, long exposure times are usually helpful unless the film is fast and the light is very bright. For this reason, you may need a watch to measure seconds of exposure. A few automatic-exposure SLR cameras that compute time exposures electronically (up to 60 seconds for the Olympus OM-2) are useful in macrophotography.

Exploring the close-up world can be exciting and fascinating. If your budget is limited, begin with auxiliary lenses or tubes, and graduate to a macro lens in the future. Creative imagination is challenged at close range when subjects are enlarged, sometimes beyond easy recognition.

COPY PHOTOGRAPHY

Making a photographic record of printed matter, photographs, or documents is related to close-up photography, though a lot of work can be done with the normal 50mm lens, or a wide-angle lens, on an SLR. To copy small items, of course, use close-up lenses or tubes.

Copy work requires a tripod in most cases, in order to assure sharpness, and to guarantee that the camera is lined up squarely with the subject. Either hang the material to be copied on a wall, or lay it on a table or other surface. In the latter case, you may benefit by using a copy stand that includes a baseboard and a post on which the camera can be raised and lowered, similar to the operation of an enlarger. Some copy stands are made with reflectors for photoflood bulbs on arms at either side of the baseboard, but it's easy enough to use your own lighting equipment for this purpose.

Lighting. A principal consideration when making a copy is evenness of lighting. Two lights are usually necessary, placed at equal distances from about a 45-degree angle to the subject so illumination is the same overall. This is usually judged visually, but you may also use an incident-light exposure meter to adjust the lights more precisely. Illumination need not be intense, but should be the correct balance for color films, and bright enough to stop the lens down to f/8 or f/11 where sharpness is assured.

When copying a glossy surface, a painting, or anything that reflects light to cause glare, placement of lights is subject to experiment. Instead of a 45-degree angle, lights may be better at 30 degrees. To record detail and texture clearly in copy work is often a painstaking project.

Special polarizing lights and filters are made to reduce reflections for copy photography, in case you have a considerable amount of work to handle.

VIEW CAMERA TECHNIQUES

As noted in chapter 3, using a view camera requires a deliberate technique that may seem frustratingly slow at first, but offers fine opportunities to learn the disciplines of composition, exposure, and other theory. Because the ground-glass finder of a view camera is much larger than that of a 35mm or 2¼x2¼ camera, the clarity of image is greater in terms of design and focus. If one learns to work precisely with a view camera, there's a beneficial fallout

when shooting smaller formats. Depth of field can be observed as it changes with opening or closing the lens diaphragm, and of course, the beauty of contact prints and enlargements from 4x5 negatives is gratifying.

If you have not used a 4x5 view camera, for instance, and your course of study does not include it, you can develop your capabilities quite adequately with 35mm or 2¼x2¼. Eventually, you might borrow or rent a view camera, however, to become familiar with its benefits.

Functions of the View Camera

A view camera is used primarily for static subjects such as still life, architecture, and occasionally people. Advertising photographers may choose a view camera for the size of its negative or transparency, and because it is convenient to superimpose a layout sketch on the ground glass and compose accordingly. However, architectural photographers who shoot interiors and exteriors of buildings find the view camera most adaptable for its manipulations of front and back to correct either vertical or horizontal lines to be parallel to the edges of the film. Not only do the front of the view camera with the lens, and the back with the film, tilt forward and backward, but the front moves up and down, and both extremities can be adjusted right or left and at an angle. These movements are described and illustrated below.

Lenses. A variety of lens focal lengths is available for view cameras, particularly for the 4x5 size. The normal focal length is around 150–180mm, though wide-angle lenses of 65mm and 90mm are favored for interiors and to make buildings loom more dramatically than they would from a greater distance with a longer lens. A wide-angle lens is usually mounted in a recessed lens board to allow more freedom when the front and back are tilted. However, one has greater freedom to use view camera manipulations with a normal focal length or longer.

11 Correction for convergence of vertical or horizontal lines is inherent in view camera technique. Used here, a 4x5 camera with 8½-inch lens; 1/5 second shutter speed to allow steam to blur. ▶

12

14

13

15

View Camera Manipulations

Principles of manipulation. The primary purpose of tilting the back of a view camera is to bring it parallel to a subject such as a building. This may be accomplished horizontally or vertically. By manipulating the front of a view camera, focus and depth of field are controlled and refined. Sliding the front or the back to the left or right shifts the optical viewpoint without moving the camera, a convenience in certain restricted locations.

The basic movements of a view camera are shown here in relation to a building. These same operations, plus others not illustrated, are also applied to interior and product photography.

The lens chosen for these exercises was a 180mm focal length, and the pictures were made on Type 105 Poloroid film (which produces a fully developed negative and print), using a Model 405 pack-film holder. Though conventional and Polaroid films are made in the 4x5 size, using Type 105 in the holder is more efficient and economical. Negative and print quality are excellent. The holder slips into the back of the camera in the same way a sheet-film holder does, and a dark slide is pulled before an exposure is made.

Figures 12 and 13. A Calumet 4x5 view camera on a tripod was positioned parallel to the street. Both front and back were vertical (figure 13). The resulting image (figure 12) shows that lines of the building are straight, but the top of the building is missing.

Figures 14 and 15. The camera is tilted upward to include the whole building (figure 15), and as a consequence, the edges of the structure converge away, and are no longer parallel to the picture frame.

16

18

17

19

Figures 16 and 17. To correct the perspective convergence, the back of the camera is moved to a vertical position, parallel to the building (figure 17). In the photograph taken this way (figure 16), even though focus was adjusted, the top area is out of focus at f/16. In some cases, stopping the lens down to f/32 or f/45 might achieve overall sharpness, but shutter speeds necessary at those small apertures are often impractical.

Figures 18 and 19. Final correction is made by positioning the front with the lens parallel to the back and the subject (figure 19). Upward adjustment of the front is required to maintain the composition shown in figure 18, and further adjustments of focus produced a sharp image easily at f/16.

20

21

22

23

24

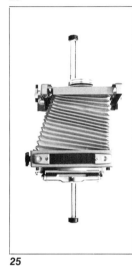

25

Figures 20 and 21. When photographing close to a tall subject, especially with a lens focal length shorter than normal, satisfactory manipulation of front and back might strain the camera's limitations. This is shown in figure 20 when the front of the camera was raised to a point (figure 21) where corners darkened because the lens could not cover the full format from its position. This can be solved by moving further from the subject and switching to a longer-focal-length lens if necessary.

Figures 22, 23, 24, and 25. Convenience of the shifting front is demonstrated here. Figure 22 was taken with the back and front tilted slightly as shown in figure 23. Without moving the camera position, figure 24 was taken by shifting the front to the right as shown in figure 25. This manipulation can be helpful for altering the image in a tight spot where the camera itself cannot be moved easily.

26

28

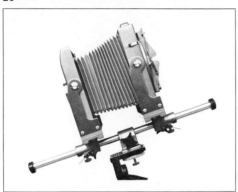

27

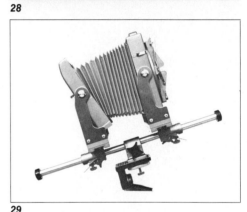

29

Figures 26, 27, 28, and 29. Use of the tilting front of a view camera for dramatic correction of depth of field is illustrated in this series. Figure 26 was taken with the camera position shown in figure 27, and the lens nearly wide open at f/5.6. Without stopping the lens down, figure 28 was shot by merely tipping the front of the camera more parallel to the lumber, as seen in figure 29. This attribute of a view camera can be very useful when photographing a subject in which great depth of field is required, and the smallest lens openings are not feasible because of the light or subject movement. A slight shift of the lens plus stopping down achieves the effect.

A modern view camera such as the Calumet with its rotating back offers excellent versatility for many subjects, including close-ups when the camera is fitted with extra-long bellows. Some brands are now made of lightweight wood and fold very compactly for easy carrying in the field. Make your own tests of a view camera's manipulations to discover how precise it can be, as well as its limitations.

30–35 This six-picture sequence is the heart of Ruth Orkin's classic series that won a Life contest award in 1951. It was Ruth's first published picture story in Look (1947), and also appeared in the first issue of Modern Photography, September 1949. The dialogue in Look and Modern Photography are different from that which appears here as printed in Life. "Jimmy Hendon came up to my apartment after I had the prints," Ruth told me, "and I typed while he told the story all over again—inspired by his own image in action." Here is Jimmy's digested version of Kitty, a costume movie starring Paulette Goddard:

SEQUENCE PHOTOGRAPHY

There are two categories of sequence photography, in which a series of pictures depicts something that happens in a relatively short period of time. Sports events and action subjects lend themselves especially to sequences, but everyday occurrences often make a more interesting story in a series than as individual images.

Nonmotorized Sequences

Of the many examples that illustrate this first category, here are a few that are typical. A group of children are playing ball. You photograph the pitcher throwing to the batter, the batter waiting, swinging, connecting, tossing his bat, running for first base, and so on. As fast as you can move and wind off the pictures, you shoot a sequence of the action, and hope that the last image of the series includes humor, or a dramatic moment which becomes the payoff for the story. With a 35mm camera it is possible to shoot, advance the film, hold focus, and shoot again approximately every two seconds. Practice can improve this if you are skillful.

Another group of children are sitting on some steps. One youngster is telling

30 "Da pitchah starts where da king is tellin' off Kitty's boyfriend."

31 "Da king is puttin' on da dog for Kitty."

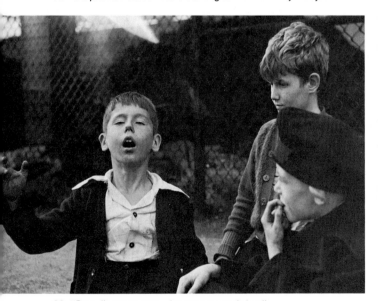

32 "Den dis crazy guy—he goes to grab her."

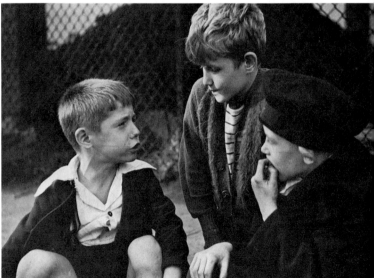

33 "Annuder woman chases her up da stairs and yells 'Ya won't get away wid dis!' "

a story to several others. Hopefully, they ignore you and the camera, and in a few minutes you capture the quiet scene which unfolds primarily in the childrens' changing expressions, plus the hand and arm motions of the storyteller. Your camera position may remain stationary or change slightly, but its consistency is usually an asset to the series. If you use a zoom lens, you might single out certain faces including that of the storyteller, and zoom back to the full group frequently.

Figures 30–35. Photographer Ruth Orkin is known for several sequence stories of this genre which are models of nonmotorized achievement. One series was included in *The Family of Man,* and a selection from another is shown here. First published in *Life,* this sequence story remains vivid two decades later.

Motorized Sequences

In recent years motorized 35mm single-lens reflex cameras have become more popular with both professionals and advanced amateurs. News and action benefit most from use of a motor, but I've discovered it is also an asset in portraiture. One is able to concentrate on the subject without removing his eyes from the viewfinder to advance the film. In addition, a lightweight motorized unit, such as the one made by Olympus, allows you to shoot at slower shutter speeds with less risk of camera movement. Several times recently I have taken a roll of portraits at 1/60 second on Tri-X film in natural light, and have been particularly pleased at the sharpness of the images. The camera can be held more securely as you squeeze the shutter release using the motor drive.

By combining a zoom lens and a motorized camera, you have a versatile outfit for sequence photography indoors and out. Since it is so easy to shoot this way, one must exercise more discrimination, and not depend on accidental success simply because one is able to take five or more frames per second. To discipline myself, I usually use a motorized camera on the single-shot setting, which means I press the shutter release for each exposure. On the sequence setting, a motor continues to wind the film and cock the shutter as long as the shutter release is depressed. For special purposes, some motorized cameras can be fitted with 250-exposure backs that are rather bulky, but very useful to the professional.

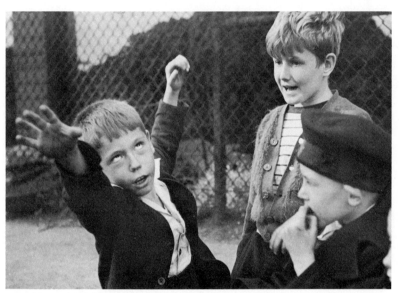

34 *"Den da udder woman screams an' falls down da stairs."*

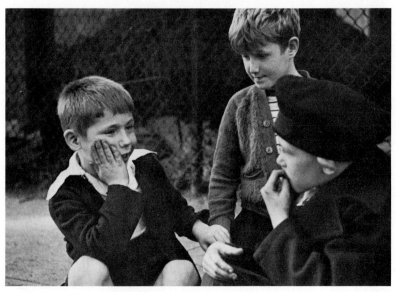

35 *"Wait…I'll go back a little furder, I skipped some."*

Figures 36–39. As an example of how a motorized camera makes sequence photography easy, these pictures of a leaping pilot whale were shot within two seconds using an Olympus MO-1 and a 75–150mm zoom lens. Had I used the sequence setting, I would have had about ten frames in two seconds. In some cases, this can be an advantage if you wish to edit a sequence later, using only a selection of frames for the final series.

To many photographers, a motor drive is an unnecessary luxury, and they are correct in this conclusion. However, if you learn to think in sequences when the subject is appropriate, you can achieve pictures with unusual impact through rapid hand operation of a 35mm camera.

36

37

38

39

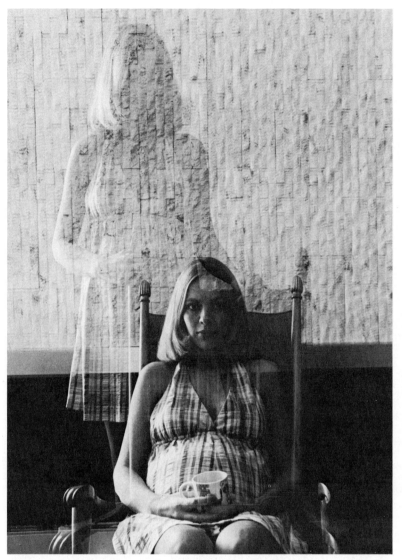

40 *The standing figure was guaranteed to be pale and ghostly because its detail was washed out by double-exposing it with the light-colored fireplace wall.*

41 *The standing figure against a dark background gives it more prominence. Figures 40 and 41 were shot with a Konica Autoreflex T3 on a tripod; the camera has a multiple-exposure lever.*

EXPOSURE SPECIAL EFFECTS

Exposure special effects have been mentioned previously, and are detailed here. Each of these effects can be functional to illustrate a theme more effectively than a conventional approach, or the effect may be primarily pictorial.

Multiple Exposures

There are several ways of overlapping images in prints or slides. Two or more negatives may be printed on the same sheet of paper, and two or more transparencies may be sandwiched in the same slide mount. It is safer to create a multiple image using individual images, because you have control over tonality, color, and composition.

Making multiple exposures in the camera is usually riskier, but just as rewarding when serendipity plays a role. Here is the technique briefly:

Plan the images. The images should overlap harmoniously, or be composed to make a visual point. Since dark colors and tones show up best against lighter ones, try to anticipate how the mixture will finalize. Bright areas, such as sky, will wash out almost any other tones; deep red flowers superimposed on a sky in a multiple exposure will be seen as pale pink.

If you place a subject against an off-white wall, as I did in figure 40, you know it will be rather faint in a slide or print. The theme of these pictures was "Lady In Waiting" to symbolize an expectant mother's thoughts and feelings. The standing figure in figure 36 becomes a ghostly remnant, the way I planned it. However, in figure 41 I placed the woman against a dark background where I knew she would be preserved intact.

Important details, such as facial expression, will hopefully be clear in multiple exposures planned carefully. On the other hand, if you aim for a decorative pattern, serendipity, or the lucky accident, may lend a hand as it

42 *Success of multiple exposures in the camera is due to planning the blend of images as far as possible, realizing that serendipity is also involved.*

43 *Honeywell Repronar, a sophisticated and precise copying stand with which existing images may be multiply exposed, tinted, or optically manipulated.*

did in figure 42. A bed of flowers was superimposed over an attraction at Disneyland, which is pleasing in black and white, but might have been less so in color.

An alternate manner of planning images is outlined in an article called "Moons in the Refrigerator" by Paul D. Yarrows, which is part of *The Here's How Book of Photography* published by Eastman Kodak in 1971. Yarrows shot a whole roll of color of the moon and stored it in his refrigerator. By keeping track of registry so he could reload the film and have the frames again in the same position, he later photographed other night subjects in which the moon appeared dramatically. It sounds easier than it is, but variations on this technique are worthwhile.

Exposure considerations. For a double exposure you must cut total exposure in half; for a triple exposure, total exposure is divided into thirds, etc. By this means the film "collects" the proper amount of light. The easiest way to do this with a 35mm SLR is to multiply the film speed setting by two or whatever is necessary. Therefore, using Kodachrome 25 for a double exposure, correct the film speed dial to ASA 50, and the slide should have satisfactory density. Colors, however, will alter each other's brightness.

Equipment. More recent 35mm SLR cameras and newer 2¼x2¼ models such as the Bronica EC/TL, have multiple-exposure levers built into them. After you shoot one image, you activate the lever, and cock the shutter. The film and film counter will not advance, and registry of images is perfect. Figures 40–42 were shot with a Konica Autoreflex T which makes the technique simple.

On SLR cameras without a multiple-exposure lever, you may tighten the film via the rewind knob and take a picture. Carefully press the button or clutch that releases film for rewinding, and gently cock the shutter. While the film should not advance, it will shift slightly, and if you shoot several multiple exposures in a row, off-registry will be cumulative. Processors choose not to mount slides that overlap the frame lines, so this film will be returned to you uncut. Take your chances, anyway, because your equipment may adapt more easily.

Multiple exposures are simple with a Polaroid Land camera that has a non-cocking shutter, with a view camera, or with a larger-format SLR with removable back. Using the latter, you shoot one image, remove the back, cock the shutter, replace the back, and shoot a second image.

An alternate in-camera multiple-exposure technique is to copy two or more slides onto one transparency with a slide-copying accessory that mounts on the front of an SLR. The most sophisticated of this equipment is a copy stand called the Honeywell Repronar, figure 43. It accepts most 35mm SLR cameras, and has both incandescent and electronic-flash light sources housed in the base. With a Repronar you may not only crop a slide as you copy it, but also add colored filters to tint the image. Photographer Pete Turner has produced some outstanding photographs by this method.

DARKROOM SPECIAL EFFECTS

The effects discussed here are supplemental to chapter 9 where the fundamentals of printing are stressed. Only a few techniques are mentioned here. For more thorough details, I refer you to *Creative Darkroom Techniques* published by Eastman Kodak in 1973, and Peterson's *Guide to Creative Darkroom Effects,* also published in 1973.

The Sabbatier Effect and Solarization

The Sabbatier effect refers to film, while solarization refers to prints; both are products of exposure to light during development which causes partial reversal of the image. The phenomenon was discovered by a Frenchman named Sabbatier in the 1860s, but was not aesthetically exploited until the 1920s by Man Ray. Results are only partly predictable, but are frequently artistic enough to make experimentation worthwhile.

The Sabbatier effect. Though it is feasible to work with roll film, each image on the roll will be partly reversed, and control of an individual image is not feasible. Therefore, it is advisable to use sheet film, though one could use short lengths of 35mm film or a roll of 120-size film. Here's how:

1. Shoot three or four identical images of a subject. If the first one does not reverse to your satisfaction, you'll have others with which to make improvements.

2. Choose a developer that takes at least 10 or 12 minutes total time, or dilute your developer with water.

44 *The Sabattier effect in an image that began with contrasty sidelighting.*

3. Begin development in the normal way. When about a third of the total developing time has elapsed, turn on the white light for a few seconds. Roll film may be reexposed on a reel or a sheet film in a hanger.

4. In the dark again, continue development until the time is complete. Rinse, fix, wash, and dry in the normal manner.

The density of the negative, contrast effects in the subject, and timing all affect Sabbatier results. Figures 44 and 45 are examples of this technique. Notice that in figure 40 which is mine, and in figure 41 by Bud Gray, there's a thin black linc outlining much of the subject. This is called a *Mackie line* and occurs between adjacent highlight and shadow areas because of chemical concentration in the film emulsion. It is this black line that distinguishes the Sabbatier effect from solarization. The latter is more prevalent in reexposed prints, such as figure 45, which will be described in a moment.

Timing is tricky to produce best results with the Sabbatier effect. The length of reexposure time, the time during development before reexposure takes place, and the length of development after reexposure all affect the amount of image reversal. If you want to increase the reversal effect, expose longer to white light, or reexpose slightly earlier in the development. If you develop sheet film by inspection, reexpose when you see a faint image emerge.

Solarizing prints. The basic process for solarizing prints is the same as for film, but the effects are different, because paper tends to fog quickly if not controlled properly. Here are the steps:

1. Make a test strip for a normal print with a full scale of tones that will emerge in about 1½ minutes.

2. Make the print as usual, and begin development with continuous agitation for about 20 seconds.

3. Turn the paper face down and allow it to settle for about 10 seconds without agitation. Reexpose with a flash of white light.

45 *Bud Gray calls his montage Sabattier composition "A Bad Trip." Several negatives were printed together and the final image was then copied after slight retouching of blending lines.*

4. Continue development to completion. Rinse, fix, and wash as usual.

Here is an alternate method for solarizing prints:

1. After the full 1½ minutes of development, lift the print from the tray and rinse it.

2. Place the print on a flat surface such as a piece of glass, and reexpose it 1 or 2 seconds.

3. Inspect the solarization under a safelight, and when it seems satisfactory, place the print in stop bath and fixer.

Variations on this theme include contact printing one solarized print to another sheet of enlarging paper, and reexposing the second one for additional effects. This was done several times by Everett McCourt to achieve figure 46, which was part of his winning portfolio in the 1975 Kodak Scholastic Awards. With each step some tone values disappear while others pick up contrast. You may also

46 *"Girl With Sunglasses" by Everett McCourt was created by "numerous contact prints and solarizations," according to Kodak's data.*

contact print a negative that has been solarized or copy a print, using high-contrast Kodalith film, to extend the possibilities of this special darkroom technique. The Mackie line around the image is very pronounced with a high-contrast film.

Color slides produced by the Sabbatier effect often improve on the originals, and high-contrast film manipulations are also applicable. Colored filters may be used when reexposing to tint the slide in a variety of ways. Try Kokak Ektacolor Print Film 4109 with which you get positives from color negatives and negatives from slides. The latter can be made positive by a further contact-printing step. I suggest you consult Kodak's book mentioned above for further directions.

Posterization

This is another process that depends on using high-contrast films, and is subject to exciting and creative variations. Briefly, you project or take a picture on high-contrast film and develop it. By projecting a normal negative onto 4x5 Kodalith, for instance, you retain the original, and can return to it when necessary. The Kodalith Ortho film is developed in a tray (by red light because it's not sensitive to that color), and can be washed and dried with relative speed, since the film base is thin.

In a high-contrast positive, some of the middle gray tones have disappeared, and more will be gone when the positive is contact printed to

47 *By solarizing the negative, and going through several high-contrast contact-printing stages, Richard Greenstone created a strong and decorative impression of a track meet.*

another sheet of high-contrast film. At this point, a print on enlarging paper may be quite satisfactory, or you may have to go through the positive and negative steps again to further reduce the image to black and white only. This is the way Richard Greenstone produced figure 47 which was printed on Agfa grade 6 paper to assure all halftones were removed. With 4x5 sheet film, some remaining halftones may also be eliminated with an opaque liquid and brush.

Further ramifications of posterizing with several negatives printed slightly out of register for controlled grays, and directions for color posterization are included in the Kodak and Peterson books listed. In the latter, Robert D. Routh has an excellent, concise chapter

about color variations with cumulative effects illustrated. Posterizing in color is more complicated, but becomes a terrific challenge to skill and imagination.

Reticulation

Reticulation is a crinkling of the negative emulsion, usually caused by an extreme shift of temperature during processing. Several decades ago films reticulated fairly easily if rinse water was too warm or fixer was 15 degrees warmer than developer. Today you must work to achieve reticulation, and if your darkroom habits are careful, you'll never see it. Here's how to reticulate for a variety of patterns:

1. Use sheet film, and shoot a subject two or three times to have duplicate negatives.

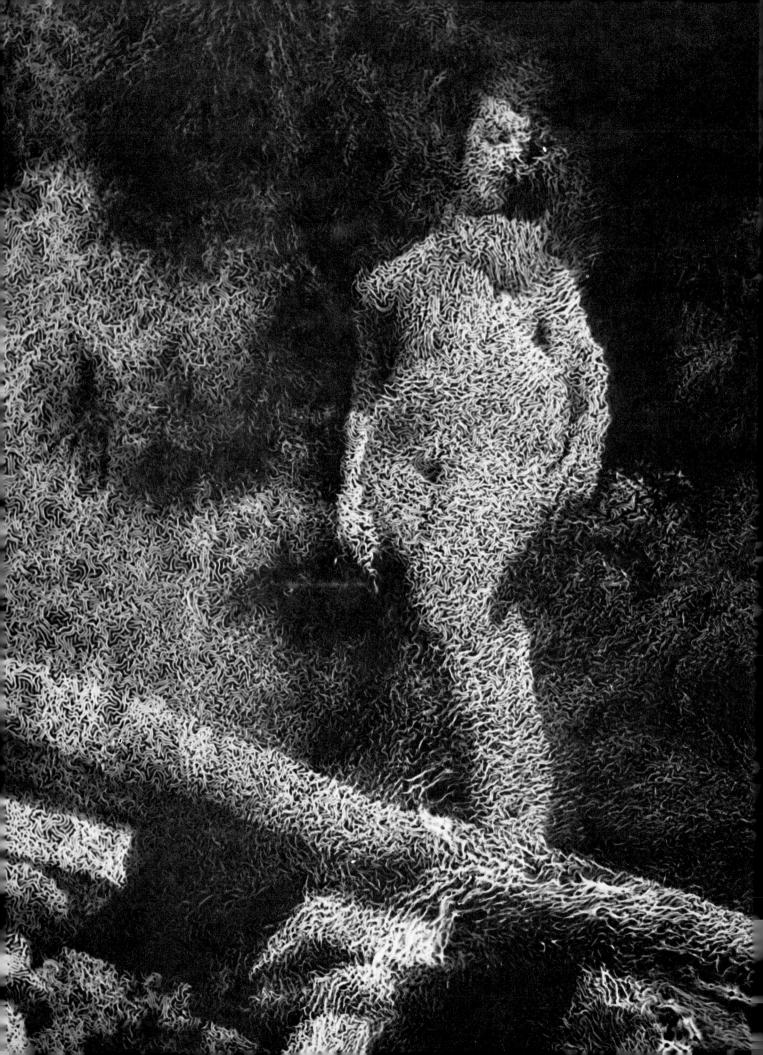

48 *Extremes of hot and cold water reticulated the negative violently before it was fixed into the printed pattern. Use of 4x5 negative material is advised for reticulation experiments.*

49 *Making a photogram gives you immediate experience with the reaction of photosensitive materials to light and chemicals, plus control over the shades of gray in the design.*

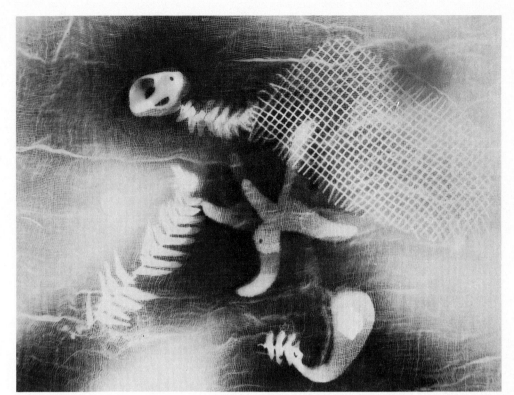

2. Develop the film normally, and rinse in a very dilute acetic acid stop bath heated to 140–150°F.

3. Dip the film in cold water, 40°–50°F, for another minute, and then fix and wash as usual.

4. Instead of using an acetic acid stop bath, after development immerse the film in hot water, 180°–190°F, for one minute. Then soak it in the cold water, and wash and fix it. The reticulation pattern will be more pronounced with this technique.

Both black-and-white and color negatives can be reticulated, as can color slides as well. The color will be affected; details are included in Kodak's *Creative Darkroom Techniques*. Figure 48 is an example of strong reticulation of 4x5 film. What looks like a cloud pattern around the figure is actually caused by irregular clumping of the negative emulsion as it reacted to hot and cold temperatures. If you want a reticulation effect without "ruining" a negative, there are texture screens that can be sandwiched with a normal negative, and then enlarged.

Photograms

This is another creative darkroom process pioneered by Man Ray. A photogram is made by placing a variety of objects on a sheet of printing paper, and subjecting the combination to white light for a short period. Control of the light is easiest under an enlarger that can be stopped down. Figure 49 was made by placing a rough woven cloth on the printing paper first, followed by sea shells and leaves. Light background areas appeared where the cloth was clumped into several layers.

If you leave an opaque object on the paper for the full exposure time, the image it produces will be white. If you shift it or remove it for part of the exposure, tones of gray result. Photogram possibilities are endless and often very decorative. It may be said that a photogram is not photography because a camera is not used, but you may copy a photogram on conventional or high-contrast film to extend the potentials of this technique.

Additional offbeat processes using 3M color materials, dyes, silk screens, special filters, and tinting of black-and-white papers may be of interest to experimenters who wish to adventure in creativity.

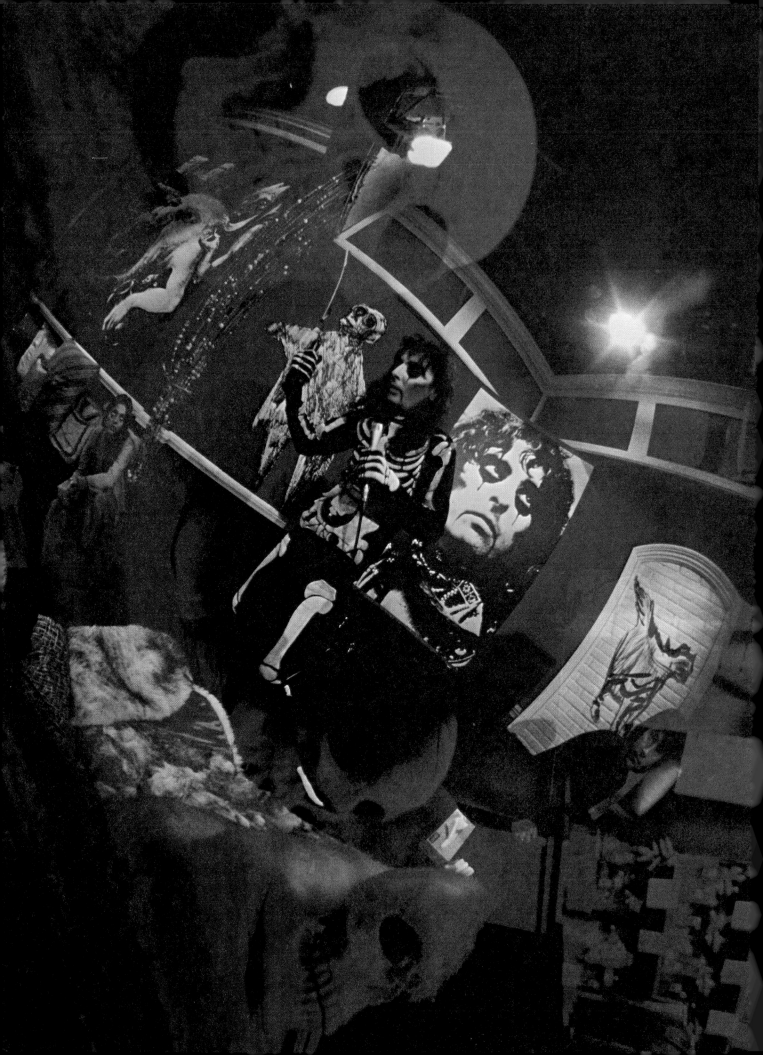

COLOR PHOTOGRAPHY

1 *A montage by Bud Gray in which several images were copied together to create strong visual impact.*

Several decades ago color photography was considered more "difficult" than black-and-white, primarily because precise exposure required careful measurement with a separate meter. Today accurate exposure is relatively easy using cameras with built-in meters or automatic exposure systems. In fact, color photography in some ways has distinct advantages:

 1. The aesthetic appeal of color itself, whether brilliant or subtle.

 2. The more accurate representation of reality in color prints or transparencies, since we see the world in color.

 3. The relative ease of separating tone values of different hues that may be close together in a scene. We work hard to achieve that same separation in black and white and sometimes fail.

 4. The excellent latitude and fidelity of color negative materials, once exclusively used by amateurs or in large sizes by professionals.

Color slide films are much faster than they were in the 50s; you can also boost the ASA rating of some films to make them almost as fast as many black-and-white films. Best of all, color printing from both negative and positive films has been simplified and expedited to a point where the necessary skills, equipment, and materials are all available to the average photographer.

 Enough light of the correct color temperature has always been the concern of aware photographers, but today it's easier to manage. Electronic flash units are small and portable with plenty of power for many indoor situations. Quartz floodlights also pack a lot of illumination into versatile, miniaturized equipment. With existing light indoors or out, or with artificial light, you can shoot with a 35mm camera and solve the technical problems of color more comfortably than ever. In the next decade, improved films and light sources will eliminate more technical distractions, allowing us to concentrate more fully on composition, creativity, and picture content.

COLOR THEORY

Color in Painting and Decorating

If you have studied color from an art approach, you know there are three primary colors (red, yellow, and blue) and three secondary colors made by mixing pigments of the primaries: yellow + red = orange, red + blue = violet, and blue + yellow = green. Each color has its complement or exact opposite, as shown in a basic color wheel.

2 *While helping a favorite model assemble a portfolio, Mark Molesky posed her with a somewhat incongruous background that became an artistic combination.*

3 *Though contest judges see more scenic sunsets than any other subject, Sydney Sandoz's harbor scene has winning qualities aided by slight underexposure on Kodachrome 25.*

4 *With a macro lens on a Konica Autoreflex NT-3 camera, the author explored a beach looking for semi-abstract excerpts from nature.*

5 *In early morning Sydney Sandoz captured a stripe of rainbow in a drop of water by focusing very closely with a Nikon F, a macro lens, and a bellows.*

6 *The interior of the Sistine Chapel required a one second exposure at f/3.5 with a 28mm lens on a single-lens reflex. The author's arms were braced on a railing. Eastman color negative 5247 was rated at ASA 100.*

Barbara Jacobs created a decorative double exposure with a Konica NT-3 and a 5mm Hexanon fisheye lens by underexposing each image one stop.

This is a very simplifed digest of a complex and fascinating subject which many readers might find worthy of additional study. Keep in mind that the color relationships described apply only to mixed pigments or fabric dyes. The following terms are applicable to both pigments and the colors of light that are covered below.

Hue. This is the characteristic of a color we know by its appearance and a specific name such as blue, green, or orange.

Value. Each hue has a tonal value described as light or dark. For instance, orange is inherently lighter than red and darker than yellow. Color values are translated into tones of gray with black-and-white films.

In nature the color value scale has a consistent order, but in creating a photograph or working in other media, we may *reverse* the natural order of values to attract attention or to create visual shock. When orange is juxtaposed with pink, or a pale violet is placed beside a dark green, the reversal can result in dramatic or disturbing effects.

Intensity or saturation. In painting the word intensity is equivalent to the word saturation in photography. Both refer to the degree of purity or vividness of a color. Brilliant or strong colors are said to be very saturated, and color slides are often slightly underexposed to accentuate them. Less intense colors are tints or pastels occurring naturally or found in shadow areas. Overexposure "washes out" or diminishes color saturation.

Color in Photography

When a slide is projected or viewed against a light source, colors within each of the dye layers combine to produce an image. This is called the *additive* method of color, because we see the hues as rays of light mixed together, rather than seeing color reflected from pigments or fabric dyes. The additive primary colors are red, violet blue, and yellowish green. The secondaries are magenta (blue+red), cyan (green+blue), and yellow (red+green).

8 *The unique and luxurious home of photographer Victor Diaz in Guadalajara was dramatized by the author using a 16mm Zuiko fisheye lens on an Olympus OM-2 camera, and Eastman 5247 color negative film.*

9 *By boosting the speed of High Speed Ektachrome to 650 with special processing methods of his own, Tom Carroll was able to shoot in the relative darkness of a radar room aboard a Navy ship.*

10 *During an extensive assignment covering much of California, Maurice Manson created a unique impression of refineries in Richmond using a star filter over a 105mm Nikkor lens.*

This may seem confusing, since red and green mixed as pigments certainly do not produce yellow. However, when red and green rays of light combine, the result is yellow.

While positive transparency films reproduce the mixture of hues we see in a subject, negative color films reverse those hues. Each negative color layer is the complement of those photographed, so that a red subject, for instance, is represented by cyan and yellow layers that block all but red light when the negative is projected to make a positive print. This is called the *subtractive* method because some portions of the spectrum are absorbed, filtered out, or subtracted. The subtractive primary colors are cyan, magenta, and yellow, and the subtractive secondary colors are red, blue, and green.

It takes a little rethinking to adjust to color theory in photography, particularly in terms of filters and in color printing. A yellow filter, for instance, allows red and green to pass through, but blocks or absorbs blue light. In color printing, if a subject is too green, more magenta filtering is necessary to subtract additional green from the negative and produce an image with better color balance. Confusion gives way to conditioning with experience.

PSYCHOLOGY OF COLOR

The psychology of color is another fascinating subject worth reading about and investigating. Decorators and graphic designers, among others, use color in various ways. For example, warm colors are called "advancing" colors, and cool colors are called "retreating." A red or orange pops out at you, while a cool blue tends to stay in its place behind warmer colors nearby. Combinations of warm and cool colors create visual effects, and dominant hues are elements of a composition.

Color is also *associative*, meaning that it has come to symbolize certain emotions or material properties in our lives. Red is fire or danger, blue is ice or depression, yellow is cheer or coward-

11 *At an air show Ken Rogers followed a performing skydiver with his motorized Nikon F and a medium-range zoom lens to shoot a complete sequence for a magazine story.*

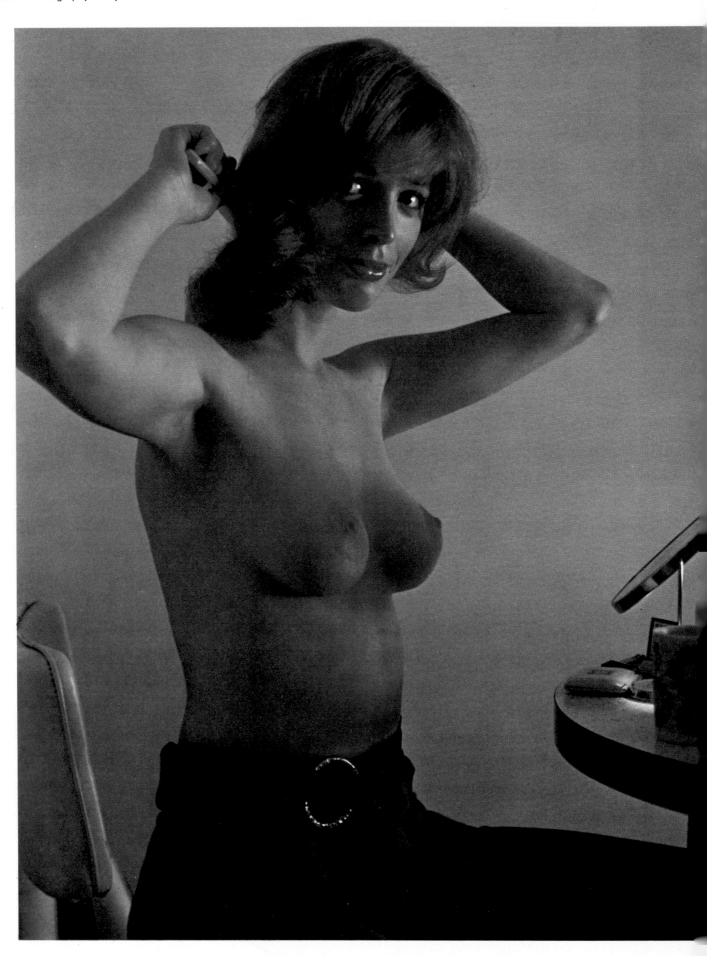

13 *The author used a modern zoom lens with macro-focusing capability (the Hexanon UC 80–200mm) to work a few inches from the flower, and throw the background completely out of focus.*

14 *Ken Rogers sandwiched a close-up and a long shot of flowers to form an exciting image that does not exist in reality.*

◀ 12 *One reflected floodlight warmed the color in a daylighted room photographed on Ektachrome-X with a 50mm lens on an SLR camera.*

ice. Photographers need to be aware of both pleasant and objectionable connotations of color, such as using certain types of green dishes in a table setting that may repel viewers. In the same sense, a model wearing bright purple may look cheap even if she has an innocent face, and a rugged-looking man in pale pink might seem effeminate.

When the choice of color is yours, think carefully about its associative values, as well as your own taste and the dictates of the job. Keep in mind that sometimes an unconventional color combination can give a picture distinction. Perceptual color is the way you see it in actuality. Conceptual color is more subjective, perhaps bizarre, and should be used to support an idea or impression. Awareness of how color will affect viewers is important to photography.

WORKING IN COLOR

Once the emulsions, theories, and other technicalities are absorbed, shooting color is more of an exciting challenge, and you may concentrate on personal expression. You'll find yourself thinking in color, just as you learned to translate color into tones of gray to think in black and white. You will take chances when the light isn't "right," make long exposures from a tripod, and experiment with the "wrong" films indoors or out. Overcast days can be a blessing or a curse, depending on the color and brilliance of the subject. I enjoy portraiture in such conditions of light (with a skylight filter), but I recently shot sailboats at sea on a cloudy day, and the flat color was unattractive to me. Indoors you will take advantage of the warm lighting of an average room, and outdoors when it rains, you'll protect your camera in a plastic bag and take color pictures. Anywhere you are, you may be seduced by the beauty of nature's palette to interpret the commonplace in your own way.

While most photographers in training use slide films, you should become familiar with negative materials as well. It is not a betrayal of artistic effort if slide films are processed by professional labs, and color prints are made by paid experts. (The same cannot be

15 *Sharp focus on the foreground flowers and the distant building called for a 21mm lens which Maurice Manson mounted on his Nikon F for an industrial client.*

16 *Simulated studio lighting came from a nearby window as the model, Sandra Holle, rested on a carpeted floor beneath the author's 35mm lens on an SLR camera.*

17 *Joel Marcus posterized an action shot using 3M color materials for a distinguished magazine cover.*

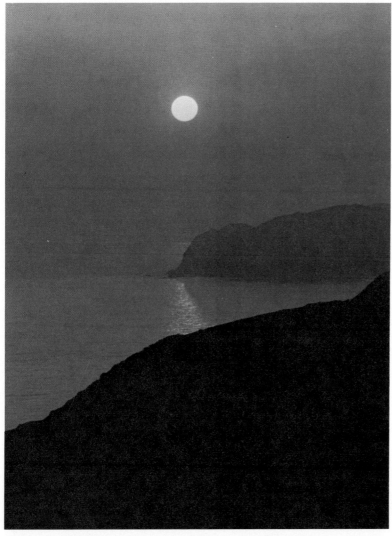

18 *Sunset along California's Big Sur coast was photographed by Barbara Jacobs using an Olympus OM-2 and Zuiko 75–150mm lens.*

19 *With a 15mm Hexanon fisheye lens on a Konica Autoreflex NT-3, the author was able to climb inside a tall steel sculpture by Alexander Leiberman to make a semi-abstract composition.*

said for black and white, in which medium I feel the photographer owes it to himself or herself to develop the film and print the negatives in order to gain the greatest potential from the creative process, and to polish technique.) Since color printing from slides or negatives has become so much easier, however, in time photographers will be expected to enlarge their own images, just as artistic and particular photographers do now in black and white.

The Color World

The images in this chapter represent a cross-section of the color world in the studio and on location. These are only samples of the stimulating color photography available in books, magazines, and exhibitions. Assign yourself to find such books and annuals and become knowledgeable about the wide variations of style and approach today.

As you explore the world of color with a camera, don't be afraid of getting lost. You may find your way along paths that are new—at least to you. Don't worry at first about being imitative, because your own style will evolve through the influences of others. *Do* be concerned about allowing color itself to seem so important that picture content may be inferior or pointless. Simply recording color with fidelity is not enough. It's what you do with the subject in color that counts, and leads to more imaginative images.

Most of all, don't be inhibited. Experiment with sandwiching slides, or rephotograph your transparencies to alter the color in a personal way. Stretch every opportunity; use slow shutter speeds, zoom a lens during exposure, combine flash with natural light, bracket exposures, try multiple images in the camera, and do anything that may give the ordinary a new look.

A final note: Don't neglect to explore the potential of instant color with Polaroid Land cameras or attachment backs. Both Polacolor 2 and SX-70 films have been improved during 1975–76. As a means of experimenting and reshooting immediatcly, instant photography offers a valid means of achieving greater color awareness.

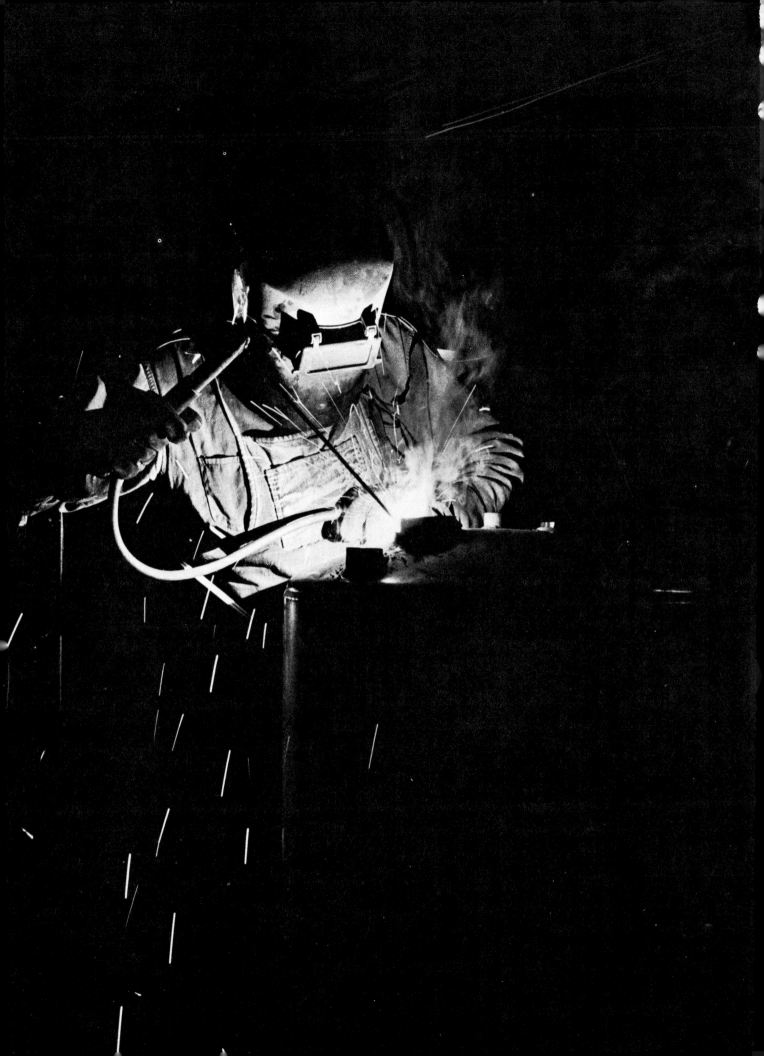

ADVERTISING AND COMMERCIAL PHOTOGRAPHY

1 Tom Carroll's picture for an appliance company was illuminated exclusively by the welder's arc. The functional, artistic image was made with a 35mm camera, a 50mm lens, and an exposure of f/5.6 at 1/30 second.

This is the first of three chapters devoted to applications of photography. Illustrations and discussions in previous chapters have touched on the three categories into which photography generally falls: commercial, informational, and personal expression. Now we delve a little further into each of these.

You already know, or will discover, that the categories are related and overlap occasionally. For example, you may shoot some very personal, offbeat pictures of people or things, and find that they have commercial potential for brochures, posters, or advertisements. In contrast, an industrial photographer may creatively complete an assignment, some images from which are worth publication for their aesthetic value or are of exhibition quality. Portraiture falls into all three categories, though it is included in this one.

Sharp boundaries do not exist between commercial, informational and personal expression because each type of photography is a form of visual communication. A print or a slide is an *idea* on film or paper. It may be complex and technical; it could be a product photographed for advertising or promotion. A picture may be journalistically meaningful, aesthetically memorable, or personally expressive and revealing. In each case you need to develop what instructor Robert Routh calls "visual literacy." This means you learn not only the basic techniques for taking pictures and printing them, but also "how to read a photograph," to evaluate its content and its aesthetic impact.

Impact is the quality in a photograph that causes you to stop and look and be affected by *feeling* something such as empathy, desire, excitement, or envy. To quote a Nikkormat ad, "You start [to learn] by getting involved. In photography. By looking at pictures and for pictures. By reading and asking questions. By taking classes. And most of all by taking pictures." To which I might add, you also learn to make more effective photographs by analyzing images everywhere—by talking with others about pictures in print, in exhibits, in class, at home. An exchange of opinions helps to solidify and sharpen your system of aesthetic values from which you benefit each time you make an exposure.

If you have no plans at present to make a living, even part-time, in photography, you should at least be aware of pictures by those who do. There are no limits on visual literacy nor on its sources. Studying pictures you would not choose to shoot may very well stimulate you in your ideas.

ADVERTISING PHOTOGRAPHY

Advertising photography is a large and specialized branch of the subject, the highlights of which we can only skim. Advertising photography is characterized by two basic aspects: (1) Space is purchased in print media such as magazines, newspapers, brochures, or billboards. Still photography is also

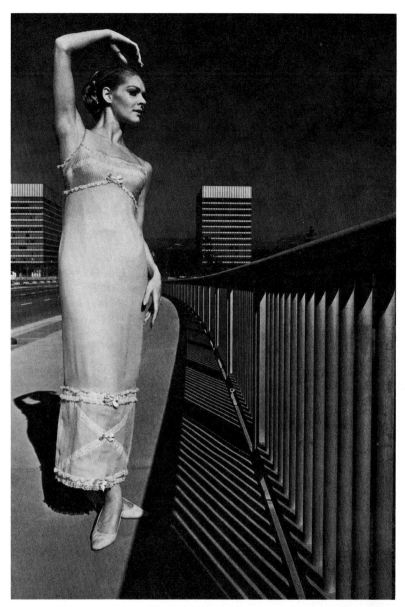

2 *For a department store ad, Maurice Manson hired the model, scouted locations, chose the time of day, and was assisted by a stylist. A variety of outdoor settings and garments were photographed with several lenses.*

3 *Large expensive products require elaborate studio sets, and negatives are often retouched. American Motors distributed this photo when their Pacer was introduced to the press in 1975.*

translated to motion-picture film for television commercials. (2) Its pictorial goal is selling—a product, service, or organizational image—and the photographer's personal feelings are secondary to his/her imagination and creativity.

Types of Advertising Photography

Most successful photographers work from a studio, but are capable of shooting anywhere a client requires. One expert I know set up electronic flash on both sides of a Boeing 707 to simulate daylight because the aircraft was available only at night. His interior shots were part of an airline ad campaign.

Finding locations is a large part of this business. Another photographer I know spent nearly a week shooting color in dozens of spots where he would eventually park a series of cars and trucks for the advertising agency that hired him. He owned a studio where in previous years various new cars had been given a different photographic treatment.

Interviewing and hiring models, and working with stylists and clothes, makeup artists, and other technical people, are all part of the advertising business. Little is left to chance, and most ad photographers have several assistants on staff full time. One day the job might entail a still-life arrangement of perfume bottles, and the next day a whole set might be built to simulate a kitchen for a client's food or appliances. The skills of composition and lighting are paramount to an advertising photographer who often makes test pictures that must be okayed before a final shooting begins.

The scale of advertising is vast, from simple studio pictures to huge sets or locations worthy of a major motion picture. It follows, then, that advertising is the highest paying market for photographers, and at the same time is the greatest source of headaches and ulcers. Breaking into this category is difficult, and requires ''being discovered'' through your photographs that advertising agencies may see in print, plus regular visits to ad agencies to show a varied portfolio to art directors and account executives. Busy photographers

4 Alan Bergman combined smooth lighting with reflected electronic flash, careful posing of the model, and a simple concept, all typical of the successful advertising photographer.

have representatives in several cities whose job it is to show portfolios and negotiate assignments.

One cannot expect to originate photographic ideas and sell them to agencies unsolicited, as you may do in the editorial field. Many advertisers plan a complete campaign of ads that may last for months before hiring a photographer to shoot the necessary pictures.

Therefore, a photographer might be expected to follow a designer's layout to the last detail, or he may be fortunate enough to contribute his/her own ideas in the planning stage, and shoot variations on a theme later. The degree of improvisation and imagination one may bring to an advertising job depends

5 *Here is the first of three views of the Century Plaza Hotel in L.A. taken by Tom Carroll for Alcoa Aluminum Company. From across the roadway he exposed for 1/2 second to include an interesting foreground.*

on the personnel with whom you work, and the rigidity of the client. Of course, there are established photographers whose talent and ideas are hired because they *can* and do contribute to advertising concepts from the outset.

You might expect to start a small studio on a limited budget of five to ten thousand dollars for equipment, remodeling of a building, and for one assistant. If work volume increases with success, additional investment in lights, cameras, and other equipment, plus more staff might be expected. Advertising is a risky business, but it is the only field in which you may be paid $2,500 and more for one transparency, or be hired to shoot a campaign that could gross $20,000.

Advertising Media and Rates

National advertising. Photographs may be sold for advertising in national magazines and newspapers or by direct mail. Photography rates are often based on the number of publications in which a photograph will appear, their circulation, the reputation of the photographer, and the amount of effort involved. *All* expenses for models, film, processing, labor, rented materials or locations, transportation, and special equipment are billed above and beyond the fee for photography. Purchase orders should be requested from the agency to assure that all terms and requirements agreed upon verbally are

6 *With a 21mm lens on the Leica, Tom Carroll accentuated the structure, assuring drama in tonality and design.*

7 *From a helicopter, after receiving clearance from the FAA, Tom Carroll shot another series of the hotel on a clear day to complete his assignment.*

mutually understood. Rates may begin at $1,000 or $1,500 per shot depending on many variables. The best source of information in the advertising, editorial, and publishing fields is the *ASMP Guide to Business Practice*, available from ASMP, 60 East 42nd Street, New York, New York 10017. This authoritative book is updated regularly. It includes sample contracts and other business forms.

Regional advertising. Photographs may also be required for advertisements in publications that are limited to a certain geographical area, such as the Southwest or New England. The types of photography parallel those required for national media, but rates are somewhat lower because circulation of the publications is also lower.

Local advertising. At the local level, the photographic challenge may be equal to that offered by a national advertiser, but rates are less due to more limited circulation. Assignments are usually less complex and demanding for local advertisers.

Trade publications. These may be national or regional, but because their circulations are much lower than consumer publications (all of the above listings), rates are comparatively lower as well. A black-and-white photograph of a product for advertising in *Time* or equivalent magazines might begin at $1,000; the same type of photograph for the *Poultryman's Journal* may bring only $350 and up, with many contingencies.

The *ASMP Guide to Business Practice* suggests: "A good rule of thumb to use in national advertising is five percent of the *media cost,* which is the cost of the space to the advertiser."

Advertising Photography Techniques

In the studio. The range of problems in the studio depends on the type of photograph. Small products and pictures of individuals may be handled with simple backgrounds and floodlights, while large products or sets require electronic flash. Studio flash units are far more powerful than the portable equipment used by the average photographer, but their greater output is necessary in order to shoot color and cover fairly wide areas, to guarantee depth of field, and to freeze subject movement.

In a limited area, three or four reflected floodlights are feasible, which was the illumination for figure 8. This Sony trade-magazine ad photograph

8 *For a trade magazine ad, floodlights reflected into an umbrella were concentrated at the left, with additional lights on the seamless paper background. Bronica with 75mm lens.*

9 *Alan Bergman's studio has one large window offering diffused daylight; a large white reflector at the right filled shadow areas. Nikon with 35mm lens.*

was made with a roll of seamless background paper behind the subject, and a 2¼x2¼ camera on a tripod.

Figure 9 by Alan Bergman is an example of daylight in a studio augmented at the right by flat white reflectors. The subject, a Los Angeles television newsman, stood on an enlarged Channel 7 symbol for a newspaper ad announcing a change of personnel at the station.

Almost all studio lighting for advertising is reflected from either flat or umbrella-type reflectors, or the light source is diffused. Frosted acetate is usually the diffusion material, and the result is similar in softness to bounced lighting. Analyze the illumination in a selection of advertising pictures of your choice. You'll note it is usually shadowless, or shadows are very soft or very directional.

In the studio, a view camera may be necessary for large setups, or for future use of the pictures on billboards. However, the most popular camera size is 2¼x2¼, such as the Hasselblad and Bronica. Negative or transparency quality from this size is preferable for reproduction, and clients are better able to see results in the original color slides or contact prints.

Most photographers expose transparency films because engravers prefer them. Color prints may be made to create a dummy ad layout to show a client, but a print (called *reflective copy*) does not usually reproduce as well as a transparency. However, if retouching is called for, a color print is the answer.

10 Advertising and commercial photographers create posters and smaller mailing pieces to promote their services. Marv Lyons used an abandoned merry-go-round horse and nude rider which he elongated during the enlarging.

On location. Subdued daylight is often very satisfactory outdoors, though all types of lighting may be seen in advertising illustrations. Indoors, electronic flash is generally used, sometimes in combination with existing light. When a more realistic feeling is desired, the photographer may take a journalistic approach and use natural light and settings, often shooting with a 35mm camera. The same camera size is also used if a subject requires a lot of mobility, such as people in a sports event. Photographers know the potentially excellent quality of 35mm color or black and white, but often face prejudice from clients (advertisers more so than ad agencies) who look upon 35mm as the "amateur" picture size they themselves shoot.

Not only does the photographer require technical skills for advertising (and for many other categories of photography), but he or she must also know how to direct people. Professional models are usually easier to handle, but nonprofessionals have become just as popular for their authentic appearance. Therefore, a basic knowledge of psychology is a requisite for this profession from which some of the best directors have graduated to television commercials and motion pictures. Howard Zieff is a prime example. (He used to shoot all the Polaroid ads, and later directed a number of movies including *Hearts of the West.*)

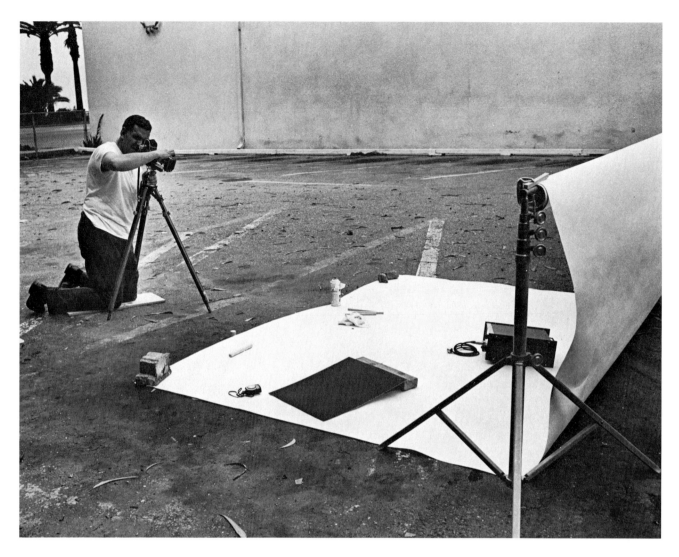

11 Tom Carroll ingeniously improvised a "studio" setup for a product at the factory location, taking advantage of an overcast day. A 135mm lens on a 35mm camera offered a distortion-free image.

12 The special meter as photographed by Tom Carroll in the outdoor set.

COMMERCIAL PHOTOGRAPHY

In this category are those who work in industry, or from studios that specialize in product or architectural photography. You can operate a limited commercial business from your own home by improvising studio setups there or on location, and by shooting where clients' needs take you. In some ways, commercial and advertising photography overlap, for many shots of people and products may be used for brochures, folders, catalogues, and advertisements as well. However, the commercial business usually involves more medium- and small-volume jobs than does straight advertising. A commercial photographer must be quite versatile in the studio or on location, and be able to improvise as Tom Carroll is seen doing in figure 11. With seamless background paper in open shade, he photographed the heat-measuring instrument seen in figure 12, with a 35mm camera, though a larger format is more typical.

**People.
The power behind the most successful
aluminum sheet mill in the U.S.**

13

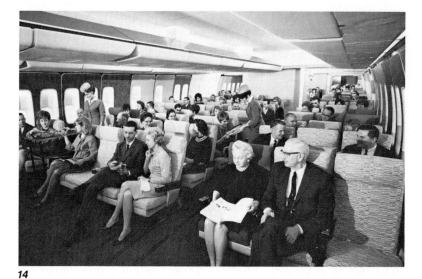

14

Commercial Photographic Case Histories

Figure 13. More than 200 employees of the Martin Marietta Aluminum Company were photographed by Tom Carroll for the front and back covers of this brochure. All were taken in natural light, indoors and out, with a 35mm camera. Prints were cropped to size and mounted in the final layout for the engraver. The fee for such a job in 1976 ranges from $500 per day and up (plus expenses), similar to the rate charged for annual report photography.

Figure 14. A company photographer made this publicity photo of a Boeing 747 full-scale mockup with a 4x5 camera and wide-angle lens. Lighting was subtly augmented by hidden floodlights, and models were chosen carefully. A commercial photographer might be called upon for similar promotional assignments.

15

16

Figures 15 and 16. Sydney Sandoz placed glassware on a piece of glass against a white background and lighted it from beneath to accentuate the sparkle and transparency. Small products are typical commercial subjects. Glenn Edwards made what appears to be an outdoor setting (figure 16) for the silver dish, but he worked in a studio. He constructed a "tent" around the subject, which means surrounding it with white reflecting paper and aiming several floodlights at the paper. In this way, images of the camera or background are avoided on metalic subjects. A typical tent may include a front reflecting panel through which a hole is cut for the camera lens. In some studios a tent setting is permanent, and lighting is arranged as needed.

17

Figure 17. For Wilkinson Precision Metals Company Tom Carroll photographed an industrial process for use in a brochure. Dark-colored seamless background paper was placed behind the workman to eliminate confusion, and a small quartz light added contrast to the scene from the left side. Overhead lighting, common in offices and industrial plants, often needs an accent from floodlighting which the photographer may add. The picture was shot with a 35mm lens on a 35mm camera.

Figure 18. Publicity portraiture is an important aspect of commercial photography. When the subject moved into a new business, she called upon Alan Bergman for a series of glamorous portraits she released to the trade press of the music industry. Many such portraits are also taken at the person's desk or in offices with plain backgrounds.

19

20

Figure 19. Architectural models are often photographed, such as this one of Newark Airport for the Port of New York Authority. Small spotlights directly on the model are helpful along with reflected floodlighting. While a look of realism is desirable, techniques used are similar to those for small products. An 8x10 view camera for this situation allowed the client to send out clear, sharp contact prints with news stories.

Figure 20. Eastman Kodak Company sets an excellent example in its publicity photography, typified by this hand-out picture promoting an early Instamatic camera. The model seems to be coming through an opening in the background paper on which is spread a collection of early-twentieth-century flash apparatus to create extra visual interest among editors to whom

ing and commercial fields, you aim to please individuals who represent a business enterprise. Occasionally you work for the client, but usually for an art director or executive who has only partial autonomy. In the portrait and wedding business, you must please the subject, for there are rarely intermediaries. In one way this is an advantage; by contact with an individual, you try to learn his or her tastes, and adapt your photography without compromising yourself. There's also a disadvantage in that individuals tend to be more temperamental and unpredictable than companies, though both suffer from ego problems.

Portrait and wedding photographers are capable of starting into business with less equipment, overhead, and capital than those in the commercial field, and may even work from a home office shooting weddings, especially, as a weekend activity at first. In both categories, a 2¼x2¼ camera is preferred because contact proofs and transparencies are easier for clients to view, and retouching is possible on negatives. However, a majority of portrait and wedding pictures are taken today on color negative materials, and small color prints (4x4 from 120-size films or 3x5 from 35mm films) become practical proofs.

the photograph was sent. Reflected electronic flash was used, probably with a 4x5 view camera.

Commercial photography runs the gamut of requirements and styles. Once known as a "nuts and bolts" business, it now demands creativity in most phases. Many of the illustrations of equipment and processes in earlier chapters were taken by the author using basic commercial techniques with a 35mm camera, a 55mm macro lens, short lengths of seamless paper, and reflected floodlighting.

PORTRAIT AND WEDDING PHOTOGRAPHY

While portrait and wedding photographers may be more specialized than their commercial brethren, the work is no less demanding. In the advertis-

Portrait Photography

The range in size and volume of portrait studios in America is large. Some specialize in children, but most do posed photographs of individuals and groups, usually with reflected and direct floodlights and electronic flash. The trend toward outdoor settings and daylighted studios is also growing, lending portraiture a more natural, less formal style. Photographers are locating in suburban areas where adjacent outdoor locations are especially popular with young people. Older people may still prefer a traditional studio setting, and retouching is more common for these people.

In the beginning one might concentrate on outdoor photography until

21 *Modern portrait studio of Greer Lile, Little Rock, Arkansas.*

the need for a studio setting becomes greater. At that time, a selection of backgrounds, lighting equipment, reflectors, and perhaps a window facing north will outfit an average studio. A successful photographer will graduate to a larger studio located in a business district or nearby. More elaborate backgrounds and electronic flash units may be desired, and one may hire an assistant to shoot and handle lab operations. The larger studio will often add wedding photography to its activities, because it is closely allied to portrature in the public mind.

Figure 21. A typical successful portrait studio, begun in 1946, is owned and operated by Greer and Mary Lile in Little Rock, Arkansas. In a downtown location they worked from a studio built onto their home until 1974 when a second building behind the home was

22 *Elegant portrait by Greer Lile; original in color.*

completed. Built primarily as a Gallery of Photographic History where the Liles' unusual and valuable collection of historic cameras and equipment is displayed, the Gallery is a second studio. The shooting area is lighted by a huge window as seen in figure 21, where Greer conducts a portrait sitting using a solid, old 5x7 view camera. Mary is an expert retoucher, and one assistant makes appointments and handles the files, while another does the darkroom chores. Greer also works with a 2¼x3¼ SLR camera and a 4x5 view camera, depending on the requirements of the subject. One of Greer's portraits of the young lady in his studio is shown in figure 22.

less formal posing. A dynamic change in life-styles for photographers and their subjects alike seems to bode well for photographic realism in a strongly traditional field.

Wedding Photography

While pleasing people with portraits has its headaches (as does *any* phase of professional photography), shooting weddings is often a profitable rat race. The work is usually hectic, and may become routine, though the talented photographer finds ways to vary pictures of different couples and families. A wedding photographer needs an instinct for timing, and it develops from experience. With dependable equipment, and a feeling for the type of pictures the client prefers, there is assurance of satisfaction in gratitude and income. However, a majority of wedding pictures seem to be taken with electronic flash on the camera, which produces a rather boring sameness that is perhaps unavoidable in some cases, but offends the photojournalist in me.

A more contemporary approach to weddings can be taken with the 35mm camera, using natural light, and *bounced* electronic flash when possible. Clients can easily be conditioned to this style, particularly modern couples for whom the traditional wedding itself is too staid. Excellent 3x5 color proofs can be made by professional labs, and aware people will value the journalistic flair of the photographs. The following series by Tom Carroll illustrates the 35mm approach.

Figure 24. There is almost a formula for wedding situations to photograph, beginning with the bride's preparations, but only a few of these are included here. When photography is allowed during the ceremony, a fairly long exposure such as $\frac{1}{8}$ or $\frac{1}{4}$ second with the camera on a tripod is often feasible with color film. Tom Carroll used a 21mm lens for this shot, and switched to longer lenses and a horizontal format to better emphasize the actual wedding.

23 Outdoors in the shade, a white wall background can be a very agreeable setting for portraits. Konica Autoreflex T with 100mm lens, and B-G "brush stroke" texture screen added in enlargement.

The Liles' studio, and especially their marvelous collection of photographic memorabilia, is more elaborate than the average, but illustrates the manner in which a traditional photographer has moved into a modern setting, while retaining many quality characteristics of portraiture.

In contrast, a number of photographers have turned to 35mm cameras using natural light or electronic flash, and found an appreciative clientele. The atmosphere of a studio is important to its success, and subjects are relaxed by the pleasant personality of the photographer, music in the background, and simplicity of the surroundings. Today the public is far more receptive to honest portraits with no retouching and

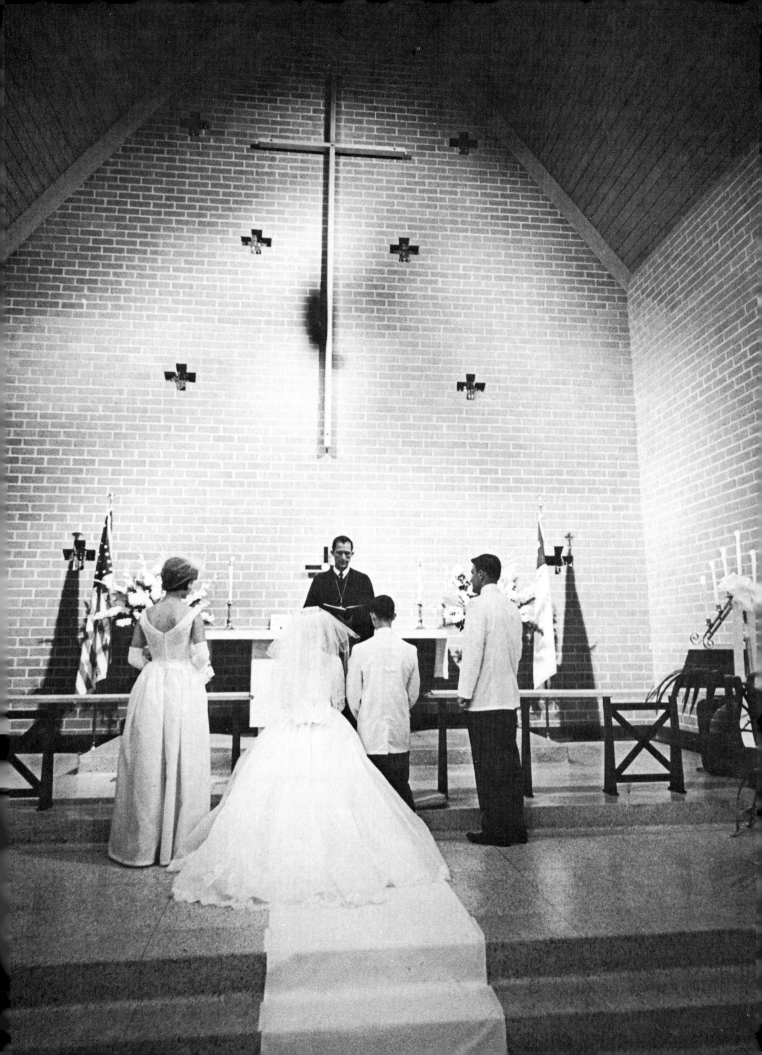

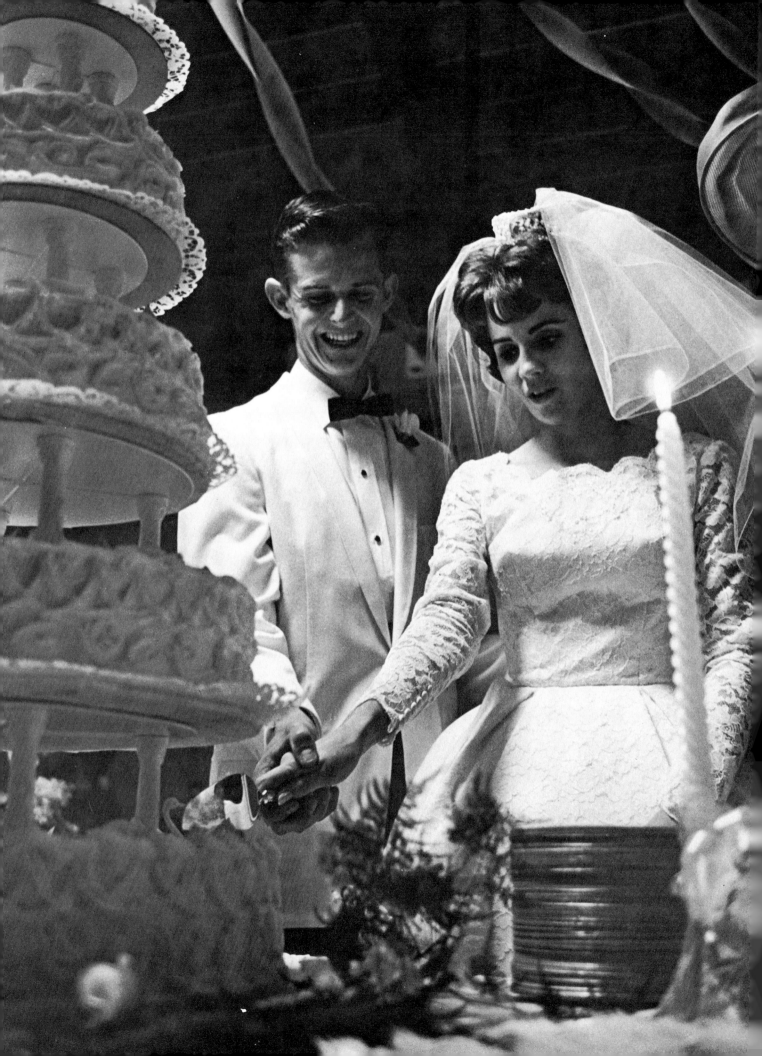

26

25

27

Figure 25. Cutting the cake is a "must" situation, and the usual photograph is taken with flash on the camera, which assures you of sharpness, depth of field, spontaneity, and unimaginative lighting. However flash is usually necessary because unless most of a wedding is outdoors in daylight, the illumination level in reception halls and homes is too low for color. Nevertheless, Tom Carroll shot at ½ second in this spot, and captured a realistic image that stands apart from the average. He probably asked the couple to hold a natural looking pose momentarily, and shot several frames as they went through a sequence of action. If in doubt about exposing in existing light, try it, and augment your coverage with flash.

Figures 26 and 27. Taken a moment apart at 1/250 second, these pictures show the bride and groom emerging from the church amidst a hail of confetti. Flash-fill in color might be appropriate in such a case, as long as the f-stop used is appropriate for both background figures and the dominant target. Though the bride is slightly out of focus, sharpness is quite acceptable. For these pictures Tom used a 21mm lens, which provided extended depth of field. Any wide-angle focal length would be useful in order to zone focus in a fast-moving situation. Backlighting here helped accent the confetti and separate the bride and groom from the background.

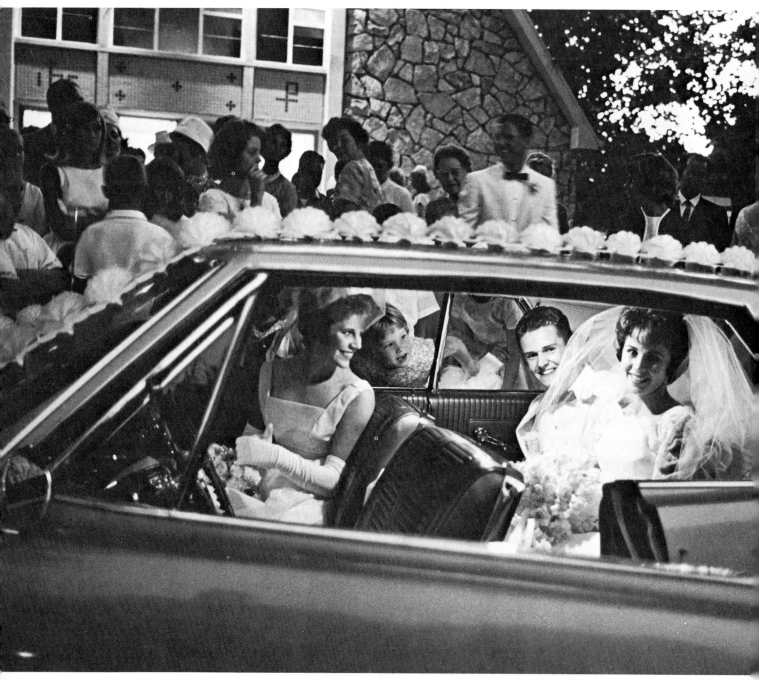

28

Figure 28. About this handsome photograph Tom Carroll comments, "Dusk and a dome light in the car combined for the illumination and an exposure of 1/15 second at f/4 with a wide-angle lens. I was constantly aware of the excitement shown by the young lady in the front seat, and I featured her reactions to the bride and groom when it was appropriate." If Tom had used flash here, the occupants of the car would have been flatly lighted, and those in the background too dark. It takes courage to shoot color in such circumstances, but it is possible, and the rewards are often worth it.

THE PHOTOGRAPHER IN BUSINESS

References are made in this and in the next chapter to the business aspects of photography. Readers whose interest in camera and darkroom work is primarily

for personal expression and communication of ideas may skip this very brief excursion into business techniques. For others who may even vaguely anticipate going into some facet of photography as a profession, here are some recommendations.

Learn to read, write, and speak as literately as possible. Communication in any business is almost as important as the specialty involved. Reading gathers knowledge and helps keep you current with technology that changes quickly. Being able to write a concise, persuasive letter, or outline an idea (on a typewriter), can impress clients, and can be supportive to your visual talent. Speaking articulately—and listening carefully—can boost your business opportunities.

All the above skills are combined, plus more, to create an effective sales technique. "Selling" is not a dirty word. It can be a subtle and sensitive means of projecting your ideas and photographic potential to prospective clients. Reading about and studying the art of selling can add to your self-confidence, whether you are in the advertising, commercial, or editorial field. You may also need to sell your work to gallery owners, publishers, or individuals who could be collectors.

It also helps to learn the rudiments of bookkeeping, at least until you're successful enough to hire an accountant. I've maintained business records in a 10-column ledger for many years. Billings cover two pages each month, followed by itemized expenses on two more pages for the same month. Separate columns have headings such as "Post Office," "Car & Transportation," "Photo Supplies," "Magazines & Books," and "Stationery." On the billing pages, each job is briefly described with entries for the fee and expenses plus total. It should be easy to set up your own ledger in a way that keeps track of your specific business income and expenses. From one year to the next my ledgers are a history of sales, clients, expenses, and total monthly income. Comparisons are fast, and knowledge of bookkeeping is minimal.

It does not pay to be innocent or ignorant in business any more than it does in the art of photography itself. All the above recommendations can be implemented by supplementary reading and/or courses that may be readily available to you. As the Prudential says on it's Rock of Gibraltar trademark, "The future belongs to those who prepare for it."

There are dozens of ways to make a living with a camera as a full- or part-time professional. Small businesses, theater groups, local newspapers, schools, collectors, organizations and individuals staging social events, parents, and various types of publications are all potential markets or clients. Let me suggest a few other books to consult if you are interested in more details:

Free-Lance Magazine Photography, by Lou Jacobs Jr. (Amphoto)

How to Make Money With Your Camera, by Ted Schwarz (HP Books)

Photography for the Professionals, by Robin Perry (Livingston Press)

Impact—Photography for Advertising, by Bill Reedy (Eastman Kodak)

Free-Lance Photography, by Gary Miller (Peterson Publishing Company)

Information in some of these books will also help augment the material in my next chapter on photography for communication.

EDITORIAL AND INFORMATION PHOTOGRAPHY

1 A multiple exposure of an Air Force officer and a globe was the opening photograph for a magazine story. Rolleiflex made two exposures easy.

There are more career and avocational possibilities in this category than in advertising, commercial, or personal expression photography. The challenge of taking pictures for newspapers, magazines, books, exhibitions, or industry is well known. While rates of payment are generally higher for advertising than for editorial photography, there is often more personal latitude working for media where space is not purchased, but must be earned.

Several decades ago there was a more definite line between informational and commercial photography, but today they overlap loosely. Photographers may make a major part of their income from selling to publications, shooting record-album covers, taking pictures for annual reports, creating filmstrips for education or business, and working in allied fields. Most of these men and women welcome advertising assignments, to which they usually bring an editorial (nonstudio) approach. As we examine briefly a number of these options, keep in mind that some are open to part-time participation.

EDITORIAL PHOTOGRAPHY

Definitions of editorial photography tend to sound rigid, but should not be. Generally, this field encompasses news and information that is not governed by a tight deadline, for publications or business clients. Spot news coverage for newspapers must have a time limit to be useful. Today's fire or Senate hear-

ing is quickly replaced by tomorrow's automobile accident or political scandal. Pictures that may be printed today or tomorrow with equal reader interest are often called *features*, originally a newspaper term.

Photojournalism

While the word photojournalism is sometimes misused, its usual connotation is picture-word journalism that tells a story, and often probes deeply into subjects photographed with sensitivity, intensity, empathy, and perception of individuals and their environments. Dr. Erich Salomon, a German who began illustrating weekly stories for magazines in 1925, is called the

2 Symbolic of photojournalism at its best is the work of Gordon Parks, for many years a Life staff photographer. This and figures 3 & 4 are included in Gordon's book, Moments Without Proper Names *(Viking, 1975). Shot in Ansonia, Conn., 1949.*

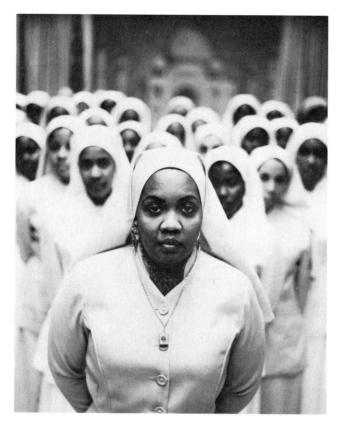

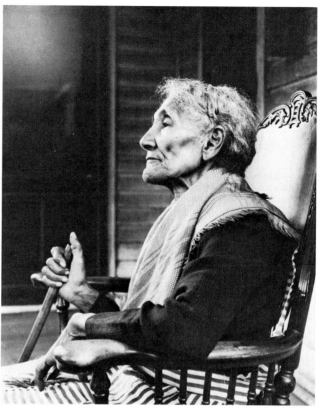

3 *Taken by Gordon Parks in Ft. Scott, Kansas, 1963.*

4 *By Gordon Parks, Chicago, 1963.*

father of photojournalism. He used an Ermanox, the "miniature" camera of its time, which had an 85mm f/2 lens and used 4½x6cm glass plates in holders. By the early 1930s he was already famous for candid and concealed-camera coverage of European statesmen. After Salomon photographed William Randolph Hearst at his San Simeon estate during a luncheon, the publisher was so impressed, he ordered Ermanox cameras for all of his newspaper photographers. Salomon switched to an early Leica about 1932. His pioneering photographs are still outstanding, giving the viewer an intimate glimpse of moments when the illustrious were off guard. Salomon was murdered by the Nazis in 1944, but his influence can be seen in early issues of *Life*.

The photography of *Life* and *Look* shaped photojournalism as we know it today. Their stories ran the gamut from parties, celebrities, and general world events, to memorable photo essays by W. Eugene Smith (such as "The Country Doctor" and "Spanish Village"), Alfred Eisenstadt, John Vachon, David Douglas Duncan, and many others. Fast films and lenses that we take for granted today were not introduced until after World War II, and have been improved in the 60s and 70s. With these materials and equipment it has become commonplace to shoot in existing light without calling attention to yourself, in situations where photojournalists once had to use multiple flashbulbs. That style of lighting looks somewhat contrived to us now. An amazingly few photographers practiced the natural-light, large-aperture, slow-shutter-speed techniques of Dr. Salomon until about 25 years ago.

Picture Story Techniques

Though there is room here for only a general digest of a broad subject, it is worth knowing how a journalistic photographer operates.

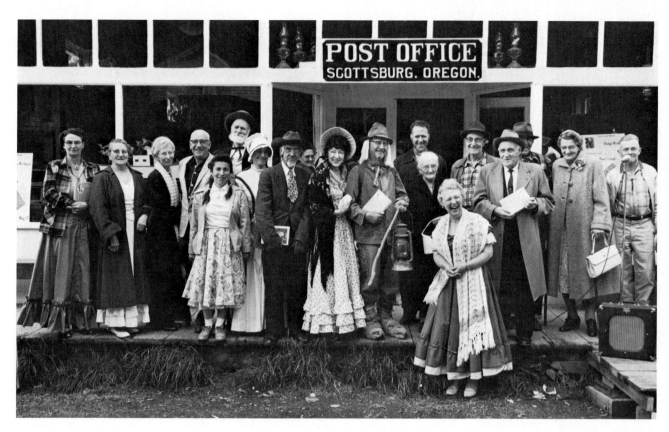

5 *Group photograph from a story about Gladys Workman (foreground with shawl) taken for* Life *by the author. The coverage was typical of journalistic photography; it was paid for but never ran in the magazine.*

The idea. As in any area of visual expression, the idea comes first. For a picture story, the idea should be tested in terms of photographic potential: Is it a subject that can be told as well in words with a few illustrations, or will its impact depend on images? Is it a salable idea that has not been done, at least recently, and if so, what publications seem to be the most likely markets? If the idea is subjective, and a market for it is not required, will the subject result in challenging, meaningful photographs? The scope of an idea is less important than its potential for the camera. Commonplace themes are often as exciting, if photographed perceptively, as well-known people and places. Ask yourself: *Is there a leading theme to prove a point?* If not, your story may just be a collection of images that may be dull.

Picture script. List the picture situations that you find from research, or feel from experience, are most likely to occur. They need not be permanently in this order, but you should have in mind a *lead* picture, one that attracts attention by action, emotion, or symbolism, and will persuade viewers to read on. Sometimes a working picture script is written on location where you shoot, because not until then do you have enough grasp of a subject to be thorough. Add or subtract from the script as the need arises; if an editor provides a picture list (unless he's on the spot with you), realize that it will be flexible. As you shoot, new situations may arise, and you will mentally insert them into the script at hand. Later you include them in the final selection of pictures, or leave them out if they don't work to your advantage.

Executing the idea. As you take the pictures, you should be constantly aware of how your idea is shaping up on film. Direct people tactfully, but firmly. Even reluctant individuals can be reached through friendly persuasion, if they are integral to your story.

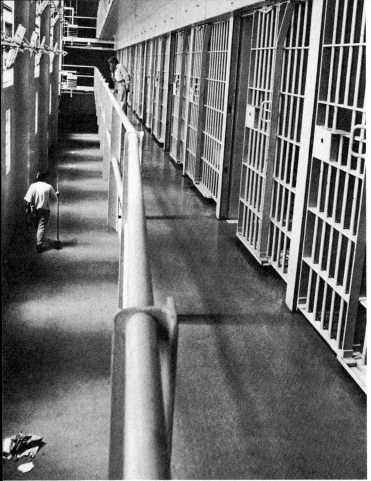

6

7

6 *The first of three pictures by Roger Tully Jr. about life at Terminal Island State Penitentiary, San Pedro, California. Using a 28mm lens on an SLR, he showed the chilly atmosphere of the cell area.*

7 *Individual prisoners in normal activities dominated Roger Tully's picture story. A normal 50mm lens on an SLR offered limited depth of field at f/2.8.*

8 *Visitors talk to prisoners in a bleak setting that Tully allows to speak for itself.*

9 *Teen couple was asked to* ▶ *romp in the grass; since they were emotionally close, the situation was simulated but honest. Several dozen 35mm frames were shot in quick succession.*

Shoot that which takes place, and simulate that which would happen in reality at another time. To set up a situation, as I did in figure 9, is not a dishonest approach. As part of a story on a teen couple, I asked them to romp in the grass, and followed this precept: Ask people to do what is natural to their lives, jobs, or to the story situation, and once you set them in motion, continue to take pictures until you feel you have it. If you concentrate on activities that are indigenous, the action, expressions, and communication between individuals will be believable. There are many occasions, such as sporting events, when simulation is not necessary. In such cases, knowing what you want and staying with it usually pay off, though that may sound glib until you have learned through failure.

Presenting or completing the story. Study black-and-white contact sheets or sets of slides carefully. Mark each black-and-white proof that is worth enlarging, and once the prints are made, edit these down to what you consider are essential images. Edit slides as ruthlessly as possible, too. Avoid repeti-

tion, and arrange the pictures to tell the story with maximum interest, visual excitement, and information. If you present the story to a publication, number each print in pencil on the back, or number the slides individually or in groups. Including contact prints is sometimes useful; number the frames you selected to coincide with the prints so an editor will know immediately which images have been enlarged.

Write succinct captions for each picture on a *separate* sheet of paper. Don't attach captions to prints or slides where they must be removed and could be lost while the photographs are being engraved. The best caption augments what the viewer sees in the picture; it clarifies, but it does not repeat verbally that which is visually apparent. Write a text long enough to include all pertinent information. Be as articulate as possible, but don't worry about literary style, since most publications have staff editors to rewrite almost everything.

If your story is not submitted to a publication, make prints or display slides according to your own taste.

10 *Editorial portraits are often made within a subject's environment. Cecil Beaton was designing sets and costumes for "My Fair Lady" at a movie studio when the author photographed him for Friends Magazine.*

For more about marketing picture stories, there are other books, including my own *Free-Lance Magazine Photography* (Amphoto), as available references.

NEWS PHOTOGRAPHY

The finest news photography is a form of photojournalism. Many freelance and magazine staff photographers cover fast-breaking events, such as political conventions, football games, or average people doing unusual things, and the difference between their techniques and those of newspaper and wire service photographers is often *time*. A newspaper picture must usually be printed within hours of exposure to have value. Newsmen have developed ways to edit and print damp negatives in order to make close deadlines. Kodak's resin-coated (RC) paper and the use of stabilization processors have quickened the pace in recent years.

Spot News Photography

Anyone who photographs war, crime, and catastrophe for publication must have above-average courage and aggressiveness to be successful. Magazine photojournalists have become famous for dramatic pictures, such as Robert Capa's classic shot of a bullet striking a running soldier during the Spanish Civil War. However, news photographers with daily or hourly deadlines face danger on a regular basis, and to many the routine is stimulating. With a press pass, a good sense of timing, and emotional insulation that prevents their feelings from hampering their work, these men, and a few women, often become rather cynical as well as skillful.

Figures 11, 12, and 13. Bud Gray is a veteran newspaper photographer from whose huge portfolio these few samples were chosen. Figure 11 represents daily events that most of us only read about. In Bud's career with several Los Angeles papers, he began with a 4x5 Speed Graphic, and later worked with a Rolleiflex and a 35mm camera for his varying assignments. While the 4x5 has been relegated to history, many newsmen still prefer the Rolleiflex for some jobs, because the larger negative can be cropped and retain quality, and 12 negatives on a roll offer a reasonable limit. Newspaper photographers must use electronic flash on the camera for many subjects, but they recognize the advantages of natural light when it is practical.

Bud used a 135mm lens on a 35mm SLR for figure 12. Baseball, football, basketball, and other sports are so repetitive that a news photographer is always looking for new angles and new ways to show familiar activity. This midair player was an eye-catching illustration of that day's ball game.

There are also plenty of undramatic assignments in the news field where the photographer must be inventive. Check presentations, social events, visiting VIPs, and the opening of the circus (figure 13) among others. Bud set up this amusing shot of a youngster reacting to the roar of a lion, and shot it with his electronic flash held at arm's length above the camera for better modeling of the boy's face.

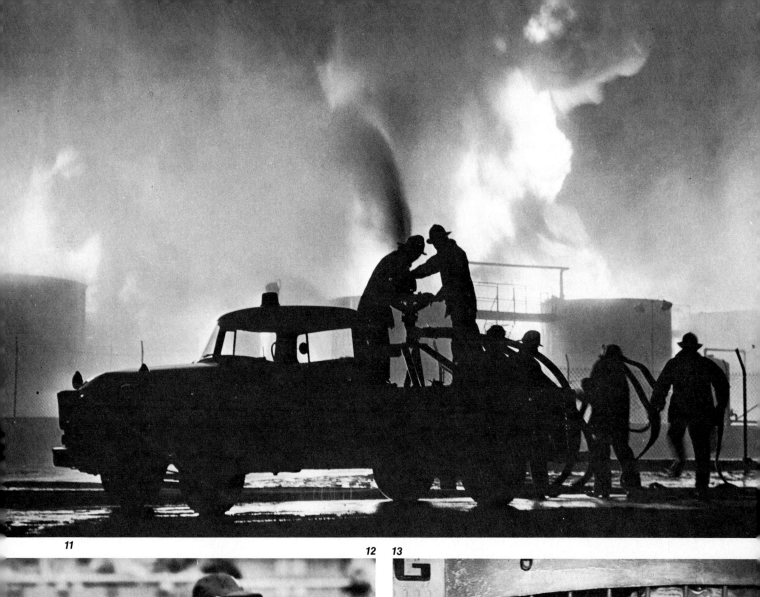

11

12 13

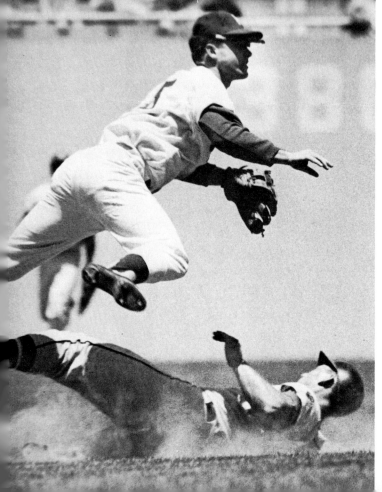

14 Ex-President Nixon making a speech, photographed by Tom Carroll.

16 News photography for magazines took Tom Carroll over the Bel Air section of Los Angeles during a fire in which movie personalities were involved.

15 Following the speech, Carroll caught Nixon signing autographs, and made an unusual composition with a 21mm lens.

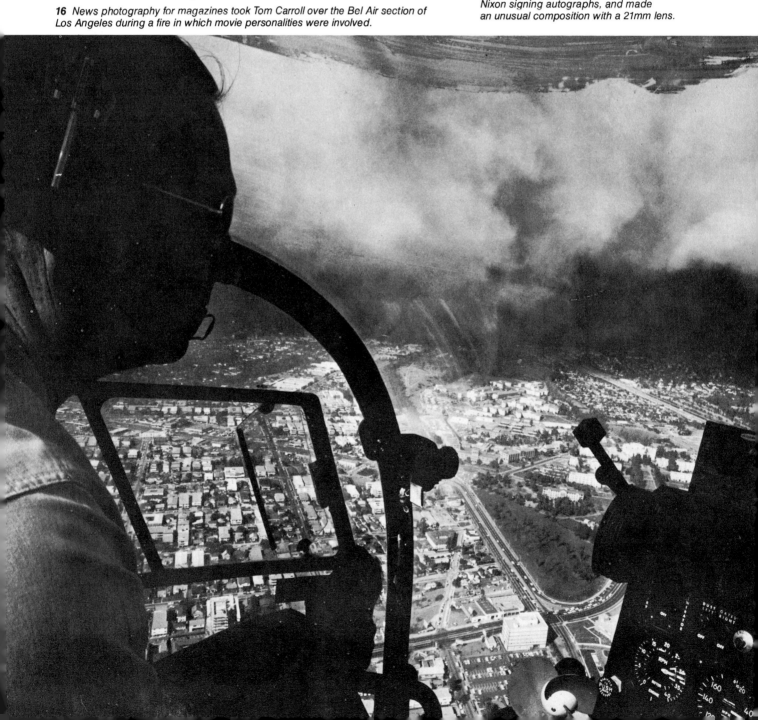

Magazine News Photography

Time inhibits the newspaper photographer who usually cannot wait around to shoot a subject in depth, a luxury often afforded the average magazine news photographer. This capability is illustrated by figures 14 and 15 taken by Tom Carroll on assignment for a news weekly when Richard Nixon was president. Using a wide-angle lens at f/5.6 and 1/60 second for figure 14, Tom caught him entertaining a Junior Chamber of Commerce audience. Had he been working for a newspaper or wire service, Tom might have left immediately to make an early edition. By waiting until the speech was over, he captured a human-interest touch of the president signing autographs in figure 15. This was shot with a 21mm lens which offered greater depth of field in the limited light level.

Figure 16. In-depth coverage of a news event also means being able to photograph more than just the most prominent aspects. Tom Carroll shot the ground-level drama of a fire in the Bel Air section of Los Angeles, and then took to the air in a helicopter for another dimension. Again the 21mm

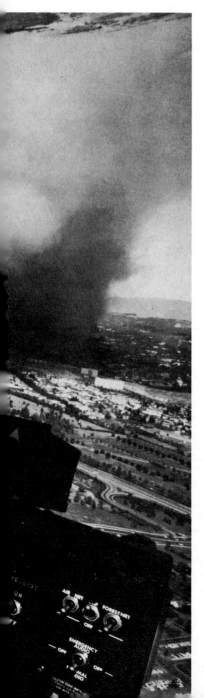

lens on a Leica was very functional for combining the pilot and controls with the background city and smoke. The picture summarized this fire so well that it was used as a two-page spread in *Time.*

Figure 17. Though David Hume Kennerly's principal subject, Gerald Ford, is hardly typical for news photographers, Kennerly's sense of visual impact and content is exemplary. This is an impromptu moment as the president's barber, Milton Pitts, completed a trim of the chief executive's hair while Mr. Ford prepared for a speech and Susan Ford offered a warm greeting. With a wide-angle lens, Kennerly was able to retain focus throughout the image and include the contrasting portrait of the president at top right. When shooting a situation that happens quickly, take as many pictures as seems feasible, and assume that you will get quality from quantity.

News photography is often a matter of expediency rather than art. Images with lasting value are usually a fortunate mixture of skill and luck. Remember the definition of luck: when preparation meets opportunity.

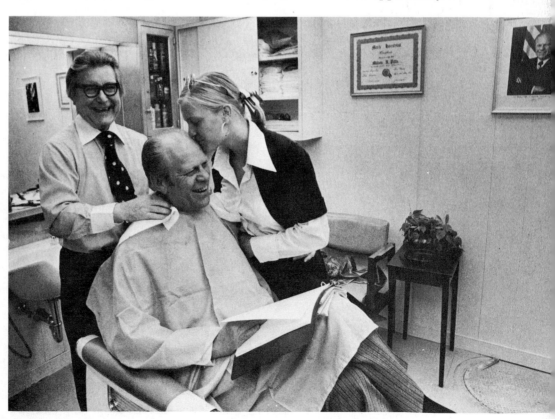

17 *David Hume Kennerly has Gerald Ford, one of the world's outstanding news figures, as a constant subject. As White House photographer, Kennerly must maintain objectivity while trying to avoid repetition.*

18 *News handout photo from North American Rockwell is an exceptionally attractive image that was widely printed some years ago.*

ANNUAL REPORT PHOTOGRAPHY

Some of the best editorial photography is published in annual reports that illustrate the business and industrial activities of many companies. Where annual report pictures were once rather static, they have become journalistic and imaginative, mainly because some of the best photographers in the world have been attracted to this medium. The lure is not only day rates that start around $500, but the opportunity to shoot imaginative images and to travel widely as well.

Figure 18 demonstrates the scope of this field. It was taken by a North American Rockwell photographer of a space spinner, used to study how men would be affected by rotation of space vehicles such as Skylab. An exposure of one second with a tripod-mounted camera showed the spinner in operation in a way that report readers would find intriguing.

PHOTOGRAPHY FOR BOOKS

The picture book or the photographically illustrated book for adults and young readers has become a viable source of income for many professional photographers, and for others new to the field. With the loss of *Life, Look,* and many magazines as potential markets for picture essays, only *National Geographic* remains, and its pages are available to a limited few. Thus, the picture book has become an important form of publication, offering a wide scope of personal and factual possibilities.

Children's Books

The principal type of children's book uses photographs to inform, as an adjunct to the text which is usually dominant. Many such books are illustrated with drawings, or with photographs bought from stock sources. However, publishers are becoming increasingly aware that young readers are far more sensitive to, and appreciative of, good photography than they were a decade or so ago. Therefore, the photographer who might have suggested a story idea to a magazine a few years ago, could develop similar ideas for children's books.

19 *From the author's book for young readers titled* Highways In The Sky.

A few of my own books serve as examples. In one, titled *The Shapes of Our Land* (Putnam's), I gathered a number of pictures shot for my own edification to illustrate land forms, and wrote a text about geology. For *Highways in the Sky* (Bobbs Merrill), the story of air traffic control, I shot a number of situations, such as a jet landing into the sunset in figure 19. It was made with a 65–135mm zoom lens on a Konica Autoreflex T, using a 2X neutral-density filter, at 1/500 second and f/16 on Tri-X. In a book about Marineland of the Pacific called *Wonders of An Oceanarium* (Children's Press), I was able to include a number of animal pictures such as the leaping dolphin in figure 20. A motorized Nikon SP rangefinder camera was set at 1/500 second, and this frame was chosen from half a dozen in a sequence.

Photography for fiction. A storybook for kids is almost always illustrated with drawings, paintings, or block prints because fiction and fantasy do not usually lend themselves to the literal qualities of the camera. However, a story set in realistic locations using actual people chosen for the roles can be—and has been—photographed suc-

20 *Shot with a motorized Nikon SP (rangefinder camera) for the author's book,* Wonders of An Oceanarium.

21 *Photo-fantasy is difficult to achieve to illustrate a children's book, because the medium of lens and camera is essentially literal.*

subjects can be adapted into picture books, but in the adult field, it is more difficult to create and sell one. Children's books, by comparison, are shorter, more specific, and usually information oriented. Longer adult books are riskier for publishers, but the potential sale may be greater, so you will see a lot of photo-dominated books on library and bookstore shelves. You may also wonder if any will ever make a profit.

In spite of the inconsistent quality of books we see published, I would encourage anyone with ideas, visual aptitude, and persistence to consider the highly varied book field eventually. Rejection of a book proposal from one publisher is rarely a sign that the idea is a failure. A few years ago I sold a children's book idea to the fourteenth publisher that considered it, because that editor's taste and values were different from the previous ones.

A picture-book proposal usually consists of an outline with chapter titles or a description of the idea; some sample photographs and writing, and a brief sales pitch in a covering letter. If you are fortunate enough to receive a contract for a book, have it checked by an agent, an attorney, or an author who knows the pitfalls. For additional information, see my chapter on selling children's books in *Where and How To Sell Your Photographs* by Arvel W. Ahlers (Amphoto 1975).

cessfully. A child's world translated through the camera also lends itself to photo-fantasy techniques such as multiple exposures, blur, or diffusion. At this time, the opportunities to exploit the less realistic qualities of photography seem quite open, and I'm certain we will see imaginative book illustrations, especially in color, in future years.

If you are a capable writer, originating a children's book that meshes words and pictures could be a stimulating project. Otherwise, find a writer with whom you can team, and split the royalties, which begin at about ten percent of the net price of the book, or five percent each to writer and illustrator.

Adult Books

The variety of approaches is greater among adult books than it is in the juvenile field. There's the travel-oriented book on a section of America or on a foreign country, the mood book with poetic text that centers on the seasons or a life-style, or the retrospective book exemplified by Gordon Parks' *Moments Without Proper Names*, some photographs from which are shown earlier in this chapter. Many

STOCK PHOTOGRAPHY

There are two basic ways of selling photographs from a stock file that must be carefully assembled over a period of years. (1) Market them yourself to publishers, calendar companies, or ad agencies by circulating lists of subjects on hand, and/or showing samples in person to buyers. (2) Send your slides and prints to a stock picture agency (most of which are in New York) where the volume of requests for pictures is constant.

The first method takes more of your time and energy, but may very well earn

22 An imaginative portrait such as this of Carl Sandburg by versatile Bud Gray would be appropriate as a book or magazine illustration. The original negative was solarized and transferred to high-contrast film.

23 A typical stock photographic subject was printed with a texture screen for added decorative value.

a better income because of the personalized attention and concentration on specific markets which you can develop. The stock agency approach may seem more promising on the surface, but unless you provide a fairly large supply of pictures—more than 1,000—and continue to replenish the agency's files, you may find yourself buried among millions of images from which your sales are minimal and disappointing.

Therefore, the promise of stock photography is limited until you have accumulated a volume of pictures, and have established a reputation for quality and/or specific subjects. It may seem appealing to travel and photograph, or to concentrate on pretty girls, scenics, or babies, and sell your output in the stock photography field, but it is overcrowded with professionals and advanced amateurs attempting to do the same thing. Do as much research as possible before investing a lot of time and expense in this category.

PUBLIC RELATIONS PHOTOGRAPHY

This category combines editorial, news, photojournalism, and some commercial photography, and may become a freelancer's specialty, an activity of a commercial studio, or a function of business and government operations. The best public relations (PR) pictures promote and publicize a product, person, service, place, or company image. They are often similar to photographs a publication might have otherwise purchased. As an example, a manufacturer assigns a photographer to shoot a complete picture series on a family using its latest tent or other outdoor equipment on a camping trip. The color and/or black-and-white photos are "planted" in an appropriate publication, which means they are given away in return for the publicity such a story generates. Single pictures may receive the same treatment. The photographer is well paid for his/her work, and the client takes the risk of speculation, though the idea may also be previously planted.

24 *Publicity photo of England Dan and John Ford Coley released by A&M Records in 1974.*

25 *Freelance photographers are often called upon to shoot subjects such as this ancient Indian sculpture, as promotion for a museum or gallery.*

Variations on the publicity theme are numerous. Assignments by business and industry to promote and announce products are often commercial jobs. Two random examples of other approaches are illustrated in figures 24 and 25.

Figure 24 appears to be a studio portrait of England Dan and John Ford Coley, a singing duo whose ''Entertainers of the Year'' award was being announced by their management company in a 1974 publicity release I happened to receive. However, the picture might have been taken in an improvised setting with a dark background hung behind them. From the highlights in their eyes, we can deduce that electronic flash reflected from a round umbrella was used fairly high (see nose shadows) at the left. Similar promotional portraits by studios and freelancers are set outdoors, with props, and in performance.

Figure 25 was a hand-out photo from an art museum announcing an exhibit of Indian and Asian sculptures from the famed Avery Brundage Collection. The ninth-century Indian granite piece is 29 inches high, says the attached caption, and was photographed with a diffused (note soft shadow edges) light placed high and directly in front, as mentioned in chapter 7. One may easily arrange a studio setup at home or on location, using seamless paper for the background, to shoot objects such as this.

PHOTOGRAPHY FOR GOVERNMENT AGENCIES

City, county, state, and federal government agencies all employ photographers at various levels. Versatility would seem to be required in such jobs where people, places, and things are subjects. In some positions, more creativity may be necessary than others, but these opportunities should not be overlooked by anyone seeking a career with a camera.

An aesthetic example of photography for government is figure 26, an aerial shot of Columbia Glacier in Alaska by Austin Post of the U.S. Geological Survey. Made as part of a continuing series to show the glacial movement, Mr.

26

Post's beautiful picture was used with many others in a large chart provided to geologists and the public, and was printed in many newspapers when the 9x9-inch contact print was handed out to wire services (AP and UPI).

Not all assignments for government agencies have the pictorial possibilities of a glacier, but the need to continually inform the public about the myriad of activities financed by taxpayers creates a demand for able photographers across the nation.

27 *Robert Lewis won a Kodak/Scholastic Award for his exciting blurred-action track meet. He panned the camera at a ¼-second exposure.*

PHOTOGRAPHY EXHIBITS AND CONTESTS

Exhibiting Photographs

Since the techniques for making and mounting color or black-and-white prints vary considerably, the best guidance I can offer is to weigh carefully the potential value of an exhibition. If the location, timing, and the company in which your pictures will be seen seem to offer prestige and suitable exposure, the effort may be worthwhile. However, the benefits of many exhibitions are unpredictable in terms of sales and future jobs developing. You may, however, decide to exhibit your photographs for personal satisfaction and a sense of accomplishment, hoping that the benefits of such exposure will eventually pyramid.

Photography Contests

Some contests are worth entering, and others are a risky waste of time. The better ones offer prizes or awards you may feel are substantial enough to encourage submitting slides or prints. Publicity and publication should be considered along with money, merchandise, travel, and gold statuettes. There's also the impetus of competition as an asset.

Inferior contests offer minimal awards or prizes. Beware of any contest rules that require the photographer to assign all rights (ownership) to his/her negatives, prints, or slides. If your picture is good enough to win, it might also have sales possibilities for magazines, calendars, etc., but you could be giving it away for a pittance and third honorable mention. Unless the stakes are very high, avoid contests in which you cannot retain ownership of your photographs.

PHOTOGRAPHY RATES AND RIGHTS

The complex and important topic of photography values and rights is best covered by the *ASMP Guide to Business Practices*, mentioned previously. The following is a thumbnail summary.

Photography Rates

Day rates. Publications of national circulation, and some that are regional or local, have been conditioned to pay the ASMP minimum day rate which at present is $200 plus expenses. Negotiate on the basis of that minimum with business and industrial clients as well, if offered less.

Space rates. Most publications have a page rate for photography, or for the combination of pictures and text. In trying to decide about fees for an unfamiliar market, inquire about their page rate. In any case, the photographer should be paid a day rate or a page rate, *whichever is higher.*

Stock-picture rates. There's a sliding scale for stock-picture values, depending on the size of reproduction and the number of pictures sold in a batch, as detailed in the *ASMP Guide*. Minimum charge for a black-and-white stock print at this writing is $50, and $150 for a color slide. These figures are for editorial use; fees for advertising in any form are higher, and must be negotiated.

Story rates. Some publications have established a package rate for words and pictures that may range from $150

28 *Taken originally for a story about a rural New Mexico quarter horse track, this photograph has been reproduced half a dozen times because the author sells only one-time rights and retains the negative in his files.*

up, depending on circulation. When working for or selling to such publications, the story rate may be high enough to compensate for your time. If not, point this out to the editor, and seek an upward adjustment *before* beginning the job if possible.

Commercial and advertising rates. Some photographers charge by the shot, some by the number of hours involved, and some by the total estimated requirements of a commercial job. Local and national photography organiza-

tions publish pricing guides to which you should refer.

Advertising rates were discussed in chapter 13.

Photographers' Rights

Sales to publications, to industry, and to many types of clients are often priced on the basis of rights the buyer receives. Here is how these rights are defined:

One-time rights. The purchaser has the right to reproduce a photograph once. Prints, negatives, and transparencies remain the property of the photographer, and must be returned after use.

First rights. Stipulations are similar to one-time rights, except that the photographer agrees not to permit prior publication of the pictures. A time limit from several months to one year may be imposed.

Exclusive rights. Full rights to reproduce a photograph are sold for a fee ranging up to twice the fee for one-time rights. A time limit should be imposed if possible. If one were to sell all or exclusive rights to a photograph, the buyer would own the transparency or the negative, and the photographer could never resell the image. ASMP advises against selling exclusive rights without a time limit, and I strongly agree. The residual rights to a photograph depend on the photographer's ownership of the negative or transparency, and are as important to him/her as maintaining ownership of work is to a composer, author, or inventor.

If the reader were to gain no other value from this book except the awareness of how important it is to protect the ownership rights to pictures, no matter where they may be sold, this knowledge would be worth the time or money invested herein.

Incidentally, the outright sale (exclusive rights in perpetuity) of photographs for a book in return for a flat payment should also be avoided. In every case, ask for an advance against royalties that should be paid on all copies sold. Publishers' exploitation of photographers in this regard has increased with the economic stresses of the 1970s.

LEGAL POSITION OF THE PHOTOGRAPHER

Releases

A primary obligation of the photographer is to obtain releases from all recognizable individuals in pictures taken for advertising and commercial purposes. This is usually routine, but lack of releases will often make the sale of stock photographs for advertising impossible.

Some book publishers and magazines, especially those owned by companies and circulated to customers, may also require model releases routinely, If in doubt, ask a client if re-

leases will be required. Some, such as Chevrolet's *Friends* magazine, have their own release forms. Others, with no apparent commercial characteristics (such as *Parent's Magazine*), want releases to avoid nuisance suits from people whose pictures appear in innocuous circumstances, and threaten to sue on such flimsy grounds because they believe the publisher will pay them off rather than risk an expensive court trial.

Copyrights

You may protect a photograph *until it is published* by what is known as a common-law copyright. On the front of

29 *Everett McCourt was 17 years old when he won a scholarship in the Kodak/Scholastic contest of 1975. He obtained releases for all the subjects in his winning portfolio, shot in Mississippi. Models were friends.*

the print or slide, mark the © symbol followed by a date and your name. This signifies your intention to copyright that image. You may register the copyright using Form J accompanied by a $6 fee *after* or just prior to the date of publication. The *ASMP Guide* or the U.S. Copyright Office offers full details.

If your photographs were not copyrighted previously, and are printed in a publication the entire contents of which are copyrighted, you are protected. You should ask for a formal assignment of copyright from the publisher, but if you have sold only one-time rights to the material, your ownership of copyright is usually assumed.

30 *Successful stock photographer Grant Heilman guards the rights to his pictures, and may resell images many times to noncompetitive clients. Wild flowers were shot with an RB67 camera in color and black and white.*

Legends

Another way to protect yourself against the unauthorized publication of photographs is to rubber stamp them with a legend such as: "Reproduction or publication prohibited without written permission of the photographer." As a further safeguard, use this rubber stamp too: "This print or slide must be returned after use, or an additional fee will be charged." Don't be afraid of adverse consequences, which are far more likely if you fail to protect ownership and rights to photographs. Many buyers are too apt to assume that mere possession of a print or slide connotes the right to reproduce it, often without further fee, if the picture has been previously purchased for a specific purpose.

Billing Procedures

All photographic rights should be stated on the invoice or bill you send to a client. In most cases, negotiation about rights is verbal, and stipulation in the bill is essential. When "First-Reproduction Rights" are spelled out, and the purpose is included, such as "XYZ Magazine," this, in effect, becomes a contract. If the client reuses a photo without paying, the acceptance of terms on your invoice is implied by the fact that you were paid. You should then negotiate and bill for subsequent rights.

Incidentally, too many publications make an effort to trap the photographer by rubber-stamped legends on the backs of checks. If you're not careful, you may sign an agreement giving the payer all rights to a picture, merely by your endorsement. Crossing out unacceptable words and phrases is not legal, and you must return the check and ask for a new one without the legend on the back.

Other areas of photography, such as posters, television, postcards, photo magazines, or filmstrips, are also included in the editorial and informational category. Techniques and approaches to these markets are similar to those covered. Opportunities in photography increase along with technological and social advances.

PERSONAL EXPRESSION PHOTOGRAPHY

1 Experimenting with composition, posing, sets, perspective, contrast, or exposure leads to individual interpretation with a camera. Over-exposure here was one stop for an offbeat effect. Camera was compact Konica Auto S3.

From my point of view, personal expression photography is not primarily for sale, though prints and slides may eventually find markets. Personal expression as a way of creative fulfillment with cameras and in the darkroom is self-originated and self-directed. My definitions may be somewhat subjective, but they will serve as a reference.

Snapshots. The most elementary kind of personal expression, snapshots record people, places, things, and events that have special meaning for the taker and the subject. Snapshots are usually made without concern for principles of composition or basic technique; posing and action are often haphazard, and the most important thing the average person might say about a snapshot is that it is "clear."

Beauty and design. Photographs for the sake of beauty and design are created in literal or abstract fashion, with awareness of form, light, and content. Subject matter is unlimited,

but scenes from nature dominate. As a painter sets up an easel and canvas, the photographer carefully explores and interprets through a viewfinder.

Experiments. Often accomplished in the darkroom via processes described earlier such as solarization and multiple printing, experimental photographs are also a product of exposure variations, lens choice, and other unconventional techniques.

Documentary and journalistic approach. The world and its people, seen in their own surroundings, doing their thing, photographed with honesty and a realistic approach, are also popular subjects for personal expression. The goals of nonprofessional photographers may be similar to those who make a living with cameras.

Imitation snapshots. In imitation snapshots, the photographer adds to casual snapshot style a sophisticated or knowledgeable approach that includes a sense of design (often very offbeat)

2 An imitation snapshot has more than surface value; it may include emotional appeal or unconventional design and subject matter.

and content. Extensive variations on this theme in words and pictures are found in many books such as *The Snapshot* edited by Jonathan Green (Aperture) or *Women are Beautiful* by Garry Winogrand (Farrar, Strauss & Giroux).

Miscellaneous. Subjective, abstract, or poetic expression that does not fall precisely into any of the above categories is included here.

POINTS OF VIEW

The boundaries of personal expression are loose. Standards of evaluation are flexible and subjective, and the entire scope of this photographic area with cameras or without them is disposed to controversy. Differences of taste and visual judgment are extreme, but in many ways, healthy.

My original value system is considered somewhat traditional or "straight" in what has become a world of both formal and kinky images. I make an effort not to be pedantic or insular in my views. In fact, my eyes have been opened by dozens of photographers, mostly younger than I, whose work is stimulating and explorative. On the bottom line, however, I find a lot of published and exhibited photography to be irritating, shallow, pretentious, and of synthetic value.

Evolution of Styles

Styles of personal expression have evolved through cycles. Sharp images, except for unavoidable blur, were the goal of early and mid-nineteenth-century photographers. In the later nineteenth and early twentieth centuries, photographers turned "painterly," imitating the romantic, soft-edged, often sentimental impressions of painters. From this came the "salon" movement, characterized by greased nudes, wagon wheels, and stilted approaches by photographers who rarely took chances. A sharp negative, such as one showing every hair in the beard of a grizzled old "miner" (a model hired for the occasion), and perfection of lighting motivated generations of serious salon expressionists. "Miniature" film, as 35mm was termed, grain, and the sordid world of reality were disdained.

When the Farm Security Administration photographers plus *Life* and *Look* came along in the thirties, photojournalism began to influence nonprofessionals who were turning to "candid" photography. Since that time, the documentary camera has remained indigenous and universally popular. But the evolution continued in the fifties and sixties when a new vision emerged from at first a small number of subjective photoexpressionists. Today their inner-feeling, conceptual, unconscious, psyche-inspired, fantasy, and the-hell-with-conventions approach of making images has spread across the sophisticated world.

I say sophisticated (or aware) because the average snapshot-camera user does not relate to offbeat imagery; it is considered "crackpot" or zany. The avantguard is never revered by the masses, but eventually some styles that were "far out" do gain more general appeal. The work of Impressionist painters, cursed when they first showed at the New York Armory show in 1913, is a prime example of what also happens in photography—with less notice.

FACTS VERSUS FEELING

Painterly and salon photographers were preoccupied with sentiment and surface; documentarians are involved with showing the facts of life; and those who explore the realm of personal expression often deal with introspective feelings. Romantic and realistic images *do* evoke viewer feelings through beauty or emotion, but the content of pictures aimed at personal expression is often more powerful because it is inner-oriented. Since subjective interpretation may defy definition, some photographers resist analysis of their work, which occasionally seems intentionally obscure or mysterious.

Herein lies the distinction that sets this area of photography apart from

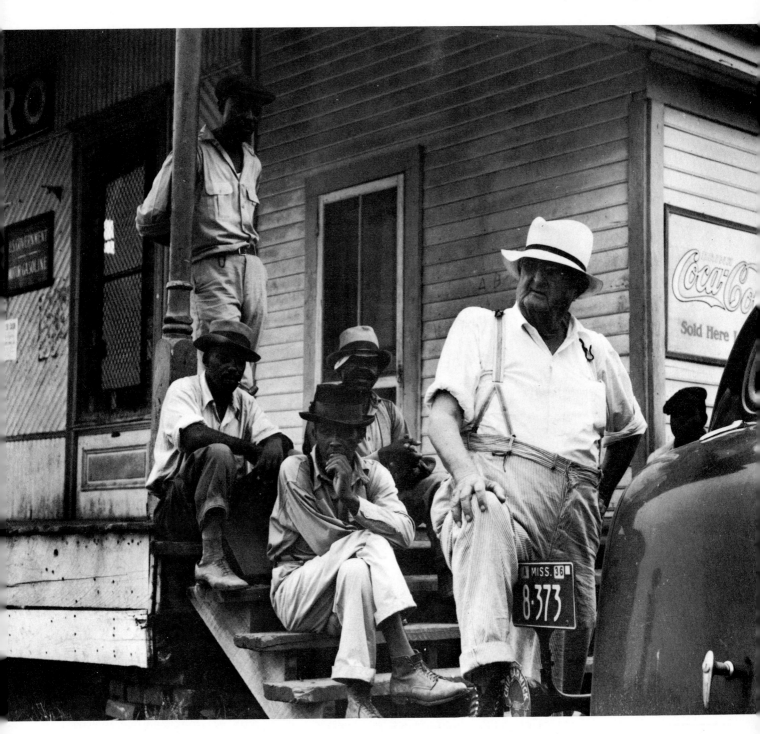

3 *The documentary style in photography matured in the 1930s with the work of FSA staffers, one of whom was Dorothea Lange. "Plantation Owner (1936)" was probably taken with a Rolleiflex, and may have been snapped surreptitiously.*

functional categories of commerce or information: a photographer is free to interpret the visible world or inner visions according to his/her own desires, inspirations, and intentions in a style that may be abstract, surreal, documentary, pure design, or a mixture.

Since photographers need not explain their images unless they wish to, it follows that understanding, appreciation, and admiration of personal-expression pictures is also subjective. Nowhere is it written that we *must* make images in a certain way, or that we must like the work of friends, widely hailed exhibitors, well-known avant-guardists, or offbeat experimentalists. Therefore, what seems dynamic to one viewer may be trash to another. One man's visual pleasure is another man's garbage.

4 *"Modern Home" by Peeter Tooming of the USSR.*

ing's picture an aesthetic delight, and have little urge to analyze it for meanings. The businessman's value system is very literal. Mine is visually flexible, and Tooming's nude-in-the-kitchen is a strong, provocative image that feasts the eye.

Julia Scully, editor of *Modern Photography*, writing in the September 1975 issue about photosurrealists Ralph Gibson and Les Krims, described certain pictures as having "vague and intangible qualities of dreams and things seen before through the juxtaposition of fragmentary images from the actual world." She continued, "Gibson has explored and communicated the mysterious quality of life, and Krims' conceptual photographs have frequently appeared to spring whole and largely unaltered from his subconscious... recognizable as fantasies many could identify with."

In her articulate way, Julia Scully added, "The photographer who delves into his psyche for inspiration and presents his uncensored results, risks more than those who record the outside world. After all, the inner-oriented photographer cannot excuse himself from criticism of what he records by saying, 'I shot only what was there.' Every photographer's ego is exposed when his pictures are judged, but the process is even more painful for the 'inner-oriented' one because his are such personal statements."

ARTICULATE DECEPTION

Perhaps you have read art criticism in newspapers or magazines, and realize that some of it is gobbledygook. That term is defined in the *Random House Dictionary* as "language characterized by circumlocution and jargon." It's not easy to write verbal impressions of visual experiences, but art critics sometimes analyze various media from what sounds like a haughty position of self-assigned superiority that is annoying and confusing.

Figure 4 is a beautiful example of my last statements. It was taken by Peeter Tooming who lives in Estonia, USSR, and was included in a portfolio of prints submitted to a magazine. Peeter's ironic title for his picture is "Modern Home," which has marvelous Freudian overtones of the trapped housewife, or whatever your literary imagination dreams up.

A conservative businessman to whom I showed figure 4 said, "It's terrible. Who would want to photograph a naked woman in a kitchen?" There was nothing I could reply. I find Peeter Toom-

5 *Rosamond W. Purcell sandwiched two Polaroid Type 105 negatives in the enlarger to create a haunting image that seems to reflect her inner feelings about nature and man.*

Those who take gobbledygook seriously are often cultists for whom the worship of the obscure offers an "in" feeling. Clearly, there are valid meanings and messages in art—which includes photography—that defy description, and it is challenging to be crisp and informative about subjective imagery. But I am reminded of the old Scripps-Howard newspaper slogan which applies here: "Give the people light, and they will find their own way."

Critics, editors, gallery owners, collectors, teachers, social researchers, and photographers have joined to create cults of personal-expression photography. They find or establish styles, trends, and schools which are defended and dissected. A lot of language spews forth to disguise an anthill declared to be a mountain. Obscure symbolism, mysterious emptiness, unconventional sensuality or eroticism, weird compositions, gigantic enlargements of trivia, and offbeat relationships are proclaimed as profound and even beautiful. There is debate, and sometimes doubters are labeled heretics.

6 *Photographs that merely record a casual moment in time are often praised, exhibited, or published because someone finds them "meaningful." The author calls this "articulate deception," a mystique one must learn to penetrate.*

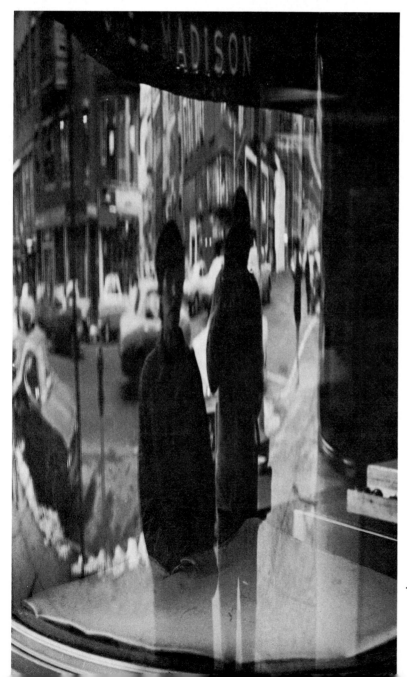

A lot of photography deserves adulation. Some is pretentious garbage to attract attention and comment. Who is to say an image will have lasting value because of its specific qualities? On what grounds can someone condemn a photograph as worthless, fraudulent, or as having barely transient value?

Explaining my own taste or alluding to images I disdain is not meant to proclaim lofty superiority. My purpose is to influence you to look for what *you* consider to be *substance* in a photograph—affecting the emotions, intellect, or both. If I can help prevent your being swayed to imbalance by trendy cultist images that are indicated as "creative" and admirable by critics (including classroom instructors), I may aid you to keep an open mind as your aesthetic sensitivity matures. Maturity comes with taking pictures, experimenting, studying images wherever you find them, and reading about the present and past in art and photography. Visual development is also nurtured by discussions and exchanges of opinion with friends, teachers, artists, exhibitors, and anyone whose values you can respect, whether they agree with yours or not.

Your own points of view about pictures —aesthetic or otherwise—are formed in the viewfinder, the darkroom, and wherever images are analyzed. Don't expect your work to be unique, but it could well be exciting and satisfying. Someday, it may be outstanding, unusual, remarkable, and pace-setting. Avoid trying to conform to any style or trend. Let motivation and visual impetus come from within you. Eventually, you'll know when your photographs have impact, appeal, or interest because of your own efforts and exposure to criticism and controversy. Sometimes, the less you say and the more you feel, the better is your achievement.

IS PHOTOGRAPHY ART?

Some photographs rank as art because they are of "more than ordinary significance," to quote the dictionary. The real test of art, however, is often the pas-

◄ **7** *A reflection of the author and his wife along New York's Madison Avenue may be interpreted as you wish, but suppose this caption said the image was "significant"? Would that influence your impression of the image?*

8 A photograph can be valued as art with the same latitude given other media. The eroded rock at Pt. Lobos, California is part of a limited edition the author assembled.

sing of time. A work may be called art minutes after it is completed, but no one is required to accept this proclamation.

It has long been established that photography can have the artistic stature of painting, drawing, etching, and other art forms. Museums hang photographs. Prints are valued in the thousands of dollars. New work is acclaimed today, and may be sanctified tomorrow. Beyond that, the question becomes academic. You can argue about photography and art as a stimulus, but the debate has long been settled.

Photography itself is an art, though it suffers the curse of usually being practiced through an optical-mechanical instrument. The challenge of materials and methods in photography is equal to challenges in other media. More than that is nit-picking.

Art moves people. Art has lasting value. Visual art needs little or no verbal support. Today's photograph may be tomorrow's art, and vice versa. Art changes, grows, flowers, dies.

Is photography art? The answer may lie in a memorable phrase attributed to Louis Armstrong that I used to see hanging on the inside of Edward Weston's front door. It said, "Man, if you gotta ask what it is, you ain't never gonna know."

PROBING PERSONAL EXPRESSION

The following photographic examples are covered in the categories mentioned previously. The simple snapshot has been omitted. We are already familiar with babies, parties, children standing

9 *Nothing short of poetic is Steve Crouch's "Dune, Eureka Valley," in the genre of Edward Weston and Wynn Bullock.*

like frozen statues, fuzzy images of the Grand Canyon or the Everglades, and similar subjects pictured by the billion every year. How *not* to use a camera is an approach I avoid.

Beauty and Design

The finest examples in the classification of beauty and design are photographs by Edward Weston (two more of which are seen in the next chapter), Ansel Adams, Elliott Porter, Ernest Braun, and similar photographic artists. The beautiful sand dune by Steve Crouch in figure 9 represents the kind of poetic seeing I mean, but subjects are not limited to scenes and extractions

from nature. People are also photographed in many ways, usually posed. For instance:

Figure 10. With some trepidation I set up a 4x5 view camera to photograph Edward Weston at his Carmel, California home in 1950. He is an idol with whose work I identify strongly for the inspiration it has always offered. Edward's sense of composition was nearly flawless. His ability to find pictures in the commonplace, and to exploit the drama of light and form has influenced several generations of photographers. Regardless of your photographic ambitions, Weston's work is worth studying, as are the images of his son Brett whose approach might be considered slightly more daring than his dad's.

10 *Edward Weston photographed by the author in 1950 with 4x5 view camera.*

11 *Man Ray photographed by the author in Hollywood, Ca. in 1949.*

Weston's empathy and easy relaxation made him an excellent subject, which is a big plus for portraits, especially with a large camera. I recall that Carl Mydans once wrote in a *Life* special issue on photography (December 23, 1966): "The very process of posing often requires a person to step out of himself, to deal with himself as though he were an object." He added that being photographed can be a profound emotional experience, because there is often a great urge to be seen in a way that you will like yourself in the final print or slide. Remembering how it feels to be the target can make you a more effective portraitist.

Figure 11. Using the same 4x5 technique in 1949, I shot a series of environmental portraits of photographer Man Ray. At that time he was living in Hollywood, California, and was included within my documentation of artists in the vicinity. Two of his paintings are on the wall, and the floodlight reflector symbolizes his pioneering activities in experimental photography. Since those years (when I was a photography student), I have wondered how different this and other artist portraits might have been, had I used a hand-held 35mm SLR instead of the view camera. Perhaps the feeling of the images would have been similar, but it is a reasonable rationalization that working more deliberately with the 4x5 offered advantages.

Figure 12. Over the years for some subjects I have tried to simulate the slower, more thoughtful technique dictated by the view camera while using 35mm and 2¼x2¼ camera. In one instance, when I visited Yosemite National Park where I had previously shot color slides, I restricted myself to a 2¼x2¼ Bronica and a 135mm lens as a discipline. In the case of figure 12, I used a 35mm SLR with several lenses, posing the model and shooting slowly, to accentuate the sculptural qualities of the figure.

12 *The nude figure is usually challenging when photographed in terms of design.*

13 *Seascape with subtlety of tones, that also avoids conventional picture-postcard composition, is most satisfying artistically.*

Edward Weston's approach to the nude has always been a constructive influence on me. Though he managed to show subtle sensuality in many of his pictures, he concentrated on the figure as an object of pictorial design. Unlike the style of romantic painting, the setting and props had little significance to Weston. The play of light on form was dominant. In many of his images, the model's face is turned or cropped from the composition, to avoid viewer distraction. Emphasis on form and design is to me the most valuable approach to photographing the nude figure.

Landscape, seascape, and cityscape are all popular subjects, in panorama or detail, for personal expression. If one tries to avoid the picture-postcard cliché, the possibilities for aesthetic fulfillment and potential sale of prints or slides are very satisfying.

Experimental Photography

In this category, the sky is the limit. Whatever turns you on in taking pictures or in darkroom manipulation is worth trying. The probability of failure is far less important than the confidence and pleasure acquired from pleasing images that are often surprisingly strong. You have only one "client" to satisfy: yourself. Negatives not printed or prints discarded are a private matter for which you need account to no one. While the professional photographer *must* produce to fill an assignment, the nonprofessional has more freedom. At the same time, the nonprofessional must create his/her own sense of pressure and control to avoid becoming a dilettante.

The examples here are a brief cross-section, and more variety may be found in books and magazines.

Figure 14. De Ann Jennings says, "I used to shoot the external environment, but I found it wasn't working very well for me, so I turned to expressing images of feeling and imagination." This provocative image was taken on 35mm film with a 21mm lens, and the entire roll was solarized by exposing it in the

tank of developer for about 20 seconds after development was three-quarters complete. "I opened the lid of the tank first by accident once," she admits, "and some of the pictures were so exciting, I experimented to standardize the processing." De Ann uses a 150-watt light to flash the film as she revolves the tank. You may try this with part of roll or with sheet film to reduce the risk if you wish.

Figure 15. Todd Walker made this semiabstract photograph using what *Modern Photography* called the "pseu-do-solarization of the Sabattier effect." The magazine's November 1975 issue included an excellent article on Todd's creative techniques with positive and negative images, with gum bichromate, photo-offset, and screen printing. Gum bichromate is a contact-printing process in which a mixture of chemicals and pigments are exposed; the chemicals are washed away, and the pigments remain and can be augmented with additional layers. Todd edits his pictures ruthlessly, and may take a week or two to make one print.

14 *The imagery of De Ann Jennings is involved with inner visions that need not be articulated to be appreciated.*

15 *By Todd Walker whose experiments with Sabattier effect and special photographic processes can be creative inspirations to others in the field of artistic personal expression.*

His silk-screen or serigraph prints begin with a negative or sandwiched color transparencies applied by contact or enlargement to a sensitized screen or tissue. The steps he takes are often complex, and his approach is always meticulous.

In creating Sabattier-effect images, Todd may make high-contrast Kodalith intermediate steps, blending color, line, and halftone areas in the final photograph. He explores and experiments, and as Ed Scully wrote in *Modern Photography*, "The print is finished when Todd feels nothing can be done to make it better."

Todd's patience and research are out-standing in the area of distinctive personal expression. In *Modern Photography* he says, "...the progress of photography in the last 100 years has had to do with expediency rather than quality...." His point of view may be debatable, but the characteristics of his work are plainly admirable.

Figures 16 and 17. The potentials of high-contrast imagery are demonstrated by both of these Kodak/Scholastic Award winners. By printing the negative for figure 16 on 4x5 Kodalith film and contact printing it several times on the same material, Ron Contarsy reduced the scene to black lines and simulated gray tones. In one step he al-

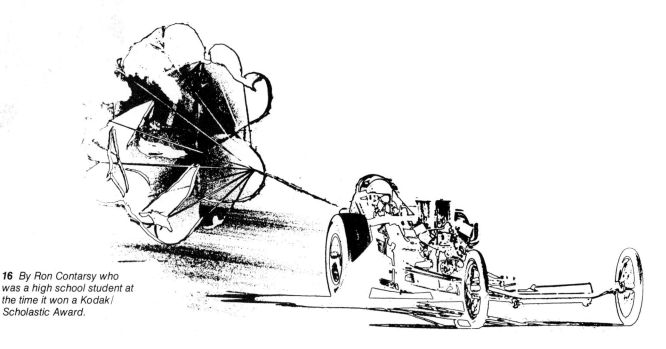

16 *By Ron Contarsy who was a high school student at the time it won a Kodak/ Scholastic Award.*

17 *Debbie Taggert titled her high-contrast scene "Journey's End."*

so flashed the negative for the Sabbatier effect, and increased the contrast on Kodalith afterward.

Debbie Taggart also used Kodalith internegatives for figure 17 to obscure detail in the land form and accentuate the fence. Though it is difficult to avoid all dust marks or pinholes in high-contrast film, if one attempt is not successful, the original negative is always available for further tries.

Figure 18. Mary Beth Hehemann combined two negatives to create this moody picture that won her a Kodak/Scholastic Award. The girl's face stood out against the transparent area in the tree negative. Choice of subjects for multiple printing is partly dictated by their contrast properties to assure individual image distinction.

Figure 19. Camera and subject movement during long exposures are always experimental, because the precise pattern on film is not fully predictable. For this picture my SLR with 135mm lens was mounted on a tripod and aimed at jets landing after the sun had set. The exposure meter indicated one second at f/2.8, so I stopped down to f/4.5 and exposed between two and three seconds while panning the camera along with the plane. Of half a dozen negatives, this offered the best ghostly impression.

18 *Mary Beth Hehemann printed two negatives for a mysterious effect.*

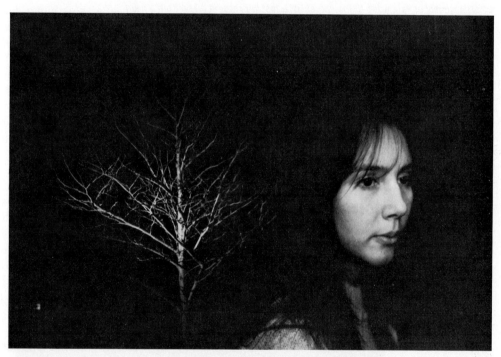

19 *Panning the camera for an exposure of several seconds amplified the impression of a jet about to land.*

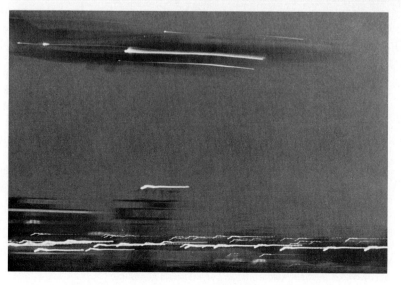

20 *The quality of light adds to the interest of a fast impression taken from a tram touring San Diego's Wild Animal Park.*

21 *Taken quickly like a snapshot, the photograph has a journalistic quality that nicely describes Harvard Square in winter.*

22 *Edwards, Mississippi by Walker Evans whose work has been called a forerunner of the current "snapshot" school of art photography. Taken in the mid-1930s with a view camera.*

Documentary and Jornalistic Subjects

When you shoot a record of any situation, you become a photoreporter for pleasure and the future value of the slides and prints. Attempts to be alert and thorough may result in pictures having more than informational value. Since travel and photography go hand in hand, two examples taken on trips typify the vast panorama of subject matter in this category.

Figure 20. When a scenic picture informs the mind and entertains the eye, it is worth walking or waiting for. In this case I was riding a tram in San Diego's Wild Animal Park, trying to steady an 80–200mm zoom lens as I aimed at passing targets. I shot these deer at the full 200mm and f/4 at 1/500 second on Tri-X moments before sunset. A portion of the negative was enlarged for the pleasant pattern.

Figure 21. While my wife snapped color slides of a snowstorm in Cambridge, Massachusetts, I reported the scene with a compact rangefinder 35mm Konica Auto S-3 which has a 38mm lens. Though it has no lens change options, the compact 35mm RF camera is ideal for casual records of people and places, and negatives or slides provide excellent enlargements. I photographed the passing crowd as well, but the impression I wanted to remember was Barbara ignoring the cold to capture the moment.

In the Snapshot Style

Probably enough has been said earlier in this chapter pertaining to new styles of photography that are stimulating, irritating, or penetrating. I might add only that the reader be consistently suspicious and questioning of the content of pictures and the motivation of their makers. The equivalent of verbal gobbledygook is pictorial pretense. As a hypothetical case, in a photograph of an empty street in flat light, there's part of a person's shadow at the right, and a wicker chair on the distant sidewalk. Give people enough rope, and they'll hang themselves in analysis of "meanings" imagined or assumed, especially

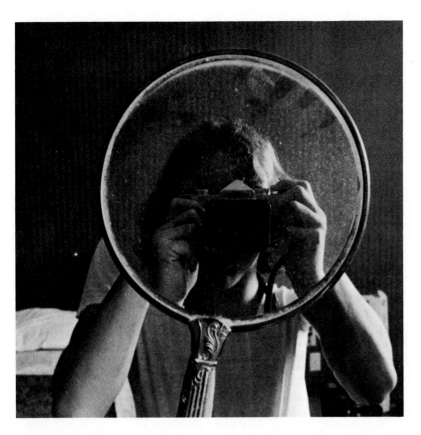

23 *An imaginative snapshot into a small mirror in front of a larger mirror, illuminated by one large electronic flash unit reflected into an umbrella. Taken by Barry Jacobs.*

if the photographer has been called "significant" or avant-guard by one or more critics.

In further support of my apprehension of humbug being passed off as meaningful, here are some words from the *Los Angeles Times* art critic William Wilson reviewing a group photography show that shall remain anonymous. Said Wilson, "The exhibition is in part a memorial to pioneer photographer Walker Evans who is represented by 20 images. He has introduced leitmotifs for excellence that are easier said than done—directness and surprise.

"Today Evans' pictures appear both formally composed and romantic. They are, however, sufficiently unstudied to qualify him as a forerunner of a current 'snapshot' school of art photographers who take their audience unawares because at first glance their imagery looks like something we might encounter in an old-fashioned photo album. All the elements of 'bad' photography—dull subjects, poor focus, awkward angles, and weird light—are combined with the unexpected formal or psychological factors that give the best of them the resonating ping of haiku verse."

Wilson then discusses some of the individual photographs in terms of "artificiality," "weariness with art," "slice-of-life pictures," "stylistic elements from Diane Arbus," "keen black humor," "sarcasm" "nostalgia-kitsch," "planned mistake of moving the camera," and "funky tangles."

This able critic's aim was *not* the same as mine in quoting from his review, but his point of view and vocabulary are graphic and symbolic. In my opinion the elements of "bad" photography remain dull, awkward, and contrived most of the time. Walker Evans just *might* have been a forerunner of the snapshot school, based on looking again at many pictures in *American Photographs* published by the Museum of Modern Art in 1938. However, Evans' images show substance, empathy, and brilliant geometry of composition that recent snapshot practitioners cannot match. (You may not find *American Photographs*, but look for Walker Evans' work in *In This Proud Land* by Roy Stryker and Nancy Wood, published by the New York Graphic Society in 1973. The book contains the best of the Farm Security Administration's monumental photographic reportage.)

Miscellany

No photographic topic engenders more visual and verbal excitement than personal expression which may be

in the purist tradition

with emphasis on abstract design

surreal

manipulated images in the darkroom or camera

romantic

trivial

a combination of the above

It is true, as I once read, that "significant communication is never dependent on technical perfection." It is also true that images of lasting value must have substance and integrity.

I would hope that some aspects of this chapter stir conversation and maybe controversy. For many readers, personal expression is what photography is all about.

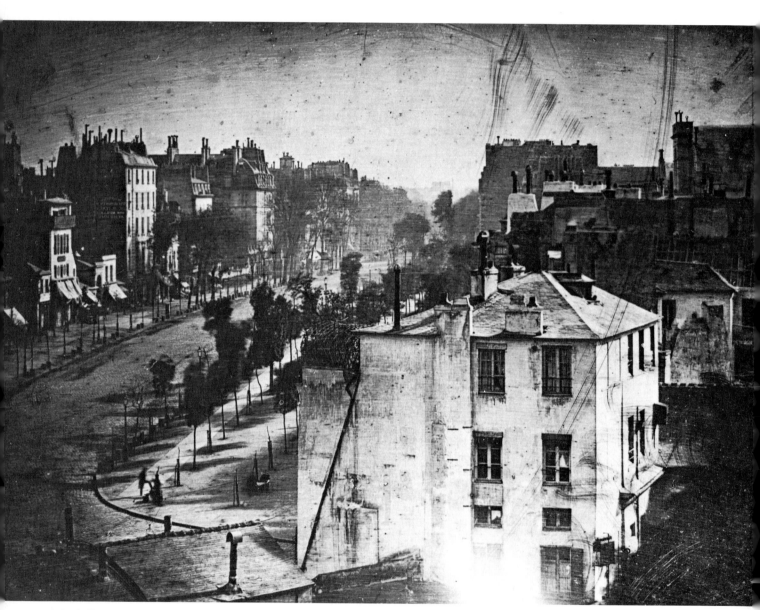

1 *Louis Daguerre's image of a Paris boulevard made in 1839 is among photography's historic firsts. From George Eastman House Collection.*

MILESTONES IN PHOTOGRAPHY

For hundreds of years before a photographic image was developed on paper or metal, the principle of the *camera obscura* was known. The term refers to a lighttight box or a room with a small hole or aperture on one side through which light rays pass to project an image on the opposite side, upside down, backwards, and in color. *Camera* comes from the Latin word for "room" or "chamber"; *obscura* is Latin from the Middle English *obscur*, meaning "dark" or "lacking in illumination." Artists used camera obscura images from which to draw realistically; for entertainment, large rooms have been built so the passing parade outdoors could be seen on a wall like a soft-edged movie. In the sixteenth century an Italian scientist devised a way to use lenses and mirrors for a right-side-up image. Plays he had staged outside the camera obscura made viewers think magic was involved.

Over the years, experiments in optics and chemistry by various European researchers lead the way to discoveries about the effects of light on silver salts treated with ammonia fumes. By 1816 Joseph Niepce had worked out a way of coating paper and exposing it in a camera, and by 1822, he learned to coat glass plates. In 1826, when his experiments turned more successful, Niepce made the world's first permanent camera image from a window of his home. This fuzzy exposure is supposed to have taken six or eight hours.

About this time Niepce joined forces with a painter from Paris named Louis Daguerre who had also been working on capturing photgraphic images. Daguerre found promise in his tests of silver iodide, but Niepce had little faith in this compound, and when he died in 1833, his son Isidore continued experimenting with his father's partner. By 1835 Daguerre discovered that mercury vapor would develop an image on an iodized silver plate exposed rather briefly to light. He took many pictures during this time, one of which remains, dated 1837. By 1839 Daguerre had perfected his methods well enough to make time exposures of five minutes and longer, though portraits were not yet possible. Even so, an 1839 daquerreotype titled "Paris Boulevard" (figure 1) includes the tiny figure of a man having his shoes shined. The man held fairly still for the whole exposure, but the person shining his shoes is a blur, and passing traffic in motion was never recorded.

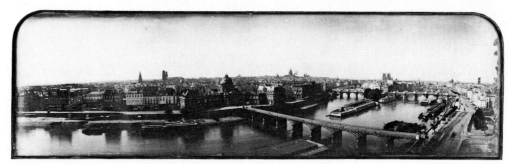

2 *Daguerreotype by Friedrich von Martens, Panorama of Paris, 1846. From George Eastman House Collection.*

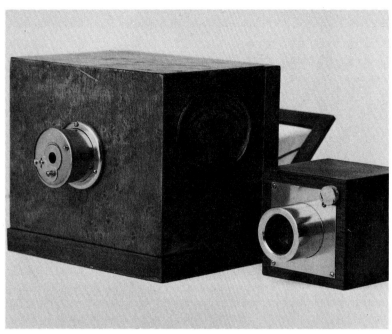

3 *Authentic scale models by Gerald Smith of original Daguerre* (left) *and Fox Talbot cameras. From Greer H. Lile Collection.*

4 *French plate camera using 3x4-inch glass plate, about 1850; shutter rotated within the sphere behind the lens. From Greer H. Lile Collection.*

Several French scientists supported Daguerre by helping to pass a bill giving him and Isidore pensions for life, and Daguerre's process was announced publicly in August 1839. Word spread in Europe and to the United States, causing excitement and confusion. Though Daguerre had patented his invention in England just before it was made public, variations on his theme were impossible to protect. In England, a man named William Henry Fox Talbot claimed that the daguerreotype infringed on his own process, but his work was with paper images and somewhat limited in scope. Fox Talbot pulled some tricks with an English chemist named Herschel who had discovered the use of hypo to fix photographic images. Eventually, all the technology of photography became known through printed information and visitors to the inventors.

PHOTOGRAPHY IN ITS INFANCY

Research with paper and metal backing for photochemicals, and with improved camera types and lenses, moved through the next several decades, and photography for portraits far surpassed painting. Fox Talbot worked on a paper negative process called the *calotype* by which copy prints could be made, but their detail and tonality could not match the clarity of daguerreotypes. The latter were easily damaged, and the image was reversed and difficult to duplicate. However, daguerreotype portrait galleries were operated in New York in the 1840s, and before the Civil War many cities and towns across America had similar studios. Sitting with your head in a brace during an exposure of several minutes was a handicap, but there was no other method of having a photograph made, so daguerreotype portraits were immediately popular.

The calotype process was also used commercially in the 1840s by photographers such as David Octavius Hill and Robert Adamson in whose outdoor studio hundreds of people were pho-

5 *"Portrait of a Minister" by Hill and Adamson, calotype, about 1845. From George Eastman House Collection.*

tographed, including an anonymous minister (figure 4) taken around 1845. This process was also slow, but seemed remarkable to those who flocked to studios for tedious sittings.

The glass plate. In 1847 a cousin of Niepce devised a means of sensitizing glass plates with a mixture of silver iodide and foamy egg white (albumen), which after long exposures produced much sharper negatives than paper calotypes. This invention was considerably improved by an Englishman named Frederick Scott Archer around 1851 when he substituted *collodion*, a gummy chemical mixture, for albumen. Scott's process required coating the glass and immediately exposing it in the camera, and became known as "wet

plate" photography. Fox Talbot claimed he had a patent on the wet plate (he was an unscrupulous operator who tried to claim many photographic advances for himself), and it was not until the end of 1854 that the courts said Fox Talbot's scheme was phony. Fred Archer, who published his process without restrictions, died poor in 1857, after a Bostonian named Ambrose actually patented the wet plate and called it the *ambrotype*.

From 1855 to about 1870, the ambrotype was a popular photographic process in America. Like the daguerreotype, the ambrotype was made on a "wholeplate" about 6½x8½ inches which was usually reduced to 1/6 plates, 2¾x3¼ inches. The ambrotype was fragile glass and had to be covered with another sheet of glass and protected in a case. The negative was backed with dark paper, or the back of the glass was blackened with dark varnish, so the image appeared positive. Ambrotypes were less expensive than daguerreotypes, and photo studios used them extensively, though they were one of a kind like daguerreotypes.

The tintype. Another version of the collodion process used a metal plate instead of glass, and was known as the *tintype*. These were cheaper than ambrotypes, and because the coating was very thin, they could be processed quickly so that portraits could be delivered while the sitter waited. Tintypes were not easily damaged, and though their images on the dark metal background were not as good as on glass, they largely replaced the daguerreotype by 1860. Despite the fact that chemicals were sensitive to light only while they were tacky, traveling photographers and cut-rate portrait studios made tintypes by the thousands. However, only the most industrious amateur photographers took the time and trouble.

Cartes-de-visite. By the late 1850s a method was devised to make positive prints on paper sensitized by the photographer from developed collodion negatives. These small contact prints

PHOTOGRAPHY'S MIDDLE YEARS

Some of the most publicized photographs of the nineteenth century were taken by Matthew Brady and his associates. Brady had been a student of Samuel F. B. Morse, remembered as the inventor of the telegraph, who was also an early daguerreotypist and studio owner. Before the Civil War, Brady had a prosperous studio of his own on Broadway in New York where Abraham Lincoln and other notables sat for their portraits. When the war began in 1861, Brady felt a challenge to document it for history. He gathered a staff of men, outfitted them with horse-drawn "darkrooms" where glass plates were coated just prior to exposure, and sent them to the battlefields. Brady financed the entire operation, hoping to sell the pictures later, but after the war, people did not want to be reminded of its realities. Though Brady's photographs were reproduced as engravings, his efforts resulted in poverty by the time of his death in 1896.

"Photojournalism" Is Born

Though Matthew Brady and his crew demonstrated the great possibilities of photography as a social and documentary medium, "news" photographs were taken earlier. Figure 8 is an example. Notice that traffic in the street is fairly sharp, because the camera shutter operating at 1/50 second was available along with more sensitive wet plates. This shot of Broadway around 1860 shows how much photography had advanced a mere two decades after Daguerre gave the medium its start.

Around 1864 another improvement, the dry plate, gave photography a further boost. Glass plates were collodion-coated and dried, so photographers could expose them later. At

6 *Cartes-de-visite viewer of 1880 held 48 photos that were changed by rotating the entire viewer in a flip-flop manner. From Greer H. Lile Collection.*

measured 2½x4¼ inches, and were usually made eight to a glass plate using a camera with several lenses. Prints were later cut into individual pictures that were mounted on cardboard and called *cartes-de-visite* by the French photographers who first made them popular. Millions of these were made into the 1880s, because they were relatively cheap and could be duplicated. Portraits of famous people were printed in quantity and sold as souveniers to the public. Prints were usually sepia toned, and families mounted them in albums or displayed them in stands with rotating frames, such as that shown in figure 6.

7 *President Lincoln and General McClellan on the battlefield at Antietam, 1862; by Alexander Gardner, an associate of Matthew Brady. From George Eastman House Collection.*

8 *A view of Broadway in New York by E. & H. T. Anthony, about 1860, is one-half of a stereographic pair. From George Eastman House Collection.*

7

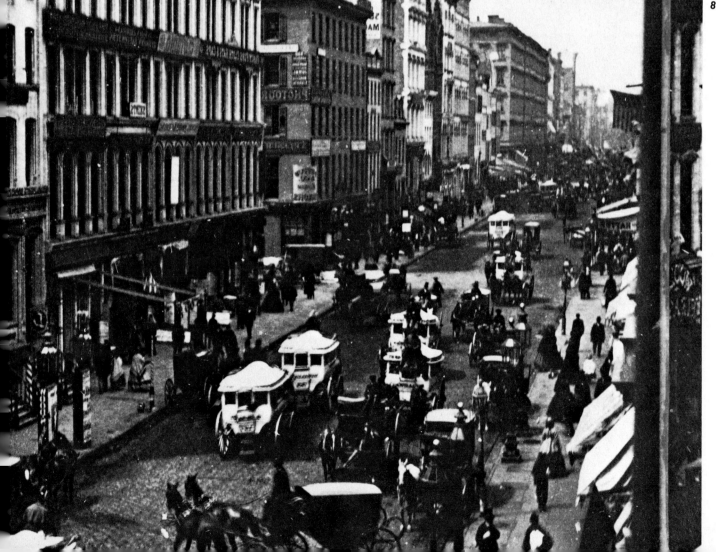

8

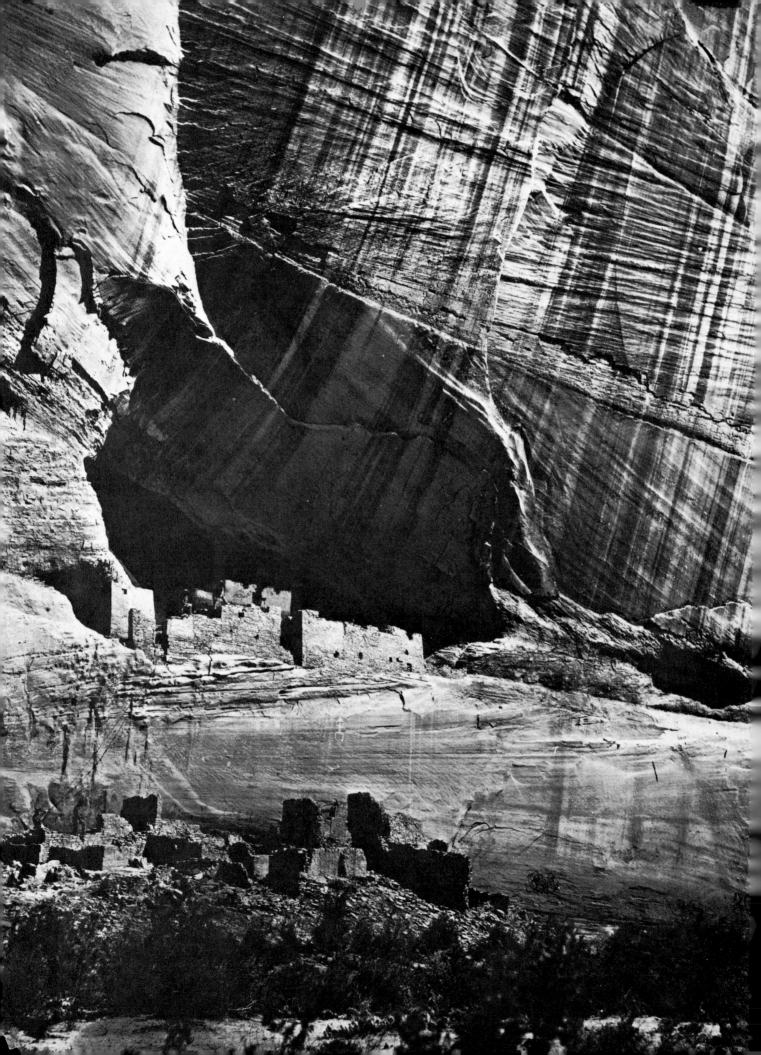

9 *Exquisite detail from an 8x10 contact print was possible more than a century ago. William Henry Jackson photographed the ruins of the White House in Canyon de Chelly, Arizona in 1873. George Eastman House Collection.*

first the process of dry plates was terribly slow, and it was not until a gelatin emulsion (which has been refined into modern film) was invented, that the dry plate process began to dominate the scene. Now you could buy ready-packaged glass plates (supersensitive to blue and insensitive to reds), expose them out in the field, and develop them on returning from a trip. However, until nearly the end of the century, few people saw the work of remarkable photographers (such as William Henry Jackson mentioned below), because there was no practical way of printing photographs in newspapers or magazines. News pictures were turned over to a woodblock engraver who copied them for use on printing presses.

Photo explorers. Despite the handicap that original photographs could not be reproduced in halftones until the 1900s, a number of men who had worked with Matthew Brady began exploring the world with their cameras. Among these were Alexander Gardner and T. H. O'Sullivan, whose names are found on many Civil War photographs. After the war, Gardner followed the transcontinental railroad builders into Kansas, and O'Sullivan joined a government surveying expedition to photograph the West.

Around 1870 William Henry Jackson set out from Omaha with a wagon train bound for Montana. His father had introduced him to photography via daguerreotypes, and Jackson eventually had his own horse-drawn darkroom from which he took pictures of Indians, prairies, mountains, and especially the Yellowstone area before it was declared a national park. He was employed by the U.S. Geological Survey, and spent many years shooting marvelous landscapes, often with huge plate cameras. His pictures inspired Congress to establish Yellowstone as the first national park in 1872. The amazing Jackson traveled widely in America, and eventually settled in Detroit where he set up a company selling picture postcards from his own negatives. He died in 1942, lived to be over 90, and his life and work create a true photographic bridge from the nineteenth century into the modern era.

Other Early and Noted Photographers

Photographic history is colorful with men, and a few women, whose images set precedents for technical and creative progress. Here are only a few:

Julia Margaret Cameron. An eccentric, strong-willed lady who came to England from India with her husband in 1848, Julia Margaret Cameron was 45 years old in 1860 when she recieved a camera as a gift. Since her friends included celebrities such as Tennyson, Browning, and Rossetti, she began making portraits of them and many other people, posing them for visual effects she found pleasing. A glassed-in chicken house became her studio, and a coal storage bin her darkroom. Viewed as a whole, her work covers a fine cross-section of Victorian society including the local butcher, fishermen, and laundry maid. In 1974 an album of 119 pictures she had made up for her sister Mia was auctioned in London for just under $100,000. It was reproduced by Da Capo Press as *A Victorian Album* in 1975.

10 *Alfred, Lord Tennyson photographed in 1869 by Julia Margaret Cameron. From the Alfred Stieglitz Collection, Art Institute of Chicago.*

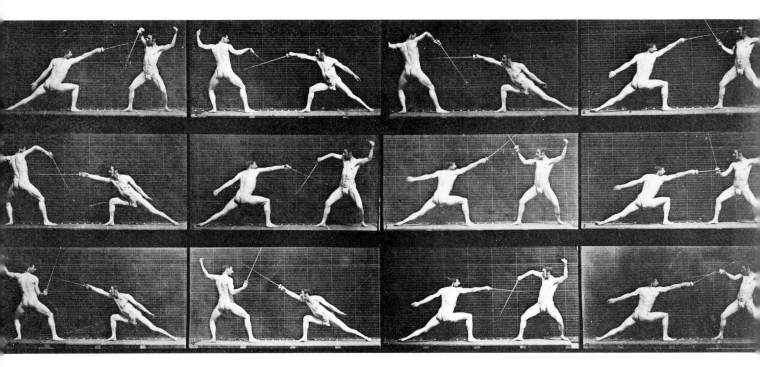

11 Fencers photographed by Eadweard Muybridge in 1885 as part of his continuing study of humans and animals in action. From George Eastman House Collection.

Eadweard Muybridge. A professional photographer, Muybridge was hired in 1872 by railroad tycoon Leland Stanford to help win a bet that a racehorse lifts all four feet from the ground simultaneously while galloping. Using an array of 12 cameras fired in rapid sequence by trip wires, Muybridge proved Stanford right, and went on in later years to refine sequence photography. His motion studies (such as figure 11) of people and animals are famous, and his work influenced others including painter Thomas Eakins who devised a camera to make multiple exposures of moving figures on one plate.

P. H. Emerson. This Englishman influenced style on both sides of the Atlantic. In 1889 Peter Henry Emerson wrote a book proclaiming that soft-focus photography best represented natural vision, and soft-focus prints were the finest art except for painting. Two years later Emerson switched his views, saying, "If the work is for scientific purposes, work sharply, if for amusement please yourself, if for business do what will pay." The man was also influential as a critic and judge of contests, and seems to have turned on Alfred Stieglitz to champion both sharp- and soft-focus photography in the beginning of his career. Emerson's philosophy was an inspiration to Stieglitz in his efforts to establish photography as a fine art.

George Eastman's Roll Film

When photography was about half a century old, it was still a cumbersome process practiced mostly by professionals. Around 1877, George Eastman, a young bank clerk in Rochester, New York, decided that the demands of picture-taking were too annoying for his taste. Working at night in his mother's kitchen, he began to experiment with making dry plates, and from his efforts came an idea for a machine to coat the glass. In 1880 he resigned from the bank and with a businessman named Strong started a company to sell dry plates.

Eastman's research continued until in 1884 he announced success in coating rolls of paper with gelatin emulsion. He also invented a roll holder that adapted to plate cameras, and went on to manufacture a simple box camera he called the Kodak. It was priced at $25 loaded with enough film for 100 exposures, and it could be hand-held. Camera and film were returned to Rochester for development, and new film was

loaded for $10. "You push the button, we do the rest" was the slogan that accompanied Eastman's 1888 Kodak. Later when nitrocellulose replaced paper, roll film and a continuing series of Kodak camera models made everyman a snapshooter.

In 1896 the 100,000th Kodak camera was manufactured, and the next year a Pocket Kodak was on sale for $5.00. The use of dry plates by photographers using larger cameras continued into the 1920s, but the hand-held Kodak helped launch a cornucopia of equipment beyond George Eastman's wildest dreams.

COMING OF AGE IN THE TWENTIETH CENTURY

It is apparent that photographic style and technology developed concurrently; a process of record-making became an art and a means of expression. Modern-day printing papers, coated with gelatin and varying in weight and surface colors, were first introduced back in the 1890s. The earliest papers often have a "bronzed" metallic silver look today. As time passed, emulsions were made more sensitive to light, and in conjunction with roll films, smaller cameras, and better lenses, photography flourished as both a hobby and a profession.

The Stieglitz Influence

Alfred Stieglitz did as much as any one individual to give photography stature and to encourage other artists such as Edward Steichen. Stieglitz became intrigued with photography while studying engineering in Berlin, after which he gave up his academic life and spent a number of years traveling and taking pictures. When he returned to his home in New York about 1890, he was renowned as an exhibitor, and began publishing a quarterly called *Camera Notes*. In 1903 he began editing and publishing another quarterly called *Camera Work* which promoted photography as a serious art, and also devoted many pages to the reproduction of paintings and drawings by artists who had formed a group called Photo-Secession. Stieglitz's headquarters was

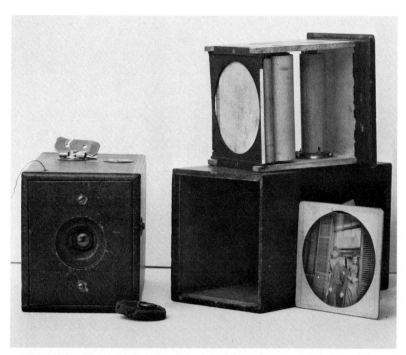

12 *George Eastman's first Kodak roll-film camera of 1888, closed (left) and open, with typical oval print. From Greer H. Lile Collection.*

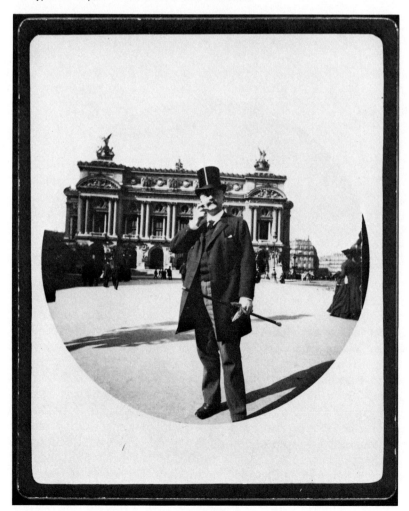

13 *A print of Paul Nadar in the Place de L'Opera, Paris, 1890, taken by George Eastman with his original Kodak. From George Eastman House Collection.*

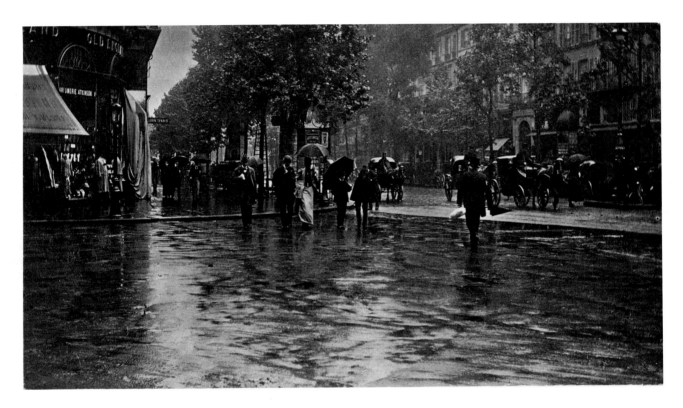

14 *Paris in 1894 as captured by Alfred Stieglitz made fine art of photojournalism long before the 35mm camera was invented. Used with permission of Georgia O'Keeffe.*

a small gallery at 291 Fifth Avenue, known simply as 291, where pace-setting photographers such as Steichen, Paul Strand, Clarence White, and Gertrude Käsebier mingled with painters such as John Marin, Georgia O'Keefe (who later married Stieglitz), and Marsden Hartley. *Camera Work* also featured Picasso, Matisse, Braque, and many Post Impressionists whose reputations were beginning to grow.

Stieglitz championed both soft, painterly photographs, and the straight documentary style in his own work and that of others. He was an experimenter who over a period of years shot a large series of cloud pictures he called "equivalents" in which he tried to show that emotion and excitement were not exclusive to images of people or buildings. While *Camera Work* was discontinued in 1917 (and was excerpted as a book published by Aperture in 1974), Stieglitz's activities ranged through the twenties and thirties, and his influence has been felt since his death in 1946. He was a strong, controversial man, with the eye of an artist and the heart of a fighter. Get to know his work and the work of painters and photographers he helped to establish.

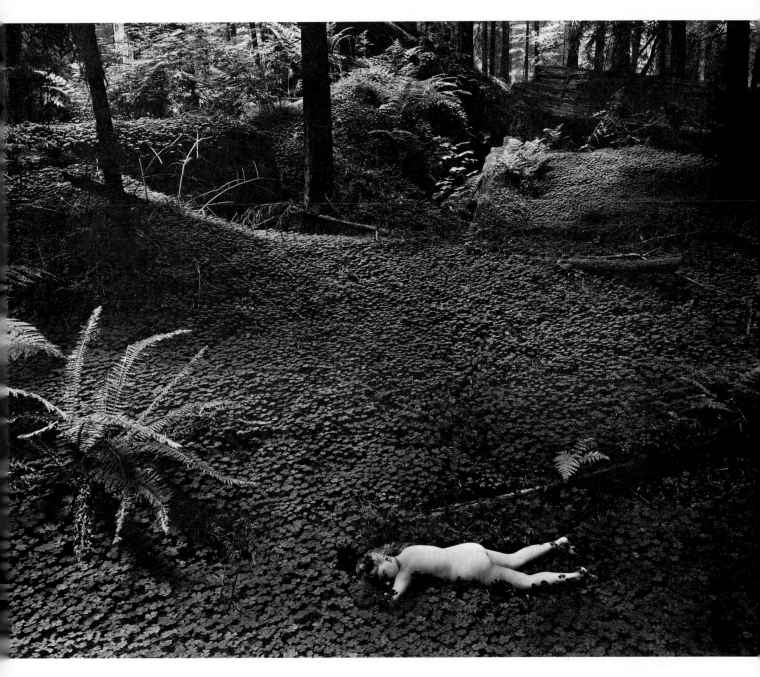

15 *"Child in Forest," 1951 by Wynn Bullock is one of the most memorable images from "The Family of Man" exhibition organized by Edward Steichen.*

Edward Steichen. As a protégé of Stieglitz, Steichen became a photo-reporter, a pictorialist, an army photographer in World War I, a fashion photographer for *Vanity Fair* and *Vogue*, a highly paid advertising and portrait specialist and the director of navy photographers in the South Pacific during World War II. Later, as head of the Museum of Modern Art's department of photography, Steichen organized *the* outstanding photo exhibit of our times, "The Family of Man." All 503 pictures are included in a paperback book of the same title, which is still available and still a viable collection for study.

Speaking at an ASMP/UC Photojournalism Conference in 1961 (which I helped organize), Edward Steichen said, "The difference between painting and photography is purely technical. Everything you see, feel, and sense comes together in photography. Instincts and intuition are united." Photographers should be aware of the social sciences, he continued, and universities should emphasize photography as they do the other arts. "We must stand with the psychiatrist and sociologist in carrying on the explanation of man to himself."

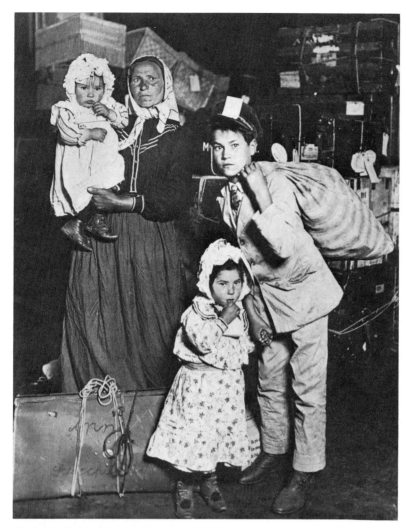

16 *"Italian Family Seeking Lost Baggage," Ellis Island, 1905 by Lewis W. Hine. From George Eastman House Collection.*

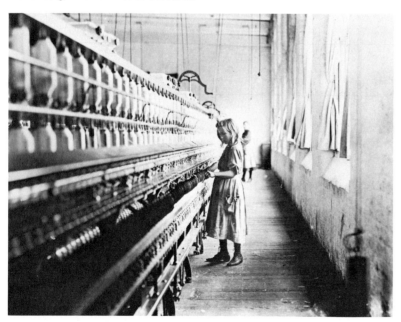

17 *"Little Spinner in Carolina Cotton Mill," 1909 by Lewis W. Hine. From George Eastman House Collection.*

The Documentarians

While some were arguing photography's standing as an art, others were making social statements that demonstrated the medium's power to inform and persuade. Among these were:

Jacob Riis. As a police reporter in New York in 1890, Riis saw the seamy side of life in the slums and wrote a book, *How the Other Half Lives* in which were a number of reproductions of his fact-finding photographs. He was one of the first to use flash powder. His pictures of tenement and alley life, gangs, sweatshops, and street scenes made enough waves to initiate reforms during which tenements were torn down and child-labor laws were strengthened. Not only were his pictures strong social statements, but many are handsome images of late-nineteenth-century life.

Lewis Hine. Hine was a sociologist who also learned to use a camera to document injustice which he found in the early 1900s. Hine's photographs of Ellis Island immigrants have become famous (figure 16), and his exposés of child labor (figure 17) and the living conditions of miners and mill workers shocked magazine readers around 1909. After World War I he spent years taking pictures of men at work, and was official photographer during the construction of the Empire State Building. (He climbed around high girders lugging a 4x5 camera!) In the late 1920s Hine supplied photographs of social conditions to Roy Stryker, who was then teaching at Columbia University, and later became photographic head of the Farm Security Administration (see below). Of this relationship, Nancy Wood wrote in *In This Proud Land*, "Perhaps no other person had so much influence on Stryker as this aging documentary photographer, who would arrive at Columbia with armloads of pictures taken twenty years earlier. Ten years later the direction in which Stryker would aim his photographers was often reminiscent of the Hine approach."

18 *"Girl in Doorway of Brothel," Paris, about 1920 by Eugene Atget. From George Eastman House Collection.*

19 *Reflections in a Parisian shop window by Eugene Atget about 1910 was a kind of photosurrealism admired by Atget's painter friends. From George Eastman House Collection.*

Eugène Atget. The streets of Paris became this Frenchman's photographic obsession at the turn of the century. With a heavy view camera he captured images of Paris streets and people with innate artistic skill which make the name Atget synonymous with artistic documentation. This is exemplified in figure 18 of the proud prostitute showing off her fur neckpiece, high boots, and short skirt at the doorway of a brothel. Atget ran a kind of stock photography business supplying prints for artists, especially Surrealists who admired his pictures of incongruous subjects related by the camera (figure 19). Another photographer, Berenice Abbott, rescued several thousand of Atget's negatives shortly after his death in 1927, and helped to establish the international recognition that Atget lacked while alive.

The FSA Legacy

In 1935 Roy Stryker organized a photographic project for the Farm Security Administration (FSA), the goal of which was to document the depression and people of the drought-stricken dustbowl. He gathered a unique staff including Dorothea Lange, Walker Evans, Ben Shahn, Arthur Rothstein, John Vachon, Carl Mydans, and Russell Lee. Stryker was not a photographer, but functioned brilliantly as a critic and "instigator," who indoctrinated his staff to shoot straight, insightful, unmanipulated pictures. Over an eight-year period, FSA photographers produced a body of work that influenced photojournalism and moved viewers through newspapers, magazines, books, and exhibitions.

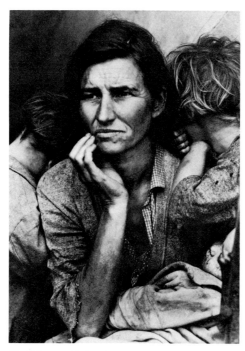

20 *"Migrant Mother," by Dorothea Lange, an FSA classic. From Library of Congress Collection.*

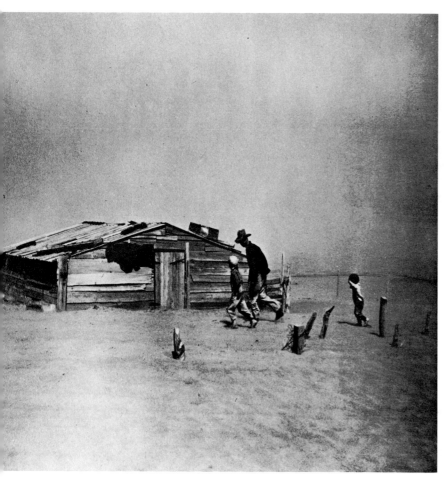

21 *Another classic from the dustbowl of Oklahoma, by Arthur Rothstein. From Library of Congress Collection.*

Figure 20. "Migrant Mother" by Dorothea Lange is a trademark of the FSA's documentation of that third of Americans who according to President Roosevelt were "ill housed, ill clothed, and ill fed." Lange's photographs of suffering Okies helped inspire John Steinbeck's novel, *Grapes of Wrath.*

Figure 21. Another classic of the FSA years is "Farmer and Sons" by Arthur Rothstein taken during an Oklahoma dust storm in 1936. Rothstein went on to become *Look's* chief photographer, and was an editor at *Parade* in 1976.

Figure 22. Walker Evans, mentioned in chapter 15, used a view camera for much of his FSA reportage to show American homes and cities with a clarity reminiscent of Edward Weston and Eugène Atget.

John Vachon became a *Look* staffer, and Carl Mydans was one of *Life's* first photographers. Gordon Parks got his start with Stryker as well, and went with him to work for Standard Oil of New Jersey, helping to create a vast photo file. Stryker also called upon ex-FSA colleagues to document the city of Pittsburgh, Pennsylvania, in the 1950s.

Nature's Realists

Much has been said previously in this book about Edward Weston. His work and writings have been published in a number of books listed at the end of this one. He started taking portraits in a modest suburban Los Angeles studio about 1911, and began submitting prints to exhibitions, then called salons. Working for clients distressed Weston, but he stuck with it until the twenties, when he took off for Mexico where he concentrated on photography with an 8x10 view camera. In the thirties he settled near Carmel, California near Point Lobos, which became a favorite photographic challenge. From that time on he was dedicated to sharp, brilliant negative and print-making. He traversed California and the West occasionally, and across the country once to illustrate

22 *Washroom and kitchen of a cabin in Hale County, Alabama, 1935, by FSA photographer Walker Evans, probably with an 8x10 view camera. From Library of Congress Collection.* ▶

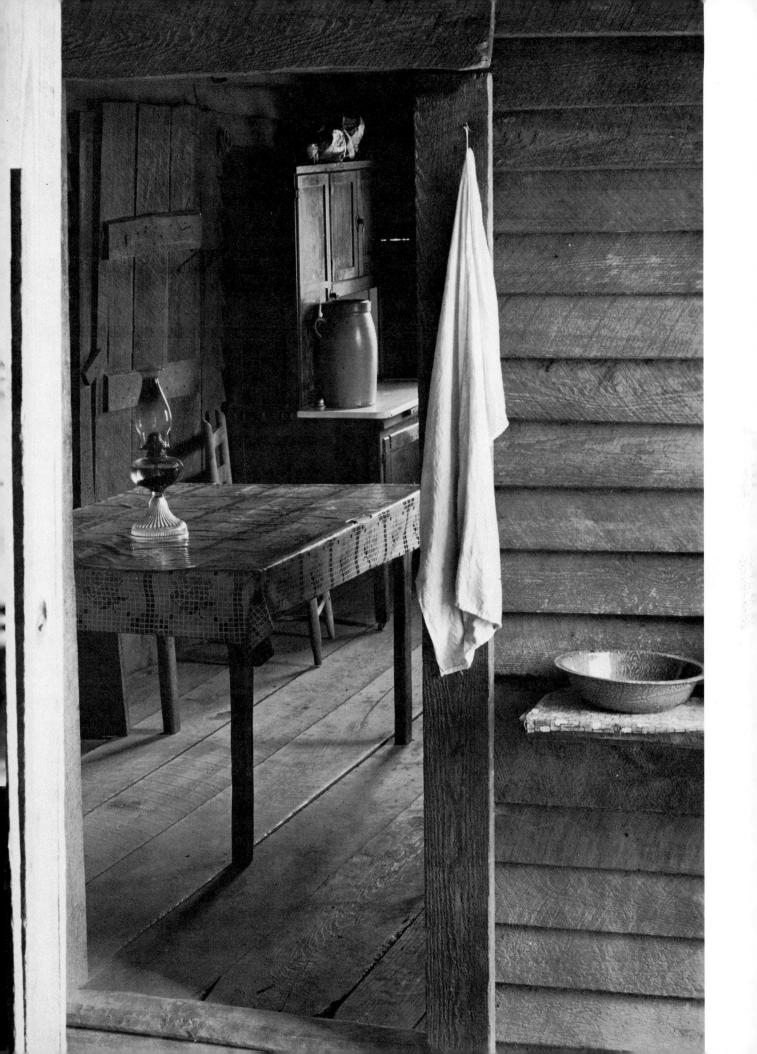

23 *China Cove at Pt. Lobos, California, 1940, by Edward Weston.*

Leaves of Grass published by Limited Editions books in 1940, and not generally available until Two Continents Publishing Group in New York republished it in 1976. About 1947 Weston did the last of his photography when Willard Van Dyke made a motion picture of him at work, called *The Photographer.* From then until his death in 1958 Weston suffered from Parkinson's disease, but was always an inspiration to his friends and his photographer sons, Brett and Cole.

Figure 23. Taken at the edge of China Cove, part of Point Lobos, this beautiful scene with its subtle specular highlights of kelp in the foreground always intrigued me. "The kelp only looked like that for 20 or 30 seconds," Edward once explained when I questioned him. "I waited and watched for it." This was taken in 1940.

Figure 24. The influence of Weston's nude photography has been mentioned earlier. To him the figure became an element of design within the composition. This was taken on the doorstep of his Wildcat Hill cabin in 1936. Edward also photographed dozens of cats—with an 8x10 view camera!—on the same premises, and those pictures also became a book.

In 1932 Weston helped form a small group called "f64" that included Ansel Adams and Imogen Cunningham. Adams had been exhibited at Stieglitz's 291 gallery, and his marvelous black-and-white images have enchanted a wide audience. His books, *The Print* and *The Negative* expound Adams's technical brilliance, and in 1974 a huge retrospective of his pictures was published by the New York Graphic Society.

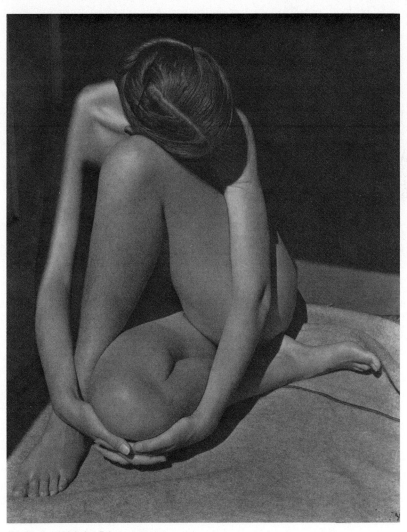

24 *Nude, 1936, by Edward Weston.*

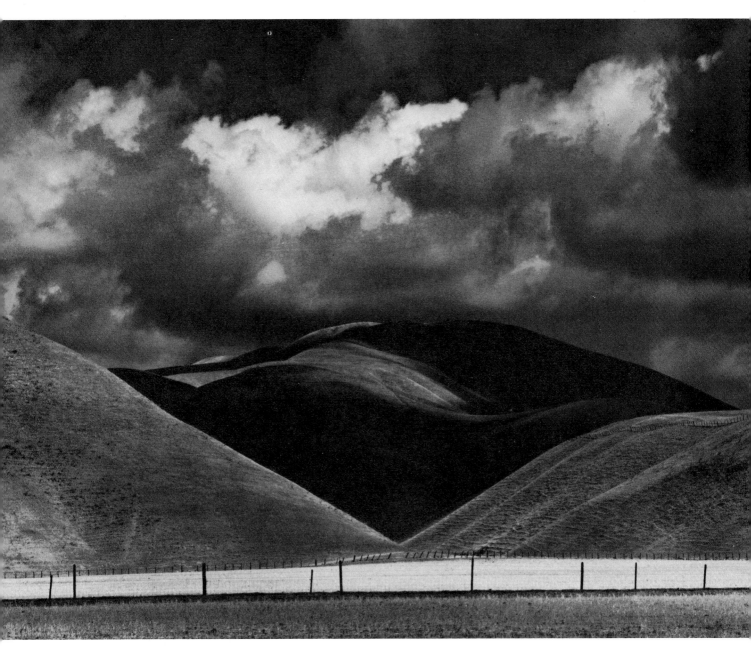

25 *Farm in Monterey County, California, by Steve Crouch.*

A number of other men in the Carmel, California area have also been outstanding interpreters of nature including Steve Crouch (some of whose photographs have been included in previous chapters) and Wynn Bullock. Wynn had been a musician (as had Ansel Adams) who turned to creative and experimental photography. He once received a patent for a method to control the solarization process. I've chosen his "Girl On Beach" made in 1968 to be the final image in this chapter and book.

From the Bauhaus

In the twenties and thirties the Bauhaus in Germany was a fine school for artists and designers who valued the camera for its contribution to the visual arts. From the Bauhaus came furniture, typography, and the influence of a teacher named Laszlo Moholy-Nagy who came to the United States in 1937 and was director of the Institute of Design in Chicago. Moholy-Nagy stressed the abstract in photography, as shown in figure 26, "Stairwell in the Bexhill Seaside Pavilion, 1936." Though this style

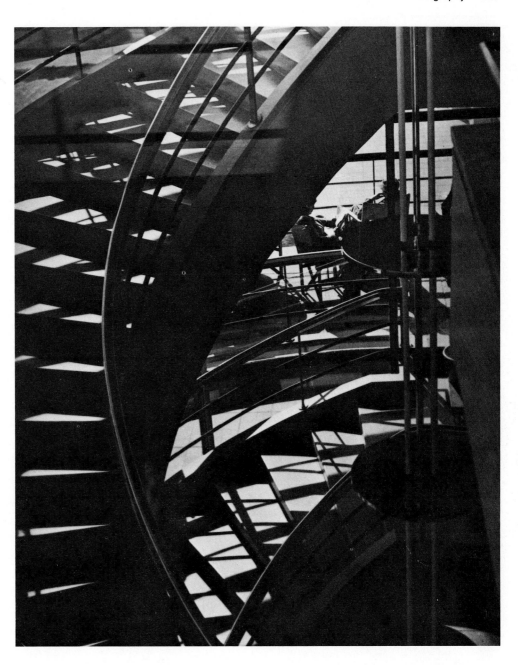

26 *Stairway in the Bexhill Seaside Pavilion, 1936, by Lazlo Moholy-Nagy. From George Eastman House Collection.*

may not seem revolutionary today, in its time it seemed a new vision, related to Weston or Steichen in its directness, but with a distinct Bauhaus style.

MODERN TIMES

It is generally conceded that Oskar Barnack's invention of the 35mm camera, placed on the market as the Leica in 1925, began the revolution in photography that gave us modern photojournalism. Dr. Erich Salomon, discussed in chapter 14, had few imitators at the

time, but since the late twenties "miniature" cameras have helped professionals and amateurs to see the world unposed and often unnoticed. The Leica, and soon after the Contax, were popular, when picture magazines in Germany were shut down by the Nazis, causing men such as Salomon, Alfred Eisenstaedt, and Philippe Halsman to become part of the American publishing scene.

It was no coincidence that *Life* and *Look* were founded in 1936, as were Pix and Black Star, both pioneering picture agencies started by German refugees.

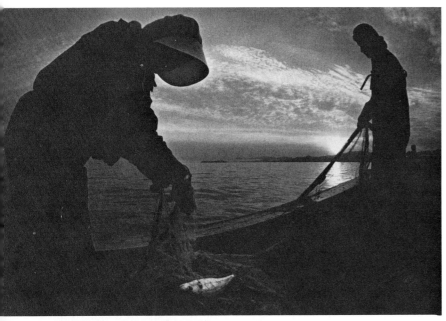

Photojournalism became a major means of communication during World War II when many notable photographers contributed to visual history. Included were Robert Capa (whose coverage of the Spanish Civil War had earlier shown his stature), W. Eugene Smith, and Margaret Bourke-White. Even before the war, and in its aftermath, Henri Cartier-Bresson was capturing the "decisive moment," as he called his first book, using a Leica in ways that have influenced many younger men and women.

David Douglas Duncan's stark coverage of the Korean War in 1952 established his reputation. In later years, photographers such as Richard Avedon, Art Kane, Ernst Haas, Cornell Capa, David Seymour, Warner Bischof,

27 *Fishermen by W. Eugene Smith from* Minamata.

28 *Painter Piet Mondrian posed in his own geometric style by Arnold Newman, 1942.* © *Arnold Newman 1976.*

29 *Igor Stravinsky photographed in 1946 by Arnold Newman.* © *Arnold Newman 1976.*

Bill Brandt, Irving Penn, Gjon Mili, Wayne Miller, Will Connell, Bert Stern, and many others (listed below) helped shape the character of modern photojournalism, advertising, and pictorial expression worldwide.

Figures 28 and 29. Representative of the integration of photography as a communicative art are these two classic environmental portraits by Arnold Newman. Painter Piet Mondrian in figure 28 was posed in the geometric style of design which has had great impact in the world of advertising and graphic arts. Igor Stravinsky in figure 29 is framed by the piano in an unforgettable composition. Both pictures were made with a 4x5 view camera. More of Arnold Newman's work can be found in his book *One Mind's Eye* (Godine 1974).

In Technology

As always, technical advances have stimulated accomplishments in every phase of photography, and after World War II the photographic industry bloomed. Films became faster, less grainy, and more reliable. Variable-contrast papers made darkroom creativity easier. But developments in camera and optics have given the greatest boost to photographers.

In the early forties the Japanese were cut off from German glass production, and began developing their own optical-glass technology, devising new lens formulas for inexpensive cameras. Taking strides for which they have become famous in other fields, the Japanese first copied German cameras, and then surpassed them. Especially, in the single-lens reflex category, Japanese camera manufacturers were ingenious and skilled. After David Douglas Duncan brought some of the first Nikon lenses to America in the early fifties, there followed a proliferation of designs and models of SLR cameras and lenses that continues to this day. Asahi introduced the first instant-return SLR mirror. Other companies incorporated exposure meters, invented automation, and redesigned photographic optics to be lighter in weight, sharper, and more versatile. Auto-exposure electronic flash units have become commonplace and modestly priced. Japanese quality is excellent, but competition is so stiff that only the most reliable brands have stayed in the running.

In Germany there are still photographic industries of quality, such as Braun, Leitz, and Rollei. In the United States Polaroid Corporation pioneered instant photography which has been beneficial to pros and amateurs alike. George Eastman's company still makes millions of quick-load cameras, and Kodak films, papers, and chemicals dominate the domestic market.

30 *Provocative multiple imagery by Jerry Uelsmann, 1969.*

Taking pictures has come a long way from Daguerre's slowly exposed metal-plate images. There are cameras for everyone from junior to grandpa, and by merely holding one steadily, you get a "clear" picture. However, it's the mind behind the camera that creates images of more than ordinary value. Expensive equipment does not a photographer make.

Other Photographers of Significance

A thumbnail history of photography must be inadequate. However, it is valuable to know about those who made history in order to be more aware of where we are going. The legacy of photography given us by living or dead is rich, exciting, and worth careful investigation. I urge you to browse in books to learn about the history, individuals, styles, or collections. The brevity of this chapter is dictated by its purpose; many photographers have not been mentioned here, or in previous chapters. I find that mere familiarity with a name may motivate us to explore more deeply the work of people who deserve attention. For this reason, I conclude with a list of additional contributors to photography's legacy from many categories of the medium. All of them have one quality in common: excellence:

Bill Brandt
Brassaï
Harry Callahan
Lucien Clergue
Alvin Langdon Coburn
Bruce Davidson
Harold Edgerton
Elliot Erwitt
Marc Riboud
Robert Frank
Paul Fusco
Bill Garnett
Arnold Genthe
Yousuf Karsh
André Kertesz
Clarence John Laughlin
Jay Maisel
Duane Michals
Barbara Morgan
Paul Nadar
Paul Outerbridge
Eliot Porter
Emil Schulthess
Charles Sheeler
Aaron Siskind
Bradley Smith
Howard Sochurek
Pete Turner
Roman Vishniac
Brett Weston
Minor White

31 *"Girl On Beach," 1968 by Wynn Bullock.* ▶

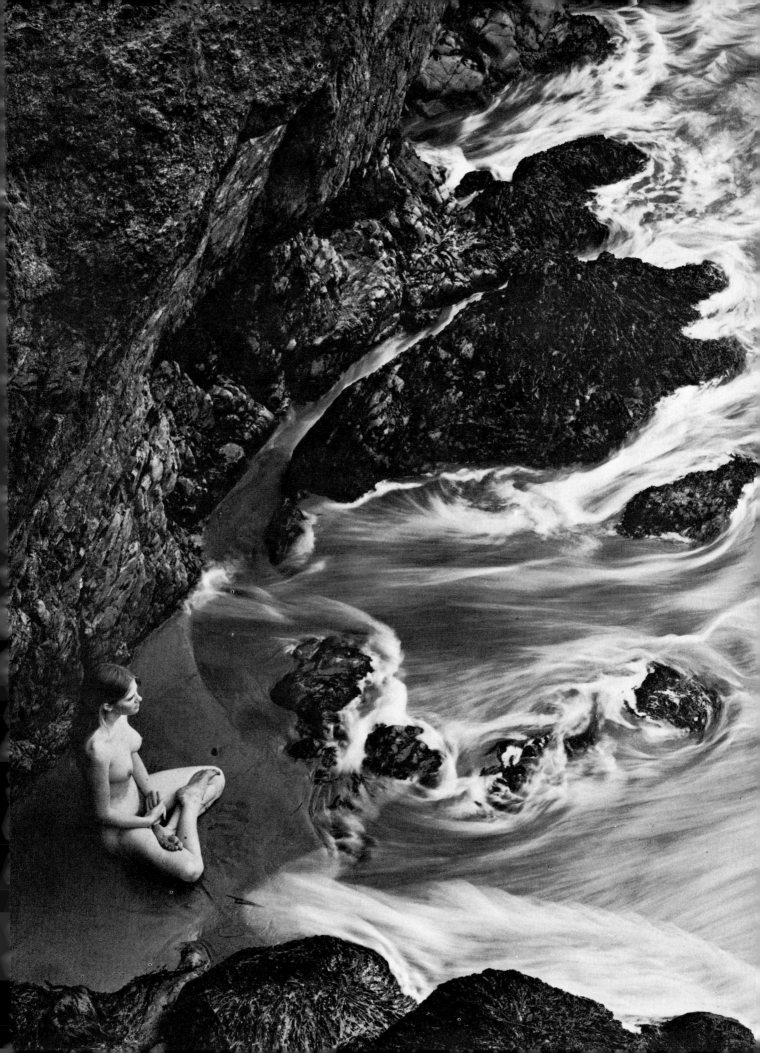

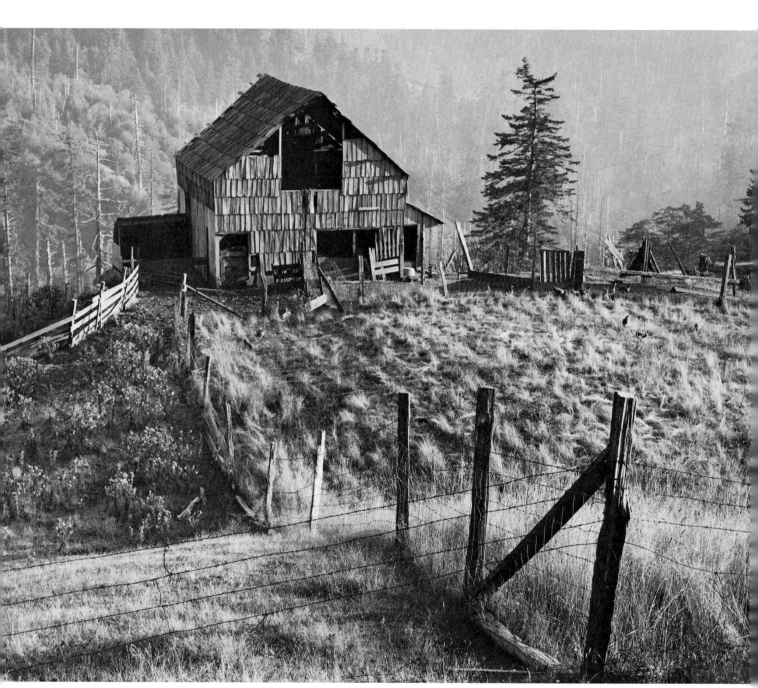

Northern Californian Barn

GLOSSARY

aberrations Optical defects in a lens due to its design or manufacture, which cause distortion that affects the sharpness of a focused image.

accelerator A chemical such as alkali in a developer that increases the speed of chemical action.

acetate base A material used in making photographic film consisting of cellulose acetate, on which the emulsion is coated.

acetic acid The acid used in dilute form for short-stop or stop bath, to stop the action of the developer in the processing of prints. It is sometimes used in film processing, but is not recommended. Acetic acid is also used in some fixers or hypo as in emulsion hardener for photographic paper.

acutance A measure of the sharpness with which a film can reproduce the edge of an object within an image, characterized by the degee of tonal separation between light and dark areas.

additive color method A term for the principles of color mixing with light. The primary colors are red, green, and blue which theoretically will combine equally to become white light, since each contains one-third of the total wavelengths in the visible portion of the electromagnetic spectrum. The method is used with color slide or transparency films.

agitation The process of stirring, twirling, or otherwise moving a chemical solution, such as developer, causing fresh solution to contact the surface of film or paper at frequent and regular intervals throughout the period of development.

air bubbles Tiny bubbles of air that cling to the dry surface of film or paper emulsion as it is immersed in developer. They appear as pinholes on film, and when projected as tiny white spots on paper. Proper agitation prevents air bubbles from affecting film or paper.

ambrotype An early photographic process that produced a negative image on a glass plate wet-coated with collodion. With a black backing, the image on glass appears positive.

analyzer An instrument with which to determine the proper filters needed to make a well-balanced color print from a color negative.

angle of view The area covered by a lens on a camera, expressed in degrees, and determined by the focal length of the lens.

antihalation backing A dye coated on the back of photographic film to absorb light rays passing through the emulsion, to prevent the most intense rays from being reflected back into the emulsion to affect image quality.

aperture The lens opening, the size of which is regulated by an iris diaphragm and expressed as an f-number or f-stop.

archival quality A quality of permanence of image and color, especially in photographic prints, attained by meticulous special processing methods.

ASA Initials of the American Standards Association which standardized the speed or light sensitivity of photographic films now known as ASA ratings.

astigmatism A common aberration of photographic lenses and of the human eye, characterized by the inability to bring into sharp focus lines that come together at right angles on the same plane.

automatic camera A camera with a built-in exposure-metering system that automatically adjusts the lens opening, the shutter speed, or both, for proper average exposure.

available light A term for light conditions of medium to low intensity (i.e., indoors, or outdoors at dusk or at night) when a photographer may choose to use a fast film, large lens aperture, slow shutter speed, or any combination of the three. Also known as *ambient light*.

backlight Illumination from a source behind the subject as seen from camera position, which tends to silhouette the subject, and may also dramatize it.

barrel distortion A form of lens aberration that causes horizontal or vertical lines to bow outward near the edges of the image, like the staves of a barrel.

bas-relief A picture produced by placing an identical negative and positive slightly off-register to create a single image, the edges of which appear to be in low relief, as if illuminated from the side at a low angle.

bellows An accordion-pleated section that connects the lens and the back of a camera; usually made of cloth or plastic, the bellows expands and contracts, allowing the camera to be focused.

bellows extension A term used to describe the expansion of a bellows for close-up focusing on a subject.

between-the-lens-shutter A camera shutter usually located between lens elements or just behind them, made of overlapping metal leaves that open and close for specific exposure intervals measured in fractions of a second or longer. Also called a *leaf shutter*.

bleed An image trimmed to the edges of the paper or mounting board, without a border; used by photographers and printers.

blocked up A term used to describe an area of a negative that is so dense, usually because of overexposure, that detail in that area is difficult or impossible to print.

blowup Photographer's term for an enlargement of an image.

box camera An early model first introduced by George Eastman, rectangular in shape, with a lens, shutter, and viewfinder at one end and film rollers at the other end.

bounced light Light reflected from a surface such as a ceiling, wall, or photographic umbrella, in order to diffuse and soften its effect on the subject.

bracketing The technique of exposing film in a "normal" manner, and then making one or more exposures over and under the "normal" one to assure a satisfactory exposure.

bulb A camera shutter setting indicated as (B) at which position the shutter may be kept open as long as the shutter release is depressed. Used for time exposures longer than one second.

burned out A term used to describe an area within a photographic print in which highlight detail is limited or absent because of extreme overexposure of the negative in blocked-up portions.

burning in In contact printing or enlarging, the process of giving an image area additional exposure while masking the remainder of the image, in order to obtain better detail in bright or highlighted portions.

cable release A long, flexible accessory that includes a thin plunger and screws into a threaded socket of a shutter release or camera body; used to activate the shutter without shaking the camera.

cadmium sulfide (CdS) cell A light-sensitive device, which when electrically powered, measures light intensity in an exposure meter.

calotype A very early photographic medium, invented by William Henry Fox Talbot around 1840 which produced a paper negative that was contact-printed to make a positive.

camera An instrument by which photographs are made, consisting of a light-tight box fitted with a lens, a shutter, a film compartment, and various controls for precise operation. From the Latin word for *room*.

camera obscura Used centuries before photography was invented, the camera obscura was a lighttight room with a small hole in one wall through which light rays entered and were projected upside down and reversed as an image on the opposite wall showing the outside scene. Early artists and painters used it for sketching. From the Latin for *darkroom*.

camera angle The position of a camera and lens in relation to a subject.

cartridge A metal container, primarily for 35mm film, with removable end pieces. Sometimes called a *cassette*, a term more often applied to special reusable cartridges.

CC filters Color-compensation filters for correction of color temperature in taking pictures and color printing. Made in six colors and several tints.

CdS meter An exposure meter using a cadmium sulfide cell that is battery powered.

changing bag A lighttight enclosure with elasticized openings for the hands, used to load film holders or developing reels in a lighted area.

circle of confusion An optical term used to describe a tiny blurred circle of light formed by a lens. In an out-of-focus image the circle is larger; in a sharply focused image, circles in clusters are smaller.

clearing agent A chemical that neutralizes fixer (hypo) in film or paper, in order to reduce washing time.

clearing time The interval required to clear the opaque backing from a negative; influenced by the strength, temperature, and agitation of the fixer, and the type of film being cleared.

click stop The interval or setting at which an aperture scale or shutter-speed ring stops as the scale or ring is turned; click stops indicate specific shutter speeds or f-stops.

close-up lens A supplementary lens which, when placed over a camera lens, allows closer-than-normal focusing; a prime lens, also called a *macro lens*, for close-up photography.

coating A thin film of magnesium fluoride or other chemical applied to lens surfaces to reduce the intensity of flare or internal reflection from lens elements, and to increase the clarity and contrast of the image formed. Coating appears as a pale magenta or amber color, but has no color influence on a slide or negative.

collodion A transparent chemical solution in which light-sensitive silver particles were mixed in the preparation of wet-plate emulsions, first described about 1851 by Frederick Scott Archer.

color balance The ability of a film or paper to accurately reproduce colors. Color films are balanced for specific Kelvin temperatures of light, primarily daylight and tungsten light.

color head In an enlarger, a specially designed lamp and condenser housing in which filters are contained or placed for use in color printing.

color temperature A standard for defining the color of light according to its warmth or coolness, which is measured in degrees Kelvin. Determination of color temperature guides the selection of color film, filters, and light sources.

coma A lens aberration that causes light rays passing diagonally through the lens to lack proper focus. The effect is most noticeable near the edges of a high-speed lens, and can be eliminated by stopping the lens down.

compensating developer A developer formula, or dilution, that works more strongly in shadow areas of a negative, and reduces its action in highlight areas as their density increases. Most effective with thin-emulsion, slow-speed films.

complementary colors Any two colors exactly opposite each other in the color wheel. In the additive method a combination of two complementary colors results in white light; in the subtractive method two complementary colors mixed together will produce black or neutral gray.

composite The image created when two or more negatives, or parts of negatives, are printed as one composition; two or more slides combined as a composite is a process called *sandwiching*.

condenser system In an enlarger, two or more condenser lenses that project light rays evenly through a negative and lens to provide a well-defined image.

contact print A method of photographic printing in which a negative is placed in direct contact with printing paper, and an exposure is made by light from an enlarger, a lightbulb, or by lights within a contact-printing machine. For average work, a contact-printing frame is used.

contact paper A photographic paper especially for contact printing; slower in speed than enlarging paper.

continuous tone A term used to describe an image with a continuous gradation of grays, from highlight white to deep black. Also known as *halftone*.

contrast In a photographic image, contrast is the degree of difference in tone values. A negative with more than average density and with fewer than average middle tones, is called *contrasty*. A print or slide with excessive differences in tone or color in adjacent areas is also contrasty. A negative or positive image with less than average contrast is termed *flat*.

contrast grade A system of numbers to describe contrast characteristics of photographic papers. The scale ranges from 0 through 6, with 2 as normal contrast, lower numbers indicating lower contrast, and higher numbers for higher contrast.

conversion filters Filters with which to correct the color temperature of light to match a specific film; generally used to convert daylight color film for use in tungsten light and vice versa.

cropping To trim or eliminate subject matter along the edges of an image in order to improve composition. A negative may be cropped when it is enlarged, and a slide may be cropped by masking along one or more edges.

cross-light Light striking the subject from one or both sides.

curvature of field A lens aberration causing the plane of focus to be curved, so that the center and edges of the image are not in sharp focus at the same time.

cut film Film supplied as individual sheets of various sizes; also known as *sheet* film.

daguerreotype The first successful photographic process, named after Daguerre, its inventor (1839), in which an image was formed on a coated copper plate by exposure to mercury vapor.

definition The sharpness and clarity of detail in an image, or the capability of a lens to produce fine detail.

deep tank Used in commercial film processing where large amounts of chemical solutions are required to handle many rolls simultaneously.

densitometer An instrument to measure the density of specific negative areas to determine optimum processing procedures.

density The quality of opacity in a negative or slide describing its capacity to transmit light. Density occurs in areas of heavy silver deposits or deep color saturation.

depth of field The area or distance in front of and behind the point at which a lens is focused that appears in acceptably sharp focus in a photograph, or as viewed through the lens itself.

depth-of-field scale A calibrated scale on a camera lens mount by which depth of field for a given distance and aperture can be approximated.

depth-of-field table A precise series of figures for a given lens showing depth of field at many distances and f-stops.

depth of focus The minute distance in which film may be shifted in front of or behind the film plane, and continue to record an acceptably sharp image produced by a focused lens. Not to be confused with depth of field.

developer A chemical solution that converts silver halides affected by light from a latent or invisible image into a visible image in film or paper.

diaphragm A device made of thin overlapping metal leaves within a lens or camera which can be adjusted to specific apertures or f-stops to control the amount of light that strikes the film. Also called *iris diaphragm*.

diffraction In optics, the tendency of light rays to bend around the edges of an opaque object.

diffusion The scattering of light rays in all directions as a result of being reflected from a surface or of passing through a translucent material. Diffusion softens the effects of light on a subject, and softens detail in a photographic image.

diffusion enlarger An enlarger that uses a sheet of diffusing glass to soften light rays passing through the negative and lens, thereby producing less inherent contrast than a condenser enlarger.

DIN The designation common in Europe for measurement of film speed, as ASA is used in the United States. Many cameras and exposure meters include both ASA and DIN figures.

diopter An optical term used to describe the power of a lens, especially a close-up lens on which a mark such as +2 indicates its power of magnification.

distortion Abnormalities in the shape or perspective relationships of an image, usually pertaining to wide-angle lenses. Some types of distortion are pictorially useful, and others are distracting.

dodging The process of masking an area of an image during enlarging or contact printing in order to reduce exposure and lighten that area.

double exposure Two or more images on one frame of film or piece of photographic paper; produced intentionally for reasons of composition and content, or accidentally in certain inexpensive cameras.

drum dryer A machine with a heated drum and canvas conveyor belt used to dry photographic prints.

dry mounting A method of mounting a print on cardboard by placing a thin sheet of dry mounting tissue between them and applying heat and pressure in a dry mounting press. Dry mounting tissue is a safe, precise, and chemically inert adhesive for photographic prints.

dry plate A term used in the late nineteenth century to describe dry glass plates as distinguished from wet plates that had to be coated just before exposure in the camera. Dry plates could be boxed, stored, and used later.

dye transfer A method of making very high-quality color prints by separately printing three gelatin matrices individually dyed cyan, magenta, and yellow onto a single sheet of photo paper. The dyes from each matrix are transferred by contact with the paper, and colors blend to become a complete print.

easel A device, usually made of metal, in which photographic paper is held flat and in position for making an enlargement; an easel may have two or more adjustable borders, or it may provide borderless prints.

electronic flash A photographic light source involving the discharge of an electrical impulse in a gas-filled tube to create a flash of very short duration that can be repeated within seconds, depending on the type and size of electronic flash (EF) unit used. EF may be referred to as "strobe" though that term more accurately describes a fast-repeating light source.

element A single glass component in the structure of a lens.

emulsion A thin coating of gelatin usually containing silver halides to provide the light-sensitive material within photographic film or paper.

enlargement A print made by projection of a negative into a larger-than-original size; also called a *blow-up*.

enlarger A piece of equipment designed to project an image from a negative or positive material onto sensitized paper or film. A light source, negative carrier, and lens can be adjusted closer to, or farther from, the paper that is usually held in an easel.

exposure The effect of light, according to its intensity and duration, on a photosensitive material, such as film or paper. The word is also used to symbolize the act of taking a picture.

exposure index A number indicating the relative light sensitivity or speed of a film; EI may be the same as the ASA rating, or a different figure determined by an individual photographer's tests.

exposure latitude The degree of exposure variation in photographic film or paper, from a point of overexposure to a point of underexposure, in which a suitable image can be produced.

exposure meter An instrument to measure the amount of light falling on (by *incident* measurement) or reflected from (by *reflected* measurement) a subject, and indicating camera aperture and shutter-speed settings according to a specific film speed rating. An exposure-metering system may be built into or be separate from a camera.

extension tubes Lighttight rings or tubes of varying length placed between a camera body and a lens to permit close-up focusing for image magnification.

fast A term used to describe films or papers highly sensitive to light, or lenses of large apertures.

ferrotype Originally the name used for the tintype process of making photographic images, popular from the 1860s to the 1880s.

ferrotype tins Polished sheets of metal or a drum against which glossy papers are dried to produce a high gloss. If paper is dried emulsion side *up*, it is less glossy, or *matte dried*.

fill light Light cast within a shadow area to produce better photographic detail and reduce contrast in a negative or slide.

film A sheet or roll of thin material coated on one side with a light-sensitive emulsion capable of recording an image when exposed in a camera.

film holder A two-sided container in which sheet film is loaded for exposure, usually in a view camera. The film is protected before exposure by a dark slide which is removed after the film holder is inserted into the camera back.

film speed The relative sensitivity of a film to light, usually rated in ASA or DIN numbers.

filter A piece of glass or other transparent material, usually colored, used to absorb certain wavelengths of light and block others; filters are used for photographic effects or correction to suit a specific film and light source.

filter factor The number by which an exposure without a filter must be multiplied to compensate for the amount of light held back by the filter. May be ignored when filters are used with cameras having built-in through-the-lens metering systems.

fisheye lens A super-wide-angle lens or lens attachment capable of covering nearly a 180-degree field of view. Fisheye images may be circular or full-frame, and are characterized by barrel distortion.

fix or fixer A chemical fixer renders film or paper insensitive to light. A fixer or fixing bath contains hypo and is also referred to as *hypo*.

flare Extraneous light appearing around the edges of an image, caused by unclean lens surfaces, by uncoated lenses, or by reflections from inside the camera. Flare may be produced by clean, coated lenses when they are pointed at a strong light source; some light is reflected between lens elements, and an image of the lens aperture may appear.

flash A term used for an instantaneous light provided by a flashbulb or cube or an electronic flash unit; flash is usually synchronized during exposure by camera mechanisms.

flashing A method of darkening an area of a photographic print by brief exposure to raw light when subject matter in that area may be obscured.

flat A term used to describe a low-contrast image in a print or negative. May also refer to a large, free-standing, portable panel, usually painted white and used as a reflector in a photographic studio.

flood A photographic light designed to offer a wide spread of illumination. May be a flood bulb within a reflector or a self-contained reflectorflood bulb. The word flood is used as a short version of floodlight.

f-number A number used to indicate the size of a lens opening. The larger the f-number, the smaller the opening or aperture. Interchangeable with the word *f-stop*.

focal length The distance from the lens to the film plane when the lens is focused at infinity. The greater the focal length, the smaller the field of view of a lens. In reverse, as focal length decreases, field of view widens.

focal plane The surface where film is located inside a camera, and where the image is brought into sharp focus.

focal-plane shutter A mechanism consisting of several lighttight curtains which form an adjustable-size slit that passes just in front of the film plane, horizontally or vertically, to expose the film in fractions of a second or longer. The presence of a focal-plane shutter in a single-lens reflex or rangefinder camera makes possible the removal of a lens without exposing the film.

focus The adjustment of a camera lens to provide an image that is sharp on the focal plane. Also, the convergence of light rays to a point.

fog A hazy darkening of a negative or print caused by extraneous light or chemical action. Fog may be caused by light leaking into a film holder or cartridge, by using outdated film, or by storing film in hot humid conditions.

f-stop See f-number.

frame To position the camera viewfinder in order to compose or "frame" the picture. Also refers to a single image in a roll of negatives, particularly a frame of 35mm film.

frame numbers Printed along the edges of 35mm and 120-size roll film and on the paper backing for cameras with small windows, frame numbers are useful in identifying individual pictures for filing purposes.

gamma A numerical expression of the characteristic curve of a film indicating image contrast according to development practice.

gelatin A substance used to bind silver halide particles in film emulsions.

gradation The range of tone values from highlight white to deep black found in a photographic print.

grain Individual silver particles or groups of particles in the emulsion of photographic film that form the image and are not visible until a negative is enlarged or viewed under a microscope.

gray A term used to describe a print that is flat or lacks sufficient tonal contrast.

gray card A standard average gray tone with 18-percent reflectance often used within a picture area as a target for determining exposure. It is the tonal reference an exposure meter uses to average all tones in a scene.

ground glass A section of glass frosted on one side used as the image-viewing material in a view or reflex camera.

halation A blurred halo effect around very bright objects in a negative image caused by light passing through the film and being reflected back, despite an antihalation backing.

halftone A term used by printers and engravers for an image of continuous tones reproduced by a screen of dots proportional in density to the original image. The finer the screen, the greater the number of dots per inch, and the higher the quality of reproduction.

halide A metallic compound that, with silver, constitutes the light-sensitive material for the photographic process.

hanger A frame made of plastic or metal into which sheet film is slipped for processing in a tank.

hard A term that describes high contrast in an image, or connotes harshness of lighting.

hardener A chemical used in fixing baths to harden the gelatin in a photographic emulsion after development.

highlight The bright accent in a subject itself, or the brightest areas of a photographic print or slide. A highlight is often rather small, and is represented by the most dense spots in a negative.

hue The visual aspect of a color that distinguishes its specific character, such as red, blue, yellow, etc.

hyperfocal distance The distance from a camera lens to the nearest point where depth of field begins, when the lens is focused on infinity. Hyperfocal distance changes with the f-stop of the lens and is integral to cameras with limited or fixed focus.

hypo A common term for the fixing bath used to stop development and dissolve undeveloped silver salts remaining in photographic negatives or prints. The term is derived from the original chemical, sodium hyposulfite, which is part of the fixing solution.

hypo eliminator Also called *hypo clearing bath,* hypo eliminator is a solution that speeds the removal of fixer from films and papers, and thereby saves washing time and reduces the amount of water needed.

image The visual representation on photographic film or paper of a scene or subject recorded by a camera; sometimes used to describe the visual impression received through the camera viewfinder.

incandescent light A term used to describe any type of artificial light produced by electricity in a continuous manner (i.e., not a flash).

incident light The light *falling* on a subject from any direction.

incident-light meter An exposure meter designed to measure light falling on a subject rather than reflected from it.

infinity In photographic terms, the distance beyond which a camera lens need not be focused to produce an image of satisfactory sharpness.

infrared Wavelengths of the electromagnetic spectrum beyond red, invisible to the eye and to conventional films, but capable of being recorded on special film because of the heat they generate.

intensifier A chemical used to help increase in only a limited way the density or contrast in a black-and-white negative.

interchangeable lens A lens that can be mounted, removed, and replaced on a camera quickly in order to facilitate use of differing focal lengths.

iris diaphragm See **diaphragm.**

Kelvin temperature A means of measuring the color temperature of light sources in degrees equivalent to the Centigrade scale; devised by physicist W. T. Kelvin (1824–1907).

latent image The invisible image upon and within a photographic emulsion before it is developed.

leader A strip of film or paper attached to a roll of film, which is there to load into a camera take-up spool, and to protect the remaining film from light or handling.

leaf shutter A type of camera shutter, usually located between lens components, made of overlapping metal leaves which open and close in a fraction of a second (though it may be longer) to expose an image on film.

lens A single shaped piece of optical glass or molded plastic, or an assembly of such pieces (called *elements*), designed to gather and focus light rays in a camera to form an image of a subject on film, or in an enlarger to form an image on paper. Simple cameras may have one- or two-element lenses, and more complex cameras have lenses with many elements.

lens barrel The metal housing in which lens elements are mounted.

lens board A piece of wood or metal on which a lens is mounted for a view camera.

lens hood An accessory attached to the front of a lens to shield it from extraneous light rays that may cause flare. Also called a *lens shade.*

lens mount The section of a camera to which the lens is attached.

light meter See **exposure meter.**

long lens Another name for a telephoto lens, or one that is twice or more the focal length of a normal lens.

macro lens A lens designed for close-up photography, providing greater-than-normal magnification of the subject.

main light The brightest or most prominently placed light in a photographic situation.

masking The process of blocking out areas of an image or its edges with opaque pigment or tape.

mat A frame, usually of cardboard, on which a photograph is mounted.

matte A term used to describe a nonglossy surface, usually of photographic paper; the surface may be fine or noticeably textured.

mirror optics An optical system for photographic lenses in which mirrors are used along with elements (in some designs) to form an image on film. Long-focal-length mirror optics are shorter and lighter in weight than conventional lenses.

monobath A chemical solution in which both developer and fixer are combined for fast processing of film.

negative A photographic image in which tones of light and dark are reversed. A negative is usually contained on transparent film, and the image is transferred by contact or projection to a positive material.

negative carrier A frame that holds the negative in an enlarger so it can be projected.

neutral-density (ND) filter A neutral-gray filter designed to decrease the intensity of light reflected from a subject without altering color.

normal lens Any lens with a focal length approximately equal to the diagonal measurement of the image on film within the camera on which it is used.

objective An optical term for a lens.

opal glass A milky-white glass that diffuses light uniformly; used in an enlarger, as a base for a still life, and on the front of a viewing box.

opaque Incapable of transmitting light. Also, a tempera paint used to mask a portion of a negative.

open flash A method of taking flash pictures in which the shutter is open on bulb (*B*) for a time exposure during which the flash is fired one or more times to illuminate a widespread subject.

orthochromatic A photographic emulsion that is sensitive to all colors but red.

overexposure An exposure of too long an interval during which too much light passes through the lens.

pan To rotate a camera synchronized with a passing subject during exposure, so that the subject remains relatively sharp, but the background is blurred. Also a short term for *panchromatic*.

panchromatic A photographic emulsion that is sensitive to all colors of light.

paper negative A negative image made on paper rather than film, either in the camera or by projection in the darkroom. May be contact printed to make a paper positive.

parallax The degree of difference between the viewfinder image and the image actually recorded by the lens of a camera, due to their varying axes. Parallax error does not occur with through-the-lens viewing.

photoflood A type of incandescent light-bulb screwed into a reflector housing, or with a self-contained reflector. The term also denotes a bulb-and-reflector assembly.

photogram An image made by placing objects on a sheet of photographic paper and exposing it to light.

pinhole camera A camera with a tiny hole in place of a lens, made in various shapes and sizes for experimental purposes.

polarizing filter A disc of glass designed to reduce reflection and alter the appearance of sky or surfaces by affecting certain polarized light rays without altering color. Also called a *polarizer* or *pola filter*.

print An image, usually positive, on photographic paper.

prism A solid shape made of transparent material with at least two polished surfaces which bend or refract an image carried by light rays. Used within the viewfinder system of a single-lens reflex camera.

process The sequence of chemical steps used to develop and fix films or papers in the photographic idiom.

projection print A print made in an enlarger in which an image is projected to a sensitized material, as opposed to a contact print.

projector A machine used to project an enlarged image onto a screen, such as a slide; or a movie projector.

push The term used to indicate increased film developing time, i.e., to push or force development to compensate for underexposure.

RC paper Resin-coated printing paper which is made with a special base that limits absorption of liquid, providing for accelerated washing and drying.

rangefinder An optical device used to focus a camera lens in which two images are made to coincide precisely when a subject is in focus.

reciprocity law A principle which states that exposure varies uniformly in relation to time and intensity of light. Reciprocity failure may occur in disproportionate combinations when light levels are low and exposures abnormally long, or when the duration of light is extremely brief, such as that of electronic flash.

reducer A chemical solution used to dissolve some of the silver in a developed negative image to reduce abnormal density caused by overdevelopment or overexposure.

reel The metal or plastic holder with a spiral track into which film is loaded for development in a small tank.

reflector A piece of photographic equipment or a surface from which light is reflected or bounced onto a subject, thereby softening the effect.

reflex camera A type of camera in which the image gathered by the lens is reflected to a mirror and onto a ground glass for viewing. In a single-lens reflex a prism may be used to correct the left-to-right orientation of the image.

refraction The bending of light rays as they pass through transparent materials of varying densities.

register To superimpose images so they are aligned precisely. Colors or shapes not so aligned are said to be off-register or out of register.

replenisher A concentrated solution of chemicals similar to those of a developer used to maintain developer strength, which diminishes with the amount of film processed.

resolving power The ability of a lens to record or of a film emulsion to reproduce fine detail.

reticulation A pattern of fine wrinkles in a negative caused by temperature extremes during processing, or by adverse chemical effects. The phenomenon is rare with normal darkroom practice.

reversal Most commonly, the process of turning a negative image into a positive one, through the action of light or chemicals, during the development of color transparency films.

rim light Backlight that forms a thin, bright outline around a subject.

Sabattier effect The partial reversal of an image in a film emulsion caused by brief exposure to light during development; often referred to as solarization, which is not technically correct.

safelight Darkroom illumination of a color and intensity that will not normally affect photographic papers during the time of processing.

saturation The intensity of a color in terms of its value; high saturation produces more brilliant color and is a result of a minimum practical exposure.

screen A pattern of dots used to translate an image for halftone reproduction. Also refers to a flat surface used for projection of an image.

selenium A material used in exposure meters to provide an electrical measurement of light intensity without battery power. Less sensitive to low light levels than cadmium sulfide.

separation The distinction between light and dark tones in an image. Also, the process of recording three primary colors on black-and-white films through the use of filters for color printing such as dye transfer.

sharpness The impression of fine detail, texture, and definition in a photographic image.

sheet film Film made in individual sheets. Also called *cut film*.

short lens A lens of less-than-normal focal length; also called a *wide-angle lens*.

shutter A mechanism that opens and closes within a camera to provide the time interval necessary for exposure. Time intervals are called *shutter speeds*.

silver halide See **halide**.

slide A mounted color transparency.

slow A term that refers to relatively low light sensitivity of a film, paper, or photographic lens.

SLR Initials for single-lens reflex, a popular and practical type of camera.

soft Describes an image that is not sharp or in precise focus. Also refers to an image or a photographic paper of low contrast.

solarization The reversal of an image, often caused by extreme overexposure. The term used popularly, but not precisely, for the Sabattier effect.

spectrum The sequence of colors found in visible light, such as that of a rainbow.

speed A term that relates to the relative light sensitivity of a photographic film or paper, or to the light-admitting property of a lens.

spot meter An exposure meter that measures a very small area of a subject.

spotting The process of painting out tiny spots or defects in a print using a special dye and fine brush; dark spots are eliminated by etching the emusion to blend the defect into its surroundings. An etching knife or tool is used.

stabilization A printing process using special papers, chemicals, and equipment by which an image is developed and fixed in one step lasting less than half a minute. Stabilization processing is capable of producing excellent tone values in black-and-white prints, which must be additionally fixed to be permanent.

stain A colored or toned section, usually of a print, caused by chemical contamination or handling; stains may also occur on negatives if not properly processed or stored.

stock A concentrated form of a chemical solution which is diluted for use. Also the base or support material, such as paper, on which sensitized emulsion is coated.

stop bath A diluted solution of water and acetic acid that stops developing action, particularly of prints, before they are transferred to the fixer. Also called *short-stop*.

stop down To reduce the size of a lens aperture for decreased exposure.

strobe A rapidly repetitive form of electronic flash, as opposed to the conventional form which requires from half a second to a few seconds to recycle, or be ready for use again. Taken from the word *stroboscopic*.

supplementary lens A lens placed over a camera lens to alter focal length, usually to allow closer-than-normal focusing.

swings and tilts Terms applied to the adjustments of lens board and back of a view camera, for control of perspective and/or focus.

synchronizer A device, usually built into a camera shutter mechanism, that fires a flashbulb or flash unit at a time when the shutter opening is at its widest.

tank A lighttight container made of metal or plastic in which film is placed on reels for processing. Also larger containers without tops for processing sheet film.

telephoto lens A lens with focal length of 135mm or more used to "reach out" and provide larger-than-normal-lens images of distant subjects, or of closer areas.

test strip A strip of paper on which one or more separate exposures are made to determine the correct exposure, especially for an enlargement.

thin A term used to describe a negative of low overall density.

time and temperature The two factors that vary in the development process for film or paper. Manufacturers provide charts of time and temperature relationships which photographers revise according to their own needs and experience.

time exposure An exposure usually longer than one second, the longest camera-activated interval on most cameras, after which the photographer must time the exposure by using a watch or counting. Some cameras with electronic shutters make automatic time exposures from a few seconds to one minute.

tintype An early photographic process of mid-nineteenth century that used a wet emulsion on a metal plate, and became both inexpensive and popular.

TLR Initials for twin-lens reflex.

tonality The overall sequence of grays in a photograph; may also be used to describe the relationship of color values.

toner A chemical solution used to tint a black-and-white print; the most common toners are sepia and selenium blue.

translucent A quality to describe a diffusing material that allows light to pass through in scattered rays; it is neither transparent nor opaque.

transparency The common term for a color slide which is viewed by transmitted light, such as by projection.

tripod A three-legged support for a camera, adjustable in height, with a head mechanism for tilting the camera in some or all directions.

TTL Initials for through-the-lens, describing a type of exposure meter built into cameras such as the single-lens reflex.

tungsten light A general term for artificial illumination from any source; derived from the use of a tungsten filament in photoflood bulbs.

Type A A color film balanced for 3400K flood bulbs.

Type B A color film balanced for 3200K flood bulbs.

ultraviolet Light rays in the invisible part of the spectrum which may give color films a bluish tint and may be filtered out with an ultraviolet (UV) filter.

underexposure Refers to an exposure of too short an interval in which not enough light reached the film or paper to produce an acceptable image.

value The degree of darkness of a gray tone or a color in a print, negative, or slide. The value scale ranges from highlight white to deep black.

variable-contrast (VC) paper A type of printing paper with which contrast may be altered by the use of VC filters calibrated in separate grades of contrast.

view camera A type of camera in which the image is viewed on a ground glass set opposite the lens and usually connected by a bellows. A view camera must be used on a tripod; the image is upside down, but allows precise composition and focus because of its size.

vignetting A term describing the gradual shading off of an image at the edges resulting in a soft edge and no definite border line.

washed out A term describing a pale, gray, or pastel image lacking detail in both highlights and shadows, usually caused by overexposure in a slide and underexposure in a print.

wavelength A measurement of the electromagnetic spectrum including light rays; varying lengths of their waves produce different colors of light.

wet plate A name for the collodion process in which glass or metal plates were coated with a light-sensitive emulsion that had to be exposed and developed before it dried.

wide-angle lens A lens of a less-than-normal focal length which produces a wide-view coverage and provides good-to-excellent depth of field.

working solution A chemical solution mixed from stock and ready to use

zone system A system of exposure and development devised by Ansel Adams, using exposure-meter measurements from various areas or zones in a subject, and determining exposure according to the variation from one zone to another. Zones are numbered to coincide with calibrations on a Weston exposure meter.

zoom lens A lens with moving elements that provide a continuous adjustment of focal length within its designed limits.

BIBLIOGRAPHY

Some years ago André Malraux wrote several thoughtful books, one of which was *Museum Without Walls*. That is his brilliant phrase to describe the availability of man's cultural and artistic achievements to be found as words and graphic images in books. The truth of Malraux's contention is constantly reinforced by more and better books which record creative effort in all the arts, as well as in science and the humanities.

My list is only a selection from many that inform and inspire. There are excellent books among them, and there are titles which you or I might find mediocre. The latter are included because I feel you should know they exist, for our opinions about them may differ. Of course, you won't know this, because I am not evaluating the bibliography.

Familiarity with libraries, bookstores, and book catalogues offers many rewards. Photographic exhibits, esoteric images, special technical data, and collections come to you via books. Work by photographers whose original prints you may never get to see are alive and exciting on printed pages. You owe it to yourself to browse and explore, no matter what the scope of your interest is now. The culture of the world in its broadest form is found in camera images. The legacy of books is our common inheritance.

Books known to be out of print are marked (OOP) but they may be found in libraries, or through bookshops, one of which is listed later.

History of Photography

American Heritage, ed. *An American Album.* New York: American Heritage, 1968.

Braive, Michel F. *The Photograph: A Social History.* New York: McGraw-Hill, 1966.

Coke, Van Deren. *The Painter and the Photograph.* Albuquerque: University of New Mexico Press, 1971.

Doty, Robert. *Photo-Secession: Photography As A Fine Art.* Rochester, N.Y.: George Eastman House, 1960.

Friedman, Joseph S. *History of Color Photography.* London: Focal Press, 1968.

Gassan, Arnold. *A Chronology of Photography.* Athens, Ohio: Handbook, 1972.

Gernsheim, Helmut. *Creative Photography: 1839–1960.* New York: Bonanza Books, 1962.

———. *A Concise History of Photography.* New York: Grosset and Dunlap, 1965.

———. *The History of Photography.* New York: McGraw-Hill, 1970.

Greenhill, Ralph. *Early Photography in Canada.* Toronto: L. J. Publisher, 1965.

Mees, C. E. Kenneth. *From Dry Plates to Ektachrome Film: A Story of Photographic Research.* New York: Ziff-Davis, 1961.

Moholy, Lucia. *A Hundred Years of Photography.* England: Harmondsworth, 1939.

Newhall, Beaumont. *The History of Photography from 1839 to the Present Day.* New York: Museum of Modern Art, 1964.

———. *Latent Image: The Discovery of Photography.* Garden City, N.Y.: Doubleday, 1967.

———. *The Daguerreotype in America.* Greenwich, Conn.: New York Graphic Society, 1968.

Pollack, Peter. *The Picture History of Photography.* New York: Abrams, 1970.

Rinhart, Floyd and Marion. *American Daguerrian Art.* New York: Crown Publishers, 1967.

Rudisill, Richard C. *Mirror Image: The Influence of the Daguerreotype on American Society.* Albuquerque: University of New Mexico Press, 1971.

Taft, Robert. *Photography and the American Scene: A Social History.* New York: Dover Publications, 1964.

Wall, E. J. *The History of Three-Color Photography.* New York: Amphoto, 1970.

Technical

Adams, Ansel. *Camera and Lens* (1968), *Natural-Light Photography* (1965), *Artificial-Light Photography* (1968), *The Negative* (1968), *The Print* (1968). Dobbs Ferry, N.Y.: Morgan & Morgan.

Asher, Harry. *Photographic Principles & Practices.* New York: Amphoto, 1975.

Burk, Tom. *Do It In The Dark.* Tucson, Ariz.: HP Books, 1975.

Davis, Phil. *Photography.* Dubuque, Iowa: William C. Brown Co., 1975.

Eastman Kodak Co., Rochester, N.Y. Catalogue A3-75 of books, including *The Here's How Book of Photography* series, *Bigger and Better Enlarging, Creative Darkroom Techniques, Adventures in Color Slide Photography, Basic Scientific Photography,* plus many booklets for ready reference on almost every phase of photography.

Encyclopedia of Photography. New York: The Greystone Press, 1971.

Feininger, Andreas. *The Complete Photographer* (1966), *Successful Color Photography* (1969), *The Creative Photographer* (1975). Englewood Cliffs, N.J.: Prentice-Hall.

———. *The Perfect Photograph* (1974), *Darkroom Techniques* (1974). New York: Amphoto.

Focal Encyclopedia of Photography. New York: McGraw-Hill, 1975.

Gassan, Arnold. *Handbook for Contemporary Photography.* Athens, Ohio: Handbook, 1970.

Hattersley, Ralph. *Discover Your Self Through Photography.* Dobbs Ferry, Morgan & Morgan, 1971.

Isert, G. *The Art of Colour Photography.* New York: Van Nostrand Reinhold, 1971.

Jacobs, Lou, Jr. *How To Take Great Pictures with Your SLR.* Tucson, Ariz.: HP Books, 1974.

———. *Basic Guide to Photography.* Los Angeles: Peterson Publishing Co., 1973.

———. *How to Use Variable Contrast Papers.* New York: Amphoto, 1970.

———. *Electronic Flash.* New York: Amphoto, 1971.

———. *Instant Photography.* New York: Lothrop, Lee & Shepard, 1976.

Kemp, Weston D. *Photography for Visual Communicators.* Englewood Cliffs, N.J.: Prentice-Hall, 1973.

Life Library of Photography: The Camera, Light and Film, The Print, Color, Pictures As Persuaders, Seeing the Unseen, The Classic Themes, Photojournalism, Great Photographers, The Studio, Photographing Nature, Special Problems, Frontiers of Photography, Travel Photography. New York: Time/Life Books, 1970.

Mees, C. E. Kenneth, and T. H. James. *The Theory of Photographic Process.* New York: Macmillan, 1966.

Perry, Robin. *Creative Color Photography.* New York: Amphoto, 1974.

Picker, Fred. *The Zone VI Workshop, The Fine Print.* New York: Amphoto, 1975.

Pittaro, Ernest M., ed. *Photo-Lab Index.* Dobbs Ferry, N.Y.: Morgan & Morgan, 1973.

Peterson How-To Photography Library: *Blueprint Series, Close-up Photography, Darkroom Techniques, Special Effects, Figure Photography, Free-Lance Photography, Guide to Architectural Photography, Interchangeable Lenses, Photographing Children, Photo Lighting Techniques, Polaroid Photography,* Los Angeles: Peterson Publishing Company.

Reedy, William. *Impact: Photography for Advertising.* Rochester, N.Y.: Eastman Kodak Co., 1973.

Shipman, Carl. *Understanding Photography.* Tucson, Ariz.: HP Books, 1974.

Sussman, Aaron. *The Amateur Photographer's Handbook.* New York: Thomas Y. Crowell, 1973.

Swedlund, Charles. *Photography: A Handbook of History, Materials, and Processes.* New York: Holt, Rinehart and Winston, 1974.

Todd, Hollis N., and Leslie Stroebel. *Dictionary of Contemporary Photography.* Dobbs Ferry, N.Y.: Morgan & Morgan, 1974.

White, Minor. *The Zone System Manual.* Dobbs Ferry, N.Y.: Morgan & Morgan, 1968.

Woolley, A. E. *Photography: A Practical and Creative Introduction.* New York: McGraw-Hill, 1975.

———. *Photographic Lighting.* New York: Amphoto, 1974.

Zakia, Richard D., and Hollis N. Todd. *101 Experiments in Photography.* Dobbs Ferry, N.Y.: Morgan & Morgan, 1969.

General Interest and Picture Books

Abbott, Berenice. *Berenice Abbott, Photographs.* New York: Horizon Press, 1970.

Adams, Ansel. *Images 1923–1974.* Greenwich, Conn.: New York Graphic Society, 1974.

———, and Nancy Newhall. *The Eloquent Light.* San Francisco: Sierra Club, 1963.

Ahlers, Arvel W. *Where & How to Sell Your Photographs.* New York: Amphoto, 1975.

Anderson, Sherwood. *Home Town: Photographs by Farm Security Photographers.* New York: Alliance Books, 1940 (OOP).

Bischof, Werner. *Werner Bischof.* ICP Library of Photographers: series (see also Robert Capa) New York: Grossman Publishers, 1974.

The Best of Life. New York: Time-Life Books, 1973.

Brandt, Bill. *Perspective of Nudes.* New York: Amphoto, 1961 (OOP).

Brassaï. New York: The Museum of Modern Art, 1968.

Braun, Ernest, and David Cavagnaro. *Living Water.* Palo Alto, Ca.: American West, 1971.

———. *Tideline.* New York: Viking Press, 1975.

Bullock, Wynn. *Wynn Bullock; Photographer: A Way of Life.* Millerton, N.Y.: Aperture, 1970.

Capa, Cornell. *The Concerned Photographer.* New York: Grossman Publishers, 1968, 1972.

Capa, Robert. *Robert Capa.* ICP Library of Photographers: New York: Grossman Publishers, 1974.

Cartier-Bresson, Henri. *The Decisive Moment.* New York: Simon & Shuster, 1952 (OOP).

———. *The World of Henri Cartier-Bresson.* New York: Viking, 1968.

Crouch, Steve. *Steinbeck Country.* Palo Alto, Ca.: American West, 1973.

———. *Desert Country.* Palo Alto, Ca.: American West, 1976.

Imogen Cunningham: Photographs. Seattle: University of Washington Press, 1970.

Dater, Judy, and Jack Welpott. *Women and Other Visions.* Dobbs Ferry, N.Y.: Morgan & Morgan, 1975.

Davidson, Bruce. *East 100th Street.* Cambridge, Mass.: Harvard University Press, 1970.

Doty, Robert, ed. *Photography in America.* New York: Random House, 1974.

Duncan, David Douglas. *This Is War!* Reprint. New York: Bantam, 1967.

———. *Picasso's Picassos.* Reprint. New York: Ballantine, 1968.

———. *Yankee Nomad: A Photographic Odyssey.* New York: Holt, Rinehardt & Winston, 1966.

———. *Goodbye Picasso.* New York: Grosset & Dunlap, 1975.

Eisenstaedt, Alfred. *Witness to Nature.* New York: Viking Press, 1971.

———. *The Eye of Eisenstaedt.* New York: Viking Press, 1969.

Erwitt, Elliott. *Photographs and Anti-Photographs.* Greenwich, Conn.: New York Graphic Society, 1972.

———. *Private Experience.* Text by Sean Callahan. Los Angeles: Alskog/Peterson Publishing Company, 1974.

Walker Evans. New York: Museum of Modern Art, 1971.

The Family of Man. New York: Museum of Modern Art, 1955.

Paul Fusco & Will McBride: Photo Essay. Text by Tom Moran. Los Angeles: Alskog/Peterson Publishing Company, 1974.

Frank, Robert. *The Americans.* Millerton, N.Y.: Aperture, 1969.

Gibson, Ralph. *Déjà-vu.* New York: Lustrum Press, 1973.

———. *The Somnambulist.* New York: Lustrum Press, 1970.

Goldsmith, Arthur. *The Nude in Photography.* New York: Playboy Press/Simon & Schuster, 1975.

Goro, Herb. *The Block.* New York: Random House, 1970.

Green, Jonathan, ed. *Camera Work.* Millerton, N.Y.: Aperture, 1974.

———. *The Snapshot.* Millerton, N.Y.: Aperture, 1974.

Haas, Ernst. *The Creation.* New York: Viking Press, 1971.

———. *In America.* New York: Viking Press, 1975.

Harbutt, Charles. *Travelog.* Cambridge, Mass.: M.I.T. Press, 1974.

Hine, Lewis W. *Lewis W. Hine.* Text by Judist Mara Gutman. ICP Library of Photographers: New York: Grossman Publishers, 1974.

Hurley, Gerald D., and Angus McDougall. *Visual Impact in Print.* Chicago: American Publishers Press, 1971.

Jackson, Clarence S. *Picture Maker of the Old West: William Henry Jackson.* New York: Scribner, 1947 (OOP).

Kalisher, Simpson. *Railroad Men.* New York: Clarke & Way, 1961 (OOP).

Art Kane: The Persuasive Image. Text by John Poppy. New York: Alskog/Thomas Y. Crowell, 1975.

Karsh, Yousuf. *Faces of Our Times.* Toronto: University of Toronto Press, 1971.

Karsten, Kenneth. *Abstract Photography Techniques.* New York: Amphoto, 1970 (OOP).

Kertesz, André. *Day of Paris.* New York: J. J. Augustin, 1945 (OOP).

André Kertesz, Sixty Years of Photography: 1912–1972. New York: Viking Press, 1972.

Kirstein, Lincoln. *Eugene Smith, Photographs.* Millerton, N.Y.: Aperture, 1969.

Lange, Dorothea, and Paul Taylor. *An American Exodus.* Reprint. New Haven, Conn.: Yale University Press, 1969.

Dorothea Lange. New York: Museum of Modern Art/Doubleday, 1966.

Lartigue, Jacques Henri. *The Photographs of Jacques Henri Lartigue.* New York: Museum of Modern Art, 1963.

Lesy, Michael. *Wisconsin Death Trip.* New York: Random House, 1973.

Lieberman, Archie. *Farm Boy.* New York: Abrams, 1974.

Lucie-Smith, Edward. *The Invented Eye: Masterpieces of Photography 1839–1914.* New York: Two Continents/Paddington Press, 1975.

Lyons, Nathan, ed. *Photographers on Photography.* Englewood Cliffs, N.J.: Prentice-Hall, 1966.

McCullin, Donald. *Is Anyone Taking Any Notice?* Cambridge, Mass.: M.I.T. Press, 1973.

McDarrah, Fred. *Photography Marketplace.* New York: Bowker, 1975.

Maddow, Ben. *Edward Weston: Fifty Years.* Millerton, N.Y.: Aperture, 1974.

Maroon, Fred. *These United States.* New York: EPM Publications/Hawthorn Books, 1975.

Duane Michals: The Photographic Illusion. Text by Ronald H. Bailey. New York: Alskog/Thomas Y. Crowell, 1975.

Michals, Duane. *The Journey of the Spirit After Death.* New York: Winter House, 1971.

———. *Sequences.* New York: Doubleday, 1972.

Morgan, Barbara. *Summer's Children.* Dobbs Ferry, N.Y.: Morgan & Morgan, 1951 (OOP).

Moholy-Nagy, Documentary Monographs in Modern Art. New York: Praeger, 1970.

Morris, Wright. *The Home Place.* Lincoln, Nebr.: University of Nebraska Press, 1968.

———. *God's Country and My People.* New York: Harper & Row, 1968.

Muybridge, Eadweard. *The Human Figure in Motion.* Reprint. New York: Dover, 1957.

———. *Animals in Motion.* Reprint. New York: Dover, 1955.

Newman, Arnold. *One Mind's Eye.* Boston: Godine, 1974.

Nilsson, Lennart, in collaboration with Dr. Jan Lindberg. *Behold Man.* Boston: Little, Brown, 1974.

The Nikon Image. Edited by Ed Rooney. New York: EPOI, 1975.

Norman, Dorothy. *Alfred Stieglitz: An American Seer.* Millerton, N.Y.: Aperture, 1973.

Newhall, Beaumont and Nancy. *T. H. O'Sullivan, Photographer.* Rochester, N.Y. and Ft. Worth, Tex.: George Eastman House/Amon Carter Museum, 1966.

Paine, Wingate. *Mirror of Venus.* Reprint. New York: Bantam, 1970.

Parks, Gordon. *Whispers of Intimate Things.* New York: Viking Press, 1971.

———. *Moments Without Proper Names.* New York: Viking Press, 1975.

Penn, Irving. *Worlds In A Small Room.* New York: Grossman Publishers, 1974.

———. *Moments Preserved.* New York: Simon & Schuster, 1960 (OOP).

Plowden, David. *The Hand of Man on America.* Washington, D.C.: Smithsonian Institution Press, 1971.

———. *Bridges: The Spans of North America.* New York: Viking Press, 1974.

———. *Commonplace.* New York: E. P. Dutton, 1974.

Photography Year. New York: Time-Life Books, yearly.

Photojournalism: Mary Ellen Mark & Annie Leibovitz, The Woman's Perspective. Text by Adrianne Marcus. Los Angeles: Alskog/Peterson Publishing Company, 1974.

Private Realities: Recent American Photographs. Greenwich, Conn.: New York Graphic Society, 1974.

Porter, Eliot. *The Place No One Knew—Glen Canyon on the Colorado.* New York: Sierra Club/Ballantine, 1966.

———. *In Wilderness Is the Preservation of the World.* New York: Sierra Club/Ballantine, 1967.

———. *Summer Island.* New York: Sierra Club/Ballantine, 1968.

Purcell, Rosamond W. *A Matter of Time.* Boston: Godine, 1975.

Riboud, Marc. *Face of North Vietnam.* New York: Holt, Rinehart & Winston, 1970.

Rooney, Ed, editor. *The Nikon Image.* New York: EPOI, 1975.

Rothstein, Arthur. *Photojournalism.* New York: Amphoto, 1965.

Sander, August. *Men Without Masks.* Greenwich, Conn.: New York Graphic Society, 1973.

Seymour, David. *ICP Library of Photographers.* New York: Grossman Publishers, 1974.

Shahn, Ben. *The Photographic Eye of Ben Shahn.* Edited by Davis Pratt. Cambridge, Mass.: Harvard University Press, 1975.

Shirakawa, Yoshikazu. *Eternal America.* New York: Kodansha International/USA Ltd., 1975.

Aaron Siskind. Rochester, N.Y.: George Eastman House, 1965.

J. Frederick Smith: Photographing Sensuality. Text by Sean Callahan. New York: Alskog/Thomas Y. Crowell, 1975.

Smith, W. Eugene. *Minamata.* New York: Holt, Rinehart & Winston, 1975.

W. Eugene Smith: His Photographs and Notes. Millerton, N.Y.: Aperture, 1969.

Steichen, Edward. *A Life in Photography.* New York: Doubleday, 1963.

———. *The Bitter Years: 1935–1941.* New York: Museum of Modern Art, 1962.

Bert Stern: Photo Illustration. Text by Jim Cornfield. Los Angeles: Alskog/Peterson Publishing Company, 1974.

Stouman, Lou. *Can't Argue With Sunrise.* Millbrae, Ca.: Celestial Arts, 1975.

Strand, Paul, and Nancy Newhall. *Time in New England.* New York: Oxford University Press, 1950 (OOP).

———. *Paul Strand: A Retrospective Monograph.* Millerton, N.Y.: Aperture, 1972. Stryker, Roy Emerson, and Nancy Wood. *In This Proud Land.* Greenwich, Conn.: New York Graphic Society, 1973.

Szarkowski, John. *Looking At Photographs.* New York: Museum of Modern Art, 1973.

———. *The Photographer's Eye.* New York: Museum of Modern Art, 1966.

Tice, George A., *Fields of Peace.* New York: Doubleday, 1970.

———. *Paterson.* New Brunswick, N.J.: Rutgers University Press, 1972.

Tucker, Anne, ed. *The Woman's Eye.* New York: Knopf, 1973.

Uelsmann, Jerry. *Silver Meditations.* Dobbs Ferry, N.Y.: Morgan & Morgan, 1975.

Vishniac, Roman. *Roman Vishniac.* Text by Vishniac and Euegene Kinkead. ICP Library of Photographers. New York: Grossman Publishers, 1974.

Ward, John L. *The Criticism of Photography as Art.* Gainesville, Fla.: University of Florida Press, 1970.

Weiner, Dan. *Dan Weiner.* Text by Weiner, Arthur Miller, and Alan Paton. ICP Library of Photographers. New York: Grossman Publishers, 1974.

Weston, Brett. *Voyage of the Eye.* Millerton, N.Y.: Aperture, 1975.

Weston, Edward, and Charis Wilson Weston. *California and the West.* New York: Duell, Sloan and Pearce, 1940 (OOP).

———. *The Daybooks of Edward Weston: Vol. 1 Mexico* (1961), and *Vol. 2 California* (1966). Edited by Nancy Newhall. Rochester, N.Y.: George Eastman House.

———. *Edward Weston: Photographer.* Millerton, N.Y.: Aperture, 1965.

———. *Leaves of Grass.* Reprint. New York: Two Continents Publishing Group, 1976.

Whiting, John. *Photography Is A Language.* New York: Ziff-Davis, 1946 (OOP).

Willoughby, Bob. *The Platinum Years.* Text by Richard Schickel. New York: Random House, 1974.

Winogrand, Garry. *Women Are Beautiful.* New York: Light Gallery/Farrar, Straus & Giroux, 1975.

———. *The Animals.* New York: Museum of Modern Art, 1969.

Writer's Market. Cincinnati: Writer's Digest, yearly.

Zakia, Richard D. *Perception and Photography.* Englewood Cliffs, N.J.: Prentice-Hall, 1975.

Zimmerman & Kauffman: Photographing Sports, with a section by Neil Leifer. Text by Sean Callahan and Gerald Astor. New York: Alskog/Thomas, Y. Crowell, 1975.

Camera Guides

All published by Amphoto, New York:

Official Nikon Nikkormat Manual, Amphoto Editorial Board

Nikon-Nikkormat Handbook, Joseph D. Cooper, loose-leaf

The Minolta Book, Clyde Reynolds

Minolta System Handbook, Joseph D. Cooper

The Canon Manual, Paul Jones

The Canon Reflex Way, Leonard Gaunt

Konica Autoreflex Manual, Lou Jacobs Jr.

The Honeywell Pentax Book, Clyde Reynolds

The Honeywell Pentax Way, Herbert Keppler

Leica and Leicaflex Way, Andrew Matheson

Hasselblad Way, H. Freytag

Olympus Camera Guide, Lou Jacobs Jr.

Periodicals

Aperture. Aperture, Inc., Millerton, N.Y.

Camera. C. J. Bucher Ltd., Lucerne, Switzerland.

Camera 35. Popular Publications, 420 Lexington Ave., New York, N.Y. 10017.

Color Photography Annual. Ziff-Davis Publishing Co., 1 Park Ave., New York, N.Y. 10016.

Invitation to Photography. Ziff-Davis Publishing Co., 1 Park Ave., New York, N.Y. 10016.

Modern Photography. ABC Leisure Magazines, 130 East 59th St., New York, N.Y. 10022.

Peterson's PhotoGraphic Magazine. Peterson Publishing Co., 8490 Sunset Blvd., Los Angeles, Ca. 90069.

Photomethods. Ziff-Davis Publishing Co., 1 Park Avenue, New York, N.Y. 10016.

Popular Photography. Ziff-Davis Publishing Co., 1 Park Ave., New York, N.Y. 10016.

Studio Photography. PTN Publishing Co., 250 Fulton Avenue, Hempstead, N.Y. 11550.

Technical Photography. PTN Publishing Co., 250 Fulton Avenue, Hempstead, N.Y. 11550.

35mm Photography. Ziff-Davis Publishing Co., 1 Park Avenue, New York, N.Y. 10016.

Out-of-Print Book Source

The Photographer's Bookshelf, 65 W. 90th Street, 26D, New York, N.Y. 10024; will send free catalogue and invites "want lists."

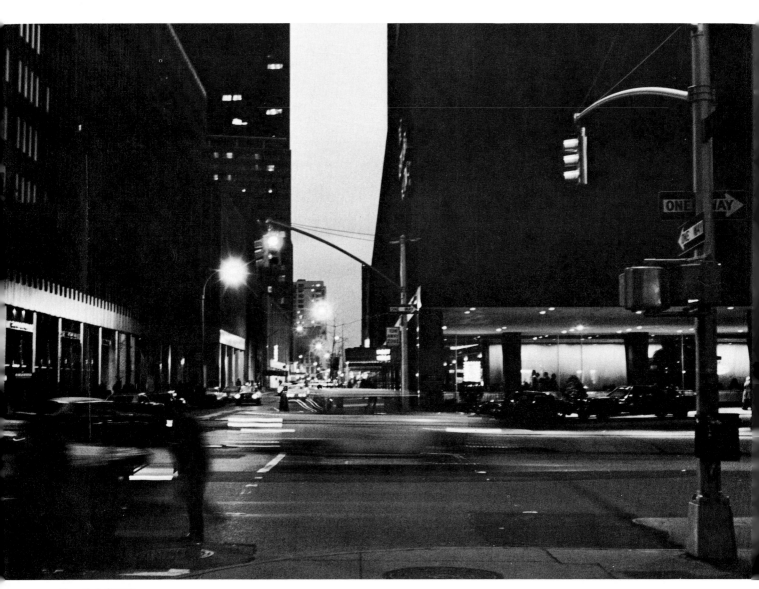

New York Streets

INDEX